NOVEMBER

PANDEMIC DEATH!

RACIST POLICING!

FASCIST MILITIAS!

CLIMATE CHANGE!

THOMAS SANKARA

BE WELL +

"I would like to leave behind me the *conviction* that if we maintain a certain amount of caution and organization we deserve victory.

"You cannot carry out fundamental change without a certain amount of *madness*. In this case, it comes from nonconformity, the courage to turn your back on the old formulas, the courage to invent the future. It took the madmen of yesterday for us to be able to act with extreme clarity today. I want to be one of those madmen.

"We must dare to *invent* the future."

E(ditors)

EDITOR & CREATIVE DESIGNER
Ben Stahnke

MANAGING EDITOR
Ethan Deere

ASSOCIATE EDITORS
Jarrod Grammel
Christian Noakes
Samuel Parry
Antony LeRoy

EDITORIAL BOARD
Joshua Hodges
Shane L. Pick
Seán Ó Maoltuile
Zhong Xiangyu
Molaodi Wa Sekake

CONTRIBUTING EDITORS
Red Starr
Tharron Combs
Chris Costello

SOUTH AMERICAN EDITOR
Tony Chamoles

RESEARCH AFFILIATION
*The Center for
Communist Studies*

PUBLISHER
Iskra Books

Peace, Land, and Bread strives to be a leading voice of international Marxist-Leninist scholarship, offering communist perspectives on politics, history, ecology, economics, literature, and aesthetics. Released quarterly, the print journal is dedicated to the publication of rigorous, peer-reviewed, and avant-garde work.

COST
$19.50 US (print)
Free (online)

SUBMISSION GUIDELINES
peacelandbread.com/
submissions
editors@peacelandbread.com

Copyright © 2020 Iskra Books

Peace, Land, and Bread is brought to you by the research fellows at the Center for Communist Studies. The CCS is an international research center engaged in academic and public scholarship dedicated to the advancement of Marxist-Leninist theory and practice.

The CCS was founded in 2017 by three early-career researchers and has since grown to a diverse and lively international fellowship of academic-activist scholars engaged in various aspects of research on the intersection of communist studies and law, philosophy, history, ecology, education, activism, art, literature, and theology. The CCS exists to foster inter and trans-disciplinary research amongst communist scholars and activists, and to build bridges between researchers, writers, theorists, and activists across the globe. At present, our CCS research fellows live and work in Brazil, Ireland, Vietnam, Africa, Australia, Wales, Canada, and the US.

In addition to *Peace, Land, and Bread*, the CCS research fellows are engaged in diverse projects such as the podcast *People's Pulse Radio*, the creation of audio texts, art, and agitpróp, longitudinal research projects, dissertation and thesis projects, as well as the translation and preparation of out-of-print works of communist theory, writing, journalism, and more.

Peace, Land, and Bread is a vibrant reflection of our collective academic vision: diverse and rigorous peer-reviewed scholarship, with a place for all disciplines and peoples. We are creating a platform for Marxist-Leninist thought through which we hope to raise awareness on the carcinogenic nature of capitalism, and the scientific sustainability of communism.

We can be contacted at:
editors@peacelandbread.com
center@communiststudies.org

F(eatures)

D (epartments)

C(ontributors) (omrades)

TAYLOR GENOVESE is a Ph.D. Candidate in the Human and Social Dimensions of Science and Technology program at Arizona State University, where he draws on his background in sociocultural anthropology, political theory, and religious studies. His research focuses on investigating the overlaps, continuities, disjunctions, and distortions of techno-utopianism—from the Russian Cosmists at the turn of the 20th century to Silicon Valley technologists at the turn of the 21st. Taylor is an organizer with AFT Academics and the Phoenix chapter of the IWW. More at taylorgenovese.com or on Twitter @trgenovese.

CHRISTIAN NOAKES is an urban sociologist and geographer whose work is grounded in historical materialism and anti-imperialism. Much of his work looks at the relationship between capitalism and the built environment. He has contributed to several publications including *An Spréach, Marxism-Leninism Today*, and *Cosmonaut*.

SAMUEL PARRY is a Ph.D. student in Political Economy at Cardiff University, where he studies the links between culture, geography and the economy through a Marxist lens to explain the peripherality of stateless nations in Europe, namely his home of Wales. Sam holds an MSc in Welsh Politics and Governance from Cardiff University and a BSc in Government from the London School of Economics. More widely, he is researching the vi- ability of using development and de- pendency theories to explain the pe- ripherality of areas at the edge of Europe and looking how the EU entrenches these inequalities.

AMAL SAMAHA is a Lebanese-Australian writer living in Aotearoa. They are currently writing a book of recollections from the Ihumātao campaign against developments on confiscated Māori land, and study history and politics at Victoria University, Wellington.

JACKSON ALBERT MANN is a Ph.D. Candidate in Ethnomusicology at the University of Maryland, College Park. He is a member of Democratic Socialists of American and co-administrator of the Democratic Socialists of America Leftist Music & Art Repository.

LUCAS HUANG is a classically trained violinist and an aspiring labor attorney. He is currently studying Management Information Systems, and aims to apply his experiences in practical work. When not studying Marxist theory, he can often be found practicing traditional Chinese Wushu or learning new recipes from his relatives in Shanghai.

MARK LaRUBIO is an ASU Ph.D. student in English Literature. They are a Critical Theorist who explores the beginnings of Capitalism through their work in the Early Modern Period. Their areas of expertise are Economic, Queer, and Critical Race theory. They are currently working on a forthcoming book titled *The Market of Eden* for CCS's Iskra Press.

SERGIO DIAS BRANCO holds a Ph.D. from the University of Kent, and is Assistant Professor of Film Studies at the University of Coimbra, Portugal. His latest book is *O Trabalho das Imagens: Estudos sobre Cinema e Marxismo* [*The Work of Images: Studies on Cinema and Marxism*] (Lis-

bon: Página a Página, 2020). He is a member of the Portuguese Communist Party, a trade unionist affiliated with the National Federation of Teachers and sits on the Executive Board of the General Confederation of the Portuguese Workers (CGTP-IN).

JARROD GRAMMEL is a worker, political philosopher, and historian. He holds a Bachelor's degree in philosophy from George Washington University with a minor in history. There he focused on political philosophy and economic history, and took his senior philosophy seminar on the Philosophy of Fascism and anti-Fascism.

ETHAN DEERE holds a Bachelor's Degree in Secondary Education with a Concentration in Life Sciences. His research interests include the intersection between natural science, education theory, philosophy, and Marxist-Leninist theory and practice. Ethan is currently employed as a high school science teacher.

JOE DWYER has, since July 2016, been Sinn Féin's Political Organiser for Britain and Office Manager for the party's London Office in Westminster. Prior to this, he was a student at the University of Liverpool's Institute of Irish Studies. He was the recipient of a first-year scholarship and spent a semester of his second year studying at the National University of Ireland Galway. Whilst in Liverpool, he was a 'Unite the Union' activist and sat on the North-West Young Members Committee. He holds a Degree of Bachelor of Arts with Honours in Irish Studies and Politics

JOHN FORTE is a high school history teacher, co-chair of South

Jersey Democratic Socialists of America, and grad student at Pace University.

BEN STAHNKE is a Ph.D. Candidate of Political Ecology and a doctoral fellow in the department of Environmental Studies at Antioch University, where he is currently writing his dissertation on the intersection of climate migration, border militarization, and dialectical theory. Ben holds a M.A. in social and political philosophy and a M.S. in environmenal science, and his writing has been featured with the CPUSA, the Hampton Institute, *Forward! Popular Theory and Practice, Climate and Capitalism, Peace, Land, and Bread*, and elsewhere.

UMA ARRUGA is a prospective history researcher and consultant with a focus on anti-fascism and armed conflicts. Born in Barcelona in 1998, Uma is now currently studying a Master of Arts in International War Studies in Germany.

DONALD COURTER is an American 21st century Marxist-Leninist journalist, political analyst, and historian. He is living and working in Moscow as RT International's youngest News Anchor and Correspondent, and is the host of *TheRevolutionReport* YouTube channel. Donald graduated from Rutgers University – New Brunswick in New Jersey, USA, where he completed a Bachelor's degree in history, specializing in the late-Soviet period, and another in Russian language and literature. He is originally from East Brunswick, New Jersey.

JOSHUA CALEB GOVENDER is a member of the *Economic Freedom Fighters* in South Africa. He

is passionate about social justice and has flare for history. His involvement in radical revolutionary politics has earned him the name 'Lil Gandhi' by his peers.

ANTON REGALA is a poet and a revolutionary socialist from Southeast Asia. He is involved in several protests and mobilizations to further advance the interest of the working class.

AZRIEL ROSE *bio forthcoming online.*

DYLAN PARSONS is a poet and student organizer from West Virginia. Along with being the founder and president of his university's socialist student organization, Dylan is also a member of the West Virginia chapter of the International Workers of the World and sits on the executive committee of his state's Green Party.

JAKE EDGAR is a poet, father, husband and food service worker from Portland Oregon. He tries to write bearing in mind the notion that "the personal is political." He hopes that the world won't go up in flames before we have a chance to try something better

JENSEN SAERE is a 24-year-old communist living unwillingly in the United States with a very patient and supportive husband. He is a self-taught photographer and poet, as well as a student of psychology and social work.

JOHN BEACHAM is a socialist, a podcast host, and a college writing teacher who writes political commentary, and poetry, some code, and science fiction. He is founder of MASS ACTION podcast and publications platform: https://www.mass-action.org.

He would bird more if he could. Over the last twenty years or so, Beacham has organized hundreds of mass protests for social justice. Over the same period, he has organized even more socialist educational events. Beacham now lives in the Seattle area.

SANDY DI YU is an artist, writer and researcher currently based in London, UK. Originally from Canada, she obtained an MA in Contemporary Art Theory from Goldsmiths, the University of London in 2018 following her BFA in visual arts and philosophy. She has exhibited her paintings internationally, and her writings have appeared in various publications. Her current research interests include the dissolution of temporality in digital systems and Marxist-feminist critiques of technology.

JOHN SCHLEMBACH has been writing poetry for a number of years, with a heavy influence from Brecht and other working class writers. During this time of pandemic, he hopes that his writing will help to build mass class consciousness in the US.

KONSTANTINOS DIMOPO is a student of History and Political Science with a focus on the early Soviet Union and Marxist political theory respectively.

DUNC X is an artist and anarcho-communist revolutionary based in occupied *Akimel O'odham* land, so-called Phoenix, Arizona, USA. His work utilizes a punk/DIY-ethic and the brash collision between simple colors along with unfiltered imagery to illustrate the ridiculousness of contemporary, Euro-American, capitalist society, and to aid the Revolutionary cause and message.

C(ontributors)
(omrades)

MICHAEL ARAUJO is a 50 year old union rigger, and a father of three. He lives in Rhode Island, in the US.

MARTINS DEEP is a Nigerian poet and photographer. He is passionate about documenting muffled stories of the African experience in his poetry & visual art. Writing from Kaduna, or whichever place he finds himself, the acrylic of inspiration that spills from his innermost being tends to paint various depictions of humanity/life in his environment. His creative works have appeared, or are forthcoming on *Barren Magazine*, *Chestnut Review*, *Mineral Lit Mag*, *Agbowó Magazine*, *Writers Space Africa*, *Typehouse Literary Magazine*, *The Alchemy Spoon*, *Dream Glow*, *The Lumiere Review*, *Variant Literature*, and elsewhere. He is also the brain behind *Shotstoryz Photography* and can be reached on Twitter at @martinsdeep1

NICHOLAS HEACOCK has been published in magazines and journals including: the *Journal of NJ Poets*, *Lips*, *Prism*, and other small college literary journals. He has an Associate's Degree in Creative Writing and currently works in the field of computer technology.

PRAKASH KONA is a writer, teacher, and researcher who lives in Hyderabad, India. He is Professor at the Department of English Literature, The English and Foreign Languages University (EFLU), Hyderabad, India.

SINDYAN is a Marxist-Leninist and a medical science and biology student from the Middle East.

RUSHAM SHARMA is a 17-year-old student who loves to read, learn, unlearn, and repeat. They are looking for ways to create tangible changes by learning more about Marxism-Leninism, along with pursuing Law as a career ahead. They love learning about gender and class, along with the pedagogic changes these can make to our education systems as a whole.

S.T. BRANT is a teacher from Las Vegas. He has publications in/coming from *EcoTheo*, *Door is a Jar*, *Santa Clara Review*, *Rain Taxi*, *New South*, *Green Mountains Review*, *Another Chicago Magazine*, *Ekstasis*, *8 Poems*, a few others. You can find him on Twitter @terriblebinth or Instagram @shanelemagne.

SUGAR LE FAE is an activist, musician, photographer, Radical Faerie, and prize-winning poet. Sugar le Fae (Ph.D.) has taught English Composition and Literature for over 15 years; served as Social Media Director (2012) and Poetry Editor (2013) of PRISM international (UBC); and published dozens of poems and essays across North America. Follow Sugar on Instagram @sugar_lefae.

REBEL POLITIK is a New Delhi-based visual artist and freelance multimedia journalist, who explores and uses various art forms (including photos and videos) to produce agitational propaganda material for the cause of working class and people's struggles across the world. He is part of the central communications department of the Communist Party of India (Marxist-Leninist) Liberation.

"ALL SCIENCE would be SUPERFLUOUS if the OUTWARD appearance and the ESSENCE OF THINGS DIRECTLY COINCIDED."

Capital Vol. III

K III

Communist Publishing in an Era of Uncertainty:

An Introduction to the Third Issue of *Peace, Land, and Bread*

Editorial Board

Today, while the neoliberal state and the capitalist class remain *infatuated* with the hourly convulsions of obscure financial statistics, the tables and graphs produced by epidemiologists seem to tell an unrelated story—one both more clear and more devastating. Capital alone offers no salvation for the ravages of an uncontrolled pandemic. The dual logics of profit and accumulation are directly opposed to epidemiology, to virology, and to public health. And, as we are now able to juxtapose the pandemic impacts in the United States against those of the socialist states—against the examples provided by China, Vietnam, and others—we are able to see most clearly what has been true all along: that the neoliberal state and the capitalist class care *nothing* for the lives of the public. Profit and accumulation, *rested atop a pile of corpses*, are their only motivation. Capitalism has utterly failed public health and well-being.

We are witnessing today what occurs when the neoliberal state comes up against a problem untethered from the logic of the market, and we are suffering all the more for it. Amidst the pandemic, amidst political upset, and amidst social uncertainty, capital accumulation continues both unabated and unfettered, concentrating the sum total of an *unimaginable* wealth into ever fewer hands.

As the domestic politics of the empire descend into an ever greater absurdity, things like systematized racism, electoral uncertainty, and a complete dismantlement of public trust in the institutions of gov-ernment work to create a maelstrom of friction. The empire itself sits upon the precipice of catastrophe, and still the needs of the working class remain unheeded. As the imperial state itself is contested among warring factions of the capitalist class, the needs of the working poor are increasingly neglected—the great masses left alone with no social sureties amidst death, illness, houselessness, and unemployment. We are left with a barrier, one we know all too well by now, between separated worlds: the world of *capital* on one hand and the world of *life* itself on the other.

For those of us who try as we might to live our daily lives in the *latter* world, we are forced to face the palpable consequences of the whole capitalist system bearing incessantly upon us, intensifying by the hour: unemployment and underemployment, lack of or poor quality healthcare, unsafe working conditions, looming and ever increasing rents, stagnated wages, loss of social benefits, hunger and homelessness, state violence (both threatened and actual), sanctions and coups, and increasing social frictions grounded in a racism as old as capitalism itself.

At this juncture, we are faced with such inhumanity that we would do well to recall Gramsci's maxim: "Pessimism of the intellect, optimism of the will." Amidst a disputed election, we know that neither US presidential candidate will change these first nature facts, nor will we find our saviors in the ruling classes of Western and Northern Europe. It is the responsibility of revolutionaries everywhere—those both within and outside of the imperial core—to provide not just a clear view of the catastrophe we

face, but to guide society toward a just solution, to provide a diagnosis, and the hope for a cure. We are *pessimistic* because we see the vast martial and ideological arsenal of the ruling class; *optimistic* because we know it is the will of the masses that shapes history.

As Evo Morales relates in the introduction to Vijay Prashad's *Washington Bullets*, "It is likely that the world that will emerge from the convulsions of 2020 will not be the one that we used to know. Everyday, we are reminded of the need to continue our struggle against imperialism, against capitalism, and against colonialism. We must work together towards a world in which greater respect for the people and for Mother Earth is possible."[1] It is in this spirit we hope that the third issue of Peace, Land, and Bread makes a lively contribution to the growing literature of revolutionary theory with which we confront—and construct—this coming world.

Opening the issue, Taylor Genovese argues for a compelling reimagining of a *communist morality* with which to confront the new world. On page 38, Christian Noakes provides a poignant and striking account of dispossession, displacement, and community development; and on page 52, Sam Parry argues strongly for that we view the modern European Union as a new era in European imperialism, rather than a salvific force for global reparation. Our poetry and arts section, *Poiesis and Physis*, is the biggest it has ever been with over thirty pages of revolutionary art, writing, and poetry. And, as we continue to establish our journal as the leading voice of critical scholarship in the Marxist-Leninist tradition, we promise to ensure that revolutionary arts will always have a place alongside revolutionary scholarship.

On page 101, Amal Samaha pays brilliant tribute to the late David Graeber with an innovative and groundbreaking synthesis of Graeber's own writing with the work of Jürgen Habermas and Zak Cope in *Innovators, Bullshitters, or Aristocrats: Towards an Explanation of Unproductive Work*. Following Samaha, Lucas Huang writes a brilliant, must-read treatise on the intersection of idol culture and capital in *Idol Empire: East Asia's Pop-Music Industry and the Conquest of Creativity*. And in our newest section, *Litteratura Comunista*, we present three masterfully written articles on the intersection of musical theory, literary analysis, film studies, and Marxism by Jackson Albert Mann, Mark LaRubio,

and Sérgio Dias Branco; as well as a poignant review of renowned critical theorist Mackenzie Wark's newest book, *Sensoria: Thinkers for the Twentieth Century*.

In our biggest history section yet, *Things Before: History and Materialism*, we bring you articles by Joe Dwyer, John Forte, and our editor Ben Stahnke, as well as critical analyses by Uma Arruga, and Donald Courter. In short, this issue of *Peace, Land, and Bread* is nothing short of Herculean. At almost 300 pages, issue three is our biggest issue yet.

We on the editorial staff bring you *PLB* as a labor of love. As committed scholars and activists, *Peace, Land, and Bread* is part of our contribution to the great and lengthy history of revolutionary writing in the era of capital; it sits in concert with several hundred years of revolutionary publishing—publishing which has often been outlawed, and has seen editors and authors exiled, killed, or driven underground. We bring you *Peace, Land, and Bread* in this spirit: in the spirit of writing and research amidst dark times, of radical scholarship in the face of empire, and in the spirit of both pessimism and hope—pessimism that what we now face upon the eve of what might be the most troubling winter in a hundred years is nothing short of historic, and optimism that, as communists and as radicals, we shall persevere as we always have: through community, camaraderie, and connection—and overall with solidarity.

Marx famously wrote that revolutions are the locomotives of history. We continue to walk the tracks placed before us—laying down our own tracks upon which the next generations will build ever farther—with Marxism-Leninism as our guiding light, as the science on which we ground our revolutionary work, our community, and our hope.

ENDNOTES

1. Morales, Evo. "Introduction to *Washington Bullets*," by Vijay Prashad. *Washington Bullets*. Monthly Review Press, p. 11, 2020.

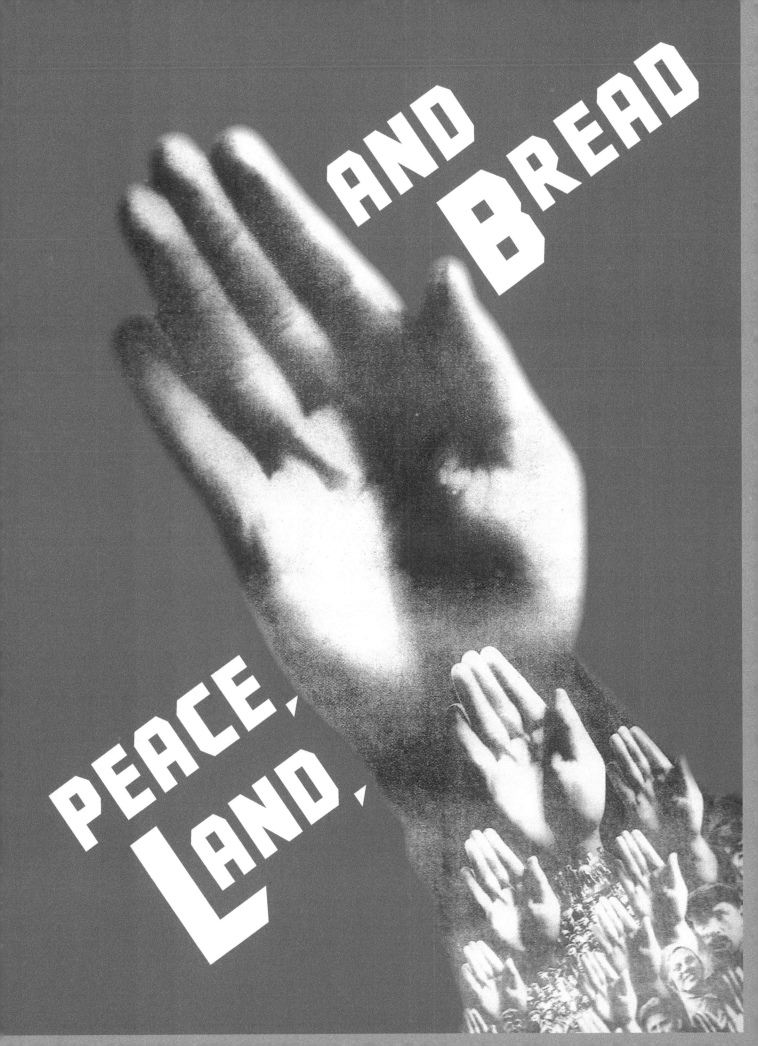

capitalism of free competi

its indispensable regulator

Exchange, is passing away.

alism has come to take its pl

ng obvious features of somet

ient, a mixture of free comp

and monopoly. The question r

arises: into what is this

alism "developing"? But

eois scholars are afraid to r

question.

ty years ago, business

y competing against one anot

rmed nine- tenths of the

cted with their business o

manual labour. At the pre

our banks: Si...

Russian, inte...

Discount Bank

(signature)

413.7 - 859.1

7 Kurt Heinig

THE NECESSITY OF
COMMUNIST
MORALITY

by Taylor R. Genovese

THE UTTERANCE of morals or morality within a communist space is one that may, in the best of cases, raise a few eyebrows or, in the worst of cases, summon calls for condemnation or accusations of being unscientific. The subject of communist morality is one that is often ignored within the broader revolutionary left, while at the same time—especially within our current insurrectionary moment—beckons to be engaged with.[1] When I speak with comrades participating in the revolts and rebellions erupting around the world, or those engaging in mutual aid efforts to bridge the failures of the imperial state in their response to the pandemic, I've had to confront my own relative discomfort—or, to put it more truthfully, my lack of ontological seriousness—concerning what seems to be the stark empirical tenacity of *good and evil* within our material world. These moral realties, while perhaps eliciting a scoff by Western intellectuals, are an obvious part of the lived experiences of many of the world proletariat.

As the hydra of neoliberalism begins its inevitable collapse, throwing capitalism once more into a global crisis—and thusly its im-

perialist head begins to twist fascistically from the periphery back inward toward the United States and Europe—these categories that before seemed abstract and idealistic suddenly become vivid and tangible. Every crack of the police baton across the back, every rubber bullet or tear gas container lodged into a bike helmet, every lie uttered and inscribed by the cops, every rebel disappeared off the street by the secret police, every choked breath of air laced with tear gas all become imbued with obvious, empirical, evil intent. And these examples do not even delve into the multiplicity of wider evils within the capitalist system, of which the so-called "justice system" acts as its armed and punitive wing. *Evil* is how these injustices are described—in a non-hyperbolic fashion—by those engaged in the frontlines of revolutionary activity. So why is morality eschewed and denounced in left academic discourse? Are morals solely the provenance of the reactionary right or the dreamy idealist?

Famously, Marx wrote very little on morality, at least directly. The reasons for this have been hotly contested, but I will synthe-

size this aversion with a couple of historical examples: the first is due to Marx equating morals with ideology. For Marx, concepts like justice, morality, good, and evil are to be analyzed applying the framework of historical materialism—these concepts are notions suspended within a society's superstructure wherein they spiral in a dialectical relationship with the means and relations of production, thereby assisting in the stabilization of a society's base.[2] Marx recognized that there exists a dialectical double-helix between the material/ideal and the abstract/concrete but, unlike his philosophical mentor Hegel, Marx (and Engels) insisted that this relationship blossoms first from that which is tangible—"in direct contrast to German philosophy which descends from heaven to earth, here it is a matter of ascending from earth to heaven."[3] Additionally, Marx is sometimes accused of being flippant or hostile to the idea that capitalism itself is an unjust system. Indeed, in *Capital*, he seems to describe that the exploitative extraction of profits from the worker by the capitalist is not an unjust social relation at all:

The owner of the money has paid the value of a day's labour-power; he therefore has the use of it for a day, a day's labour belongs to him. On the one hand the daily sustenance of labour-power costs only half a day's labour, while on the other hand the very same labour-power can remain effective, can work, during a whole day, and consequently the value which its use during one day creates is double what the capitalist pays for that use; this circumstance is a piece of good luck for the buyer [the capitalist], but by no means an injustice [Unrecht] toward the seller [the worker].[4]

Despite the word *Gerechtigkeit* (justice) barely appearing in Marx's writing, he remains far from taking an amoral stance.[5] His fiery descriptions of capitalism's injustices erupt from a righteous fury over the apparent immoral character of the entire system of production. In a later passage in *Capital*, he seems to back down from his previous outward amorality:

There is not one single atom of [capital's] value that does not owe its existence to unpaid labour...even if the [capitalist class] uses a portion of that tribute to purchase the additional labour-power [from the working class] at its full price...the whole thing still remains the age-old activity of the conqueror, who buys commodities from the conquered with the money he has stolen from them.[6]

Marx's consistent use of morally loaded words like "stolen," "exploited," "embezzled," etc. hint at an internal conflict that have led some Marxist scholars to suggest-

ed a controversial psychological explanation: while Marx may have *believed* that capitalism was immoral or unjust, he did not believe that *he believed* it was so—or perhaps he suppressed these instincts in an attempt to remain positivist or scientific.[7] It was in unguarded moments within his writing that Marx's communist morality shined through.

The same could be said in this passage by Engels, who starts with a materialist description of morals but, like his partner Marx, begins to let his guard down:

All moral theories have been hitherto the product, in the last analysis, of the economic conditions of society obtaining at the time. And as society has hitherto moved in class antagonisms, morality has always been class morality; it has either justified the domination and the interests of the ruling class, or ever since the oppressed class became powerful enough, it has represented its indignation against this domination and the future interests of the oppressed.

That in this process there has on the whole been progress in morality, as in all other branches of human knowledge, no one will doubt. But we have not yet passed beyond class morality. A really human morality which stands above class antagonisms and above any recollection of them becomes possible only at a stage of society which has not only overcome class antagonisms but has even forgotten them in practical life.[8]

Here Engels hints at a higher conception of morality—one that is disparate from solely class relations and antagonisms—or, as I will argue later, a time in which morals have withered away. He begins to steal a mischievous glance over the horizon toward a communist future, while still remaining grounded in the Marxist resolve that morality is an historical phenomenon produced by human beings and, as such, is entirely dependent upon a society's material relations.[9] That said, morality, much like religion, was looked upon by Marx as suspect, as he saw these metaphysical engagements as ultimately serving the bourgeoisie.

However, it becomes hard for me to think of morality as inherently an oppressive tool of the ruling class. After all, we would be hard pressed to find a communist who isn't drawn to Marxism—or any left tendency for that matter—who doesn't possess a strong, disciplined moral conviction that guides their actions and assists them in determining what is the right or wrong course of revolutionary action. And the choice that is deemed good/right—whether it is derived from a scientific or utopian framework—tends to be similar no matter the

tendency: a devotion to toppling capitalism, a love for humanity and the drive to assist in the liberation/empowerment of the dispossessed, the desire to bring about and defend communism, a rejection of racism, sexism, transphobia, homophobia, xenophobia, etc. It is only in the strategies for achieving these morally correct choices that the many left-tendencies begin to diverge. In short, I argue that a communist is foremost a *moral actor* and as such, we draw from an explicit, yet often nebulously defined, *communist morality*. In order to develop this assertion further, I will pivot from thinking with Marx and Engels to thinking with Lenin.

The Dialectics of Communist Morality

The concept of a communist morality is not a novel idea. Lenin confronts the myth that communism is an immoral, or at best amoral, system during a speech to the third All-Russia Congress of The Russian Young Communist League on October 2, 1920. He addresses this falsehood head on: "Is there such a thing as communist morality? Of course, there is."[10] Lenin argues that morality not only exists for a good communist, but it also serves as a uniting factor within communist organization—particularly in its ability to suss out and defeat who he calls "the exploiters."[11] That said, Lenin remains suspicious of any kind of morality that stands outside of class struggle. Much like Marx, he finds this formulation of morals to be synonymous with a *bourgeois morality*, which often places its moral and ethical positions upon the foundation of re-

ligion—specifically Christianity—and therefore, according to Lenin, these philosophies become part of the undemocratic dominion of the clergy.[12]

Consequently, Lenin saw a *moral* struggle being waged in a similar manner—and upon the same historical stage—as *class* struggle. Bourgeois morality is predicated on exploitation, with its ultimate goal being the annihilation of the working class—both of their spirits and their physical beings. In contrast, proletarian morality exists not only as a class unifier, but also as the motor of history, leading the way toward human liberation. Although Lenin explicitly and repeatedly states throughout his speech that communist morality is subordinated to the interests of proletarian class struggle, I argue that we must also consider additional dialectical relationships between morals and the revolution.[13] Namely, I argue that we must account for a relational moral dialectic between the proletariat/bourgeoisie, the individual/society, and the semiotic/nature.

Proletariat/Bourgeoisie

This dialectic is perhaps the most obvious to even the most novice student of communist philosophy. The bourgeoisie and the proletariat exist as the two fundamental classes since the Industrial Revolution—locked in an eternal struggle in which neither achieves complete victory until the other is entirely vanquished.[14] Ultimately, in each of these paired relational moral categories, with it being the most pronounced in the case of the proletariat/bourgeoisie, there exists this struggle—this core dialectic—of *oppression* and *subordination*.

To put it simply, bourgeois morality rests on a societal flattening of the world; at its core lies an unnuanced simplification of social categories. Let's take, for example, the classic moral trope of stealing. The "evil of stealing" is often touted as being proof of some kind of a universal moral imperative for humanity. Bourgeois moralists will often preach that throughout history, humanity understood that stealing was wrong, and it is only those that suffer from a pathology of immorality who resort to stealing the property of others. This is often asserted with very little historical evidence to back up such a claim—or the evidence is criminally cherry-picked. Furthermore, cross-cultural subtleties within the concept of "stealing" are often ignored. Relatedly, never have I heard this argument being made using anthropological evidence (probably because the ethnographic data is far too rich, nuanced, and is completely counter to the bourgeois Manichean worldview).

Of course, the great hidden truth in this kind of bourgeois moral proselytizing is that stealing is not inherently wrong in capitalism.[15] It happens every day. The development of the capitalist system itself is predicated on the theft of life and land from Indigenous peoples and the theft of life, labor, and place from the peoples of Africa. For a contemporary example, the United States government regularly rewards thieves, such as in the passing of the Emergency Economic Stabilization Act of 2008 —more colloquially known as the "bank bailout" in which bankers made off with billions of dollars following their deliberate crashing of the economy. Meanwhile, millions of working-class Americans were rewarded with broken lives—lost jobs, families, and homes. Today, many of us remain little more than indentured servants to the bourgeois state, drowning in our compounding student loan debt.

Additionally, corruption and bribes are so ordinary within the halls of bourgeois government that they have decided to bring the practice out from behind the curtain of illegality/immorality. To make bribing more palatable to the average American, they employed a modern capitalist tactic called "re-branding"—bribing is now referred to as "campaign contributions."[16] The effect is still the same: businesses pay enormous sums of money to lawmakers who, in turn, act as intermediaries. The businesses themselves employ lawyers to write legislation that would allow them to further pillage Indigenous land, hasten the degradation of the Earth, continue the theft of wages from the working class, and otherwise build a buffer of pilfered wealth to protect themselves from the next inevitable crash of capitalism and the accelerating collapse of the environment. The lawmaker then dutifully delivers this legislation to Congress for passage into law, thus reinforcing that this is a supposed legitimate, effective, and moral practice of governance.

Stealing only becomes a grave moral sin when the bourgeois hegemony is challenged. It is only when the proletariat begins, *en masse*, to expropriate food from groceries and merchandise from department stores that the appeals to (bourgeois) morality begin to flood social media, news networks, and tabloids. Of course, it's also no coincidence that all these commu-

nicative platforms are owned by the same couple of individuals. The last thing a capitalist wants is for the working class to get a very small taste of reclaiming what is rightfully theirs—the fruits of their labor. As has been demonstrated by the popular rebellions of the past ten years, but especially since 2016, the role of the oppressor and the subordinate are not static categories— these are dialectical relationships forged in struggle. The establishment of autonomous zones, the taking over and burning down of police stations, and the expropriation of goods, food, weaponry, and equipment from the state have cracked the apparent monolithic veneer of exclusionary bourgeois morality and illuminated good proletarian morality based on community, self-defense, mutual aid, and equitable justice. Put plainly, the moral actions of the rebels are laying the foundations for a possible communism. These initial forays into *moral proletarian oppression* of the bourgeoisie are necessary first steps toward eroding their hegemony and working toward their eventual eradication as a class.

Individual/Society

The relational dialectic between the individual and society is at the core of communist morality. It is also often the most fraught. The individual is not the society in microcosm, nor is a society just made up of self-interested individuals. The relationship between these two categories is fast-moving and ever-changing—and for that reason, it becomes challenging to attack the hegemony of bourgeois morality. A communist morality must always take as its conceptual point of departure what is best for the collective over the individual. The

word *conceptual* becomes important here as this detail is often ignored by communism's critics, and it's instead taken up as some kind of *absolute*. Many attacks initiated by anti-communists will assert that socialist experiments in the past and present are inherently driven by selfish authoritarian impulses in which the ends always justify the means. In actuality, this is a simple case of psychological projection in which the bourgeoisie implicate their own cruel morals upon their enemies, since a philosophy in which the ends are justified by any means is vital to the survival of capitalism as a system.[17]

Often, anti-communists will trod out some perversion of an unsubstantiated quote from Lenin in which he supposedly said that "the rights of the individual are bourgeois fiction."[18] At best, this is an amalgam pieced together out of context. In fact, Lenin's ideas about the role of the individual in a socialist society were quite nuanced and they shifted considerably over time. First and foremost, Lenin held in high regard the notion of individual *talent*, and in many of his writings he expressed that the establishment of socialism would lead to a blossoming of the individual.[19]

This is largely because capitalist conditions necessarily suppress the creativity of individuals, which ends up transmogrifying on a societal scale. Much like in my previous example, this leads to an ironic projection about communism only generating drab, barracks-gray uniformity and dictatorial cheerlessness when, in actuality, these are the precise conditions produced by capitalism. One only needs to drive through any suburb in the United States to see capitalism's sprawling creation of dreary identical subdivisions and/or spend two minutes negotiating with a landlord or petty despot of a Homeowners Association to experience the cold, irrational logic of capitalism's authoritarian soullessness—but I digress.

I am focusing specifically on Lenin in this subsection because I feel that he was genuinely attempting to grapple with the complexities of the individual/society dialectic, particularly in its relationship with the development of communist morality. There are numerous historical examples for this —for example, his theorizing on the shift from the destructive tasks of revolution toward creative ones or his modification of the accelerated communistic practices of War Communism to the innovations of the New Economic Policy. His ultimate motivation— which may come as a surprise to his critics—has its roots in his deep and undying confidence that the proletariat is more than capable of developing, shaping, managing, and perfecting moral attitudes and mass movements themselves.[20]

Lenin's commitment to an uncompromising and independent Vanguard Party reached its peak in 1901–02 following his publishing of the influential pamphlet *What Is to Be Done?* However, following the first Russian Revolution in 1905, these ideas began to fade as he quickly recognized that the people themselves may be capable of organizing and carrying out revolution —or at least that a vanguard party might form more organically than he had initially theorized.[21] By the time he published his *April Theses* on the eve of the July Days and the October Revolution in 1917, he shocked many of his own Bolshevik base because it seemed as if he took an ultra-radical turn. The theses in his *Tasks of the Proletari-*

at in the Present Revolution included such iconoclastic proposals as: the transformation of the "predatory imperialist war" (World War I) into a revolutionary struggle to be launched against the world bourgeoisie; a rigid refusal to work with the Russian Provisional Government; the immediate transference of the entirety of state power to the system of established *soviets* (councils) modeled on the Paris Commune; the abolition of the police, the army, and the bureaucracy; the equitable leveling of all incomes; and the nationalizing of all lands, including banks.[22]

Lenin's *April Theses* laid the possibilities for an actually existing communist morality. While the demands were political, they were founded upon a sense of deep moral justice—reckoning with what would be best for both the individual and the socialist society he demanded be created from the ashes of the Provisional Government.

The moral draw was so powerful that even several anarchist affinity groups heeded Lenin's call, drawn to his Bukuninesque appeal for "a break-up and a revolution a thousand times more powerful than that of February."[23] As an aside, these "Soviet anarchists" fought so fiercely and loyally against the White Armies during the Civil War that Lenin praised them as "the most dedicated supporters of Soviet power."[24]

Following the establishment of the Soviet Union, Lenin did not cease trying to develop a communist morality that accounted for both the individual and Soviet society. He singled out the *subbotniks* (literally, Saturdayians), which was a movement initiated "by the workers on their own initiative" that spent Saturdays working without pay on public works projects in cities throughout the Union—in other words, quite literally building socialism.[25] In a manuscript entitled *A Great Beginning*, Lenin declares that the *subbotnik* movement is engaged in a struggle "more difficult, more tangible, more radical, and more decisive than the overthrow of the bourgeoisie."[26] Lenin himself was so impressed with this organic attempt at morally transitioning one's individual relationship to labor within society that he became a *subbotnik* himself, rolling up his sleeves and assisting workers in the shunting yards or helping lay bricks in the streets of Moscow.

Despite the organic success of the *subbotnik* movement, Lenin did not sink into the utopian logic that with the success of revolution came the immediate harmony of a working class for-itself. In his *How to Organize Competition?*, Lenin discusses how a society might organize itself in order to develop comradely competition in order to spark innovation—as well as how to combat those that act against their own/the so-

ciety's interest (he castigates these individuals with a variety of epithets: parasites, hangers-on, spongers, lackeys, etc.).[27] While not exclusively, these "hangers-on" metamorphize into the broader problem of the *kulak*, which is discussed and acted upon at great length just a few years later. Lenin and others were working to make sure that *competition* did not become designated "for-capitalist-use-only." Socialist competition, Lenin argued, was more than capable of surpassing the innovations of cutthroat capitalist competition by severing the "financial fraud, nepotism, [and] servility" from competitive practice and allowing workers to "display their abilities, develop the capacities, and reveal those talents, so abundant among the people whom capitalism crushed, suppressed and strangled in thousands and millions."[28]

Lenin then identified two foundational tenants for the development of a communist morality: (a) trust in the proletariat as an agentive class and (b) placing an emphasis on the development of political education programs to help channel intrinsic talent. He notes: "But every *rank-and-file* worker and peasant who can read and write, who can judge people and has practical experience, is capable of organisational work."[29] The great C.L.R. James found enormous inspiration in this sentiment, summing up Lenin's ideas and applying them to the anti-colonial struggle in his *Every Cook Can Govern*.[30] This sentiment further serves as the foundation of revolutionary praxis today and has been a proven moral model historically taken up by a variety of radical movements ranging from the Cuban Revolution to the National Liberation Front in Vietnam to the Black Panthers in the United States.

The project of building a communist morality bridging the individual with society is not without its dangers. One historical example that we can learn from is the Moral Code of the Builder of Communism adopted at the 22nd Congress of the Communist Party of the Soviet Union. This was an attempt to codify the terms of the relation of a person to Soviet society. However, this deontological method—like the vast array of religious decrees of virtue—is not dialectical nor is it materialist. When morals are inscribed and codified as commandments—particularly within a state structure—they have the potential to lose their ability to shift organically and dialogically as a society's material conditions shift. Without this ability to fluidly respond to, and intertwine with, the material conditions of the society as a whole, the risk of the individual becoming dominated and coerced by the values of the ruling class increases and, consequently, the project of morality becomes unmoored from the communist struggle.

Semiotics/Nature

This last subsection will be less comprehensive than the first two, but this in no way means it is less important. The way that we, as communists, make meaning out of (and with) Nature, both materially and otherwise, is paramount in this age of ecological collapse.

With the intensification of capitalist extraction and the resulting ecological fallout from this abusive relationship, it becomes exceedingly essential for (settler-)colonizers around the world to listen to what Indigenous peoples have been saying since the first European landed on foreign soil, eyes blazing with greed, surveying the land and its people and seeing only resources. The immorality of this semiotic torsion—that nature only exists for its materials—is an Enlightenment tradition that even contemporary Marxists struggle to overcome. Comrades at The Red Nation, the K'é Infoshop in the Navajo Nation, and the Táala Hooghan Infoshop in occupied Flagstaff have helped me considerably in working to overturn these Western biases.

Further afield, one can gain an enormous amount of knowledge regarding semiotics/nature by studying some of the early proletarian scientists, many of whom took the moral stakes of this dialectic quite seriously. Scientists like Vladimir Vernadsky theorized the interconnectedness between human beings and nature. In 1926, he published his seminal work *The Biosphere* in which he essentially outlined a version of the Gaia Hypothesis fifty-three years before James Lovelock released his *Gaia: A New Look at Life on Earth*.[31] While not succumbing to neo-vitalism, Vernadsky provided a material analysis that illustrated the symbiotic and interconnected nature of our planet.

Vernadsky's legacy on the semiotic/nature dialectic continues to influence contemporary Marxist theory and science. I see his work having elective affinity with Georg Lukács' argument for the necessity of the "double transformation" between human social relations and humanity's relationship with Nature.[32] Exemplary work has been done in this regard by Cuban ecologists who—heeding Marx's notion of the "irreparable rift in the interdependent process of social metabolism"[33]—have been able to increase crop productivity while decoupling damaging industrial agricultural practices, thereby closing this metabolic rift through an alternative method of food production known as agroecology.[34]

Finally, the naturalist and anarchist philosopher Peter Kropotkin has given us a wealth of scientific field data illustrating the moral practices of non-human animals, highlighting that vicious self-interest and ruthless competition are not within the "nature" of any animal— human or other-

wise. Instead, these ideas must be taught, entrenched, and stabilized through collective social interaction.[35] Kropotkin argues that "animals living in societies are also able to distinguish between good and evil, just as [humans do]."[36] From ants to marmots to hedge sparrows, Kropotkin gives observational data illustrating that the entirety of the animal kingdom seems to live by a natural law of solidarity within their own communities, following the dictum "do to others what you would have them do to you in the same circumstances."[37] Many non-human creatures that are caught acting selfishly and devoid of solidarity within their communities regularly receive capital punishment from their comrades.

The Counter-Hegemonic Project of Communist Morality

So—what is to be done?

On the one hand, this is simply a call for the radical left to engage with moral discourse in order to meet our fascistic enemies head-on and not cede any ground to their putrid ideology. The fascists have historically and contemporarily mobilized discourse on morals quite effectively. Moral arguments tend to enliven the North Atlantic base, in part because of a phenomenon I call the *hegemony of the sermon*—embodied elements of theological performance and discourse that have been practiced and emulated within the sphere of Western politics for centuries.

These fascistic moral arguments have mutated rapidly in the past few years and are now an even more imminent threat to leftists—in particular, I'm thinking here of the evolution of QAnon and am reminded of Comrade Leroy's short profile on that movement's effective engagement with morals and the divine.[38] At the time of this writing, paramilitary fascists have initiated setting up roadblocks across wildfire evacuation routes under the moral guise that "ANTIFA" has set the fires that are devastating the Western United States. A quick material analysis would illuminate the fact that the intensity and frequency of these wildfires is largely due to capitalist accelerated climate change and human negligence[39]—but the fact that an irrational fascist moral fad has spread so quickly, and generated such a rapid armed response, demonstrates the need and necessity of a counter-hegemonic communist morality.

In order to contemplate how this might be accomplished, let's turn to thinking with the theorist who originally developed the idea of cultural hegemony: Antonio Gramsci. One of the most pertinent components of Gramsci's social theories were his distinctions between what he termed the *war of maneuver* and the *war of position*. The war of maneuver is the classic revolutionary model by way of a (para)military insurrection; but Gramsci argued that this method has been supplemented within late capitalism by a multifaceted, subterranean, *longue durée* cultural struggle—the war of position.[40] These terms originally emerged as descriptions of war tactics, but they have seen numerous intellectual engagements at the intersec-

tion of military theory and Marxism. Contemporary theorists to Gramsci—such as Engels, Lenin, and Trotsky—have each written on the nature of political strategy and war; as have countless others who were inspired by him, such as Mao Zedong, Vo Nguyen Giap, Che Guevara, Régis Debray, Josip Broz Tito, Kwame Nkrumah, and countless Soviet military theorists.[41]

A *communist morality*, then, must be built within the framework of Gramsci's war of position. A war of maneuver will not manifest without significant progress being made by a counter-hegemonic war of position. In some ways, this work is already underway. Despite the liberal tepidity of organizations like the *Democratic Socialists of America*, one thing they have succeeded in doing is introducing the word "socialist" back into the collective consciousness of the United States.

Decades of Red Scare brainwashing arrested even the utterance of the word in many political spaces; but today, numerous comrades in Generation Z seem to exemplify Gramsci's concept of the *organic intellectual* who—being far enough removed from Cold War propaganda—unflinchingly research and fight that war of position for socialism and communism. Why is this? I believe it has its roots in the base moral motivation for every budding communist: a yearning for the collective good life.

Marx frequently wrote that communism would create a society of abundance—most famously in his oft-quoted summation of the system: "from each according to [their] abilities, to each according to [their] needs!"[42] Without capitalist alienation and exploitation, goods and services could be organically provided through solidarity and collective ties.[43] The demand, for example, of peace, land, and bread is nothing if not a demand for the good life. That deep moral desire is the fuel which feeds a communist's resolve while engaging in a counter-hegemonic struggle.

Socialist and communist projects have long attempted this counter-hegemonic war of position—through the creation of dual power organizations, food programs, prison outreach and support, etc. However, what our Zoomer comrades teach us—through viral tweets or through TikTok's one-minute videos extolling poignant moral arguments for why one should be a communist—is that the *political* war of position is not enough; in fact, these political wars of position tend to veer into the realm of a war of maneuver quite often.[44] We must foster a disciplined focus on engaging in a *moral* war of position.

Our enemies have understood this for longer than we have. Through meme pages, message boards, and discord servers, the right-wing has mobilized easily digestible moral arguments for why fascism is supposedly good and right. At first, these looked to be deranged, on the fringe, and easy material for communists to turn up their nose and laugh. I, for one, am guilty of this short-sightedness. Little did we know, Hitler memes and the appropriation of Pepe the Frog were serving in a fascist war of position to corral and mobilize the latent racist, sexist, white patriarchy. Partially due to this careful—but probably unwitting—subterranean war of position altering the moral bourgeois hegemony, fascists are now able to publicly mobilize as heavily armed paramilitaries while even most liberals remain silent. This would have been unthinkable as recently as the 1990s.[45]

If fascists are already successfully implementing and utilizing Gramsci's theories (albeit perhaps unknowingly), then we have a *moral obligation to wage revolution*. To flip a sentiment from J. Moufawad-Paul—communism, then, is more than an historical and material necessity: it is a moral necessity.[46]

The Withering Away of Morals

By way of a brief conclusion, I wish to indulge in some grounded, speculative thoughts on what might happen to morals post-revolution by using Lenin's *State and Revolution* as a point of departure. The ultimate purpose of this article was to present a series of comradely provocations to initiate radical discussion (as opposed to a deeply researched article). As such, I feel a conclusion of this nature will fall within the general theme of this piece.

As communists, we are not moral nihilists. Whether we realize it or not, every day, we are using dialectics in order to weigh both tactical and strategic decisions. Likewise, we utilize this framework to deliberate upon individual and collective moral dilemmas. Within our current capitalist system, we must balance the *value* of what we say or do on behalf of communist revolution with the potential moral and political *costs* of those words and actions. If we alienate members of the proletariat with what we say and do, then we are failing to advance toward revolution. This is a delicate dialectic that each of us are tasked with every day of our lives, in addition to eking out an existence—trudging together slowly on this neoliberal treadmill.

But let's indulge in some collective dreaming together. Let's imagine, for example, that we have carried out what Lenin had theorized: we have smashed the bourgeois, capitalist state.[47] It might seem like I'm baiting, but this should not be a controversial statement. Marx, Engels, and Lenin all agreed that the bourgeois state must be smashed, particularly after they analyzed the demise of the Paris Commune. What follows *after* we smash the bourgeois state is where most anarchists and Marxists tend to butt heads.

Marx, Engels, and Lenin call for the *revolutionary dictatorship of the proletariat*. Marx saw the wistful beginnings of this from afar during the Paris Commune and named it using the parlance of the time. Initially, this "dictatorship" is where we would see the

proletariat squeeze the bourgeoisie out of existence through, among other methods, redistribution and expropriation. Next, a new "state" apparatus would be built inside the violently molted exoskeleton of capitalism. I put "state" in scare-quotes here because I believe that this core tension between anarchists and Marxists can begin to be resolved through comradely discussion and conceptual reconstitution—especially in the midst of accelerating planetary collapse in the 21st century.

So, I pose this question: should we call a workers' state, which is tasked with the oppression of the bourgeoisie, a state at all? If this hypothetical workers' state, which is completely controlled by the proletariat in service to their material conditions—and therefore, *does not act like any state that has ever existed in the history of humanity*—then is it even scientifically responsible to call this a state? If we begin to conceptualize and take seriously this organizational uncertainty as something outside of what we

traditionally think of as a "state," what dialectical openings might we see emerge? Ultimately, when this level of ambiguity exists within a period of struggle, we would be existing in a revolutionary stage that Lenin named the *withering away of the state*.[48] *Withering* not because it's fading—but because it's so dissimilar and unrecognizable to anything we have ever experienced that it would be like calling a butterfly a cocoon.

Why am I harping on this? In his speech to communist youth, Lenin said that "morality serves the purpose of helping human society rise to a higher level and rid itself of the exploitation of labour [therefore] communist morality is based on the struggle for the consolidation and completion of communism."[49] The development of communist morality does not solely serve the purpose of building a counter-hegemonic program and overthrowing capitalism. We must develop a communist morality because it will guide our actions as our material conditions drastically shift both before and *after* the revolution into the lower stage of communism. But then that begs the question: if our material conditions are such that the bourgeoisie has been eradicated and we are drifting toward the higher stage of communism—if our communist morals are no longer in the dialectic of oppression/subordination with bourgeois morals and, therefore, are suddenly not acting like any morals we have ever seen in the history of humanity—then do we still name them morals?

I would like to draw the reader back to the beginning of this essay in which I quoted Engels as he imagined "a really human morality which stands above class antagonisms *and above any recollection of them*."[50] I believe Engels was dreaming of a time when

both the state *and* morals had withered away—a time when they had, like a vaporous mirage or rainbow that blends so flawlessly with the sky, transformed into something so new and beautiful and unlike anything any human has ever seen before. That withering isn't a gentle vanishing of these prior conceptions; it is instead a reconstitution of concepts—they morph, they alter, they *wither*—into political objects that are discretely and distinctly unique to whatever objects they used to be. Only following this process of communist dialectical reformation do these oppressive political structures become unnecessary and begin to fade from our recollection.

Money can no longer exist when there is only communal abundance. Rights can no longer exist when there is only justice. Morality can no longer exist when there is only collective love and solidarity.

So, I implore you, comrades: we must, from every recess of our hearts and souls, cry in unison and paint upon our banners:

Smash bourgeois morality! Toward the withering away of morals!

Endnotes

1 One of the most glaring deficits of this piece is a lack of engagement with the rich tradition of liberation theology. Many liberation theologians (as well as a plethora of other traditions on the religious left) have grappled with the concept of morality and have reckoned their religious roots with Marxist philosophy quite skillfully. This is a topic I hope to explore in the future.

2 Marx 1904.

3 Marx and Engels 1998, 42.

4 Marx 1990, 301.

5 Additionally, although the word *Unrecht* is translated as "injustice" above, it has been interpreted in other editions of *Capital* as "a wrong" or "an injury." This point has also been raised by scholars such as William McBride (2016), who also points to the limited use of the word "justice" in Marx's work. However, McBride concurs that this does not necessarily prove that Marx was amoral and/or not attuned to capitalism's inherent injustices.

6 Marx 1990, 728.

7 Cohen 1983. This also begs the question of how one defines empiricism. Would not the conscious disregard of a moral reality as obvious as capitalism's evil actually be a rather unscientific endeavor? Perhaps not, but this is the concept work I'm attempting to tease out for radical discussion within this essay.

8 Marx and Engels 1987, 87–88.

9 Wills 2011.

10 Lenin 1966, 291.

11 Lenin 1966.

12 *Ibid*. It is especially important to historically contextualize this kind of visceral disgust toward theology. This allergy to any philosophy that utilized religion as its logical foundation was common during the Russian Revolution(s) since Orthodox Christianity was heavily implicated in the Russian state and served as the chief pillar of the tripartite reactionary political program of the imperial Russian Empire since Nicholas I (1796–1855)—that platform being Orthodoxy, Autocracy, and Nationality.

13 *Ibid*.

14 That said, it should be mentioned that this analysis leaves out, in particular, the nuanced power dynamics of the colonizer and colonized. For great works that analyze these important and complex histories, see Estes 2019 and Simpson 2014.

15 For a good, succinct argument on how theft is not only the basis of capitalism, but also markets in general, see Graeber 2014, 384–387.

16 I owe this insight to my late friend and mentor David Graeber.

17 Trotsky 1973.

18 Quoted from Gecys 1955. If Lenin ever uttered such a statement, isolating it in this way is most

disingenuous and, as I stated above, most likely horribly out of context. However, if I were to engage with this hypothetically, I could see this kind of position being used in a discussion about the progression of communism and the role of rights within a bourgeois state. Citizens of bourgeois states appeal to individual and collective rights precisely because we do not live under communism—it is because the framework of rights is the sole legal recourse we have under a system rife with inequalities. Granted, this same conceptualization of rights might still be necessary during a transition period—what Lenin named, in *State and Revolution* (utilizing Marx's formulation in the *Critique of the Gotha Programme*), "the first phase of communist society" (i.e. Socialism). However, as the state withers away and the higher phase of communist society (i.e. Full Communism) emerges, there would be no reason for rights to exist because inequalities themselves would cease to exist—hence, individual rights can be seen as a bourgeois fiction because when the working class focuses *all* their attention on using the *bourgeois* political framework of rights, it simultaneously legitimizes the bourgeois state while also closing off communist possibilities for the future. And all of this assumes the bourgeois state is even willing and capable of upholding rights! Their track record since at least the 1790s has been dismal at best.

19 Krutova and Krutov 1970.

20 I am not attempting here to erase Lenin's commitment to the Party form and vanguard, nor am I attempting to whitewash Lenin's historical mistakes. However, whether one is a critic or supporter of Vladimir Ilych, commentators tend to focus solely on his contributions to the Party form while ignoring some of his more populist, egalitarian sentiments. Much like the conceptual dialectics he grappled with throughout his life, Lenin the man was open about—and struggled with—his contradictory impulses toward both authoritarianism and egalitarianism. As communists, if we do not also recognize and analyze the complexities of Lenin and his ideas, we will end up teetering on the brink of idealism, threatening to fall out of a materialist analysis.

21 I owe a great deal of this theorizing to George Ciccariello-Maher, Viktoria Zerda, Todd Chretien, and the 50 or so other comrades who regularly attended GCM's Revolutionary Change seminars that took place in the Summer of 2020.

22 Lenin 1964a.

23 Avrich 1973, 16.

24 *Ibid.*, 20.

25 Lenin 1965, 411.

26 *Ibid.*

27 Lenin 1964b.

28 *Ibid.*, 404.

29 *Ibid.*, 409; Lenin's emphasis.

30 James 1956.

31 Vernadsky 1997. Vernadsky was a fascinating and influential Soviet scientist. As the title of his book suggests, he was the first to coin the term *biosphere* to mean how we use the concept today. He was a member of the Russian (and then Soviet) Academy of Science and was a chief advisor to the Soviet atomic bomb project. Toward the end of his life, he was one of the most adamant voices arguing for atomic energy and fission research—as well as for increasing Soviet uranium prospecting—but died prior to the establishment of atomic power projects.

32 Lukács 1978, 6.

33 Marx 1991, 949. Marx used the concept of "metabolism" (*Stoffwechsel*) to reference the exchange—and subsequent rupture induced by capitalist industrial agriculture—between human societies and the environment. For more on the concept of "metabolic rift," see Foster et al. 2010 and Stahnke 2020.

34 Betancourt 2020.

35 Kropotkin 1909; 2002.

36 Kropotkin 2002, 89.

37 *Ibid.*

38 Leroy 2020.

39 In the case of one of the wildfires in California, it was determined that the fire was started by a malfunctioning explosive charge as part of a so-called "gender reveal ceremony." This painful irony is palpable in that fascists are blaming leftists and Black Lives Matter activists for the fires when in reality it was caused by an oppressive and subjectivizing ritual equating biological sex with gender—a myth that

has been scientifically refuted many times but remains revered by right-wing and liberal traditionalists alike.

40 Gramsci 1971.

41 For more on this, see Egan 2013.

42 Marx 1978, 531.

43 Graeber 2014.

44 This is not necessarily a bad thing. Direct action, skirmishes with police, ICE, DHS, etc. is incredibly important *and should continue*. However, without a contingent of radicals focusing on a counter-hegemonic program to eat away at anti-communism, the war of maneuver will always fail. That said, let us heed this axiom attributed to Hugo Chávez: "let this be a peaceful, not an unarmed, revolution."

45 While the United States has always operated as implicitly fascistic, I implore the reader to remember that in the 1990s, the state waged numerous wars on underground fascist movements, from Neo-Nazis to the Ku Klux Klan. In the 1990s, the same folks who "back the blue" would probably be firing at them from places like Ruby Ridge or Waco.

46 Moufawad-Paul 2014, 31. As a side note, although it's rather obvious, I chose the name of this article as an homage to JMP's monograph.

47 Lenin 2014.

48 *Ibid*.

49 Lenin 1966, 294–295.

50 Marx and Engels 1987, 88, my emphasis.

Bibliography

Avrich, Paul. 1973. *The Anarchists in the Russian Revolution*. Ithaca: Cornell University Press.

Betancourt, Mauricio. 2020. "The effect of Cuban agroecology in mitigating the metabolic rift: A quantitative approach to Latin American food production." *Global Environmental Change* 63. doi: 10.1016/j.gloenvcha.2020.102075

Cohen, G.A. 1983. "Review of Karl Marx by Allen W. Wood." *Mind* 92 (367): 440–445.

Egan, Daniel. 2013. "Rethinking War of Maneu-ver/War of Position: Gramsci and the Military Metaphor." *Critical Sociology* 40 (4): 521–538. doi: 10.1177/0896920513480222

Estes, Nick. 2019. *Our History Is the Future: Standing Rock versus the Dakota Access Pipeline and the Long Tradition of Indigenous Resistance*. New York: Verso.

Foster, John Bellamy, Brett Clark, and Richard York. 2010. *The Ecological Rift*. New York: Monthly Review Press.

Gec ys, Kazys. 1955. "Communist Ethics." *Lituanus* (3–4). http://www.lituanus.org/1955/55_23_03Gecys.htm.

Graeber, David. 2014. *Debt: The First 5,000 Years*. Brooklyn: Melville House Publishing.

Gramsci, Antonio. 1971. *Selections from the Prison Notebooks*. New York: International Publishers.

James, C.L.R. 1956. "Every Cook Can Govern." *Correspondence* 2 (12). https://www.marxists.org/archive/james-clr/works/1956/06/every-cook.htm.

Kropotkin, Peter. 1909. *Mutual Aid: A Factor of Evolution*. New York: Doubleday.

———. 2002. "Anarchist morality." In *Peter Kropotkin, Anarchism: A Collection of Revolutionary Writings* edited by R.N. Baldwin. New York: Dover: 79–113.

Krutova, O.N. and N.N. Krutov. 1970. "Lenin on the Independent Initiative and Creativity of the Personality in the Moral Sphere." *Soviet Education* 12 (3–5): 153–173. doi: 10.2753/ RES1060-939312030405153

Lenin, V.I. 1964a. "The Tasks of the Proletariat in the Present Revolution." In *V.I. Lenin Collected Works* Volume 24. Moscow: Progress Publishers, 19–26.

———. 1964b. "How to Organise Competition?" In *V.I. Lenin Collected Works* Volume 26. Moscow: Progress Publishers. 404–415.

———. 1965. "A Great Beginning: Heroism of the Workers in the Rear. 'Communist Subbotniks.'" In *V.I. Lenin Collected* Works Volume 29. Moscow: Progress Publishers, 409–434.

———. 1966. "The Tasks of the Youth Leagues."

In *V.I. Lenin Collected Works* Volume 31. Moscow: Progress Publishers, 283–299.

———. 2014. *State and Revolution*. Chicago: Haymarket Books.

Leroy, Antony. 2020. "Queue Anon?" *Peace, Land, and Bread*. September 3. https://www.peaceland-bread.com/post/queue-anon.

Lukács, Georg. 1978. *Marx's Basic Ontological Principles*. London: Merlin Press.

Marx, Karl. 1904. Translated by N.I. Stone. *A Contribution to the Critique of Political Economy*. Chicago: Charles H. Kerr & Company.

———. 1978. "Critique of the Gotha Program." In *The Marx-Engels Reader* edited by Robert C. Tucker. New York: W.W. Norton & Company, 525–541.

———. 1990. *Capital: A Critique of Political Economy*. Volume 1. Translated by Ben Fowkes. London: Penguin Classics.

———. 1991. *Capital: A Critique of Political Economy*. Volume 3. Translated by David Fernbach. London: Penguin Classics.

Marx, Karl and Frederick Engels. 1987. *Collected Works*. Volume 25: Engels. New York: International Publishers.

———. 1998. *The German Ideology*. Amherst: Prometheus Books.

McBride, William L. 2016. "Evil in the philosophy of Karl Marx." *Journal of Chinese Studies* 1 (1): 1–10. doi:10.1186/s40853-016-0003-y

Moufawad-Paul, J. 2014. *The Communist Necessity: Prolegomena to Any Future Radical Theory*. Montreal: Kersplebedeb.

Simpson, Audra. *Mohawk Interruptus: Political Life Across the Borders of Settler States*. Durham: Duke University Press.

Stahnke, Ben. 2020. "The Poverty of Metabolic Rift Theory." *Peace, Land, and Bread* 2: 146–171.

Trotsky, Leon. 1973. *Their Morals and Ours. New York: Pathfinder*. Vernadsky, Vladimir. 1997. The Biosphere. New York: Copernicus.

Wills, Vanessa. 2011. *Marx and Morality*. Ph.D. Dissertation. Pittsburgh: University of Pittsburgh.

by Christian Noakes

Displacement of the Dispossessed

Community Development Under Capitalism

THE DISPOSSESSION of working class communities has always served as a prime avenue for the accumulation of capital. In places like the US this practice is aimed disproportionately at communities of color. However, the ideological dominance—and thus stability—of capitalism requires that this process be framed as benevolent or progressive. With regards to urban development, the bourgeois conception of community reinvestment is key.

Under capitalism, the concept of community reinvestment is not defined by the continuity or maintenance of relations between people in a particular place but by property value and potential profit. As such, many who invoke the term take devaluation for granted. The ecological common sense of urban change has in many ways evolved to justify not only the devaluation of place but its gentrification as well. Lenders are now competing to make loans in previously divested areas not for the benefit of the dispossessed but to expand to new markets and increase profitability. Under this increasingly global form, class and ethnic inequality are intensified through processes of divestment, reinvestment and the closing of the rent gap.[1]

38

THE DESTRUCTIVE NATURE OF CLOSING THE RENT GAP

ACCORDING TO the rent-gap theory,[2] gentrification occurs where the gap between current ground rent and potential ground rent is the greatest. A decline in exchange value or price is in fact what makes changes in land use and occupation profitable. Because of the need for capital to expand outward and toward the highest possible profits, investors are drawn to the cheapest land available. The preceding devaluation of land is itself signaled by widespread negative perceptions of place and communities—a sociosymbolic process of *territorial stigmatization*. Coined by Loïc Wacquant,[3] this is the phenomenon of symbolic dishonor and denigration projected onto a given place so that negative connotations come to define it in the public psyche. Stigmatization and the subsequent devaluation and disinvestment it signals are prerequisites for gentrification. Kallin and Slater[4] demonstrated how territorial stigmatization created the conditions for the gentrification of Craigmillar—a working-class district in Edinburgh. This case reflects a common cycle of devaluation and displacement in which the blemish of place designates areas as eligible for "regeneration" or "revitalization." Neoliberal development is most effective because it does not openly contest community reinvestment but subverts it for the sake of profit.

Residents of these communities find themselves stuck between disinvestment and displacement.[5] The duality of devaluation and reinvestment divorced from the needs of community functions to justify the creative destruction inherent in processes of gentrification.[6] Rather than being seen as development that monetizes and rips apart communities, gentrification is taken to be a natural and necessary process to build communities. This creative aspect obscures the destructive nature of gentrification. The neoliberal assumption that supposedly natural market signals can and should dictate development is central to this reconstruction of space. The process is thereby reduced to a series of "market signals" in which stigma justifies divestment and divestment justifies gentrification.

UNDER THE neoliberal paradigm, community reinvestment has become a means of softening rather than preventing gentrification.[7] The colonial mentality of improvement serves to support the hegemonic view in which the antagonism between community reinvestment and gentrification is obscured. A significant source of this antagonism comes from the blemish of place that is rubbed off onto residents. To do away with the associated "blight" while maintaining a benevolent image of communal uplift therefore requires divorcing conceptions of community from the people that comprise them.[8] Public and private developers can then claim to be reinvesting in a community while promoting practices that displace long-time residents who, through popular discourse, come to personify the stigma of place. This conception turns communities into commodities, thereby reducing human relations to the relations of things. It is this reification of communities that enables investors and developers to equate gentrification with community reinvestment. It is after all, reinvestment in the neoliberal conception of community. With strict adherence to individualism, people become atomized and replaceable components. Even

more important, the reduction of community to property implies community uplift is nothing more than investing to increase property values or profitability. It is through the commodification of community that gentrification becomes taken for granted.

In addition to naturalizing this form of neighborhood change, devalorization of place enables public and private institutions to frame development that has been shown to displace long-time residents as a beneficent force.[9] Territorial stigmatization plays a fundamental role in misrepresenting the destruction of communities as the conservation of communities that are apparently on the verge of falling into irredeemable blight through misuse. As Jackson[10] states, "[v]iewing a neighbourhood as a wasteland uninhabited by anything or anyone useful, waiting there for the taking, resonates as a new form of *terra nullius*."[11] Much like the rent gap, the construction of colonial space (i.e. space of the subaltern) is rooted in territorial stigmatization. It is through the blemish of place that appropriation for the sake of "improvement" is justified. Therefore, gentrification is a process with intersecting neoliberal and colonial components of the capitalist system.

There is perhaps no more explicit example of the colonial, anti-poor mentality than Christian Evangelical pastor and urbanist Robert Lupton's "gentrification with justice." For Lupton, gentrification benefits low-income communities that are exposed to values that he assumes they would otherwise lack.[12] Justice to him is little more than colonization by a supposedly beneficent and superior gentry. Unlike other apologist paradigms that ignore or downplay the po-

tential for displacement, the gentrification with justice paradigm celebrates displacement as a positive means to separate what Lupton considers deserving from undeserving poor. He sees the latter as a sickness to be purged from blighted communities.[13] Lupton asserts that gentrification is not unconditionally positive but is dependent on a "gentry with vision who have compassionate hearts as well as real estate acumen."[14] This assumed superiority of middle-class Christian consumers facilitates appropriation by making it appear altruistic. Just as with the colonial expansion of European imperialists, the church operates for Lupton as a superstructure to support exploitation and appropriation. While Lupton's Evangelical gentrification is uniquely similar to European colonization for the role of the church, more secular apologists for gentrification retain the use of implied superiority as license for appropriation. This melding of paternalistic stigmatization of the working-class communities and the tendency of opening up "new markets" in search of profit is characteristic of modern neoliberalism.[15]

FIGURE 1
GENTRIFICATION AS "HIGHEST VALUE, BEST USE"

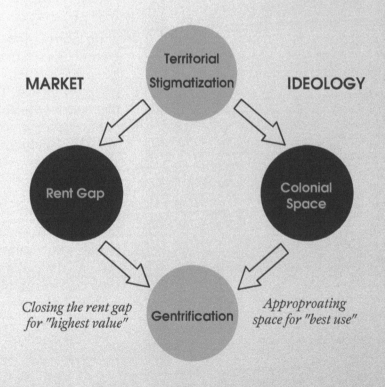

MARKET IDEOLOGY

Territorial Stigmatization

Rent Gap

Colonial Space

Gentrification

Closing the rent gap for "highest value"

Approproating space for "best use"

Programs & Policies

The process of gentrification turns around an ideology of blight and the supposed naturalness and efficiency of "free market solutions." It is common to see news stories suggesting that commerce-based culture is the remedy for urban poverty.[16] Likewise, programs such as HOPE VI have sought private, market-based solutions at the cost of low-income residents. This assumed benevolence is reflected in the language of "regeneration" and "renewal." Euphemisms for a process that objectifies and demonizes as means of appropriation discourages contesting gentrification as a natural outcome of development. It is this misrepresentative language—supported by an ideology of blight and the commodification community—that perpetuates the façade of gentrification as community reinvestment.

HOPE VI—a program that was intended to address the needs of public housing residents via mixed-income development—also reflects the conflation of community uplift with privatization and profitability. While it has changed to some degree throughout the program's implementation (from 1992 - 2010), its development has always been firmly rooted in neoliberalism and stigmatization of working-class communities. Early in the program's development HUD tilted the scales in favor of greater private, market-based development. The shift began in 1994 when they ruled that public housing could be privately owned. They also repealed the one-for-one replacement requirement meant to protect affordable and public housing stock. In 1996, HUD also adopted a mixed-finance approach in which grantees were encouraged, by limits on government contributions, to leverage additional private investments, thereby further strengthening the role of private entities. The increased deregulation and privatization led to the inclusion of more moderately subsidized and market rate units.[17] While HOPE VI projects have varied greatly, the neoliberal logic and process of development remain consistent across sites. Projects were united by the core practice of public-private partnerships and the assumed validity of transforming public housing into mixed-income developments to address the needs of low-income residents.[18] As the pro-

The process of gentrification turns around an ideology of blight and the supposed naturalness and efficiency of "free market solutions." It is common to see news stories suggesting that commerce-based culture is the remedy for urban poverty (Davis, 2015; Smart, 2016). Likewise, programs such as HOPE VI have sought private, market-based solutions at the cost of low-income residents. This assumed benevolence is reflected in the language of "regeneration" and "renewal." Euphemisms for a process that objectifies and demonizes as means of appropriation discourages contesting gentrification as a natural outcome of development. It is this misrepresentative language—supported by an ideology of blight and the commodification community—that perpetuates the façade of gentrification as community reinvestment.

gram developed, focus shifted further away from helping public housing residents through revitalization efforts and more toward attracting business investment. Site selection became less about the need for improving living conditions and more about whether developers thought a location could generate profits.

HOPE VI projects have varied due to the lack of standardization or criteria for mixed-income development that might otherwise differentiate between integration and appropriation. To overcome this obstacle Hanlon[19] limits his analysis to the project often considered one of the most successful —Park DuValle in Louisville, Kentucky. He found that, rather than addressing the needs of public housing residents, the program effectively took the area over at the cost of low-income residents. On-site (i.e. in the community), there was a total loss of **753** public housing units, with 603 units directly lost while factoring in the 150 units built elsewhere. While 67.1% (876) of displaced households received some form assistance in relocating, 69.7% (611) of these households were merely moved to non-HOPE VI public housing. The remaining 30.3% (265) of assisted displaced households received vouchers which were

then concentrated in other high-poverty areas. 32.8% (428) of displaced households received no form of assistance. The fact that such a disruptive program can be regarded as a success is evidence that "public housing policy has increasingly become aligned with the broader unfolding of neoliberal urban processes."[20] The case of the Park DuValle project reflects the trend of private, market-based development that appropriates space under the guise of poverty alleviation and community uplift.

Centennial Place in Atlanta is also lauded as one of the more successful HOPE VI developments.[21] This project entailed a severe reduction in public housing—much of which was replaced with market-rate units. Approximately 17% of original residents were able to return, thereby pushing the majority to private market routes.[22] With only about a third of the units reserved at a level manageable for most original residents, Atlanta also saw one of the most severe reductions in public housing stock. Such cases illuminate the stark contrast between the rhetoric and reality of HOPE VI. If Park DuValle and Centennial Place were successes, then the goal of such projects

was not to address the shortcomings of public housing but to reclaim space for development. The framing of these projects as successful responses to the needs of public housing residents reflects the dominant belief in private market solutions and the stigma of poverty and public housing.

In 2010 HOPE VI was effectively replaced by the Choice Neighborhoods Initiative (CNI) as a mixed-income solution to public housing and in 2011 the first implementation grants were distributed to support projects in Boston, Chicago, New Orleans, San Francisco, and Seattle.[23] Like its predecessor, CNI pursues a mixed-income solution to low-income housing and distributes funds through competitive demolition and rehabilitation grants. It also retains the neoliberal logic that emphasizes public-private partnerships, mixed-finance, and market-based solutions.[24] Just as with HOPE VI, the lack of standardization has meant wide variation in practices and outcomes. The program also built off of HOPE VI to make developments both more ambitious and inclusive. Gebhardt identifies three key

areas of expansion: it expands the development from single properties to entire neighborhoods (and districts in some cases), eligibility from Public Housing Authorities (PHAs) to include cities and non-profit organizations, and eligible properties from public housing to other distressed HUD-assisted housing.

CNI has addressed one of the most immediate and fatal design flaws of HOPE VI by requiring one-for-one replacement of all public housing units subject to demolition.[26] Policy makers have also sought to address the issue of displacement by promising the right of return to all residents that have not violated their lease. However, more research is needed to determine the extent to which the right of return is enforced or effective in preventing displacement. The right to return also does not appear to help many considered "hard to house" who might be ineligible for participation. As with other mixed-income developments that exclude segments of the original community, CNI practices lay implicit blame on the victims of community divestment and decline. For all its important differences and early observable improvements, HOPE VI has served as the foundation of Choice Neighborhoods. Like its predecessor, it often equates community development with business or private market in-

terests. Both programs rely on the assumptions of trickle-down economics, the implied pathology of working-class communities, and the increased privatization of housing assistance. This capitalist orientation leaves the door open for further neglect of and attacks on the very communities intended to be helped.

In addition to the stigmatization of poverty, recent trends in neoliberal development have invoked principles of inclusion and self-representation. Community Benefits Agreements (CBAs) are an increasingly common way to promote more inclusive community development. These agreements are "standalone, legally enforceable contract[s] between multiple community groups and … private developer[s], requiring community benefits from the developer[s] in exchange for the community groups' support of (or non-opposition to) [a] project."[27]

Terms of agreement are often used to push for development that benefits the community by establishing quotas for affordable housing and jobs. While CBAs have the potential to include communities in the processes of development, it is largely up to developers whether to sign any such agreement. Where developers have no desire to meet the needs of residents they can simply refuse —as developers did to the

neighborhoods surrounding Turner Field in Atlanta. Despite the enforceability of community contractual obligations, participation is voluntary.[28] As the case of Los Angeles' Sports and Entertainment District CBA illustrates, developers might also fail to meet all provisions.[29] This suggests that CBAs are not always as legally binding as proponents suggest. It is also not clear if positive outcomes such as higher wages and more affordable housing are attributable to CBAs.[30] Like

many contemporary neoliberal norms of development, this public-private partnership often equates inclusion with empowerment and community uplift with little regard to the actual power imbalance. CBAs engage communities in ways that are safe for developers and in keeping with neoliberal common sense. They "can achieve 'value-conscious' growth, but… do not fundamentally alter dominant standards of growth or growth machine processes."[31] Therefore, as a means

of community-based development, CBAs provide legitimacy for capitalist development rather than an alternative.

An even more popular means of development to invoke community empowerment is inclusionary zoning or housing. This trend in development refers to "a range of local policies that tap the economic gains from rising real estate values to create affordable housing, tying the creation of homes for low- or moderate-income households to the construction of market-rate residential or commercial development."[32] Developers are required or encouraged to set aside a portion of housing for low-income residents to live near newly constructed market-rate housing and commercial development. Like the HOPE VI and Choice Neighborhoods programs, inclusionary zoning looks to address the housing needs of working-class communities via mixed-income development. As such, it also implicitly targets the concentration of poverty—rather than underlying inequities—as the source of neighborhood decline. With this logic, it is the positive influence and tax base of wealthier residents that saves communities. Inclusionary zoning is also intended to address the crisis of affordability felt across the US. However, its focus on new development does little for long-established communities stuck between

devaluation and gentrification. Furthermore, because the construction of affordable housing is dependent on the construction of market rate and commercial development, inclusionary housing has often fallen short of providing adequate access to affordable housing.[33] In his analysis of New York City's Mandatory Inclusionary Housing program, Samuel Stein[34] points to the fundamentally neoliberal character of inclusionary housing programs that invoke the economic stability and self-representation of marginalized communities while often offering only a "modicum of protection to the working class while safeguarding the interests of capital and property."[35]

CO-OPTING COMMUNITY FOR CAPITAL

THE DEVELOPMENT of the Turner Field neighborhoods in downtown Atlanta has relied on the assumption that a bustling consumer culture and the profitability that comes with it are legitimate and adequate means of community reinvestment.[36] Georgia State University and private developer Carter—who together make up Panther Holdings LLC—assert that the proximity of profit will trickle down throughout the community. Despite the benevolent image developers have cultivated, several community organizations have fought to prevent looming gentrification. A central concern for these community members has been the affordable housing crisis felt by longtime residents. In their Summerhill Community Investment Plan (CIP), developers proposed to define "affordable housing" as 80% AMI—the ceiling for what is considered "affordable." They also approximate anywhere from 50-250 of these units. A range this large promises very little to the long-established community.

As Garboden and Jang-Trettien[37] point out in their study of the Baltimore neighborhood of Oliver, the distinctions between community revitalization and gentrification meant to accumulate capital are increasingly obscured due to the nature of public-private partnerships and the use of Community Based Organizations (CBOs) as a source of legitimacy for neoliberal development. In the case of Atlanta's Turner Field, developers have partnered with the pro-business Organized Neighbors of Summerhill (ONS) and Mechanicsville Civic Association whose members define community through property relations and community reinvestment as little more than creating a booming consumer district.[38] They also claim that a binding Community Benefits Agreement (CBA) that provides affordable housing comparable to the incomes of longtime residents is not necessary—despite the fact that other community members and organizations that have been kept largely out of the process have been vocal about the need for a CBA to protect residents from displacement.[39] According to former president of ONS Suzanne Mitchell:

"Georgia State and Carter, because they're going to be making long-term commitments in the neighborhood, are vested to create something that is lasting and benefits their customer. In Georgia State's case, students and their families. And then in Carter's, the residents that will come into their buildings and any retail and commercial that they own."[40]

The above statement inadvertently illustrates the market-oriented conception of community. The benefit of the surrounded communities is reduced to their ability to consume. As such, residents are reduced to customers and legitimate residency is restricted to those that can consume housing and the products of new businesses.

As the above illustrates, community reinvestment has too often been invoked to describe and legitimize projects that take neighborhood change for granted.

RECLAIMING COMMUNITY

RATHER THAN be used as a means to address spatial inequality, it has become a powerful ideological tool in perpetuating uneven development. It has come to reflect the neoliberal common sense of "positive gentrification" based on a commodified community. However, if community is to entail not just property but the people that inhabit a place, gentrification is clearly incompatible with authentic community reinvestment. Community reinvestment needs to be redefined in public discourse to entail direct benefits and the empowerment of community members to use reinvestment to address community needs rather than the interest of public-private partnerships and finance capital. This will require more than just concessions aimed at mitigating the effects of gentrification; it implies that long-time residents have the social, political, and economic control necessary to prevent gentrification entirely. To realize such a radical reconfiguration of social-spatial relations requires a counter-hegemonic understanding of collective rights to contest individualized, property-based rights. This means replacing the atomized and objectified communities of things with communities of people. Only then can the façade of progress and fair development be thrown off and the truly destructive character of gentrification be laid bare. It is this collective sense of community that enables people to come together to resist the twin pressures of displacement and deterioration.

One of the clearest manifestations of residents reclaiming their communities is the direct and organized action of the rent strike. In line with its historical use to combat both deplorable living conditions and rising rents, the collective withholding of rent can empower politically and economically disenfranchised communities.[41] In refusing to choose between decline and gentrification, tenants in Los Angeles have stood up to the ever-increasing pressures of displacement. Although ending in a 14 percent increase in rent, the recent rent strike in Los Angeles' Boyle Heights—a rapidly gentrifying area—was successful in establishing new leases with a cap on yearly rent increases at 5 percent and the right to collectively bargain lease terms.[42] Given that prior to the strike, many residents were facing up to an 80 percent increase in rent this shows the potential strength of communities to resist gentrification and displacement. The biggest rent strike in Los Angeles history also developed out of the ongoing affordability crisis. Ninety tenants in a complex in the Westlake neighborhood withheld rent in response to poor living conditions and rising rents.[43] Well-organized rent strikes might be particularly useful where rent control laws are either non-existent, not applicable to a particular building (as was the case in Boyle Heights), or otherwise ineffective.

The direct action of tenants to organize effective rent strikes, while key to empowering communities, is not enough to prevent gentrification. In fact, rent strikes are a strategy of resistance under capitalism—the very cause of displacement and commodification of community. They are subject to being crushed by landlords and a

government that rules in favor of the wealthy—as was the case with tenants facing retaliation in the form of eviction after the Westlake rent strike. As such, rent strikes alone cannot be both adequate and irreversible. As Engels states, "only by the solution of the social question, that is, by the capitalist mode of production, is the solution of the housing question made possible."[44] Tenants can and should organize under capitalism to resist both neglect and displacement. However, the ultimate solution lies in a far larger form of organization than local rent strikes—the building of *socialism*.

Only through socialism can community reinvestment be built around concepts of social relations and collective well-being rather than the atomistic conception of community as a mere sum of interchangeable and quantifiable property. The path to authentic community reinvestment is organizing resistance to what gentrifiers pose in the name of community. The first step is to re-establish the centrality of human relations to the collective understanding of community in order to contest the inevitability of gentrification and the confusing of the interests of landlords and developers with those of community members.

ENDNOTES

1. Lees, Slater, & Wyly, 2007
2. Smith, 1979; 1996
3. 2007; 2008
4. 2014
5. Newman & Wyly, 2005
6. Harvey, 2006; Weber, 2002
7. See Silver, 2016
8. In the US, this practice goes back to the Progressive Era of the early 20th century when the concept of "slum clearance" was widely regarded as a benevolent solution to urban poverty.
9. Newman & Wyly, 2005; Lees, 2008
10. 2017
11. 49
12. Hankins & Walter, 2011
13. Lupton, 1997
14. 1997, quoted in Hankins & Walter, 2011
15. Peck & Tickell, 2002; Wacquant, 2009a, 2009b
16. Davis, 2015; Smart, 2016
17. Polikoff, 2009
18. Cisneros, 2009
19. 2010
20. Hanlon, 2010, p. 94
21. See Glover, 2009; Turbov & Piper, 2005
22. Hankins, Puckett, Oakley, & Ruel, 2014
23. Joice, 2017
24. Pendall & Hendey, 2013
25. 2014
26. Schwartz, 2015
27. Gross, 2012, p. 229
28. Salkin & Lavine, 2008
29. Marantz, 2015
30. Ibid.
31. Cain, 2014
32. Jacobus, 2015, p. 7
33. Schwartz, 2015
34. 2018
35. 773
36. Davis, 2015
37. 2018
38. Bevington, 2017
39. Stafford, 2017
40. Bevington, 2017
41. Lawson, 1984; Wood & Baer, 2006
42. Chiland, 2018
43. Lang, 2018
44. Engels, 68

REFERENCES

Bevington, R. (2017). *Turner Field Neighbors Divided Over Community Benefits Agreement.* Georgia Public Broadcast, May 12, last accessed on June 27, 2017.

Cain, C. (2014). "Negotiating with the Growth Machine: Community Benefits Agreements and Value-Conscious Growth." *Sociological Forum,* 29(4), 937- 958.

Cisneros, H. (2009). *A New Moment for People and Cities. In From Despair to Hope: HOPE VI and the New Promise of Public Housing in America's Cities.* Edited by Henry G. Cisneros and Lora Engdahl. Washington, DC: Brookings Institution Press.

Davis, J. (2015, December 26). Turner Field Holds Future for Georgia State, Neighborhoods. Atlanta Journal-Constitution.

Dymski, G. (1999). *The Bank Merger Wave: The Economic Causes and Social Consequences of Financial Consolidation.* Armonk: NY: M.E. Sharpe.

Engels, Friedrich, 1872 (1935). *The Housing Question.* New York: International Publishers.

Fishbein, A. (1992). "The Ongoing Experiment with 'Regulation from Below': Expanded Reporting Requirements for HMDA and CRA." *Housing Policy Debate:* 3, 601-636.

Garboden, P., & Jang-Trettien, C. (2018). "There's Money to be Made in Community": RealEstate Developers, Community organizing, and Profit Making in a Shrinking City. *Journal of Urban Affairs.*

Gebhardt, M.F. (2014). "Race, Segregation, and Choice: Race and Ethnicity in Choice Neighborhoods Initiative Applicant Neighborhoods, 2010-2012." *Cityscape,* 16(3), 93-116.

Glover, R. (2009). The Atlanta Blueprint: Transforming Public Housing Citywide. In *From Despair to Hope: HOPE VI and the New Promise of Public Housing in American Cities.* Edited by Henry G. Cisneros and Lora Engdahl. Washington, DC: Brookings Institution Press.

Goering, J., & Wienk, R. (1996). *Mortgage Lending, Racial Discrimination and Federal Policy.* Washing DC: Urban Institute Press.

Gross, J. (2012). "Commentary on Laura Wolf-Powers, Community benefits agreements in A value capture context." In G. K. Ingram & Y.-H. Hong (Eds.), *Value capture and land policies* (pp. 229–232). Cambridge, Mass.: Lincoln Institute of Land Policy.

Hankins, K., & Walter, A. (2011). "'Gentrification with Justice': An Urban Ministry Collective and the Practice of Place-making in Atlanta's Inner-City Neighborhoods." *Urban Studies,* 49 (7), 1507-1526.

Hankins, K., Puckett, M., Oakley, D., Ruel, E. (2014). Forced Mobility: The Relocation of Public-Housing Residents in Atlanta. *Environment and Planning A,* 46, 2932-2949.

Harvey, David. (2006). "Neoliberalism as Creative Destruction." Geografiska Angler: Series B. *Human Geography.* 88, 145-158.

Immergluck, D. (2004). *Credit to the Community: Community Reinvestment and Fair Lending Policy in the United States.* Armonk, NY: M.E. Sharpe.

Jacobus, R. (2015). *Inclusionary Housing: Creating and Maintaing Equitable Communities. Policy Focus Report for the Lincoln Institute of Land Policy.*

Joice, P. (2017). "HOPE and Choice for HUD-Assisted Households." *Cityscape,* 19(3) 449-474.

Kallin, H., & Slater, T. (2014). "Activating Territorial Stigma: Gentrifying Marginality on Edinburgh's Periphery." *Environment and Planning A.* 46(6), 1351-1368.

Lawson, R. (1984). "The Rent Strike in New York City, 1904-1980: The Evolution of a SocialMovement Strategy." *Journal of Urban History,* 10(3), 235-258.

Lang, M.J. (2018). "Rent strikes grow in popu-

larity among tenants as gentrification drives up rents in cities like D.C." *Washington Post*, June 9, 2018.

Lukacs, G. (1971). *History and Class Consciousness: Studies in Marxist Dialectics*. Cambridge, MA : MIT Press.

Lupton, R. (1997). "Gen-tri-fi-ca-tion," *Urban Perspectives*, February.

Marantz, N.J. (2015). "What Do Community Développent Agréments Deliver?: Evidence From Los Angeles." *Journal of the American Planning Association*, 81(4), 251-267.

Peck, J., & Tickell, A. (2002). "Neoliberalizing Space." in N. Brenner and N. Theodore (eds.), *Spaces of Neoliberalism: Urban Restructuring in North America and Western Europe*. Pp. 33-56 Malden, MA: Blackwell.

Pendall, R., Hendey, L. (2013). *A Brief Look at the Early Implementation of Choice Neighborhoods*. The Urban Institute.

Polikoff, A., (2009). "HOPE VI and the Deconcentration of Poverty." In *From Despair to Hope: HOPE VI and the New Promise of Public Housing in America's Cities*. Edited by Henry G. Cisneros and Lora Engdahl. Washington, DC: Brookings Institution Press.

Salkin, P.E., Lavine, A. (2008). "Negotiating for Social Justice and the Promise of Community Benefits Agreements: Case Studies of Current and Developing Agreements." *Journal of Affordable Housing*, 17(1-2), 113-144

Schwartz, A. (1998). "Bank Lending to Minority and Low-Income Households and Neighborhoods: Do Community Reinvestment Agreements Make a Differences?" *Journal of Urban Affairs*. 20, 269-301.

Schwartz, A. (2015). *Housing Policy in the United States. 3rd ed.* New York: Routledge.

Silver, J. (2016). *The Community Reinvestment Act: How CRA can promote integration and prevent displacement in gentrifying neighborhoods*. Washington, DC: National Community Reinvestment Coalition.

Slater, T. (2006). "The Eviction of Critical Perspectives from Gentrification Research." *International Journal of Urban and Regional Research*. 30, 737-757.

Smart, T. (2016). *Bringing Central Johannesburg Back to Life*. Retrieved from http://www.bbc.com/news/business-35830583

Smith, N. (1979). "Toward a Theory of Gentrification: A Back to the City Movement by Capital, Not People." *Journal of the American Planning Association*, 45(4), 538-548.

Smith, N. (1996). *The New Urban Frontier: Gentrification and Revanchist City*. New York: Routledge.

Smith, N. (2002). "New Globalism, New Urbanism: Gentrification as Global Urban Strategy. Pp. 80-103, N. Brenner and N. Theodore (eds.), *Spaces of Neoliberalism: Urban Restructuring in North America and Western Europe*. pp. 80-103. Malden, MA: Blackwell.

Stafford, L. (2017). "GSU-Turner Field neighborhoods strike deal to address community change." *Atlanta Journal Constitution*. Monday, April 24, 2017.

Stein, S. (2018). "Progress for Whom, Toward What? Progressive Politics and New York City's Mandatory Inclusionary Housing." *Journal of Urban Affairs*, 40(6), 770-781.

Taylor, J., & Silver, J. (2003). "Organizing Access to Capital: Advocacy and the democratization of financial institutions." In Gregory D. Squires (ed.). *Organizing Access to Capital: Advocacy and the Democratization of Financial Institutions* (pp. 168-188). Philadelphia, PA: Temple University Press.

Torbov, M., Piper, V. (2005). "HOPE VI and Mixed-Finance Redevelopments: A Catalyst for Neighborhood Renewal Atlanta Case Study." *Brookings Institution Metropolitan Policy Program*. September 2005.

Wacquant, L.D. (2007). "Territorial Stigmatization in the Age of Advanced Marginality." *Thesis Eleven*, 91(1), 66-77.

Wacquant, L.D. (2008). *Urban Outcasts: A Comparative Sociology of Advanced Marginality*. Cambridge, UK: Polity Press.

Wacquant, L.D. (2009a). *Prisons of Poverty. Expanded Edition*. Minneapolis: University of Minnesota Press.

Wacquant, L.D. (2009b). *Punishing the Poor: the Neoliberal Government of Social Insecurity*. Durham: Duke University Press.

Weber, R. (2002). "Extracting Value from the City: Neoliberalism and Urban Redevelopment." In N. Brenner and N. Theodore (eds.), *Spaces of Neoliberalism: Urban Restructuring in North America and Western Europe*. pp.172-193, Malden, MA: Blackwell.

Wood, A., Baer, J.A. (2006). "Strength in Numbers: Urban Rent Strikes and Political Transformation in the Americas, 1904-1925." *Journal of Urban History*, 32(6), 862-884.

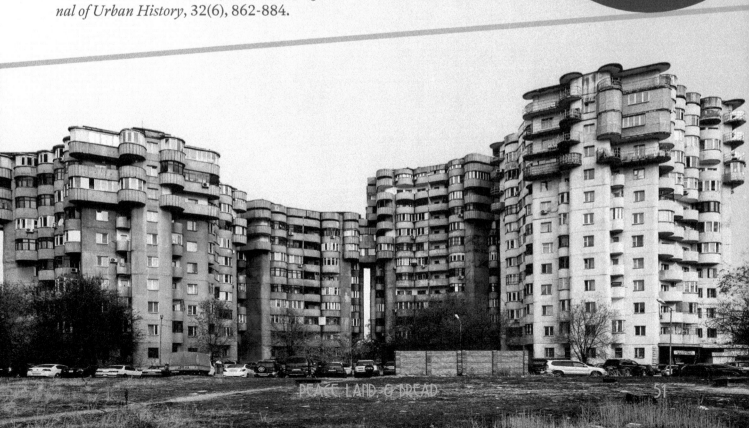

PEACE, LAND, & BREAD

SAM PARRY

THE EUROPEAN UNION

A NEW ERA IN EUROPEAN

IMPERIALISM

Bourgeois hegemony lies not in the violence of the ruling class but in its ability to manufacture the spontaneous consent of the general population.

Europe is a continent shaped by conflict. Since the rise of mercantilism, this conflict has taken place on both inter and intra continental levels. European states have held power over vast swathes of the globe, doing so for resources, labour power and access to markets. In Europe, the carving up of the globe led to a fragile détente between imperial powers, yet the fragility of such cordiality became clear with the onset of the First World War. Today, the evils unleashed by European colonialism continues to stamp those countries who were so viciously brought to heel. Yet, Europe has never come to terms with its past. It has never accepted it, apologised for it or renounced the privileged position that centuries of colonial conquest and imperial domination bestowed on it. As Edward Said explained, the colonised 'lost' and are therefore required to live with the very real material consequences of the period of colonial conquest.[1] Europe 'won' and therefore can choose to ignore the colonial enterprise as just another episode of history, to be acknowledged or not as Europeans deem fit. This reality means that a popular narrative has been allowed to develop within Europe. It is the notion that fascism and Nazism were not in keeping with Europeanism and its culture. Furthermore, the notion that since the Second World War, Europe - via its institutions like the EEC and the EU - has become a continent of peace and prosperity obfuscates the price paid for this peace.

The internal harmony of Europe and the European Union has been predicated on the continuation of neo-colonial practices. Europe continues to be *violent*, both via its migration policies and its external economic policies.

As Aimé Césaire argued, the barbarism of Europe was not due to the prison guard or the adventurer, but due to the 'decent fellow', the 'respectable bourgeois' across the way.[2] Neo-colonialism and the inequality

associated with it has become ingrained within the institutions of Europe and our 'respectable bourgeoisie'.

This paper attempts to map European neo-imperialism today, concentrating on the EU's migration policies and Economic Partnership Agreements and delineating how European neo-imperialist powers use the European Union as a vehicle for their policies. This will show how the EU is an organisation specifically designed for the continuation of European imperialism in the post-war era. To understand Europe, we must analyse its relationship with its neighbours and also analyse how the material realities of Europe's past continue to shape it today.

The Making of Europe

Antonio Gramsci argued that the strength of bourgeois hegemony lies not in the violence of the ruling class but in its ability to manufacture the spontaneous consent of the general population.[3] The ruled accept the conception of the world passed down to them by the rulers and this manifests itself in the institutional arrangements of the state. Gramsci further argued that hegemony therefore is characterised by both political and intellectual leadership. The role of creating and defining the EU would therefore be a political and intellectual project with the purpose of manufacturing the spontaneous consent of the governed. This intellectual and political project has at-

tempted to create a 'cosmopolitan Europe', one that recognises the institutional commonalities that European countries share whilst also celebrating its cultural diversity. The EU's motto, 'united in diversity' is meant to reflect this.

However, the diversity that the EU speaks of is narrow in nature and obfuscates the 'otherness' implicit in its definition. The EU's definition relates only to the linguistic and cultural diversity of constituent members, the multiculturalism that exists *within* member-states is not conceptualised within this understanding of diversity. According to Bhambra "these multicultural others are not seen as constitutive of Europe's own self-understanding – or as legitimate beneficiaries of the post-war social settlement – emerging from its history of colonialism; a history that is carried by individual nation-states and ... by the common European project itself."[4] The EU in effect has managed to create a dichotomy between *cosmopolitanism* on the one hand and *multiculturalism* on the other. Europe is *cosmopolitan* and those 'high value migrants' it covets are as well. Poorer migrants denote *multiculturalism* and are therefore dangerous to the European project.

These definitions are implicit in which countries are considered 'European' and which aren't. Schlenker for example maps the opinions of citizens of the European Union on prospective member countries. Perhaps unsurprisingly, Switzerland (80.9%), Norway (80.6%), Iceland (72.4%)

and Croatia (54.5%) (which was not in the EU at the time) were the countries EU citizens were most in favour of joining. On the other end, Bosnia, Herzegovina, Serbia, Albania and Turkey whose favourability ranged from 44.6% to 31.2%.[5] One could make the argument that Europeans view Switzerland more favourable because it is at the geographic heart of Europe, whereas Norway possesses a strong economy and its social welfarism - on paper at least - coincides with Europe's conception of itself. Iceland however is very far from the centre of Europe geographically and would offer nowhere near the same economic boost that the accession of a country like Turkey would offer. Furthermore, Croatia, Bosnia and Herzegovina were constituent nations of the same state just over 20 years ago, yet there is a 10% gap in favourability for EU accession. Clearly, in the consciousness of EU citizens, there is an implicit bias in favour of those countries that are Christian or post-Christian.

The Borders of Europe

The dialectical relationship between external and internal policies is often overlooked. External policies and the way in which countries and peoples are othered has a role in increasing internal cohesiveness and identity. Identity is usually understood in the negative: "I am something because I am not something else". Within Europe, the fight to maintain 'internal cohesiveness' has taken place throughout history, whether as a fight against 'Arabisation' in Iberia or against 'Islamification' and the Ottoman Empire. This continues to this day with the implicit association of Europe with Christian values and clearly plays a role as to why countries such as Albania, Bosnia and Herzegovina and Turkey are

not considered European. There is a contradiction between the static, Christian and Athenian conception of Europe on the one hand and the supposedly fluid, dynamic and cosmopolitan Europe on the other. This conception of Europeanness, and the othering implicit within it helps define those who can and can't enter the EU. The reality of life for migrants who live on the borders of Fortress Europe or precariously within it, is grotesquely different to the Europe espoused in the EU's "four freedoms". Raj characterises this reality eloquently:

"The European project, often characterized as the creation of an open space, free from barriers to flows and where national frontiers no longer mean anything, is a veneer that glosses an intense violence at the borders of an increasingly Fortress- like Europe. This latter violence is absolutely constitutive of the hegemonic project of Europe. This violence not only finds its expression in overt violence – beatings, arrest, detention of migrants – but also pervades the social realm in the most quotidian of instances, such that certain classes of people are made to inhabit an everyday limbo of precarity and indeterminacy in which they have to be borders. The concern of hegemonic projects such as an attempt to build a Fortress Europe, is to create a political order that relies upon maintaining a delicate and generalized violence directed against people who live their experience marked as borders, standing in welfare lines, asking for public housing, sitting in police stations and waiting for hospital treatment.[6]

The borders of Europe are an institutional embodiment of the contradictions within the European project. It is the institutional embodiment of the othering process whereby the relationship individuals have with the borders of Europe is dependent on their gender, ethnicity and country of origin. Balibar describes the borders of Europe as a spatio- temporal home for migrants who repeatedly encounter, and are regulated by it, whereas the privileged are allowed to pass freely through those very same borders.[7] "So when a local government official in Calais declares: 'I feel the whole world and his wife have twigged that...the port is as full of holes as a piece of Gruyere cheese,' this is only partially true: the myth that the border is porous is true for some but serves precisely to make others reside there in a state of semi-permanence."[8] The EU is a part and driver of Balibar's "world apartheid."

An equally insidious yet overlooked consequence of EU migration policy is how EU bloc neo-imperialism "promotes the subsidisation of the EU by the African, Caribbean and Pacific Group of States (ACP) regions through migration to the EU of professionals such as nurses, teachers, doctors, etc."[9] This has a dual role: Firstly, these professionals were trained and paid for by the home country, and therefore these poorer nations subsidize rich European countries. Secondly, these countries are usually in dire need of such expertise due to the legacy of European colonialism which developed their state apparatus to be extractive. A further consequence of this notion is that some migration to Europe is necessary because of declining population rates and an ageing population that reduces migrants to nothing more than tools for European consumption, to be thrown away when no longer necessary. In essence, this

process reduces the capacity of underdeveloped countries to build their own productive forces, thus exacerbating and continuing the circle of dependency and the exploitative relationship between Europe and the South.

Globalisation, Imperialism and the State

The internationalisation of capital, or globalisation, has paradoxically coincided with the proliferation of nation states; the UN in 1945 had 51 members, today that number has reached 193. Ellen Meiskins Wood stated that "the world today is more than ever a world of nation states. Global capitalism is nationally organised and irreducibly dependent on national states."[10] Transnational firms, although important within the wider system of imperialism, do not "organise imperial economic and political relationships, rather the existence of transnational firms would not be possible without a system of states maintaining stable relations of unequal influence across the globe."[11]

Robert Cox calls the process at hand the "internationalisation of the nation-state."[12] In essence, the functions of the state, such as education, welfare and taxation, and the restructuring of state assets to a deregulated and privatised model is not a retreat of the state, but instead a change in its role. It now works as a facilitator for the global-national economic paradigm. We can best define globalisation as a reorganisation of the state, rather than as an attempt to by-pass it. Governments regularly use state power to quell discontent and the anger that bubbles to the surface as a reaction to the state's neoliberal project. As Hardt and Negri explain:

When the proponents of the globalisation of capital cry out against big government, they are being not only hypocritical but also ungrateful...where would imperial capital be if big government were not big enough to wield the power of life and death over the entire global multitude?

The EU plays an important yet nuanced role within this system. The purpose of the European project was not to create a single state but a common framework; a framework that helps standardise trade flows between Europe and the wider economy. Furthermore, the EU ties poorer countries - such as the ACP - to Europe as a bloc. On the one hand, this restricts the 'trade' between a single mother country and a colony while simultaneously "bind[ing] the ACP to the EU, indefinitely in a new type of mercantilism."[14] This new mercantilism (or imperialism) attempts to confine trade between the ACP regions and the EU as a whole, rather

economic might like the USA. Hansen and Jonsson argue that calls for creating a European union were marked by the waning influence of European states.[17] The EU, therefore is a new form of an old system, it is a way for European countries to maintain a sphere of influence over Africa and further afield. As far as the European project is an endeavour for peaceful coexistence, it has been bought with the lives, land and labour of Africans.

Trade as Neo-Colonialism

'Illegal' migration is the outcome of EU neo-imperialism arriving at the shores of Europe. However, where European neo-imperialism is most pernicious and damaging is via its trade agreements, the European Partnership Agreements. Europe's relationship with its ex-colonies remains relatively unchanged since the time of colonialism.

Trade between Europe and Africa is veiled in terms of 'development' by the EU, yet "it

than in a more linear colonised-coloniser dichotomy, yet the outcomes are strikingly similar. Kwame Nkrumah was able to both perceive and define this change, stating that "the neo-colonialism of the French period is now being merged in the collective neo-colonialism of the European Common Market."[15] The EU therefore is best understood as a vehicle for larger European states to continue their imperialist and neocolonial practices. The main difference in postwar Europe is not that Europe has 'become civilised' and has fundamentally changed; it is that Europe became acutely aware of its new place within the world system.[16] European states no longer possessed the comparative advantage that they were used to; it firstly had to come to terms with being the USA's junior partner during the Cold War before more recently attempting to assert its influence in competition with the USA. The EU has attempted to export its 'values' rather than relying solely on military and

is striking that the development of the South became their priority just as the colonisers were leaving for home. Such passion was not in evidence during colonial rule. The 'civilising mission' was recast as development, although its 'implicit racism' was never jettisoned. In Europe's colonial repertoire, development was the new ace."[18] The way in which Europeans 'justified' colonialism and continue to justify unequal North-South trade today shares the same root. "Colonialism was justified by the grand lie that the West developed autonomously; it was thus superior and obliged by its history and ethics to invade the inferior, incapable non-West."[19] This *white man's burden* continues with Europe's 'mission', our 'duty' to help the 'undeveloped' South. Colonialism did not end due to European goodwill but due to the struggle and determination of the colonised and because the colonial powers had created new conditions within the colonies. There now existed colonial legal systems, traditional society had been eradicated and Western 'values' had become the norm. The economic advantages that arose from colonialism "could now largely be obtained by more politically acceptable, and, at the same time more effective methods."[20]

Walter Rodney explains how the so called 'international' trading system was developed within Europe and how those origins meant that, historically, trade between Africa and Europe was unequal:

From the beginning, Europe assumed the power to make decisions within the international trading system. An excellent illustration of that is the fact that the so- called international law which governed the conduct of nations on the high seas was nothing else but European law. Africans did not participate in its making, and in many instances, African people were simply the victims, for the law recognized them only as transportable merchandise. If the African slave was thrown overboard at sea, the only legal problem that arose was whether or not the slave ship could claim compensation from the insurers! Above all, European decision-making power was exercised in selecting what Africa should export – in accordance with European needs.

Although the "merchandise" being transported has changed, the underlying unequal exchange between African and Europe has not. These trade agreements continue to be 'made in Europe'. As Mary Farrell explains: "the origins of European relations with the countries of Africa and the Caribbean can be found in the historical ties between them, based largely upon the legacy of colonialism. Through the Yaoundé Convention of the 1960s and the successor Lomé agreements, the European countries sought to retain the economic links, the access to natural resources and raw materials and other strategic economic interests they had enjoyed under colonialism."[22]

Both Kwame Nkrumah and Sekou Toure correctly warned that the new neo-colonial system would be a continuation of asymmetric trade between Africa and Europe. Although countries in Africa were now formally independent, money from aid and

pressure from European governments would push African elites to agree to trade agreements that would hinder Africa's long-term development.[23] As Sekou Toure remarked, trade and aid arrangements between Africa and the European Economic Community would maintain Africa's position as "hewers of wood and drawers of water."[24] From the very beginning it was clear that Africa would continue to supply Europe with raw materials while Africa would continue as a market for European value-added consumer goods. The EU, via its policies, continues to perpetuate the international division of labour which maintains the status quo of the global capitalist system.

The Price of 'Free' Trade

The Cotonou Agreement (the overarching framework for EU-ACP relations) stresses the importance of "equitable development", supporting "the principles of the market economy" and "developing the private sector."[25] Trade opening and economic liberalisation are central tenets of Eurafrican relations, with the EU lauding free trade as a win-win for all parties involved.[26] This description of Eurafrican trade obfuscates the effects of the unequal relationship between Europe and Africa that affects who wins and loses from such trade. Trade tariffs imposed by African governments were a vital source of government revenue, ranging from 10% of total government resources in the more developed African states[27] to a staggering 35% of total treasury receipts in the case of Uganda and Senegal.[28] 'Free' trade between the EU and Africa therefore cut government revenue by up to a third overnight, leading to deeper, more entrenched poverty and the loss of social safety nets. African Governments feel obliged to enter into Economic Partnership Agreements with the EU as the failure to do so leads to terms under the Generalised System of Preferences. This would further hinder African development as it would entail higher export tariffs on African products. Due to European pressure, Africa is unable to develop its own productive forces or its own internal market as it deems fit, and this unequal relationship between both continents means that the structure of African economies becomes deformed as they specialise in sectors beneficial to European consumption. The sectors that Africa possesses a comparative advantage over the EU are those very same sectors that are deemed of low market value. This situation is further exacerbated by a balance of payment deficit between European and African states due to the im-

portation of high market value goods and exportation of cheaper goods or raw materials. Reciprocal free trade results in job losses and deindustrialisation in the underdeveloped world due to the import-flooding of cheap European consumables detrimental to local production. Any net gain that is seen via cheaper shopping bills pale in comparison to the wider economic hardships felt, such as rising unemployment and lack of economic diversification as value-added sectors collapse under the weight of cheaper foreign imports.

Not only is this approach neo-imperial, it is also hypocritical. "European countries reached their own current levels of economic prosperity through use of protectionist trade policy tools which are now being denied to African governments."[29] Ha Joon-Chang has called this the "kicking away [of] the ladder of development."[30] Today, the EU promotes free trade in commodities in mature European industries whilst it continues to protect its vulnerable industries. The EU's Common Agricultural Policy is a clear form of economic protectionism, yet the EU insists that ACP regions open up their agricultural sectors for free trade. This has very real consequences for food security. In Ghana, 200,000 jobs have been lost in the poultry sector. In 1992, 95% of Ghana's domestic poultry needs were supplied by the domestic market, by 2002, that number was 11%.[31] The World Food

Crisis of 2006-08 was precipitated by the rising price of food commodities. A reliance on imported foodstuffs prone to price volatility makes such crises more likely in future.

The EU's imperialist policy of trade protectionism at home and trade liberalisation abroad will further exacerbate food insecurity on the continent. This seems almost criminal considering the very real issues such places already experience due to climate change and centuries of intentional underdevelopment. The EU's trade policies therefore not only make it difficult for countries in the Global South to develop in a way that benefits their local populations, but also as 'uncompetitive' value-added sectors become de- industrialised, these trade policies have, and will continue to exacerbate food insecurity, which in turn is exacerbated by climate change; a product of Western overconsumption.

Concluding Remarks

The EU facilitates European neo-imperialism. Due to Europe's changing place within the world system, it is hard to quantify how individual European states could have continued their pre-war imperial practices without such an institution. We must also call into question the ability to 'reform' the EU. The act of reforming something assumes that it is not doing its role as effectively as it could, or that it needs modernisation. The EU is doing the exact thing it was designed to do, namely to continue the underdevelopment of ACP countries, export market economy principles and maintain an uneasy alliance between European capitalists. The EU does not need reforming, it is a reformed kind of European imperialism. What is also clear is that Brexit Britain and the EU have more in common than some may care to admit. They both possess an imperialist arrogance, support neoliberalism and maintain an identity grounded in the exclusion of others. The people of Europe can push genuine, real change by showing solidarity with those Europe oppresses and by understanding that the capitalist system also leaves the workers of Europe downtrodden. Another Europe is possible, but another European Union is not.

Endnotes

[1] Said, Edward W. 1986. "Intellectuals in the Post-Colonial World." *Salmagundi* 70/71: 44-64.

[2] Césaire, Aimé. *Discourse on colonialism*. NYU Press, 2001, pp.7-9.

[3] Femia, Joseph. "Hegemony and consciousness in the thought of Antonio Gramsci." *Political studies* 23, no. 1 (1975): 29-48.

[4] Bhambra, G.K., 2016. *Whither Europe? Postcolonial versus neocolonial cosmopolitanism*. Interventions, 18(2), pp.195.

[5] Schlenker, Andrea. "Cosmopolitan Europeans or partisans of fortress Europe? Supranational identity patterns in the EU." *Global Society* 27, no. 1 (2013): 25-51.

[6] Varada Raj, Kartik. "Paradoxes on the Borders of Europe." *International Feminist Journal of Politics* 8, no. 4 (2006): 517.

[7] Balibar, E., 2002. *Politics And The Other Scene*. London: Verso, pp.87-104.

[8] Varada Raj, Kartik. "Paradoxes on the Borders of Europe." *International Feminist Journal of Politics* 8, no. 4 (2006): 518.

[9] Canterbury, Dennis C. "European bloc imperialism." *Critical Sociology* 35, no. 6 (2009): 805.

[10] Wood, Ellen Meiksins. "Unhappy families: global capitalism in a world of nation-states." *Monthly Review* 51, no. 3 (1999): 1.

[11] Barrow, Clyde W. "The return of the state: globalization, state theory, and the new imperialism." *New Political Science* 27, no. 2 (2005): 127.

[12] Cox, Robert W. *Production, power, and world order: Social forces in the making of history. Vol. 1*. Columbia University Press, 1987 p.254.

[13] Hardt, Michael, and Antonio Negri. *Empire*. Harvard University Press, 2000, p.248-249.

[14] Canterbury, Dennis C. "European bloc imperialism." *Critical Sociology* 35, no. 6 (2009): 804.

[15] Nkrumah K (1965) *Neo-Colonialism: The Last Stage of Imperialism*. New York: International Publishers, p.19.

[16] Wallerstein, I. 1991. *Geopolitics and geoculture. Essays on the changing world-system*. Cambridge: Cambridge University Press/Editions de la Maison des Sciences de l'homme.

[17] Hansen, Peo, and Stefan Jonsson. 2012. "Imperial Origins of European Integration and the Case of Eurafrica: A Reply to Gary Marks' 'Europe and Its Empires.'" *JCMS: Journal of Common Market Studies* 50 (6): 1028-41.

[18] Dossa, Shiraz. "Slicing up 'development': Colonialism, political theory, ethics." *Third World Quarterly* 28, no. 5 (2007): 887.

[19] Dossa, Shiraz. "Slicing up 'development': Colonialism, political theory, ethics." *Third World Quarterly* 28, no. 5 (2007): 889.

[20] Goldsmith, Edward. "Development as colonialism." *Ecologist* 27, no. 2 (1997): 69-76.

[21] Rodney, Walter. *How europe underdeveloped africa*. Verso Trade, 2018 (1972), p.118.

[22] Farrell, Mary. "A triumph of realism over idealism? Cooperation between the European Union and Africa." *European Integration* 27, no. 3 (2005): 263-283.

[23] Nkrumah K (1965) *Neo-Colonialism: The Last Stage of Imperialism*. New York: International Publishers.

[24] Touré, Sékou. "Africa's Future and the World." *Foreign Aff.* 41 (1962): 141.

25 https://eur-lex.europa.eu/legal-content/EN/TXT/?uri=celex:22000A1215

26 Puig, Gonzalo Villalta, and Omiunu Ohiocheoya. "Regional Trade Agreements and the Neo-Colonialism of the United States of America and the European Union: A Review of the Principle of Competitive Imperialism." *Liverpool Law Review* 32, no. 3 (2011): 225-235.

27 Langan, Mark. "Budget support and Africa–European Union relations: Free market reform and neo-colonialism?." *European Journal of International Relations* 21, no. 1 (2015): 101-121.

28 Puig, Gonzalo Villalta, and Omiunu Ohiocheoya. "Regional Trade Agreements and the Neo-Colonialism of the United States of America and the European Union: A Review of the Principle of Competitive Imperialism." *Liverpool Law Review* 32, no. 3 (2011): 225-235.

29 *Ibid*.

30 Chang, Ha-Joon, ed. *Rethinking development economics*. Anthem Press, 2003.

31 Bagooro S (2011) *Report of the National Civil Society Forum on the EPA*, 25 August, Accra. Accra: Third World Network-Africa, p9-13.

Bibliography

Bagooro S (2011) *Report of the National Civil Society Forum on the EPA*, 25 August, Accra. Accra: Third World Network-Africa.

Balibar, E., 2002. *Politics And The Other Scene*. London: Verso.

Barrow, Clyde W. "The return of the state: globalization, state theory, and the new imperialism." *New Political Science* 27, no. 2 (2005): 123-145.

Bhambra, G.K., 2016. *Whither Europe? Postcolonial versus neocolonial cosmopolitanism*. Interventions, 18(2), pp.187-202.

Canterbury, Dennis C. "European bloc imperialism." *Critical Sociology* 35, no. 6 (2009): 801-823.

Césaire, Aimé. *Discourse on colonialism*. NYU Press, 2001.

Chang, Ha-Joon, ed. *Rethinking development economics*. Anthem Press, 2003.

Cox, Robert W. *Production, power, and world order: Social forces in the making of history. Vol. 1*. Columbia University Press, 1987.

Dossa, Shiraz. "Slicing up 'development': Colonialism, political theory, ethics." *Third World Quarterly* 28, no. 5 (2007): 887-899.

Farrell, Mary. "A triumph of realism over idealism? Cooperation between the European Union and Africa." *European Integration* 27, no. 3 (2005): 263-283.

Femia, Joseph. "Hegemony and consciousness in the thought of Antonio Gramsci." *Political studies* 23, no. 1 (1975): 29-48.

Goldsmith, Edward. "Development as colonialism." *Ecologist* 27, no. 2 (1997): 69-76.

Hansen, Peo, and Stefan Jonsson. 2012. "Imperial Origins of European Integration and the Case of Eurafrica: A Reply to Gary Marks' 'Europe and Its Empires.'" *JCMS: Journal of Common Market Studies* 50 (6): 1028-41.

Hardt, Michael, and Antonio Negri. *Empire*. Harvard University Press, 2000.

Langan, Mark. "Budget support and Africa–European Union relations: Free market reform and neo-colonialism?" *European Journal of International Relations* 21, no. 1 (2015): 101-121.

Nkrumah K (1965) *Neo-Colonialism: The Last Stage of Imperialism*. New York: International Publishers.

Puig, Gonzalo Villalta, and Omiunu Ohiocheoya. "Regional Trade Agreements and the Neo-Colonialism of the United States of America and the European Union: A Review of the Principle of Competitive Imperialism." *Liverpool Law Review* 32, no. 3 (2011): 225-235.

Rodney, Walter. *How europe underdeveloped africa*. Verso Trade, 2018 (1972).

Said, Edward W. "Intellectuals in the post-colonial world." *Salmagundi* 70/71 (1986): 44-64.

Schlenker, Andrea. "Cosmopolitan Europeans or partisans of fortress Europe? Supranational identity patterns in the EU." *Global Society* 27, no. 1 (2013): 25-51.

Touré, Sékou. "Africa's Future and the World." *Foreign Aff.* 41 (1962).

Varada Raj, Kartik. "Paradoxes on the Borders of Europe." *International Feminist Journal of Politics* 8, no. 4 (2006): 512-534.

Wallerstein, I. 1991. *Geopolitics and geoculture. Essays on the changing world-system*. Cambridge: Cambridge University Press/Editions de la Maison des Sciences de l'homme.

Wood, Ellen Meiksins. "Unhappy families: global capitalism in a world of nation-states." *Monthly Review* 51, no. 3 (1999): 1.

Art and the Revolutionary Spirit

THE REVOLUTIONARY

by Joshua C. Govender

In the midst of poverty and grit
In the face of *tyranny*
When the people are down in the pit
And suffering has reached the stage of *absurdity*
When the children are starving
so the rich can continue indulging
When hope totters on the cliff edge of desolation
And human value is in clutches of obliteration

There arises a group of heroes
Proud and *defiant*
Firmly refusing to give in to the power of circumstance
Driven by a singular mission of emancipation, of freedom, of *liberation*
A towering stance of resoluteness

These heroes are not activists
Neither statesman
They, far from simple populists
They transcend the politician
Neither are they in the ranks of the noblest
Clergymen

Yet history is saturated with their names
Lenin, Mandela, Slovo
Malcolm, Sankara, Castro
Newton, Guevara, Biko
They are uttered on lips
In nostalgia and pain
Forever immortalized in fame

They are in one word
Revolutionary
To be a revolutionary
Is to be a soldier
committed and unafraid of death.
With the consciousness of history
Ingrained within the heart
With the urgency of change
With the passion and rage against the existing state of affairs
We declare *ourself*
To be a be a revolutionary

Amidst Slumber

by Anton Regala

in time, the capital will hear of its lullabies,
that was built to strive among every mind
and restructualize the human self and its kind,
arching over the consciousness of the skies
as it exposes their selves in black and white,
unveiling the spectacles of dusts, and stars,
and thoughts, and sights it has kept and denied
from every thugs and proles that has bided
to the vices of the system, and clashed tendencies
with those of their classes and the high society.

and when such hour comes, when the tainted
has been undressed from its charlatan goods,
the exploited will emerge, insurrected, in its slumber,
and fashion the fabrics of concrete in blood red,
with raised fists, along the silhouette and hems
of the revolution, whilst interlocking with the seams
of the commoner's hustle as their path for liberation,
weaving their existence and struggle in the threads
of history, that will echo the beat of their footsteps
across dimensions and what is to be sewn.

THE CIRCUS COMES

(And Beckons!)

by Azriel Rose

Here they come! A gang of crooks, bandits, and plunderers, and in their posse comes another type: their bankers, financiers, and provocateurs.

Gleefully they scurry the commons, amassing a base, an oh so fake base! Poor base! Wretched base! Fooled base!

They seek out thier support, telling platitudes and promising hope. Wretched promises! Wretched hope! Wretched lies!

It comes every four years, this pitiful circus, and the people (the people!), they eat it up. But not a thing has changed, no.

On the contrary, each four years builds upon the last, plundering and stealing from the mass. Legislature after legislature, taking. No giving!

More and more, this circus is less welcomed. Their tickets no longer sell. A few poor people (poor people!) still clinging to the past.

The time will come. The tent will burn. Mass after mass, the herd will overturn. No more circus. No more show. Striking soon, an almighty blow.

Jesus & Lenin

Smoking Cigarettes in Hanoi

by Dylan Parsons

Flicking their ashes,

the purest form of matter,

into Uncle Ho's urn,

shooting the bull.

Lot cooler where I'm from,

says Lenin.

Lot drier where I'm from,

says Jesus

as the red sun rises in the East.

LEAVES, or SALT

by Jacob E.

I am mid action
(an agent of myself—
I suggest)
warming a towel
for my sickly daughter's neck.

Here on the sofa
this young person
bears witness
to my ever failing
paternal powers.

I am just a person
like everyone else.
She will learn one day,
long after the nausea fades,
that being ordinary is
what makes us special.

That being ordinary places us
in the belly of the beast
with tiny folding knives
plotting with everyone else,
the sudden and graphic death
it will one day meet.

That being ordinary
and afraid of the police
and late on rent (again)
and working while enrolled at university
and sleeping through alarms
and reading whenever you can
the most dangerous writing in history
(Marx, Lenin, Mao)
places us together,
neatly piled up
like leaves, or salt.

STOCK ★

by Jensen Saere

The spiders don't know
The value of a stock
The birds know nothing
Of debt to a bank
What does this mean?
The peddlers of lies
Imaginary value
And lack thereof
While the lowest people
Determined by fabrications
Gasp for air
Drowning in an ocean
Created by deception
And born of malice
From the elite
Who gave themselves
That conceited title

"Sink or swim"
They proclaim advice
From the deck of
A luxury yacht
Calumniations of laziness
And erotic fantasies
Of bootstraps and grit
Masturbation to pornography
Of human suffering
They can only cum

From facilitated suicide
The masses so jaded
So hopelessly lost
They comfort themselves:
"One day I'll have a boat"

To spoil the ending:
They never will
Military is unnecessary
In a system designed to kill
Paradoxical friendly fire
It isn't an accident when
That was the plan all along
Trenches full of bodies
Written off as statistics
Another perversion
Of sound sciences

We will die how we were born
Naked and afraid
And beholden to the actions
Of those who never asked
For any semblance of consent

WALLS

by John Beacham

Forest fire surrounds, breaking 6-story pines into t-ah-wigs.

The United States stands in a steaming suburban pool on the outskirts of Los Angeles. Stretches its infected arms out and back, leathered wings. With a bounding thrust into the water catches the circling virus-waves and hurls them into the Vast. Into the oceans, seas, rivers and lakes. Into the into the into…

Half a mask. Half a heart. Lopsided nation killing the world

It is not the United States that needs walls

"Making individual decisions is the American way," Max, a 29-year-old lineman for a power company said as he picked up his lunch at a barbecue joint at a rural crossroads south of Jacksonville. "I'll social distance from you if you want, but I don't want the government telling me I have to wear a mask"

Don't blame Max, please. No individual alone could conjure such logic

(Max needs to wear a mask, but how can I make him?)

"It is in the best interests of people to comply and wear a mask, but I am afraid the idea that we need to be safe is waning," said the epidemiologist

The governing people with hands up, then wringing hands, then washing hands off:

Don't wear a mask if you don't want to

Fuck!

Does a childish "civilization" deserve to live? Yes, it does. But, without a doubt, a society-child must grow up, abandon its cannibalism and know peace. Or else

You see, a mask is not divisive. It is to be worn. **Now!**

Class rule, however, is extremely divisive

But we will not let social distancing divide us. In the considerate, spaced between us now, impending rose-crafted collective will we hug again and again and again. We will lick our tears together, finger caress, spit with great aim and make the best soups ever savored

Final thought: Why does the media give so much damn airtime to the minority who embrace death and disease and not to the army of us who are bravely sacrificing to save all our people?

ШCP rides

orking lass

by John Beacham

TV commercial: "Coming from nothing, his story is our story"

What does that even mean? None of us come from nothing, mister master voice

To them—the snakes at the top and their copywriters—coming from nothing m[...]
born poor or born a worker

Fuck that. I am, we are, a worker. I am, we are, not your nothing.

I am not your story to tell or your dream drugs to shove down our throats

You know what nothing is?
A billionaire who dreams of escaping to Mars while the planet burns
A billionaire who does not know how to make things
A billionaire

We are not just something. We workers create it all (it'll!) and your time is up, up[...]
We'll run this planet—those who you call came from nothing

Anyway—with trombone, ukulele, violin background music from your favorite
commercial—proclaim it, bullhorn it at the billionaire's attic and basement:

"From nothing, everything!"
"From nothing, everything!"
"From nothing, everything!"

by Sandy Yu

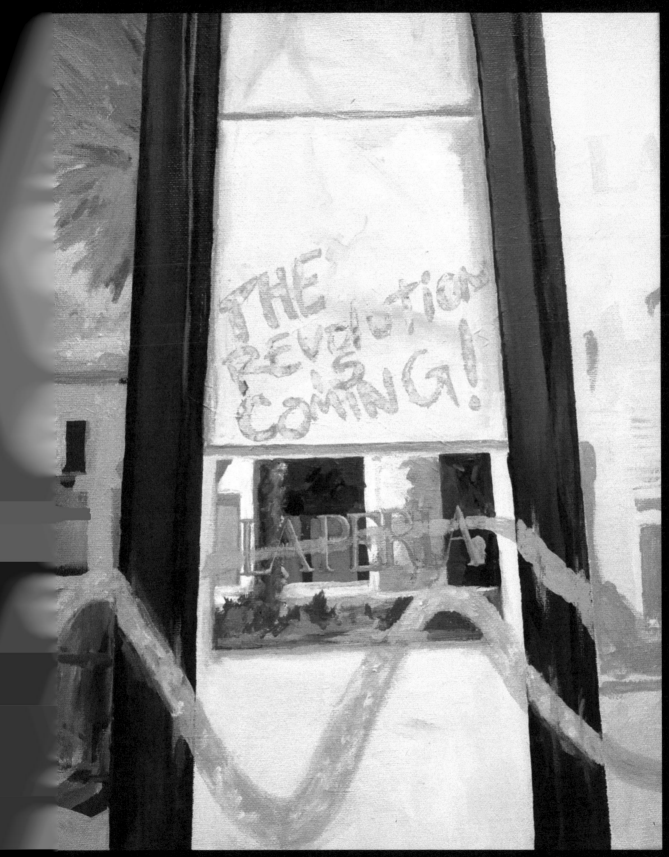

Untitled
Poem

by John Schlembach

I met an old man

living

out of his car

and we talked

about how this came to be

while our backs faced a row

of vacant houses

** * **

NOSTALGIYA

by Konstantinos Dimopo

The mirror of the past catches
Your transcendent gaze – and you look:

The red flag of so many
Struggles drapes around you
Like a fierce dress – unwrinkled,
Motionless in the howling wind

Warm blood runs frantically
Beneath your pale white skin –
A flaming Siberia melts under
The scorching vitality of the rebel
Sun

The endless grey of your
Bottomless eyes dissolves all
Colors – a tireless horse races
Past the Steppe to announce the
Coming of a better world

Your cascading tears quench
The thirst of so many generations –
An army of furious waves
Storms the palaces and floods
The streets

You leave the mirror, but
The reflection lingers on your
Trembling lips – and I look:

Your impossible promises
Dance with the Stars like
Untold prophecies – I am ready
To believe

Your naïve dreams walk
Among us like marble statues –
Are they our visions or
Are we their shadows?

I close my eyes and
Understand: You are my Soviet
Union – the one that wasn't,
The one that could be, the one
That will be

You
Have
Made me
Nostalgic
For the future

GUILLOTINE

2020

by Dunc X

Local 23

by Michael Araujo

He goes over the list with me one more time—cigarette dangling from his mouth. He was small, hunched, his skin pulled tight on his skull, not an ounce of fat on him, and no telling his age; he was old, maybe—always wore a tattered winter coat, no matter the weather. It was another big call—120 workers in all—some of them Journeymen, a few apprentices, and 200+ overhires hoping to get work for the day, a 4-hour minimum, and a meal. Managing this was hard, very hard. There were regulars of course, solid hands, older skilled, sometimes they brought their sons or daughters to try to earn some pay for the family. Joe kept his list close—he knew who would work, who was drunk but had a place, who was high. He kept the names and their stories. 150 shifts to fill that day, a bad economy, more than 200 show up with hope and empty bellies. Joe had to balance what was right, but he knew that there would be disappointment, some workers who would be passed over again and again. They would travel to the next city on the tour hoping again for the slot.

It was cold in the loading area. The wind ripped through the loading area. The workers bundled as warm as they could. Huddled together in little groups, talking about the last show they worked on, or how they got passed over, how they hoped to get picked for apprenticeship someday. Too early for the sun; the February cold was particularly cruel. The quick fading smoke from the breath blending in with the long-lasting smoke of the cigarettes. Holding their coffees with two hands and dancing from foot to foot for warmth. Standing by the loading doors which rattle loudly with every wind, they would talk about how they hoped this show had 30 or 40 trucks, and that they heard there were as many as 20 positions for the show. These workers weren't Journeymen, or apprentices, or cardholders of any kind so they gathered an hour before the call time, hoping the shape up would shape up for them.

Joe and I stood in the empty arena. Sometimes he would stand in the darkened space smoking, taking in the last hour to go over his list, to make sure it was right. I gave him space, I checked that the office was locked, and that the show call had qualified people for what this show wanted—they were all different. Joe left me to this quiet; no jokes now, no bullshitting about the old days. This time was a precious minute. Our day starts early before the first of the overhires show up—5 a.m., make the list. Our day wouldn't end until the show was over, and the last truck had left, and the last of the journeymen riggers was done with their adrenaline-fueled chatter. Our day ended at 4 a.m. 23 hours: ½ hour for breakfast, ½ hour for lunch, ½ hour for dinner. The work loading in a show was

dangerous. It required a vast array of skills. From truck loaders—there would be 12 on this show, paid by the truck to motivate speed—2 forklift operators, 30 pushers—this was the least desirable job, very cold and chaotic—the push for this show was almost 100 yards, and a pusher may make more than 100 round trips. 20 lighting techs, 15 sound techs—the second least wanted job—5 pyrotechs, 15 props, 10 costume, and 18 riggers who work in the high steel. This show had 35 trucks and had to be loaded, built, and ready for sound and light check in 4 hours. Joe needed his time to keep it straight; there were only 15 minutes to break the workers into crews. Joe could handle it.

I would help coordinate the timing and arrival of the trucks—2 loaders per truck meant 4 trucks could be hand-unloaded, and 2 trucks unloaded with the forks. I sketch out the loading apron, give it to Joe for approval, he nods—dropping ash on my notebook. It's 6:45. The first 4 trucks will be getting off the highway; now they were 10 minutes away, the last trucks about an hour—right on time. Joe passes me a smoke. I bend to his lighter, take a drag. Joe smiles. He hands me his list. I look it over. I've learned to read his scribbles—the tiny writing of 80 names and 40 empty spaces. That's what today is 40. 40 workers who are waiting in the cold, 80 workers who will go to a home—if they have one—

without any pay today. Maybe they have the money for gas to make it to Worcester the next stop for the show. I can handle the 40.

We walk across the empty arena floor to the loading door; it's the last minutes. I hear the first truck pull up. Joe steps up to the middle of the door, looks at me, I throw the door open—the cold air blasts up. Joe without removing the cigarette from his mouth Yells out.

ALRIGHT, BROTHERS—LINE UP AND LET'S GO TO WORK!

SELF PORTRAIT AS
fragile things

by Martins Deep

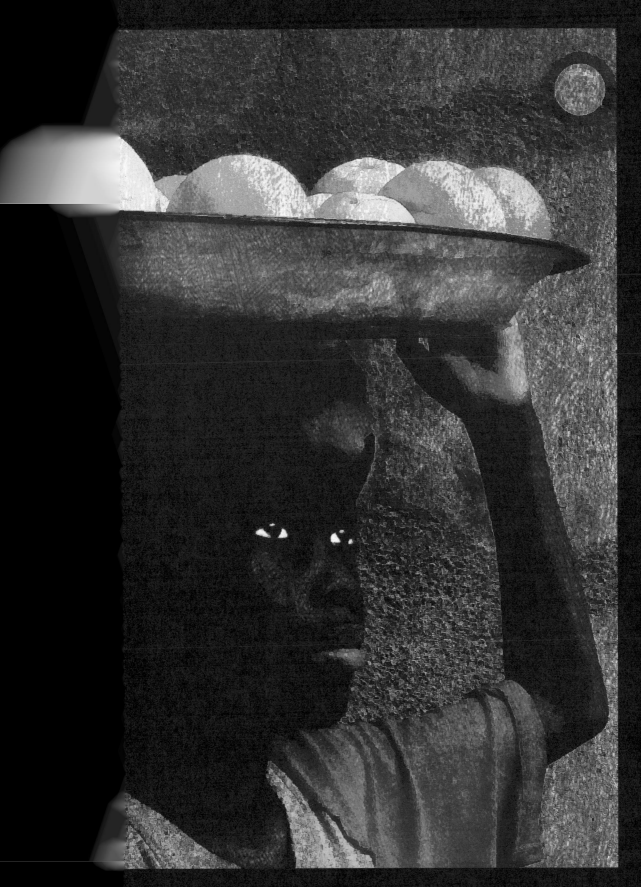

by Nicholas Heacock

V I O L E N C E

Shots fired
across social media as the news
breaks
Ahmaud Arbery Rayshard Brooks George Floyd Breonna Taylor Amani Kildea
onetwothreefourfive (justlike*that*)—

And I'm in quarantine wondering how—
Rent due. Hours
cut. My neighbor hangs
the battle flag
of the Confederacy. Calls it history.
Down
the block I hear people playing
"All You Need is Love" by the Beatles.

Rent got raised. But I keep thinking
it must be someone's job
to stack the bodies. Thousands—
and counting. Even more
sick. We sanitize
our groceries.

Love is all you need.

They say we didn't
see this coming. Profit
is down and they say we're all alone
until relief comes.
The President arrives
at a church for a shoot.

Peace
at the sit-in protest: *We want black lives
to matter.*

2020

Answer: they're gassing women and children now.

There's nothing you can see that isn't shown.

A power
walker struts by and speaks
loudly to someone on the phone, saying *there's weakness
in masks*
and complains that she *can't breathe.*

Gas
gives way to smoke in Minneapolis
and the cops fire into a crowd who repeat
I can't breathe.
A man lays bleeding on the concrete.
Is he breathing?

It's easy, all you need is love.

The media pundit
who *loves the boys in blue* attacks
the protestors and wonders how
we got so violent.
He claims *all lives matter* but in the white
space, fails to hide the subtext.

We're running low
on our essentials. Essential
workers are expected
to return to work and risk their lives.
Are we to continue
to fatten this beast that's killing us
and nail ourselves
to this cross—this runaway train—called America?
Jesus—

All together now—

We need to fight back.

ALONE

by Prakash Kona

The thing about aloneness is that it demands you imagine
 someone lonelier than you,
One can be morbidly alone without being in a state of want,
But the loneliness of those in want is about deprivation,
To be deprived is to border a state of insanity
 which happens with prolonged periods of non-belonging;
One can again feel that he or she belongs nowhere
 despite inhabiting a space of your own,
The spirit demands that one does not belong but the flesh knows better,
 it knows that as much as it could suffer,
The knowledge that all belonging is pointless,
 the security of not lying on a street at night
With no hope that the day will be any different,
Is how reality will be defined though not in abstract, philosophical terms;
That is the platform on which Hegel will battle Marx,
To the Hegelian, aloneness is about human condition,
To Marx, it is a condition of exploitation whose causes are social
But whose solution is spiritual because it recognizes
that the material world cannot be owned,
The loneliness of the homeless is a social condition,
To create a world without loneliness
is to create a world without the class system
A world where the sharing of the fruits of labor will collectively liberate humanity
 because the notion of individual liberation
That does not take the liberation of the one lying on the street into consideration,
Is both a myth and a lie.

A SENSE OF BEING

by Prakash Kona

The sense of being victimized is never the same as oneself being a victim,
You cannot feel poor
 because
Poverty is a state of the body not the mind: there is no mental poverty,
What we call poverty of the mind is
pure, deliberate ignorance combined with malice;
The sense of being deprived or taken advantage of
is not something one could live with
 without being enmeshed in contradictions;
The poor embrace their contradictions with the same intensity,
 the rich silence their conscience,
By not asking too many questions in relation to their private lives;
The language of power is about asserting one's sense of being
 what one is,
I cannot assert myself because there is too much in me a sense of loyalty
Perhaps misplaced, because you can be loyal to individuals
and not to an order;
I politely submit to a sense of passivity
 a sense of being a victim by choice;
Being a victim is an emotional state,
Even while its manifestation is a physical one,
In allowing myself to be a certain person,
I share in the contradictions of the poor
 while the conscience
I barely could silence
 is bourgeois to the core.

NO COUNTRY
for the poor

by Prakash Kona

I've never been to a country that ever welcomed the poor
Or spoke about the poor in remotely welcoming terms;
I've never met a poor man, woman or child who actually felt
 he, she or it belonged enough to a place
 to possess a sense of self of their own;
I've never known a country that did not depend on the poor
For its existence to an extent
 where I imagine cities crumble to dust
If the garbage collectors decide to strike for a month or so;
I imagine humankind goes back to
a pre-civilized state before the dawn of history
If the downtrodden classes took it upon themselves to bear
 the pangs of hunger and oppression
Rather than submit to a system of wage-slavery;
There is no greater wage slave than the one who makes money
 the goal of his existence
Because he pays a bigger and a more terrible price than the one
 who does it for mere survival,
Who is already paying a price for being born into an unequal order;

It might be genetically coded that the children of the poor
 will continue to be poor
While the children of the powerful are congenitally destined
 to be at the helm of affairs,

What is coded in the human spirit which transcends genetic limits,

Is a love of freedom and an ability to fight

in the supreme terms of art and revolution;

The spaces that go into making the borders between countries

protected by soldiers recruited from the poor,

Will one day be broken down by those very poor,

Because those borders are lands that separate humanity from itself,

They separate men and women from the consciousness of being themselves;

If the poor do not have a country it is because earth is home,

and in the country where the poor are least welcome

You can be certain that death has the last laugh.

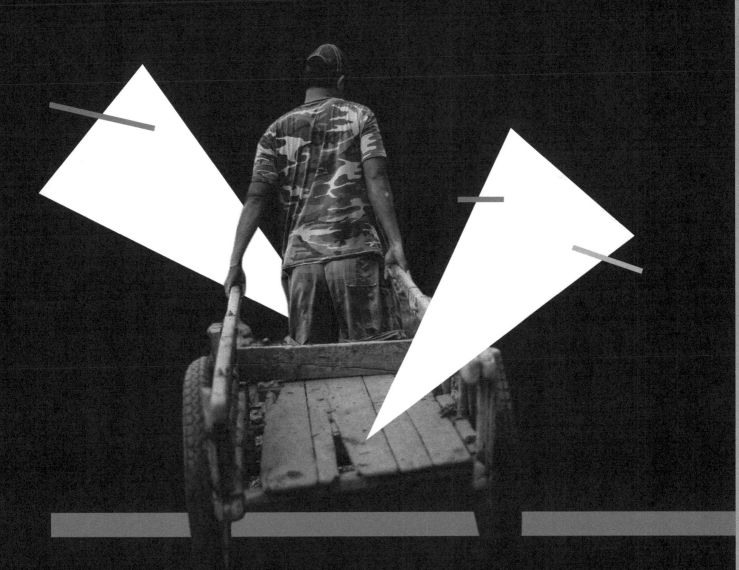

1 9 4 5 — 2 0 2 0

75 ГОД СО ДНЯ ПОБЕДЫ НАД ФАШИЗМОМ
75 YEARS SINCE THE VICTORY AGAINST FASCISM

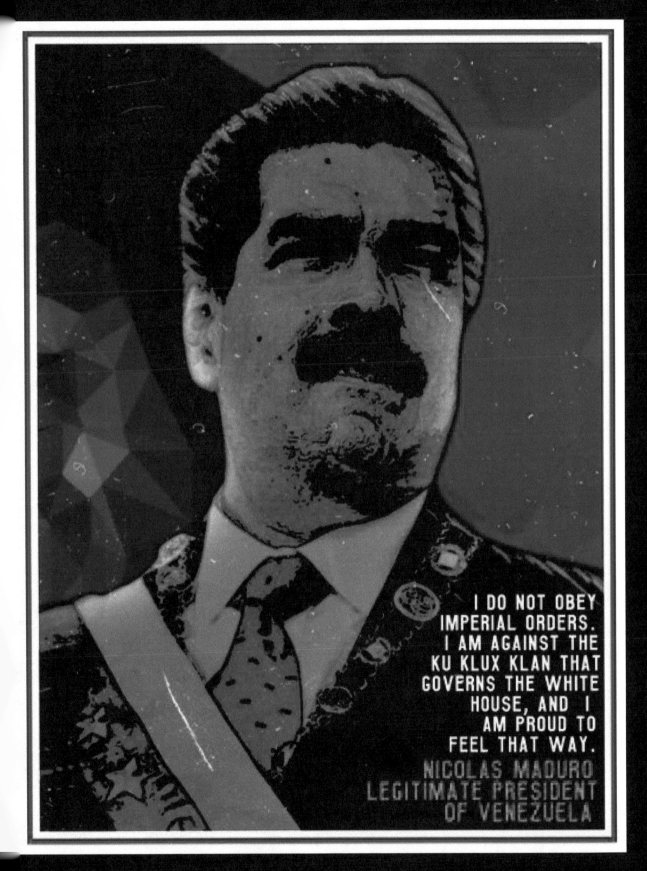

I DO NOT OBEY IMPERIAL ORDERS. I AM AGAINST THE KU KLUX KLAN THAT GOVERNS THE WHITE HOUSE, AND I AM PROUD TO FEEL THAT WAY.

NICOLAS MADURO
LEGITIMATE PRESIDENT OF VENEZUELA

WHAT DOES
— STAND FOR?

by Rusham Sharma

A.

America.

Atrocities are asked to be never forgotten.

They shun my raised fist which demands the meaning of selectivity;

Selectivity in remembering towers

And forgetting the Caribbean.

They say it reeks of the rotten smell of the past,

Like when blood is not cleaned from the dead

And is sprinkled through generations.

They say the past is better forgotten.

They ask to hide the buried,

Build towers on them

Someone needs to tell them,

Do not forget the truth of the Caribbean,

The triangular trade.

The 60 million.

If towers are remembered to forget a truth,

They will fall too.

B.

Bourgeoisie.

Bourgeoisie aren't born out of mothers' wombs. They are born of community production;

Production that they feed off to their own kind,

As they willingly extract labour and value from the majority,

They starve the majority,

While asking them to prepare the feast for an exploiting minority.

They disharmonize our songs of freedom,

And make their own textbooks,

Making themsleves our heroes.

Someone needs to tell them,

Singers die,

Songs don't.

If we are made to remember "15 hours of work a day,"

We can remember our original textbooks too.

C.

Class.

Class resembles the skin of a worker. It tends to shrink more than widen as time flies.

The worker can't afford to see their skin shrink, for it widens and then disappears;

Disappears into machines,

Into the exploitative web of the Bourgeoisie,

Juggling and stuck between pays,

Getting the entirety of their lives defined by a single web.

Someone needs to warn the Bourgeoisie,

We are questioning.

We are reading.

We are dissenting.

If we continue, we will reach to

R.

Revolution.

A Made-Up Dialogue Between
Myself **and** Jürgen Habermas

by Shane Brant

I walked into the bar, having just turned twenty-one, to meet someone whom a few of the phantoms I hang around with have recommended: Jürgen Habermas. I find him already stationed at the bar.

At my approach, he says, "One never really knows who one's enemy is." He told me that he's done too much in his life to dwell on passing thoughts. "What's your take on cognitive relativity?" I asked him. "It's relative to infinites," he said, presumably joking, not altering his stoicism. I explained to him that this is a world made of colors that no one can see clearly; we perceive them in blurs. The blurs one sees, therefore, are equally as accurate as the blurs another sees.

"Whatever I have argued before must be so," he said. I asked him if he could specifically explain to me what he meant by emancipatory knowledge. He did, and I disagreed, though I can't remember what he said or what it meant. Language is an appendix to freedom, but the idea that the two will eventually overlap is overestimated. People are not destined to be free but must be set free. Freedom and language exist as unaligned soulmates who must meet in order for each to work.

"People must liberate each other, Jürgen; the only thing that's *a priori* is an emptiness."

A person's first sentence is meaningless, it is their last sentence in which they approximate their universe. "The limits of my language are the limits of my world," I said, "said Wittgenstein." He drank. "All fools will mention Wittgenstein."

We were the last attendants in the bar when we began our leaving. As we were separating, he already at the door, I still putting on my coat, I said to him, to conclude our talk, "After all, as Democritus and Leucippus put it-" "I will hear no more from ghosts," and he was gone.

ILLUSIONS BY THE MOONLIGHT

by Shane Brant

It's Night again. How'd it come? While reading.

A desk amassed in books. The floor scabbed, too, with pages;

Bookcases with books on top; dishes where Tradition would have books.

Candles, notes, trash- all company to the change of light.

At the desk a lamp beside the chair; another, an island where the books sea.

These things and I enjoyed the sun, clouds, trees pleading Spring.

Reading. Then the dimness formulated, Darkness came, intruded,

A landlord demanding rent. The acknowledgement that Time has passed-

There is no gain in Living. All is measured in Negations;

Every moment brings subtraction.

Each time we assess our loss to be less than what we know is worst

Is an achievement; every loss less than Loss, a happiness.

AUREOLA

by Christian Noakes

LEILA KHALED

by Christian Noakes

BUFFALO NICKEL

by Sugar le Fae

Half-dissolved, he spills
from a roll of nickels,
spitting into my till:
a white man's caricature,
Native of no tribe, generic
chieftain stereotype,
feathers, leather, braids,
82-years-old, decades
of sweat and slot machines,
a lozenge on the tongue
of good, Christian charity,
too thin to stand up.
I buy him for five cents
from the change cup.
On the back, a buffalo
mourns his horns and tail,
worn away clink by clink
on trolleys, sidewalks,
dulled like sea glass
passed between hands.
His worth certainly hasn't
worn off the auction block.
Nor his owner's slogan:
'One of many' stacked on
his back like a joke.
Flip to know your fate:
life inside a sniper scope,
your head on a plate.

96

STORE RADIO

by Sugar le Fae

Patti Smith is a goddamn genius.
I love Van Morrison,
but if Patti Smith covers
your song, man, she owns it.
Suddenly, above the din,
her dry siren-call: Jesus died
for somebody's sins but not mine.
I scan the store for stiffs,
but no one's paying attention.
As a kid, her words unnerved me.
At 33, when 'Gloria'
comes on the store radio,
I freak the fuck out, singing
to customers, moshing in place.
No one else can hear it.
Patti Smith's punk-as-fuck
commentary on the male gaze.
Van Morrison appropriates
a preacher's posture,
testifying to his own glory.
Smith appropriates Morrison.
Or someone like him.
Writing a novel between
his lines, reclaiming the outlaw
fantasies reserved for men,
queering the narrative—
Patti Smith transcends gender,
frontman of her own band.

—*for Sienna*

SMASH HINDUTVA FASCISM

REBEL POLITIK
VISUALS

VICTORY FOR PALESTINE

R
ALIENATION

K
OPPRESSION

EXPLOITATION
O

LABOR UNDER
CAPITALISM

PRECARITY

&
DEPRESSION

TOIL

Innovators, Bullshitters, or Aristocrats

Towards an Explanation of Unproductive Work

by Amal Samaha

Theories which seek to explain the inadequacy of historical leftist and socialist traditions are a most cherished tradition of leftism and socialism. A common point of criticism is the fact that many wage-labourers are not engaged in "classic" productive work of the kind many Marxists are familiar with, which is to say industrial production in which the labor force, using the means of production, transforms inputs, resulting in a mass of commodities of a greater value than the prior input.

Industrial productive workers have consistently constituted a minority within any capitalist society. Such workers are the *locus of value production* in that they multiply usable values. There are also other forms of labour in the world which are or have been essential to the functioning of production, but which do not produce surplus values themselves, such as subsistence agriculture, or reproductive labour: the caring labours performed primarily by subjugated women, deeply necessary to reproduce both workers and the working day.

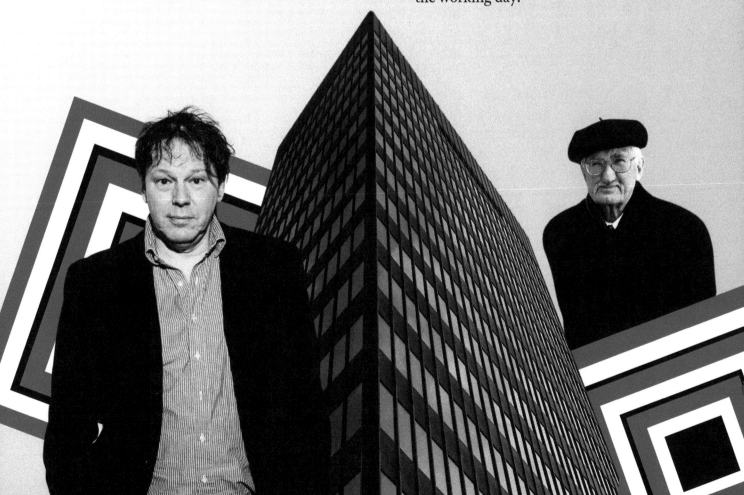

The utility of such forms of labour, and the basis of their exploitation by capitalism, can be explained by their connection to the locus of value creation. In this sense, they cohere to known laws of production. However, what has become increasingly identifiable over the course of the 20th century are forms of labour which are seemingly disconnected from the locus of value creation entirely. Labour that is, as far as one can tell, entirely unproductive.

I will be tracking the development and expansion of these forms of unproductive labour in the work of three authors. The Frankfurt school philosopher Jürgen Habermas calls this *Reflexive Labour,* the anarchist anthropologist David Graeber calls it *Bullshit Jobs*, and imperialism theorist Zak Cope might call it a symptom of *Labour Aristocracy*.

These three authors, in examining similar phenomena, draw wildly different conclusions. Habermas, ever the optimist, believes that the existence of new forms of labour which negate crisis mean late capitalist societies can continue to improve as the state is transformed through engagement in the public sphere by a revived civil society. Graeber is reluctant to draw conclusions, and tentatively points towards Universal Basic Income as a means of separating work from wages. Cope argues that we must throw away the dominant tendencies of Leftism in the Imperial Core, and locates his hopes within the most marginalised sections of the working class, as well as in the workers and farmers of the periphery. I will attempt to draw my own conclusions around how marxists might engage with the theories described, as well as what the implications of reflexive labour might be for the workers' movement.

Habermas and Reflexive Labour

Central to much of Jürgen Habermas' thought in *Legitimation Crisis* is the idea that Capitalism has transformed since the time of Marx to such a degree that it constitutes a new mode of production, and, with it, new relations of production and class hierarchies. Habermas borrows from the historical materialism of Marx and Engels, positing that instead of a trajectory through modes of production from Feudalism, to Capitalism, to Lower Communism, there has instead been a trajectory from feudal "Traditional Society," to "Liberal Capitalism," to a "Late" or "Advanced" Capitalism.[1]

This distinct mode of production came into place in four stages. The state, as the most conscious and forward-thinking sector of capitalist societies, secures the conditions of its continued existence in property and contract law, rescuing the market from self-defeating side-effects, promoting market competitiveness, and securing national sovereignty. The state then undergoes *market-complementing* actions, increasing the size and competitiveness of markets. These actions give way to *market-replacing* actions, such as regulations, price adjustments, stimulus, and other subversions of free-market principles which affect the organising principles of society, creating new "classes" such as the public service. Finally the state compensates for the dysfunctions of the earlier Liberal Capitalist period, responding to any organised aggrieved section of society such as unions, minorities,

or failing industries, taking charge of the consequences of unregulated industry and propping up unprofitable sectors through subsidies.[2]

A society which has undergone this change should possess three characteristics. The market-replacing actions of the state lead to new forms of surplus value accumulation, such as new forms of labour, new forms of reinvestment, and new social classes. A "politicised"[3] wage structure develops in which capitalists, unions, and the state collaborate to determine wage levels, a process which further changes class dynamics by promoting collaborationism. Finally the contradictions between the new society and the old "liberal capitalism" produce a legitimation crisis which creates demands around "use-values."[4]

But why would a capitalist class allow these radical state reforms to take place? Habermas calls the constellation of class relations described by Marx "improbable," which is to say that the market allocation of wages was inefficient, illogical, and unstable.[5] A "political" (class-collaborationist) system of wage allocation was a natural solution more likely to avoid the classical overproduction crisis which Marx described in *Capital*'s third volume.

Proving that late-capitalism had evolved mechanisms to avoid an overproduction crisis is essential to Habermas. To do so he attempts to prove that the Tendency of the Rate of Profit to Fall (TRPF) has been offset by mechanisms which not only *delay* crises (something Marx accounted for as *countervailing tendencies*), but prevent it entirely.[6] A basic knowledge of Marx's crisis theory is necessary before understanding Habermas' supposed negation: technology leads to more and more efficient means of production, which leads to greater outputs of use-values per unit of capital invested. This technological progress also means that labour is automated in order for businesses to stay competitive, leading to an increase in the Organic Composition of Capital (OCC). Since living labour-time is the locus of value creation, the lack thereof leads to a decline in the rate of profit. Marx considered this development of crisis theory to be his greatest innovation[7] in part because it proved the long-term instability of capitalist productivity, imposing a hard limit on any optimistic projections of capitalist futures. Any theorist who wishes to propose non-revolutionary solutions to crises, without refuting each of Marx's theories in-detail, would therefore have to disprove the TRPF and provide evidence of ongoing countervailing tendencies.

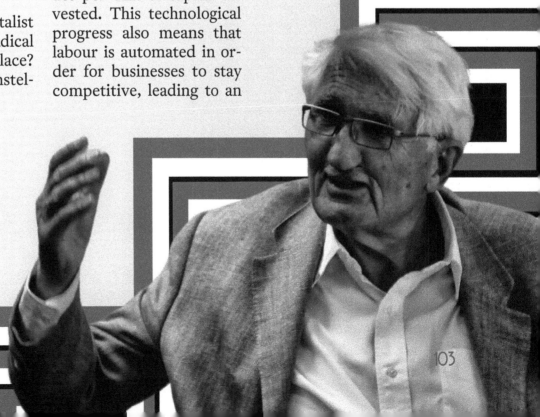

In *Legitimation Crisis*, Habermas proposes several countervailing tendencies, but the two most relevant to us are the creation of masses of public service workers, and the creation of *reflexive labour* jobs.

Habermas believed that the increasingly massive state bureaucracies of advanced capitalism would themselves delay or negate the TRPF by steering markets away from crisis;[8] buying up commodities at above-market rates, employing workers in an ever-expanding bureaucracy, and effectively compensating for any market failure through social spending.

This might appear to be one of the more dated components of Habermas' thought as it is clear to any modern reader that the meteoric rise in public spending and public sector growth he describes was short-lived. Figures from most western countries show a consistent rise in social spending around the time Habermas was writing, with most countries plateauing in the late 1970s, and some (particularly late-adopters of neoliberal policy, such as Sweden) declining.[9] However, in dollar

terms the change is less dramatic than might be imagined, and many states, including the UK and US, soon resumed the general trend towards increased spending.

Spending generally increased under Neoliberalism, but privatisation actually leads to reduced efficiency[10] and there has been a corresponding decrease in social outcomes per dollar spent. The missing value has instead gone to an increasingly thick layer of parasitic companies which exist to milk government contracts – job-searching or temping agencies, call centres, pension providers and the like – all fulfilling roles once performed by the state, and each with their own attendant armies of managers and administrators.

While Habermas did not account for these changes, this does not in itself invalidate his argument that public spending would constitute a countervailing tendency against the TRPF. However when we consider a groundbreaking study by Esteban Ezequiel Maito, which measured the rate of profit across fourteen countries, correctly adjusted for growth in

turnover speed,[11] we can see that the fall in the rate of profit *accelerated* precisely when social spending was being expanded in the west, and this acceleration halted precisely when social spending plateaued.

Habermas' other key countervailing tendency is *reflexive labour*, defined as "labour applied to itself with the goal of increasing the productivity of labour."[12] This begins as a collective property of mankind – naturally occurring human ingenuity, or inventions brought about by necessity and chance. Habermas argues that Marx considered ingenuity to be a background phenomenon, like air or land, and not a fundamental part of production. This is arguable, but for Habermas it is clear that invention is a process that can be forced to occur in a predictable and controllable fashion, but only by an "advanced" capitalist state, as in liberal capitalism there was no systematically utilizable, productivity-increasing innovations.[13] In advanced capitalism, the state can incorporate teaching, science, engineering, and management innovations into the production process by funding research institutes, schooling, and think-tanks. In neoliberal capitalism of the last few decades, we would call much of this reflexive labour force the tech or information industry, and the degree to which this form of labour has become uncoupled from the state will become important later.

In terms of the specific way in which these reflexive labourers affect productivity, Habermas is somewhat contradictory. It is important to understand that increases in productivity typically lead to lower profitability in the long term. Capitalists must continuously invest into fixed capital in order to remain competitive. This increases the *Organic Composition of Capital* (OCC) and thus reduces the rate of profit. These functions can be expressed as an equation to find an annual rate of profit:

r = The annual rate of profit

s = The annual surplus value

c = The annual cost of means of production (constant capital)

v = The annual cost of wages (variable capital)

$$r = \frac{\frac{s}{v}}{\frac{c}{v} + 1}$$

In this equation we can see that a reduction in the value of wages relative to the means of production will bring about a reduction in the rate of profit. In Habermas' model the combined efforts of reflexive labourers act simultaneously to add to the output of direct producers (increasing s), as well as additional labourers themselves (increasing v), effectively reducing the value composition of capital (which correlates with the aforementioned organic composition) *and increasing productivity*. While it would certainly be fortuitous for capitalists if this were the case, as productivity could be increased endlessly with no downside, it makes little sense while profitability decline continues to persist. Instead, one or the other must be true. Since reflexive labourers are still living wage-labourers, they add to the overall wages invested in production, increasing the value composition, and *reducing* the surplus value produced per unit of labour time in the short

term. This has the effect of increasing long-term profitability, at the cost of short-term profitability.

The capitalist alone has little incentive to engage in this process as it increases the number of labourers involved without any short-term increases to profitability. It's for this reason that Habermas is correct when he says that there are no productivity-increasing innovations that are intrinsically part of capitalism as Marx described it. It's strange then that Habermas believes that the advanced capitalist state is so much more forward thinking than its captains of industry, as if government bureaucrats read enough Marx to understand the value of counteracting the TRPF in anything but the most crude and superficial terms, such as a decline in GDP.

It's difficult to think of a critique of Habermas' work more encompassing than to point out the anti-marxist orientation of his worldview. This is not to say that Habermas is an anticommunist – he is no cold warrior – but his work is typified by a dogged determination to come to conclusions contrary to Marx no matter how improbable. This was noticed as early as 1971 by Habermas' contemporary, Göran Therborn, who

notes:

In Habermas's academic oration there is no room for any workers, still less for a revolutionary proletariat. The 'emancipatory interest' (to use a term of Habermas's) which guided Horkheimer and which he regarded as the 'only concern' of the critical theorist, was 'to accelerate a development which should lead to a society without exploitation'. It was clear from the context that this development was the proletarian socialist revolution. Habermas's interest in emancipation produces merely 'self-reflection'[14]

Habermas' distinctly anti-revolutionary development of Frankfurt school critical theory contrasts poorly with the useful contributions of other Frankfurt school writers like Walter Benjamin, in that it is "pure negation"; his objective being to insubstantiate a collection of sociological orthodoxies (mostly Marxist ones) without any real regard for developing an alternative theory of comparable coherence. He achieves this by criticising an imagined, dogmatic, ultra-orthodox Marx. For example when Habermas explains that social relations have lost a supposedly Marxian pre-determinative quality through the "politicisation" of the labour market,[15] he neglects to men-

tion that Marx described states suspending the laws of the "apolitical" labour market for economic gain several times.[16] Most of the characteristics of Habermas' "advanced" capitalism either existed long before Habermas said they should, or have ceased to exist since *Legitimation Crisis* was published.

All this said, the concept of a class of reflexive labourers who exist as a countervailing tendency to the TRPF is an interesting one, albeit a revelation undercut and distorted by Habermas' anti-Marxian analytic framework which necessarily ignores the colonial underpinnings of his "advanced" capitalism. That such higher-order intellectual labourers can exist is predicated on imperialist superprofits, as we will see. So too is the impact of anticommunism itself in the formation of this class under-emphasised by Habermas, as the rise of such workers was inexorably connected to the west's herculean crusade against Soviet communism. This is easier to see in the context of a modern information economy built on the infrastructure (internet, satellite and wireless communications) of the cold war.

The greatest mistake of Habermas' *Legitimation Crisis* was that he failed to situate his new epoch on a fluid historical continuum: his "advanced" capitalism would be superseded by later forms eerily similar to the supposedly obsolete "liberal" capitalism of the 19th century, and his reflexive labourers, once the heralds of a new crisis-free capitalism, would be subsumed into the logic of the neoliberal decades.

Graeber and Bullshit Jobs

While Habermas is single-mindedly concerned with negating the theories of others, in *Bullshit Jobs* anarchist anthropologist David Graeber is equally single-minded in his determination to prove, without doubt, the existence of the titular phenomenon, with less emphasis on why it exists or its implications.

Graeber's research—pages upon pages of testimonies

from wage-labourers across the western world—draws an undeniable conclusion: roughly a third to half[17] of all wage-labourers in developed countries are engaged in *bullshit jobs*: defined as "a form of paid employment that is so completely pointless, unnecessary or pernicious that even the employee cannot justify its existence even though, as part of the conditions of employment, the employee feels obliged to pretend that this is not the case."[18] This definition is based on the subjective experience of the worker rather than their ostensible role, as Graeber believes that workers are generally able to judge whether or not they are performing socially-necessary labour. It is difficult to establish whether a bullshit job is producing anything in terms of use values, but by definition it must be doing so at so low a rate, or in such low quantities, that the worker doesn't notice any social utility in their actions. Furthermore, bullshit jobs pay quite well compared to actually productive labour,[19] meaning that the rate of exploitation is low, or even in the negative.

In addition to jobs which are entirely pointless, Graeber suggests that most jobs are undergoing a process of *bullshitisation*, or a decline in the time spent performing socially-necessary labour. He uses the example of British nursing, wherein nurses reported that up to 80% of their time is spent doing paperwork at the expense of their primary care duties. Likewise, in many office jobs the time spent doing primary duties is declining, with one study showing a decline in hours spent performing primary duties from 49% of total working hours in 2015, to 39% in 2016.[20] Even in workplaces where workers self-report that their work produces real use values, there is an overwhelming trend towards an "inverted pyramid" structure wherein the workers who perform the most clearly necessary labours (direct production, cleaners, maintenance workers, logistical staff etc.) are increasingly understaffed, underpaid, and subject to "scientifically" precise productivity quotas, while the top of the pyramid (management, administrators, those designing the aforementioned quotas) are multiplying exponentially.[21] To have such a high ratio of management and clerical staff to labourers makes little sense, as the multitudes involved are above and beyond that which would be necessary to reproduce class relations within the workplace, or to administer scientific management techniques.

It is easy to challenge Graeber's claims by pointing out that alienation of the worker from the act of production, the segregation of the processes of production into a series of discrete, repetitive motions,[22] could account for workers under-reporting their output of use values, as this would prevent workers from seeing the end result of any action. However, while I believe that while this is a factor to consider, I do not think it accounts for all of Graeber's revelations. Alienation of the worker from production,

such as it extends outside the bounds of an individual workplace, typically applies more so when looking "up" the chain of production rather than down. To give one example, Congolese cobalt miners have at least a loose understanding that the resource they produce will end up in batteries for consumer electronics.[23] By contrast it is doubtful that workers engaged in final assembly of those batteries would know where the cobalt hydroxide comes from, in part because that information is deliberately obscured. For this reason I believe self-reportage is an appropriate means of gauging the degree to which workers are actually producing values.

From this perspective, the revelations in the first half of *Bullshit Jobs*, which is to say the parts that are wholly based in worker testimony, are relatively incontrovertible. What follows in the latter half of the book is much less clear-cut, as Graeber avoids making any definitive arguments as to why bullshit jobs exist, or at least, avoids making any sweeping political-economic claim as to their origin. To be fair, Graeber warns his readers many times that his work is light on conclusions.

As such it is more productive to talk about the dominant recurring themes in Graeber's broad discussion of tendencies which *correlate* with *bullshitisation*, rather than misrepresenting the book as a series of discrete arguments around causation. These themes include privatisation, financialisation, infeudation, and informationalisation.

This first tendency, in which social-democratic self-conscious make-work programs give way to much more inefficient neoliberal job-creation programs,[24] is a perfect illustration of something I referred to earlier while discussing Habermas' optimistic treatment of the public sector: neoliberal-

ism is an extension of the goals of social democracy with added inefficiency. As Graeber says:

For much of the twentieth century state socialist regimes dedicated to full employment created bogus jobs as a matter of public policy, and their social democratic rivals in Europe and elsewhere at least colluded in featherbedding and overstaffing in the public sector or with government contractors, when they weren't establishing self-conscious make-work programs...the new neoliberal age was supposed to be all about efficiency. But if patterns of employment are anything to go by, this seems to be exactly the opposite of what actually happened.[25]

The mass of public sector jobs that Habermas described as something which could forestall or even negate the worst excesses of capitalism, would likely have been bullshit jobs themselves, and indeed these inflated state bureaucracies are one key source of *bullshitisation* today.[26] However, such public sector bureaucracies are a lesser factor than their privatised counterparts. Most aspects of the public sector, if not privatised outright, at least outsource much of their function to private contractors, or else are subject to budgetary responsibility rules that mean that many state functions are subject to the same profit motive as private industry. These privatised replacements for what once functioned as public services run at higher costs, and also tend to employ far more managerial and administrative staff. From 1975 to 2005 the number of administrators and managers at privatised institutions in Britain increased at more than twice the rate it did in public ones, an expansion of 135% vs. 66%.[27]

Once again, neoliberalism proves to be less of a process by which states *shrink* and more of a gradual process of states expanding so as to support a thick layer of para-

sites: companies which milk government contracts by finding the least efficient means of dealing with public issues. Graeber's examples of various FIRE sector (Finance, Insurance, Real-Estate) worker testimonies illustrate the link between privatisation, *bullshitisation* and financialisation well.[28]

As states privatised their huge public sectors largely for ideological reasons, privatisation emerged as an alternative means of fulfilling some of the state's functions in terms of stimulus and job creation.

By fulfilling government functions through contracts, the state gained a means of ongoing, direct stimulation of the economy by allowing companies to milk tax dollars directly. In return, corporations fulfilled the state's political goals of reducing unemployment to acceptable levels. Many of the financial functions of the state were also given over in the great sell-off, and now the finance sector is primarily concerned with "colluding with government to create, and then trade and manipulate, various forms of debt."[29] Having been given the means to create debt, "it creates money (by making loans) and then moves it around in often extremely complicated ways, extracting another small cut with every transaction."[30]

This process naturally creates many banking jobs, as the companies intentionally mistrain employees to milk the cash cow. Most bank employees can't figure out why their particular species of bank exists. Furthermore, banks create a level of fear and paranoia as employees are under enormous pressure not to ask too many questions.[31] Banks add nothing in terms of use values, but they deal in huge quantities of exchange values, much like a state does, and it is the necessity of collusion with the state to produce these exchange values that causes much of Graeber's *bullshitisation*. To give one example, JP Morgan Chase & Co. derives two-thirds of its profit from fees and penalties, which is to say speculating off of debts which are enforceable through law.[32] The right to trade in penalties cannot simply be bought, it requires a huge amount of political capital first.

The necessity of accruing political capital to facilitate collusion between the state and finance capital is one factor leading to infeudation. Graeber believes that the entanglement of the economic and political since the 1970s has led to a neo-feudal dynamic in many corporate structures. The purpose here is to loot, steal, or extract rent from what little productive labour is being done, in order to create an entourage of followers which can create political favour.[33] Graeber here goes so far as to offer a general theory of infeudation:

In any political-economic system based on appropriation and distribution of goods, rather than on actually making, moving or maintaining them, and therefore, where a substantial portion of the population is engaged in funneling resources up and down the system, that portion of the population will tend to organise itself into an elaborately ranked hierarchy of multiple tiers (at least three, and sometimes ten, twelve, or even more). As a corollary, I would add that within these hierarchies, the line between retainers and subordinates will often become blurred, since obeisance to superiors is often a key part of the job description. Most of the important players are lords and vassals at the same time.[34]

This hierarchical structure is not only the result of financial-political elites but also a century of managerial ideologies starting with the "scientific" management of the early 1900s. Under feudalism, workers with specialised knowledge had basic rights to collectively regulate their own affairs. The alienation of production brought about by Industrial Capitalism changed this, and managerialism, later known as taylorism, pushed this further. Under financialised capitalism the map has completely become the territory to the point that efficiency is not measured by outputs, but rather, by how much effort is put into efficiency. Thus an efficiency industry, or information sector can grow, which is by its nature hugely inefficient, but which can effectively monopolise the measuring of efficiency. As Graeber says:

Efficiency has come to mean vesting more and more power to managers, supervisors, and other presumed 'efficiency experts' so that actual producers have almost zero autonomy.

But who are the "actual producers" in Graeber's view? Much of the remainder of *Bullshit Jobs* is spent on a series of comparatively unconvincing, disjointed theses: a latent cultural memory of a protestant/puritan work ethic is the cause of our collective fetishisation of employment, the real locus of value creation is in caring work, and the only way Graeber can imagine uncoupling those in *Bullshit Jobs* from their dependency upon bosses is the uninspired phantasm of the Universal Basic Income. It is his claims

around caring work which I find most condescending as a former care worker: it was clear to me even then that washing the elderly was no locus of value creation, rather I existed to assist a multinational in milking pensions in return for labour better provided by an adequate healthcare system.

Much of the problem for anyone trying to apply lessons from *Bullshit Jobs* to political economy is the fact that bullshit jobs themselves are a series of several discrete categories of work that have been collated together by reason of *social* similarities in their subjective experience of work. Some examples only fit Graeber's definition of bullshit jobs because the worker is morally opposed to their own labour (such as the bank worker opposed to usury).[35] Once again, this isn't really a criticism of Graeber as he did not set out to write a work of political economy, and in fact he divides bullshit jobs into several sub-categories based on some social similarities, or roles which make sense in the context of his feudal analogy. Nonetheless in order to draw any political economic conclusions from *Bullshit Jobs* we must devise our own system of sub-categories:

Alienated Direct Producers

As discussed previously, at least some people who feel they produce nothing useful are probably engaged in the direct production of use values but can't see or enjoy the end result of their labour.

Indirect Producers

These people include banking, real-estate, or advertising employees whose roles serve a clear purpose in capitalist society, but which are lumped in with other bullshit jobs simply because worker testimonies suggest those roles shouldn't exist in a just society. Such roles produce no use values, but they exist to siphon exchange value away from the state and public through the transfer of debt. These finance workers "generate" this exchange value, and so a cut is taken from them by their bosses. This means that they are subject to a rate of exploitation.

Exploiters

At least some managers are necessary to reproduce capitalist class relations in the workplace effectively. As representatives of the bosses' interests they are expected to meaningfully combat inefficiencies and curb workers' economic power in return for their pay. Marx refers to this as "the exploitation of the labourer by capital...effected by the exploitation of the labourer by the labourer."[36]

Reflexive-Unproductive Labourers

These comprise the bulk of those in "bullshit jobs" and are either the vestiges of the first state-sponsored institutes, or more likely, their privatised progeny. These are think-tank employees, university administrators, management consultants, data analysts, supervisors-of-supervisors and the like. They are the "efficiency experts" Graeber described earlier, but as many worker testimonies appear to suggest, they actually reduce the efficiency of the systems they are a part of, and when working in conjunction with productive labourers, tend to reduce productivity. There is a massive disconnect between the ostensible reasons for their hiring, and their actual effect on the economy: in theory they fit perfectly with Habermas' definition of "labour applied to itself with the goal of increasing the productivity of labour," but the economic impossibility of such a form of labour explains why in practice they do the opposite. Such workers decrease overall productivity, but decrease the Organic Composition of Capital, leading to a lesser rate of profit decline. In isolation, only a small portion of their labour is socially-necessary, and so they are a drain on individual businesses, but on a macroeconomic level they correlate strongly with economic stability, for reasons that policy makers don't fully understand beyond a general appreciation for the necessity of informationalization and higher employment figures. As such, these jobs are implemented through political and economic pressures, in heavily subsidised or speculative industries like tech, or else they are employed in firms intended to improve the efficiency of the state.

Once we prune away some of the socially similar but economically different aspects of bullshitisation, we can see that *Bullshit Jobs* is in part the synthesis of Habermas' earlier theories on reflexive labour with its antithesis: the redundancy and economic impossibility of reflexive labour as it actually came to exist in the world. *Bullshitisation*, therefore, is the oversized socio-political impact of the much more specific economic factors of reflexive labour and informationalisation generally.

To see the shadow of reflexive labour within Graeber's theory shows that Habermas' theory of how capitalism might avert economic and political crisis was correct in a way, but not at all in the way he imagined: far from the armies of enlightened, state-employed scientists, teachers, and engineers who would force indefinite productivity, we instead got armies of privately-employed overskilled peons, paid to shift money and paperwork hither and fro. Graeber seems to understand the irony of how the hopes and fears of the con-

traditions of the social-democratic era led us here: in discussing Keynes he says:

Automation did in fact, lead to mass unemployment. We have simply stopped the gap by adding dummy jobs that are effectively made up. [37]

The victory of this *reflexive-unproductive* labour, hollow though it may be, was to address key contradictions of the social democratic and neoliberal eras. Both have their origin in a classic overproduction crisis caused by the Tendency of the Rate of Profit to Fall, and Graeber acknowledges this briefly through discussion of a short story by Stanislew Lem. [38] I have already discussed how a decline in the Organic Composition of Capital is the key factor in initiating an overproduction crisis, but this can be interpreted in several ways.

Social-Democratic reformers have typically concluded that the key symptom of an overproduction crisis is unemployment and wage reductions, which in turn lead to reduced consumer spending and shrinking markets for goods, and so this is the cause for the correlation between an increase in OCC and the exacerbation of the TRPF. This analysis would suggest that governments stepping in to sub-sidise wages and stimulate consumer spending is enough to end a crisis, and indeed this is what governments of all stripes have done in the current crisis. [39] However this does not strike at the root of the issue: the cause of an overproduction crisis is the over-productivity of labour as a result of the *full sum* of investments into productive forces, and short of actively underdeveloping those forces, the problem can only be relocated through asset sell-offs and growing mo-nopolies. In the long term, the output of increasingly productive forms of labour will always outstrip demand, no matter how much consumer spending is stimulated. A much more direct means of retarding the development of crises is to both reduce overall productivity and artificially deflate the OCC, which is exactly what reflexive-unproductive labour achieves. This was able to effectively solve several economic and political anxieties of the social democratic era: it reduced

the likelihood of overproduction crisis, it reduced unemployment, and it secured a large consumer base in the developed countries.

To situate the role of reflexive-unproductive labour within the context of an overproduction crisis does leave one question remaining: if there is a considerable decline in the production of use values in the developed world, does this indicate a shift in the locus of value creation, or even an invalidation of Marx's theory of value? Both Habermas and Graeber suggest that their theories invalidate materialist economics in whole or in part, for curiously similar reasons. To Habermas, the incorporation of reflexive labour from an aspect of system environment (a factor external to the mode of production) into a peculiar aspect of production disproves Marx's theory of value because it represents an institutionalisation of indirect production.[40] Graeber makes a very similar claim around a form of indirect labour, in this case reproductive labour, saying that the locus of value creation has shifted into caring labour precisely because it is impossible to quantify, automate, or incorporate into materialist economic theory.[41] Habermas claims to invalidate Marx's theory of value, but he doesn't challenge Marx's definitions of value, whereas Graeber proposes an entirely new definition of value, saying that it is that which we feel is valuable, or which we care about − really just a phenomenological definition.[42]

Both authors argue against an imagined, dogmatic, inflexible Marx, and since neither works through a Marxist lens it does not feel particularly productive to be too invested in these debates around the theory of value. Suffice to say that it is a mistake to think that we are forced to look beyond Marxism, or even Marx's own writings, to uncover terms flexible enough to explain the phenomena described. While it is true

that Marx and many orthodox Marxists did not dedicate significant time to analysing reproductive and indirect labour, it is a mistake to say that in saying these forms of labour are not a locus of value creation we diminish their importance.

———————

Reproductive labour can simultaneously be the most widespread and fundamental form of labour in the world, and still not be a locus of value creation *for the capitalist*. Likewise intellectual or emotional forms of indirect labour can be socially valued and can affect use value creation, or can be loaned out by capitalists for a profit, but this doesn't mean they are a locus of value creation. In addition, Marx thought it entirely possible for more abstract forms of value, sometimes called *locum tenens* or placeholders, to be used in place of the production of use values.[43]

———————

Habemas and Graeber, taken together, have traced the development of a growing strata in developed nations which are neither the owners of capital nor engaged in any form of production or socially-necessary service. But in displacing a great deal of our understanding of where use-values come from they have not sufficiently proven where their new locus of value production is. Graeber comes the closest, actually charting the rise of the information sector (identified as a key source of *bullshitisation*) against the fall of several other sectors,

most notably agriculture and manufacturing.[44] Such industrial sectors are clearly going somewhere assuming the reader eats food and wears clothes.

This is a failure of both authors, they do not see economies and class societies as entities which stretch beyond national boundaries. The locus of global value production has always stretched across borders, and contrary to the mythology of social democracy it has been located partly in the global south long before the neoliberal wave of outsourcing, which as Graeber correctly points out,[45] can sometimes be overemphasized. Conventionally productive labour is certainly still present in the developed world, and in some settler-colonial nations such as New Zealand it is present in a much higher proportion than imperial financial hubs like the UK, but it is important to note that this proportion is declining through the trends Graeber described. To understand the link between reflexive-unproductive labour and the bulk of global production, however, we must shift our attention to the colonised world.

Zak Cope and Labour Aristocracy

The theory of *labour aristocracy* has been a part of the communist movement since it was first formulated by Engels in 1845.[46] The concept was revived by Lenin in 1916,[47] and became part of the political orthodoxy of the Third International. The theory has always been controversial, and the vast majority of western socialist parties have come to reject or de-emphasise the theory for a number of reasons. Of the writers associated with updating the theory of labour aristocracy, Zak Cope stands out as a modern innovator, while Charles Post stands out as a prominent and commonly-cited critic of the concept. The back-and-forth of criticism between the two in the early 2010s, as well as Cope's recent book *The Wealth of (Some) Nations: Imperialism and the Mechanics of Value Transfer*, will inform my discussion of how reflexive-unproductive labour fits into the global system of capitalism.

A labour aristocracy is what Lenin describes as "a section of the proletariat [which] allows itself to be led by men bought by, or at least paid by, the bourgeoisie."[48] It does this as a symptom of a specific stage in the development of capitalism. Lenin gives five prerequisite stages in his definition of imperialism:

(1) the concentration of production and capital has developed to such a high stage that it has created monopolies which play a decisive role in economic life; (2) the merging of bank capital with industrial capital, and the creation, on the basis of this "finance capital", of a financial oligarchy; (3) the export of capital as distinguished from the export of commodities acquires exceptional importance; (4) the formation of international monopolist capitalist associations which share the world among themselves, and (5) the territorial division of the whole world among the biggest capitalist powers is completed.[49]

At the summit of these stages, imperialist monopoly capitalism allows for *super-profits*: profits well above what the developed nations' companies might extract from their own workers. This is achieved through a number of methods of investment from core to periphery, such as predatory lending, exporting capital overseas in return for commodities, and exploiting the unevenness of development and labour markets.[50] Lenin believed that these super-profits were the basis for the "bribe" paid to workers in the imperialist countries, but he believed that the number of workers won over by this was "an insignificant minority

of the proletariat and of the toiling masses" which was nonetheless able to constitute a base for reformist parties.[51]

There are some empirical issues with using Lenin's model of imperialism in the present day, mainly the emphasis on exported capital. Post notes that this emphasis is misplaced (only 1.5% of total global investment is in the global south), however modern theorists of imperialism have generally accounted for Lenin's error by reframing the issue as one of overall capital flows from global south to metropole.[52]

From the outset, labour aristocracy has been theorised as a response to one question: how can we explain the relative uselessness of the leftist parties of the developed world? As Post notes, it is not a foregone conclusion that leftists in the developed world are more or less reformist than in the underdeveloped world—the relative power and vote share of reformist parties is actually quite consistent globally[53]—the debate is therefore about *qualitative* differences in the character of western parties.

These deficiencies aren't our focus and this is for the best. Professor Amiya Kumar Bagchi notes that the Post-Cope debate (itself characteristic of broader debates about labour aristocracy) is largely bogged-down in proving which theorist said what. Rather than focusing on explaining reformism, he says:

I think the real issue is how the working class in advanced capitalist countries has been incorporated as a conscious or unconscious participant in the maintenance of the highly unequal internal socio-political order and the inequitable international order that has grown up under the actually existing capitalism.[54]

This is the basis to which Cope returns in *The Wealth of (Some) Nations*. To Cope, there are four main mechanisms by which imperialism extracts wealth:

Value Transfer

This is the most direct and obvious way in which imperialism redirects profits, and can be broken down into direct (military and political intervention) and indirect (passive and market forces) Global Transfer of Value (GTV). Cope gives seven more concrete examples: brain drain, illicit capital flows, trade barriers and tariffs, flooding countries with goods at below market rates, debt repayment, unfavourable terms of trade, and trade-related intellectual property rights.[55]

Colonial Tribute

The historically imposed and racially maintained differences in the mode of production within colonised nations. This includes: semi-feudalism wherein small farmers and rural workers have their wealth appropriated by money-lenders and landowners, neo-colonialism wherein the national workforce is exploited by foreign buyers and investors, and bureaucratic capitalism wherein value is expropriated by state bureaucrats. These modes of production prevent the development of a more efficient national bourgeoisie oriented around domestic consumption, and produces wage differentials that can be further exploited.[56]

Monopoly Rents

This is the difference between the price (not cost) of production and the actual market price where that is not set by the average rate of profit, but by cartels and corporations dominating the production and sale of commodities. Modern monopsonies overwhelmingly control prices in the global north, and also force labour prices down further in the periphery.[57]

Unequal Exchange

Productive labour is bought and sold in international trade for divergent sums. Capitalists are afforded additional profits and opportunities by their possession of economic, military, and technological monopolies. Western workers are afforded higher wages through "institutionally different" rates of exploitation. This is done through the transfer of value from low OOC industries to high[58] on the national level, but on the international level this is determined by wage differentials.[59]

Combining the visible value transfer (national account balances, primary and secondary income, capital transfers) of $326 billion,[60] illicit value transfers (invoicing manipulation, tax evasion and state corruption) of $970 billion,[61] transfer pricing revenues (corporations boosting earnings by reporting high taxable profits in low-tax countries) of $1.1 trillion,[62] and disguised value transfer (a complex product of unequal exchange) of $2.8 trillion,[63] Cope arrives at a total South-North transfer of $5.2 trillion annually. This is equivalent to 75% of the total share of transfers in developed countries' profits.[64]

In order to demonstrate the connection between this looted wealth and reflexive labour, there must be proof that (1) there are no factors which negate this value transfer and (2) there is a specific mechanism by which imperialist value transfer allows for a greater proportion of unproductive jobs in the west.

A commonly cited factor which might negate imperialist value transfer is the idea that western workers are *more productive*. This is problematic for several reasons: firstly, speaking purely in terms of inputs one hour of socially-necessary labour time is the same in capital-intensive and labour intensive industries,[65] secondly, there is no correlation between high wages and productivity,[66] and thirdly, global south workers are sometimes involved in higher productivity industries.[67]

If anything, Cope doesn't go far enough in this last line of argument, as there is some evidence that, taken holistically, industry in the global south is more capital intensive, more productive, subject to a higher starting rate of profit, and subject to a greater rate of profit decline. An aforementioned study by Esteban Ezequiel Maito[68] shows that under-

developed economies had an average rate of profit of 45% per unit of capital invested in 1954, 23% higher than developed countries. This gap narrowed to 10.5% in 2009 indicating a greater rate of profit decline in the global south. Such data is typical of comparisons between high OCC industries and low OCC industries. Cope is right in saying that the gap in productivity is low *now*, but this was not always the case, indeed it is the result of centuries of vastly higher productivity differences.

Finally, it remains for us to prove the link between unproductive work practices in the west and imperial value transfers. While Graeber earlier suggested that *bullshitisation* doesn't fit with conventional economic wisdom that capitalists maximise profit *everywhere* (i.e., demand a rate of surplus value production from each economic sector), this is not a position held by any political economist. Cope says that, on the contrary, "*a negative rate of surplus value can and does apply in some regions of the world where workers are able to purchase with their wages more abstract labour than they themselves contribute with their labour-power.*"[69] In other words, the cost

of reproduction is highly subsidised in the west by the production of cheap consumer goods by workers in the global south, and even those produced by western industry rely on dead labour produced in the same way.

The sectors of many economies in which a negative rate of surplus value exists is even larger when we consider that the wages of workers in the unproductive sectors of employment must be paid out of the exploitation of productive sector workers.[70] To Cope however, unproductive workers are not directly exploiting productive workers, their wages are still paid according to the value of their labour-power and they deliver to the individual capitalist revenues in excess of the same. The key distinction between productive and unproductive workers is that the latter cannot add value simply by working more (surplus labour), there is a finite amount of "necessary labour," and it would be pointless to do more than this.[71] Here we see echoes of Graeber's *bullshitisation*: the bullshit quota is the amount of unproductive labour time beyond the necessary labour, done with the false expectation of creating a surplus.

Tracking the Rise of Reflexive-Unproductive Labour

We have now gathered the materials necessary to put together a more *unified*, if hardly comprehensive, picture of the development of reflexive-unproductive labour as a single historical arc:

1. The genesis of reflexive-unproductive labour lies in the development of "scientific" managerialism in the late 19th century, which replaced earlier intermediaries between capital and labour (foremen, guilds etc.) and led to the belief that productive labour could be "streamlined," typically by allowing for better interfacing between living and dead labour (organised allocation and storage of tools and machinery, greater alienation of the worker from production, and decreased logistical inefficiencies). Small numbers of scientific managers, using techniques like taylorism, made small improvements to worker productivity, and increased business competitiveness. They did not stay on as permanent employees of the firms they advised, as the cost of their ongoing wages would have outweighed their benefit to the capitalists. Nonetheless the idea of "labour adding to the productivity of labour" was born. Colonial wealth extraction allowed for the widespread adoption of these managers in the west with a subsidised wage cost.

2. With the onset of the Great Depression, an increasing number of western states become conscious of the propensity for capital-intensive economies to collapse. State bureaucracies and social spending initiatives massively expand in an attempt to subsidise western wages and consumption. Reflexive labourers as described by Habermas emerge as a state-sponsored effort to increase profitability endlessly through increasing productivity and providing new technologies and intellectual properties in pursuit of imperialist goals. Unions are partially incorporated into the wage-setting process, and this deepens the price differentials required for unequal exchange with the remaining colonies.

3. In the late 60s and 70s, western countries faced their greatest decline in the rate of profit aside from the height

of the depression. The blame for this is levied at the "inefficient" state bureaucracies by the late 1970s, however in many ways it is because the state had become too effective at increasing productivity in capital-intensive industries, combined with a growing lack of penetration into more profitable colonial economies. Neoliberalism temporarily halts the increases to state spending, and privatises the state-backed reflexive industries. Foreign economies are re-engineered into highly profitable, capital-intensive manufacturing and agricultural hubs, and this funds the further financialisation and informationalization of western economies. Greater inefficiency and privatisation of reflexive labour, enabled by increasingly subsidised wages, forces a lower OCC in western economies.

4. From the early 1980s to 2008, the average rate of profit stabilised across core countries and in fact increased in many areas at a rate not seen since the Second World War. During this time capital-intensive industries such as manufacturing, mining, and oil extraction were outsourced to the global south. Reflexive labourers had now transformed into reflexive-unproductive labourers in that there were few actual increases to productivity in this time. Reflexive labour evolved slowly, through informationalization, into pointless busy-work, while still ostensibly seeking to improve the efficiency and productivity of the state and productive enterprise. Such workers increasingly came to work for multinationals that fed off state contracts (performing state functions inefficiently), managed debt, or were involved in imperial transfer. Such workers evolved several uses: as a "market of last resort," as a countervailing tendency on the TRPF, and as a means of perpetuating wage differentials to facilitate unequal exchange with foreign markets.

5. By the late 2010s, reflexive-unproductive workers came to constitute a large proportion of developed countries' workforces. Informationalisation became so extensive that previously socially-necessary labour-time in unproductive industries was being replaced by redundant labour-time with "reflexive" intentions (such as Graeber's NHS nurses spending more time on productivity-enhancing paperwork than on nursing). The ostensible intent behind this socially-unnecessary labour is the same as reflexive labour—to use labour to increase labour productivity—but the sheer impossibility of doing so produces a new phenomenon: bullshitisation.

Conclusions

As we have seen, the work of Habermas is useful in understanding the *idealistic* origins of reflexive-unproductive labour. Innovations by the capitalist class are seldom the result of capitalists or state employees understanding the true nature of the systems they are involved in. The valorisation of capital, in which the role of labour in value creation is hidden in favour of a narrative of capital expanding upon itself, means that capitalist solutions to crisis are rarely carefully engineered, but are more of a matter of trial-and-error tinkering with various inputs until the most superficial of metrics (such as GDP) seem to improve. Capitalist solutions to crisis *do often work*, but only through a total subversion of the original intentions of the tinkerer. We should remember that the success of neoliberalism in combating the TRPF was not in ending state inefficiency and spending, but rather in increasing both.

Graeber too is an important part of our understanding, as he reorients the discussion around the subjective experience of the workers involved in a complex macroeconomic process. It is only when we narrow our focus down to the smallest, human connectors in a complex system, that we can see the total negation of the initial system logic. Whether or not we can explain these subjective experiences is irrelevant: they exist, and so our understandings have to evolve to account for them.

Finally, Cope shows that in the end the problem can only be resolved by uncovering deeper structural injustices, loosely patched-over by a western-centric form of political economy. Graeber's worker testimonies are only inexplicable to a form of political economy which is built around a myth of western workers' productivity. These inconsistencies between the subjective experience of western workers, and the objective frames of analysis used by political economists, exposes deeper failings in the latter to account for global value transfer.

It would be wrong to think that in saying reflexive-unproductive workers in the imperial core are indirectly parasitic I am drawing a moral conclusion. As Professor Bagchi noted, the question is more about how western workers have unknowingly bought a stake in imperialism as a result of the deception inherent in hidden revenues. This complicates the question of radicalising workers in the imperial core, but the ultimate interest of all workers remains in the development of emancipatory systems globally. It is furthermore clear from the work of Graeber that those engaged in reflexive-unproductive work are hardly more free from class relations. Even if such workers are subject to a negative rate of exploitation, or have their cost of reproduction subsidised by vastly less fortunate workers in the global south, they are still subject to dependency upon their bosses and managers, and it is difficult to see what other options are open to them. Exposing hidden imperialist revenues is therefore a crucial part of radicalising workers in the core who unknowingly have a stake in imperialist transfer of value.

The dialectic of capitalist historical progression is the dialectic between the tendency of the rate of profit to fall, and countervailing tendencies hastily thrown up to slow the inevitable. Unless we understand the often bizarre and counterintuitive state of affairs engendered by these countervailing tendencies, we will be unable to consistently analyse the capitalist system, or indeed combat its worst excesses, as the imperialist global system falls into ever-greater states of contradiction. Our task is complex, and requires a mode of thought

able to adapt to an ever-changing system, no matter how challenging that may be to our biases.

Endnotes

1. Julius Sensat, Jr. *Habermas and Marxism: an Appraisal.* (Beverly Hills, Calif: Sage Publications, 1979) p. 56

2. Jürgen Habermas. *Legitimation Crisis* (Boston, Mass: Beacon Press, 1975.) pp. 53-54

3. Habermas uses "political" to mean socially-determined, he does not consider wage labour or class relations inherently "political."

4. Habermas doesn't mean *use-values* as they appear in Marxian value theory, rather he uses this to mean anything of utility in state society. *Ibid.* p. 55

5. *Ibid.* p. 52

6. Julius Sensat, Jr. *Habermas and Marxism: an Appraisal.* (Beverly Hills, Calif: Sage Publications, 1979) p. 59

7. Roman Rozdolski. *The Making of Marx's "Capital."* (London, Eng: Pluto, 1989). p. 381

8. Julius Sensat, Jr. *Habermas and Marxism: an Appraisal.* (Beverly Hills, Calif: Sage Publications, 1979) p. 65

9. Linda Lobao et al., "The Shrinking State? Understanding the Assault on the Public Sector," *Cambridge Journal of Regions, Economy and Society* 11, no. 3 (2018): pp. 389-408, https://doi.org/10.1093/cjres/rsy026.

10. Steve R. Letza, Clive Smallman, and Xiuping Sun. "Reframing Privatisation: Deconstructing the Myth of Efficiency." *Policy Sciences* 37, no. 2 (2004): pp. 159-83. Accessed August 29, 2020.

http://www.jstor.org/stable/4532622.

11. Esteban Ezequiel Maito, *The historical transience of capital: The downward trend in the rate of profit since XIX century*, Universidad de Buenos Aires - Argentina.

12. Jürgen Habermas. *Legitimation Crisis* (Boston, Mass: Beacon Press, 1975.) p. 56

13. Julius Sensat, Jr. *Habermas and Marxism: an Appraisal.* (Beverly Hills, Calif: Sage Publications, 1979) p. 61

14. Göran Therborn, "Jürgen Habermas: a New Eclecticism," *New Left Review* 67, no. 1 (1971) p. 69

15. Julius Sensat, Jr. *Habermas and Marxism: an Appraisal.* (Beverly Hills, Calif: Sage Publications, 1979) p. 65

16. Karl Marx, *Capital Vol. I* (London, Eng: Penguin, 1990) p. 931

17. David Graeber, *Bullshit Jobs* (New York, NY: Simon and Schuster, 2018) p. 6

18. *Ibid.* pp. 9-10

19. *Ibid.* p. 14

20. *Ibid.* p. 24

21. *Ibid.* p. 18

22. Karl Marx, *Economic & Philosophic Manuscripts of 1844* (Moscow, USSR: Progress Publishers, 1959) p. 74

23. Siddharth Kara, "Is Your Phone Tainted by the Misery of 35,000 Children in Congo's Mines?" *The Guardian* (Guardian News and Media, October 12, 2018), https://www.theguardian.com/global-development/2018/oct/12/phone-misery-children-congo-cobalt-mines-drc.

24. David Graeber, *Bullshit Jobs* (New York, NY: Simon and Schuster, 2018) pp. 2,4,17,147

25. *Ibid.* p. 147

26. *Ibid.* p. 160

27. *Ibid.* p. 162

28. *Ibid.* pp. 165-166

29. *Ibid.* p. 151

30. *Ibid.* p. 167

31. *Ibid.* p. 168

32. *Ibid.* p. 177

33. *Ibid.* pp. 176-177

34. *Ibid.* p. 181

35. *Ibid.* p. 199

36. Karl Marx, *Capital Vol. I* (London, Eng: Penguin, 1990) pp. 518-519

37. *Ibid.* p. 265

38. *Ibid.* pp. 259-261

39. "Policy Responses to COVID19," IMF, 2020, https://www.imf.org/en/Topics/imf-and-covid19/Policy-Responses-to-COVID-19.

40. Julius Sensat, Jr. *Habermas and Marxism: an Appraisal.* (Beverly Hills, Calif: Sage Publications, 1979) p. 62

41. David Graeber, *Bullshit Jobs* (New York, NY: Simon and Schuster, 2018) pp. 202-203

42. *Ibid.* p. 205

43. Karl Marx, *Capital Vol. I* (London, Eng: Penguin, 1990) p. 931

44. David Graeber, *Bullshit Jobs* (New York, NY: Simon and Schuster, 2018) pp. 148-149

45. *Ibid.*

46. Friedrich Engels, *Condition of the Working Class in England*, (Moscow, USSR: Institute of Marxism-Leninism, 1969) p. 14

47. Vladimir Ilyich Lenin, *Imperialism, the Highest Stage of Capitalism*, retrieved from https://www.marxists.org/archive/lenin/works/1916/imp-hsc/, ch. 8

48. *Ibid.*

49. *Ibid.* ch. 7

50. *Ibid.* ch. 4

51. Vladimir Ilyich Lenin, *The Collapse of the Second International*, retrieved from https://www.marxists.org/archive/lenin/works/1915/csi/index.htm, pt. 3

52. Charles Post, "The Myth of the Labor Aristocracy, Part 1," *Against the Current*, August 2006, https://againstthecurrent.org/atc123/p128/.

53. Charles Post, "The Roots of Working Class Reformism and Conservatism: A Response to Zak Cope's Defense of the 'Labour Aristocracy' Thesis," *Research in Political Economy* 29 (2014), p. 255

54. Amiya Kumar Bagchi, "A Comment on the Post–Cope Debate on Labour Aristocracy and Colonialism", *Research in Political Economy* 29 (2014) pp. 261-273.

55. Zak Cope, *The Wealth of (Some) Nations: Imperialism and the Mechanics of Value Transfer* (Pluto Press, London, 2019) pp. 10-21

56. *Ibid.* pp. 22-32

57. *Ibid.* pp. 33-46

58. An earlier version of Cope's thesis held that this was also the basis for international unequal exchange, but as Post noted, there is no uniform difference in OOC between north and south. It's fortunate that Cope discarded this theory as it would have made my work a lot harder!

59. *Ibid.* pp. 47-58

60. *Ibid.* p. 76

61. *Ibid.*

62. *Ibid.* p. 77

63. *Ibid.* p. 81

64. *Ibid.* p. 112

65. *Ibid.* p. 62

66. *Ibid.* p. 63

67. *Ibid.* p. 62

68. Esteban Ezequiel Maito, *The historical transience of capital: The downward trend in the rate of profit since XIX century*, Universidad de Buenos Aires - Argentina.

69. Zak Cope, *The Wealth of (Some) Nations: Imperialism and the Mechanics of Value Transfer* (Pluto Press, London, 2019) p. 63 [emphasis Cope's]

70. *Ibid.* p. 65

71. *Ibid.* p. 66

References

Bagchi, Amiya Kumar, "A Comment on the Post–Cope Debate on Labour Aristocracy and Colonialism", *Research in Political Economy* 29 (2014) pp. 261-273.

Cope, Zak, *The Wealth of (Some) Nations: Imperialism and the Mechanics of Value Transfer* (London, Eng: Pluto Press, 2019)

Engels, Friedrich, *Condition of the Working Class in England*, (Moscow, USSR: Institute of Marxism-Leninism, 1969)

Graeber, David, *Bullshit Jobs* (New York, NY: Simon and Schuster, 2018) Habermas, Jürgen, Legitimation Crisis (Boston, Mass: Beacon Press, 1975.)

Kara, Siddharth, "Is Your Phone Tainted by the Misery of 35,000 Children in Congo's Mines?" *The Guardian* (Guardian News and Media, October 12, 2018), https://www.theguardian.com/global-development/2018/oct/12/phone-misery-children-congo-cobalt-m ines-drc .

Lenin, Vladimir Ilyich, *The Collapse of the Second International*, retrieved from https://www.marxists.org/archive/lenin/works/1915/csi/index.htm ,

Lenin, Vladimir Ilyich, *Imperialism, the Highest Stage of Capitalism*, retrieved from https://www.marxists.org/archive/lenin/works/1916/imp-hsc/

Letza, Steve R., Clive Smallman, and Xiuping Sun. "Reframing Privatisation: Deconstructing the Myth of Efficiency." *Policy Sciences* 37, no. 2 (2004): pp. 159-83. Accessed August 29, 2020. http://www.jstor.org/stable/4532622 .

Lobao, Linda et al., "The Shrinking State? Understanding the Assault on the Public Sector," *Cambridge Journal of Regions, Economy and Society* 11, no. 3 (2018): pp. 389-408, https://doi.org/10.1093/cjres/rsy026 .

Marx, Karl, *Capital Vol. I* (London, Eng: Penguin, 1990)

Marx, Karl, *Economic & Philosophic Manuscripts of 1844* (Moscow, USSR: Progress Publishers, 1959)

Maito, Esteban Ezequiel, *The historical transience of capital: The downward trend in the rate of profit since XIX century*, Universidad de Buenos Aires - Argentina.

"Policy Responses to COVID19," IMF, 2020, https://www.imf.org/en/Topics/imf-and-covid19/Policy-Responses-to-COVID-19 .

Post, Charles, "The Myth of the Labor Aristocracy, Part 1," *Against the Current*, August 2006, https://againstthecurrent.org/atc123/p128/.

Post, Charles, "The Roots of Working Class Reformism and Conservatism: A Response to Zak Cope's Defense of the 'Labour Aristocracy' Thesis," *Research in Political Economy* 29 (2014), pp. 241-260

Rozdolski, Roman *The Making of Marx's "Capital"* (London, Eng: Pluto, 1989)

Sensat Jr., Julius, *Habermas and Marxism: an Appraisal.* (Beverly Hills, Calif: Sage Publications, 1979)

Therborn, Göran "Jürgen Habermas: a New Eclecticism," *New Left Review* 67, no. 1 (1971) pp. 69-83

*This article is dedicated to **David Graeber**, who passed away on September 2nd just after the time of writing. Graeber's work forms a basis for this article, and his activism, which influenced the Occupy movement, was a genuinely radicalising factor for many comrades, including myself. This article partly serves as an attempt to reconcile some of the ideas in Graeber's book Bullshit Jobs with modern political economy, which naturally focuses on questions of productive labour and economic exploitation. Graeber challenges us to also think of the growing forms of unproductive work, and the very real forms of dependency and abuse this can engender in many workplaces.*

Marxism
Leninism

progress and
revolution.

peacelandbread.com

L. C.

X O LITTERATURA

COMUNISTA

X MATERIALISMO

Los caballos negros son.
Las herraduras son negras.
Sobre las capas relucen
manchas de tinta y de cera.
Tienen, por eso no lloran,
de plomo las calaveras.
Con el alma de charol
vienen por la carretera.
Jorobados y nocturnos,
por donde animan ordenan
silencios de goma oscura
y miedos de fina arena.
Pasan, si quieran pasar,
y ocultan en la cabeza
una vaga astronomia
de pistolas inconcretas.

Luigi Nono's Socialist Modernist Political Aesthetic

Transposing Sartre & Brecht

by Jackson Albert Mann

Luigi Nono (1924-1990) was one of the most important European composers of the 20th century. He was also a committed socialist and a life-long member of (and later leader in) the Italian Communist Party (PCI). Nono's music was intrinsically bound to his political beliefs and his pieces were always thematically connected to left-wing liberation struggles of the time. However, much of the scholarship on Nono either ignores his politics completely or mentions it only in passing. That scholarship which does comprehensively engage with his political commitments almost always does so through either a neo-Marxist or Gramscian lens. I argue that neither of these approaches provide a satisfactory picture of Nono's highly developed political aesthetic. Neo-Marxist aesthetics are ill-suited as a framework for understanding Nono's materialist approach to music composition and, while making a connection between Nono and Gramsci is understandable as a result of his numerous references to the late Italian communist leader, Nono's reading of Gramsci is mostly superficial. Rather, I believe a close reading of Nono's writings reveals that his influences lie elsewhere, specifically the literary theory of Jean-Paul Sartre and the dramaturgy of Bertolt Brecht. It is by

transposing progressive Modernist concepts from the work of these two figures to the discipline of music composition that Nono develops a left-wing political aesthetic distinct both the Socialist Realism of the communist East and the Adornian neo-Marxism of the capitalist West, a political aesthetic that I term *Socialist Modernism*.

Introduction

Luigi Nono was a Venetian composer whose work was well known for its explicit leftist political content. Born in 1924, Nono grew up under Mussolini's fascist government. He developed radical left-wing politics in his youth. As a young adult during WWII, he was able to avoid military conscription with the help of a socialist sympathizing doctor and enrolled in university as a law student, where he began secretly assisting the anti-fascist resistance movement.[1] Nono spent what free time he had studying music composition with Gian Francesco Malipiero, the director of the Venice Liceo Musicale.

After the war he was introduced to the child prodigy performer/composer Bruno Maderna and the renowned orchestral conductor Hermann Scherchen. Both men were committed socialists and their politics had an enormous impact on Nono.[2] It was through these connections that Nono was able to attend the *Ferienkurse für Neue Musik* (Summer Course for New Music) in Darmstadt, Germany, returning every summer between 1950 and 1959. During this period Nono officially joined the Italian Communist Party (PCI) and went on to become the so-called "political *enfant terrible*" of the "Darmstadt School," a result of his experimental anti-fascist compositions (*Il canto sospeso*, *3 Epitaffi per Federico Garcia Lorca*).[3][4]

In 1959, Nono accused John Cage of "colonialist thinking" and denounced his method as "orientalisms that a certain Western culture employs to enhance the attractiveness of its aesthetic..." during a public lecture at Darmstadt.[5][6][7] Nono took issue with numerous elements of Cage's practice but focused specifically on his appropriation of Zen Buddhism as simultaneously a manifestation of cultural imperialism and a conscious use of Zen's historical connection to imperialist ideology in Chinese antiquity.[8] The debate with Cage and others led to Nono's subsequent break with the Darmstadt School, after which his music became even more politically charged. His pieces dealt with themes stretching from the everyday injustices faced by factory workers in Italy (*La fabbrica illuminata*), to the struggles of Communist freedom fighters during the Vietnam War (*A floresta é jovem e cheja de vida*), the Paris Commune, the 1905 Russian Revolution (*Al gran sole carico d'amore*), and the US Civil Rights Movement (*Contrappunto dialettico alla mente*).

Much of the commentary and scholarship on Nono's music never engages with his politics directly, instead choosing to focus on the technical construction of his pieces. This approach is problematic given that Nono saw himself as a "totally committed musician... in the rich, diverse, multifaceted, and often contradictory struggle for socialism."[9] However, even the scholarship which does seriously engage with his left-wing beliefs does so on shaky grounds, either retroactively applying a ready-made neo-Marxist aesthetic lens to his work or focusing on the influence that Antonio Gramsci had on his thought, viewing his corpus within a Gramscian framework. The former approach reveals the contradictory voices in Nono's music and the explicit modernism of his method, yet understands this modernism as a conservative reaction against postmod-

ernism. The latter sheds light on Nono's use (and misuse) of Gramsci's concepts of cultural hegemony and organic intellectualism as a justification for his artistic position. However, both fail to reveal the full picture of Nono's highly developed political aesthetic.

Nono's modernism is obvious, but this modernism is not a conservative allegiance to an inter-war-period aesthetic. Rather, it is far more nuanced and progressive. It is also true that he repeatedly cited Gramscian concepts to justify his position as a revolutionary artist, which was often under scrutiny as a result of his upper-middle-class upbringing, as well as his education and participation in a style of modern classical music (Serialism) seen by many orthodox Marxists as bourgeois.[10] However, pointing out his work's modernism does not tell us much about his complete aesthetic project and presents a blinkered view of Nono as a musical conservative and, additionally, as shown by Robert Adlington, if Nono was a Gramscian, he was "in fact a highly idiosyncratic" one.[11]

I argue two points: A) the reason for Nono's awkward Gramscianism is that he is not, despite numerous claims to the contrary, a Gramscian at all and B) rather than being a conservative modernist, Nono's political aesthetic is firmly rooted in specific progressive trends within Modernism. This paper will deal with two of them: the 'epic theatre' of Bertolt Brecht (a figure who is cited often and even paraphrased in Nono's writings, interviews, and notes) and the literary theory of Jean-Paul Satre.[12] In fact, it is upon this foundation that Nono builds a forward-looking political aesthetic that I term *socialist modernism*.

Any interpretation of Nono's work which does not take into account these connec-tions misunderstands and misrepresents it. It is only by placing Nono's work within the framework of Brechtian dramaturgy and Sartrean literary theory that it can be understood.

Nono & Gramsci

Like most Italian left-wing artists and intellectuals after World War II, Nono often cited Antonio Gramsci's *Prison Notebooks*, which were enormously popular after their first publication in the 1950s.[13] In his 2016 article 'Whose Voices? The Fate of Luigi Nono's *Voci destroying muros*,' Adlington introduces us to Nono in the 1960s, a decade after his famous public denunciation of John Cage in 1959 and his subsequent break with the Darmstadt School.[14] Adlington presents Nono as a committed, albeit confused, Gramscian under attack intellectually by the "folk-ethnology" aesthetic of the then

popular Workerist movement and the Dutch anarchist group Provo[15] during the 1970 Amsterdam production of his eventually-redacted piece *Voci destroying muros* (Voices destroying walls).[16] [17] But this Gramscian frame only provides tenuous rationales for Nono's aesthetic ideas, imagining them to be a direct result of his supposed misreading of Gramsci.

Adlington points out that Nono consistently "misrepresented his compatriot's arguments" and that he accepted at face value the PCI's conflation of Gramsci's concept of the 'organic intellectual' with any intellectual whose politics aligned with those of the working class.[18] [19] Nono also seemed to misunderstand Gramsci's notion of culture as being made up of already established artistic mediums.[20]

It is difficult to take Nono's Gramscianism seriously in light of these misunderstandings, particularly his misinterpretation of the concept of the organic intellectual, about which Gramsci is incredibly clear. According to Gramsci, the organic intellectual's claim to this status is bound up in their actual labour. It is an intellectualism constructed on the basis of their experiential technical knowledge of the capitalist method of production within their specific industry.[21]

Interestingly, despite his misapplication of this concept when used in reference to himself, Nono did seem to understand it when discussing the working class. He explained, on more than one occasion, how his 1964 piece for soprano voice and magnetic tape, *La fabbrica illuminata*, was well-received by working class audiences because its status as a factory soundscape, rather than an autonomous musical piece, appealed to their technical intellectualism, an *organic intellectualism* constructed experientially.[22] [23]

According to Adlington, it is Nono's simultaneous paradoxical applications of Gramsci that led to his lifelong obsession with technology. Nono "drew from Gramsci's statement [on Organic Intellectualism] a different conclusion," analogizing the act of musical research into electronics to the experiential knowledge of the working class and ignoring Gramsci's emphasis on "locating organicity in indigeneity..."[24] [25]

Luckily, Gramsci provides Nono with a possible exit from the conundrum of his class background: "One of the most important characteristics of any group that is developing towards dominance is its struggle... to conquer 'ideologically' the traditional intellectuals."[26] Nono, as a member of the traditional intellectual category of *composer*, could conceive of himself as a conquered intellectual, won over to the cause of the working class. Unfortunately, no such conception of his intellectual position appears in his writings.

Adlington does mention that Nono, like other post-War European composers,

"wished to heed the Sartrean call to throw off the chains of oppression of creative... domains... specifically addressing the kinds of modernism that fascism had suppressed."[27] But he does not pursue this Sartrean connection any further, instead continuing to discuss Nono and his work within a Gramscian frame.

It is regrettable that Adlington does not explore Nono's reading of Sartre, as this would clarify Nono's artistic approach. Though drawing a line from Gramsci to Nono is understandable, Adlington shows throughout his article that this leaves us more confused than before regarding Nono's aesthetic choices and intentions. It is on the basis of this incomplete picture that Adlington attempts to piece together a causal connection between Nono's more direct (i.e. less avant-garde) forms of representation for working class voices in *Voci destroying muros* and the folk-ethnology critiques of the Workerist movement, even though such criticism was never leveled at Nono publicly and there is "no concrete evidence for a direct influence."[28] [29] [30]

Nono & Neo-Marxist Aesthetics

In his 2014 doctoral dissertation, *Nono and Marxist Aesthetics*, Joshua Cody attempts to interpret Nono's 1980 string quartet *Fragmente-Stille, An Diatoma* through the framework of what he calls "the four major Marxist approaches to art."[31] [32] He comes to two key conclusions. The first regards what Cody terms Nono's 'conservative late-modernism.' This is most clearly articulated in the following quote:

Far from the mystical/naive poetic visionary in the fashion of a Rothko, Scelsi, or Tarkovsky... Nono is revealed via a narratological analytic approach as a wily, canny dramatist armed with a conservative, late-modernist and even, in a sense, neoromantic (if never regressive) technique, one always consciously resisting the true postmodernity of [John]Cage...[33]

Cody places Nono on a political spectrum from conservatism to progressivism, positioning him as the reactionary modernist to Cage's progressive postmodernism.

His second conclusion regards the proper Marxist interpretation of Nono's pieces. Cody infers that only Bloch/Jameson's neo-Marxist literary theory can sufficiently interpret Nono's music. Within this aesthetic framework *Fragmente-Stille, An Diatoma* is interpreted as a subversive fairy-tale that narrates the conflicts of late-capitalism and provides a fantastical resolution to its schisms: "The 'neutrality' of the major second dyad that opens the piece, the 'hostility' of the *alla punto aperiodico* material, the 'enigmatic' nature of the tritones throughout, and the "transcendent" harmonies that close the work are the semantic content..." that make up the narrative of this insurgent fairy tale, one which chronicles the struggle between "different voices" on the late-capitalist battlefield and the eventual imagined victory of the subaltern.[34] [35] [36]

Cody's conclusions are correct on two points. Nono is indeed working within a modernist framework and his pieces do present numerous contradictory voices. However, his accusation of musical conservatism and his narrative interpretation misrepresent both the context and function of Nono's work. This is a direct result of the absence of Nono's voice in Cody's paper, in which he is directly quoted only once.

Without a clear understanding of Nono's in-

fluences and the highly-developed political aesthetic to which these influences contributed, Cody comes to a conclusion that directly contradicts Nono's own statements regarding *Fragmente-Stille, An Diatoma*. Rather than engaging with Nono on his own terms, Cody reads into Nono's corpus a reactionary tendency based on his own assumptions, and into the specific sound-clusters of *Fragmente-Stille, An Diatoma* a pointillistic narrative that is absent in Nono's writings on the piece.[37]

This is not to say that Cody's subjective interpretation is entirely incorrect, but rather that there is no evidence to support this reading as a critical and objective view on Nono's work.

A further consequence of this is Cody's quick dismissal of the 'Marx/Engels' aesthetic approach in favor of the 'Bloch/Jameson' framework. A direct precursor to Brechtian aesthetics, Engels' predilection for anti-parabolic realism, exemplified for him by the novels of Honoré de Balzac, is significantly more useful in analyzing Nono's music.[38][39] His simple desire for art that truthfully reproduces "typical characters under typical circumstances" is far more suited to Nono's materialist approach, which I will subsequently describe.[40]

Nono, Sartre, & Committed Writing

If neither a neo-Marxist nor a Gramscian approach to understanding Nono's work can reveal his political aesthetic, what approach can? In order to develop a complete picture of Nono's aesthetic we must trace the genealogy of his ideas to the literary theory of Jean-Paul Satre and the 'epic theatre' of Bertolt Brecht. It is on the foundations laid by these two figures that Nono built a progressive modernism that integrated their ideas.

The most foundational concept in Nono's aesthetic is commitment. In his article on Nono's 1974 piece *Für Paul Desau*, Luis Velasco-Pufleau traces Nono's concept of commitment to the influence of Gramsci, stating that "seeing composers as organic intellectuals, Nono granted them the hegemonic function of struggling against... the world of the ruling class (bourgeoisie) by musical creation and by promoting a revolutionary and socialist imaginary."[41]

According to Velasco-Pufleau, Nono believed it was the position of the composer as an organic intellectual which inevitably led to the necessity of political commitment in their work. However, this is an inversion of Nono's idea regarding commitment, which

he borrows directly from Sartrean literary theory.

For Sartre, the nature of writing prose is inherently semiotic as "the words are first of all not objects but designations for objects."[42] This is the result of the communicative attitude of the prose writer (Sartre contrasts this with the attitude of the poetic writer) whose writing is purely communicative in function.[43] Therefore, from the very beginning, prose-writing is inherently *committed to communicating something*, even if that *something* is mundane. Commitment is not something that is given to prose writing by an author, rather, it is intrinsic to prose-writing itself. And the best writing knows what it is communicating, *why*, and *to whom*.

Nono, actively breaking with Sartre's own conception of music as similar to poetry in attitude and function, transposes the concept of commitment as inherent in prose-writing to the process of musical composition.[44] [45] In reply to a 1966 questionnaire from the French journalist, novelist, and music critic Martine Cadieu, Nono stated the following and presented an altered version of Sartre's *what*, *why*, *and to whom* configuration:

Each musician chooses his own position in the contemporary world, and each choice is also a partisan political choice, that is, he does not act in an aristocratic or autonomous fashion but rather in a manner connected to the context of his current society, whether he is spiritualized in metaphysical abstractions, whether he is exalted by the beauty or purity of sounds, whether he considers having fulfilled his own commitment moralistically, whether he proclaims the uniqueness of the technological moment or process, or whether he identifies himself pragmatically within the musical act, whether he chooses Zen, cocaine, or irreverent anger.

Already implicit in this choice are the answers to the three questions that J.P. Sartre poses regarding literature: what is writing (music)? why write (music)? For whom does one write (music)?[46] [47]

Rather than commitment being the result of a decision to politicize music, the choice to write music is already, intrinsically, committed. Even if there is no explicit political content within a piece there is always "latent in them a precise ideological and practical interest."[48] In other words, the sounds of music are semiotic and, like Sartrean literature, they designate something. In Nono's conception, the music of an apolitical musician, no matter what they may say about it, is a sign which points to a political ideology in harmony with the status-quo.

Within this Sartrean frame, Nono's famous distinction between the postmodernist method of collage and his own use of pre-existing materials gains a new clarity.[49] While a piece by John Cage may employ collage materials merely to "enhance the attractiveness of its aesthetic..."[50] Nono understood these borrowed materials as *signs* that always pointed to something else, whether the composer wanted them to or not. For Nono, this semiotic quality of musical materials made all musical composition politically-committed.

This also brings into question the problems of working class representation that Adlington attributes to Nono during the composition of *Voci destroying muros*. Within the Sartrean framework, the entire issue of representation becomes nonsensical. From this perspective, Nono was never concerned with representing anything. Though Workerist folk-ethnology may have superficially influenced that particular piece, it is unlikely that questions of

Sono così tranquilli coloro che ci hanno condannati? Certamente no!

the authenticity of subaltern representation ever had any real meaning for Nono. Rather, his main concern was the use of musical signs to designate and communicate situations and concepts to an audience. Indeed, Nono was not content to merely reveal something to an audience, they needed to be engaged, and the question of how to engage them was answered by the 'epic theatre' of Bertolt Brecht.

Nono, Brecht, & Epic Theatre

Like Sartre, Brecht also believed in the inherent commitment of his artistic medium and prefigured both Sartre and Nono when he stated that "for art to be 'unpolitical' means only to ally itself with the 'ruling' group."[51] It was Brecht's belief in a committed art that led him to develop a dramaturgical practice that he termed *epic theatre*, a practice that was highly influential for Nono.

Brecht contrasted his theatre with what he called "Aristotelian theatre," which focused on engaging an audience "by means of hypnosis" in order to achieve "what he [Aristotle] calls catharsis," where "everyone (including every spectator) is then carried away by the momentum of the events portrayed."[52] [53] [54] [55] [56] Brecht saw theatre as a communicative, rather than empathetic, medium and believed that it should engage the audience in a different way. He came to the conclusion that in order to break the hypnosis of Aristotelian theatre a psychological distance needed to be created between the work of art and the audience. The formation of this distance is what he famously called the *alienation effect*.[57] The alienation effect severed the empathetic connection between the spectators and the characters so that, instead of being carried away, the spectators saw the characters and situations as objects of contemplation.

According to Brecht, the alienation effect has significant consequences for the way an audience engages with the play itself. Because they are no longer being pulled along by an empathetic identification with the characters, the audience is presented with choices. For example, audience members now have to choose whether they like a character or whether they agree with the characters' actions. Sometimes, in the case of scenes that present conflicts, the audience members even need to choose whose side they are on. The theatre becomes a democratic space where "illusion is sacrificed to free discussion, and once the spectator, instead of being enabled to have an experience, is forced as it were to cast his vote... a change has been launched which goes far beyond formal matters and begins for the first time to affect the theatre's social function."[58]

Throughout his career Brecht would experiment with numerous methods of creating the alienation effect. The use of peculiar scenographic elements such as projected text, images, and interchangeably maximalist and minimalist staging, a mime-like style of acting that often broke the fourth wall, scenes intentionally written to seem narratively disconnected, exaggerated demarcations between acted scenes, sung scenes, and instrumental musical interludes, and a commitment to historical realism were some of the most important methods that Brecht explored in his attempt to create the kind of critical (and political) audience that he imagined.[59] [60] [61] [62] [63] Much of Brecht's method was an intentional deconstruction of the idea of the *gesamtkunstwerk* (or the *total work of art*), a concept popular during the late 19th and early 20th centuries that

valorized the complete integration of all artistic mediums into the ideal operatic performance.64

By deconstructing the elements of *gesamtkunstwerk* in a myriad of ways, Brecht hoped to engender a critically-engaged audience, create a democratic performance space and, finally, reveal to the audience what he called the *Gest* (defined by Brecht as the social implications) contained within his theatrical situations.65 66

Nono was highly influenced by epic theatre's goal of creating a critical (and political) audience engaged in democratic debate with a dynamic work of art. In addition to Brecht, Nono's writings often mentioned Brecht's friend and contemporary, the dramaturg Erwin Piscator.67 Piscator was also associated with epic theatre and was known for his outrageous stage design, which exceeded Brecht's own idiosyncratic approach to the set.68 It was the stage design element of epic theatre that had the most profound effect on Nono. Just as he had done with Sartrean literary theory, Nono would transpose this method of set design from its origin in epic theatre to the new context of a music-based practice.69

Littered throughout Nono's writings are echoes of Brecht's obsession with using the performance space as a way to arouse critical engagement by the audience. In two articles written during the 1960s, Nono makes statements to this point. For example:

Theatre of consciousness, with a new social function: the audience is not limited to observe a 'rite' passively, involved and entranced by it for mystical-religious, escapist-gastronomic,[70] or emotional motives, but, faced with clear choices - the same ones that have made possible the expressive theatrical result is compelled to become aware of and also actively to put into effect its own choices...[71]

On the one hand, the relationship with the audience, the communication with it, its integration and participation, no longer as a spectator, within the stage action... as a result of the consideration of the audience, that formative and fundamental quality of Marxist culture is emerging, human and social commitment, precisely in the musical circles in which it had encountered the greatest opposition.[72][73]

Nono continued to express his dedication to creating art that pushed his audience to engage with his work in this way until the end of his career. For instance, in 1987 he stated:

...these wandering sounds, varied in quality, transformed and composed, must also be connected to one another by the listener, not simply to pass through him. The composition will not be given to you, dropped from Sirius. But you yourself become situated within the compositional possibilities, spatial combinatorics in constant motion, often purposefully confused - at least for me - so that a process is triggered which goes far beyond the function of a transistor.[74][75]

For Nono, the result was a lifelong experiment in how best to construct a performance space that would engender a politically-engaged audience and a democratic aesthetic experience. Nono's fixation on the exploitation of new technology can also be traced to these goals. As we have seen, Adlington attributes the technological aspect of Nono's work to a misinterpretation of Gramsci. However, it is almost certainly a result of the influence of epic theatre, particularly that of Piscator. The use of projected images and film, the placement of musicians on all sides of the audience, the concentric arrangement of speakers to project the sounds of the performance in an often acousmatic fashion, the use of pre-recorded sounds played on magnetic tape, and the live alteration of performance sounds using electronics are all common aspects of Nono's pieces.[76] This "variety of 'Brechtian' techniques" was always directed at developing the Brechtian subject that Nono desired: the critically- and politically-engaged audience.[77] For example, in the Opera Company of Boston's 1964 production of *Intolleranza 1960*, Nono, working with scenographer Josef Svoboda, was able to use CCTV to project live footage of both the protests happening outside the performance and the audience members themselves.[78][79] In this way, in the words of sound artist Andrea Santini, "the audience was visually forced to become involved."[80]

Nono's Political Aesthetic , *Voci Destroying Muros, & Fragmente-Stille, An Diatoma*

Nono's political aesthetic is undeniably a transposition and integration of Sartrean literary theory and the dramaturgy associated with 'epic theater.' In his conception, music is, like Sartrean prose, semiotic, inherently "impure," and intrinsically political as a result. To realize the full communicative potential, the composition and performance of these pieces needed to be based on the stage design practices developed in epic theatre.

The construction and performance of *Voci*

destroying muros (the eventually-redacted piece which is the focus of Adlington's article) is firmly situated within the Sarte-Brechtian framework outlined above. While Adlington understands Nono's use of proletarian materials (such as the writings of Italian factory workers) as a means of *representing* the working-class in order to build its cultural hegemony, Nono was in fact never interested in representation. His use of pre-existing materials is semiotic in function. Rather than asserting "the possibility of expressing reality using experimental means," Nono's political aesthetic turns this structure on its head: it imbues music with an intrinsic political meaning that *points to* and *reveals* reality.[81]

Voci destroying muros' more direct use of Nono's usual type of materials was one more study in a long line of experiments in how to best organise those signs musically and spatially in the tradition of epic theatre i.e. in order to excite the critical and political interests of its audience.[82] As a result of numerous technical problems, this particular piece failed spectacularly in its goals of revealing oppression and initiating "political discussion and action among the audience."[83][84] This was the reason Nono eventually redacted it from his official list of compositions.

Fragmente, Stille - An Diatoma, the piece which serves as the focus of Cody's neo-Marxist interpretation, is different from much of Nono's work in that it is instrumental and makes use of a traditional ensemble, the string quartet. However, Cody's narrative reading of the piece is in contradiction with Nono's writings during his later period, which Fragmente, Stille - An Diatoma is often said to have initiated.[85] Cody correctly interprets the title and the text[86] that Nono placed on the score as "elaborate and ambiguous"[87] signs that pointed in numerous

directions. Yet without reference to Nono's writings he is unable to correctly interpret the music itself.

In a 1983 interview, Nono stated that he had composed *Fragmente, Stille - An Diatoma* "wishing to verify certain ideas with a totally traditional ensemble."[88] But what were these ideas that needed verification and why was this necessary? Nono admits that this piece was the initial work in a series of related pieces from the early 1980s.[89] Therefore, if *Fragmente, Stille - An Diatoma*'s function was to clarify Nono's thoughts, it may be understood as a rehearsal for ideas that would be revealed more openly later on.

One year after this interview, *Prometeo. Tragedia dell'ascolto* (Prometheus. Tragedy of Listening), Nono's final major operatic work, premiered at the San Lorenzo Church in Venice. When describing the development of the stage design, Nono stated that by using a Halaphone he could create what he called "acoustic dramaturgy" and abandon "the visual projects that had been developed in collaboration with Vedova."[90][91][92] Nono believed he had found a way to transpose the spatial design of epic theatre, a design which relied heavily on visual media, into music itself. With this in mind, *Fragmente, Stille - An Diatoma* can be interpreted as an exploration of methods for designing music conceived of as a physical thing, akin to a structural part integrated within a given space, rather than something which occurs in space in an abstracted, autonomous way. This reveals the piece as a materialist exploration of sound as space rather than the pointillistic narrative structure that Cody believes it to be, existing within a postmodern pluriverse that rejects modernist grand narratives.

The transposition of Brechtian stage design practice from the layout of the theatre to the construction of a musical composition in physical terms was present in Nono's work for years. However, he always relied on either visual or textual media in his performances. Beginning with *Fragmente, Stille - An Diatoma*, Nono attempts to realize these design techniques in music alone.

Conclusion

By the end of his career, Nono had developed a highly distinctive political aesthetic through his transposition of Sartrean literary theory and Brechtian epic theatre to music. According to Nono, musical material was both semiotic (like words, phrases, and sentences in Sartrean prose) and physical (like spaces and text in epic theatre).

Because music always pointed to something, it was inherently political and therefore the choice to compose or make music was already committed. A composer who denied this was either cowardly or actively assisting the ruling class. Nono, as a result of having grown up under a fascist regime, knew that he was on the side of the oppressed, particularly the working class. His music was created as a sign that revealed capitalist exploitation and, by adopting techniques associated with the epic theater of Brecht and Piscator, pointed to its solution: socialism.

The communication of this message necessitated that the actual moment of performance be organised in a way that engaged the audience critically and politically. At first, this meant approaching his work from a scenographic perspective, seeing himself as a musician-dramaturg hybrid. But, as the last section of this paper revealed, he eventually totally transposed Brechtian epic theatre techniques to music composition alone. Therefore, Nono transformed the relation between music and space: music was no longer a semiotic sound occurring in space, but a physical semiotic object that existed *as a part of* the space.

By integrating and building upon the aesthetics of Sarte and Brecht to create his conception of acoustic dramaturgy, Nono was

able to construct an original and effective political aesthetic and a socialist modernist music that was distinct in his time.

Endnotes

1 Nielinger-Vakil, Carola. *Luigi Nono: A Composer in Context*. (Cambridge, UK: Cambridge University Press, 2015), 8.

2 Bruno Maderna had fought for the partisans during the war. He later joined the Italian Communist Party with Nono, but left after the party failed to condemn the USSR's crackdown on the 1956 Hungarian Uprising. Hermann Scherchen was a lifelong member of the Social Democratic Party of Germany. He was forced into exile after the Nazis came to power in 1933 as a result of his committed socialist beliefs.

3 Spangemacher, Friedrich. "Nono's *Prometeo*." *Tempo*, 1 no. 151 (1984): 51-52.

4 The term "Darmstadt School" was used as a shorthand for the group of young serialist composers that attended the summer courses at Darmstadt during the 1950s. However, it is also often used to refer specifically to three of these composers: Luigi Nono, Karlheinz Stockhausen, and Pierre Boulez. In fact, the term was coined by Nono himself.

5 Cage began attending the *Ferienkurse für Neue Musik* in the late 50s. His aesthetic views eventually came to dominate the Darmstadt School. See: Iddon, Martin. *New Music at Darmstadt: Nono, Stockhausen, Cage, and Boulez* . (Cambridge, UK: Cambridge University Press, 2014).

6 Nono, Luigi. "Historical Presence of Music Today." *Nostalgia for the Future: Luigi Nono's Selected Writings and Interviews*. Ed. by Angela Ida de Benedictis and Veniero Rizzardi. (Oakland, CA: University of California Press, 2018), 270.

7 *Ibid*.

8 *Ibid*, 267.

9 Nono, "Music and Resistance." 275.

10 For example, in 1958 the Union of Soviet Composers denounced Nono's music as irreconcilable to Socialist Realism. See: Kwiatkowski, Krzysztof. 'The Polish Diaries: Nono and the Countries of Real Socialism.' *The Master of Sound and Silence: Luigi Nono.* Trans. by Agata Klichowska. (Warsaw, Poland: Wydawnictwo Krytyki Politycznej, 2015).

11 Adlington, Robert. "Whose Voices? The Fate of Luigi Nono's *Voci destroying muros.* " *Journal of the American Musicological Society*. 69, no. 1 (2016): 181.

12 In most cases it is not clear whether Nono is paraphrasing Brecht consciously. However, the similarities are striking enough to be taken seriously as Nono was very open regarding the influence that 'epic theatre' had on his political aesthetic.

13 Adlington, 189.

14 Nono, "Historical Presence of Music Today." 267-268.

15 For information on Provo see: Kempton, Richard. *Provo: Amsterdam's Anarchist Revolt*. (Brooklyn, NY: Autonomedia, 2007).

16 Workerism, known as *operaismo* in Italy, was largely a reaction by Italian left-wing intellectuals against a perceived archaism of the PCI. For an overview of Workerist ideology from the perspective of Antonio Negri, one of the movement's principal intellectuals, see Michael Ryan's epilogue to: Negri, Antonio. *Marx Beyond Marx: Lessons on the Grundrisse*. Trans. by Harry Cleaver, Michael Ryan, Maurizio Viano. (Brooklyn, NY: Autonomedia, 1991), 191-220.

17 As pointed out by Adlington, many of the movement's leaders advocated ethnological co-research (called *co-reserca* in Italian, meaning interview-based ethnology) which would lead the movement to develop an aesthetic frame of folk-authenticity regarding the representation of the working class. However, the concept of 'folk art' and the ethnological research stemming from it has its own strained history. See: Cole, Ross. "On the Politics of Folk-Song Theory in Edwardian England." *Ethnomusicology*. 63 no. 1 (2019): 19.

18 Adlington, 181.

19 *Ibid*, 191.

20 *Ibid*, 192-193.

21 Gramsci, Antonio. "The Intellectuals." *Selections from the Prison Notebooks*. Ed by Quintin Hoare and Geoffrey Nowell Smith. (New York City, NY: International Publishers, 1971), 9.

22 Nono, "Replies to Seven Questions by Martine Cadieu." 280-281.

23 Nono, "Interview with Renato Garavaglia." 256-257.

24 Adlington, 196.

25 *Ibid*, 191.

26 Gramsci, 10.

27 Adlington, 195.

28 *Voci destroying muros* was notable for Nono's more explicit presentation of revolutionary songs. Nono almost always used pieces of revolutionary songs/chants/slogans as building blocks for his music but usually submerged these materials so deep in the texture of his pieces that they became inaudible. Additionally, Voci was only performed once at the Holland Festival in Amsterdam. The performance was marred by technical difficulties and was ridiculed by both the left- and right-wing press in the Netherlands. The left-wing criticism echoed that which was leveled against Nono's 1956 piece Il canto sospeso by Karlheinz Stockhausen. See: Stockhausen, Karlheinz. "Music and Speech." *Die Reihe*. 6 no. 1 (1964): 40-64.

29 Adlington, 202-203.

30 *Ibid*, 221.

31 Cody, Joshua. *Nono and Marxist Aesthetics*. (New York City, NY: Columbia University, 2014) 30.

32 Cody lists these as follows: the Marx/Engels approach, the Walter Benjamin approach, the Theodor Adorno approach, and the Bloch/Jameson approach.

33 Cody, 29-30.

34 *Alla punto aperiodico* means to periodically play phrases on a string instrument with the tip of a bow.

35 According to Bloch/Jameson the "fairy-tale" is a subversion of the oppressive realism of the bourgeois epic.

36 Cody, 47.

37 In music parlance, *Pointillism* is a term used to describe music in which the melodic, harmonic, and rhythmic material is presented in isolated fragments i.e. there is no linear melodic, harmonic, or rhythmic structure. The relation between pointillism in music and the painting technique is not straightforward. Some composers use the word Punctualism to avoid being misinterpreted.

38 Anti-parabolic realism is realism where the author's opinions are unknown.

39 Engels, Friedrich. *Marx and Engels on Literature and Art*. Ed. by Lee Baxandall and Stefan Morawski. (Candor, NY: Telos Press, 1973), 115.

40 *Ibid*, 114.

41 Velasco-Pufleau, Luis. "On Luigi Nono's Political Thought: Emancipation Struggles, Socialist Hegemony, and the Ethic Behind the Composition of *Für Paul Dessau*." *Music & Politics*. 12 no. 2 (2018): 8.

42 Sartre, Jean-Paul. *"What Is Literature?" And Other Essays*. (Cambridge, MA: Harvard University Press, 1988), 35.

43 *Ibid*.

44 *Ibid*, 25-27.

45 Though Sartre works within the frame of hard demarcations between the attitude and function of different literary (and, generally, artistic) mediums, he also admits that these hard categories are, in fact, more diffuse than he suggests and that his rigid classifications are meant to better present general differences between mediums. See: Sartre, 335.

46 Nono, "Replies to Seven Questions by Martine Cadieu." 279.

47 The specific question in the questionnaire to which Nono was replying was "What is the musician's place in contemporary society? To what extent can music contribute to the evolution of this society? What action do you expect from the modern composer?" See: Nono, "Replies to Seven Questions by Martine Cadieu." 277.

48 Nono, 278.

49 Nono was notorious for his constant use of pre-existing left-wing material to build his pieces. For example, the melodies of labour songs, the writings of left-wing intellectuals, speeches by left-wing and labour leaders/politicians, and recordings from picket lines and protests.

50 Nono, "Historical Presence of Music Today." 270.

51 Brecht, Bertolt. "A Short Organum for the Theatre." *Brecht on Theatre*. Ed. by John Willett. (New York City, NY: Hill and Wang, 1964), 196.

52 Brecht, "Indirect Impact of the Epic Theatre." 57.

53 Brecht, "A Dialogue About Acting." 26.

54 Brecht, "On the Use of Music in an Epic Theatre." 87.

55 *Ibid*.

56 Brecht often called this type of theatre and audi-

ence *empathetic*. See: Brecht, "Conversation About Being Forced into Empathy." 270-271.

57 For a brief description of the a-effect see: Jameson, Fredric. 1998. *Brecht and Method*. London, UK: Verso. 35-42.

58 Brecht, "The Modern Theatre is the Epic Theatre." 39.

59 Brecht, Bertolt. "Notes to The Threepenny Opera." *The Threepenny Opera*. Trans. by Desmond Vessey and Eric Bentley. (New York City, NY: Grove Press, 1960), 98-99.

60 *Ibid*. 103-106.

61 Brecht, "The Literarization of the Theatre." *Brecht on Theatre*. 45

62 Brecht, "A Short Organum for the Theatre." *Brecht on Theatre*. 203.

63 *Ibid*. 190.

64 For an introduction to the most well-known interpretation the concept of *gesamtkunstwerk*, that of Richard Wagner, see: Meldrum Brown, Helda. *The Quest for the Gesamtkunstwerk and Richard Wagner*. (Oxford, UK: Oxford University Press, 2016), 1-13.

65 Brecht, "On Gestic Music." 104-105.

66 An additional aspect of Brecht's aesthetic is his focus on "entertainment." He often made sure to point out that the theatre needed to be fun. In fact, throughout his life he consistently described his ideal audience as similar to the audience at a sporting event: critically engaged with the game while also being relaxed and jovial. See: Brecht, "Emphasis on Sport." 6-9.

67 Nono was actually able to work with Piscator during the 1960s. He also mentions in his 1987 interview with Enzo Restagno that in the 60s he had searched high and low for Piscator's book *The Political Theatre* which had been mostly unavailable since the 1940s, when many copies were burned by the Nazis.

68 Brecht, "On Experimental Theatre." 130-131.

69 In a number of articles from the 1960s, Nono refers to some of his work (specifically *Intolleranza 1960*) as "music theater" as opposed to simply music. For Nono, scenography (i.e. the construction of the performance space) was a pivotal aspect of his music composition. It was the necessity of a scenographically oriented musical practice that led Nono to understand his pieces as music theatre and see himself as a composer/dramaturg hybrid. For example see: Nono, "Possibility and Necessity of a New Music Theater." 209-219.

70 Nono is describing the empathetic effects of opera. Brecht often describes opera as culinary, in a similar manner as Nono is doing here when he describes opera as gastronomic. See: Brecht, "The Modern Theatre is Epic Theatre." 33-42.

71 Nono, "Possibility and Necessity of a New Music Theatre." 213.

72 Nono goes on to list examples of the experiments in audience engagement, a list that includes Brecht.

73 Nono, "Play and Truth in the New Music Theatre." 226.

74 This is in response to a question regarding Stockhausen's concept of the audience as a radio transistor. See: Stockhausen, Karlheinz. *Composers on Music: Eight Centuries of Writings*. Ed. by Josiah Fisk. (Boston, MA: Northeastern University Press, 1997), 450.

75 Nono, "Autobiography Recounted by Enzo Restagno." 90.

76 Acousmatic sound is defined as sound for which one cannot see the immediate source. This concept was first articulated by the originator of the *musique concrete* style of electronic music, Pierre Schaeffer. Nono mentions Schaeffer's Paris electronic studio, where he apparently spent some time, twice in his 1983 interview with Walter Prati and Roberto Masotti and two more times in his 1987 interview with Enzo Restagno. An English translation of Schaeffer's essay on acousmatic music is available. See: Schaeffer, Pierre. *Treatise on Musical Objects: An Essay across Disciplines*. Trans. by Christine North and John Dack. (Oakland, CA: University of California Press, 2017).

77 Wilcox, Dean. "Political Allegory or Multimedia Extravaganza? A Historical Reconstruction of the Opera Company of Boston's *Intolleranza*." *Theatre Survey*. 37 no. 2 (1996): 117.

78 Wilcox. 125.

79 Santini, Andrea. "Multiplicity - Fragmentation - Simultaneity: Sound-Space as a Conveyor of Meaning, and Theatrical Roots in Luigi Nono's Early Spatial Practice." *Journal of the Royal Musical Association*. 137 no. 1 (2012), 82.

80 *Ibid*.

81 Adlington, 182.

82 In footnote 14 of his article, Adlington briefly mentions the influence of "Brecht, Piscator, and Meyerhold" on Nono and cites an article by Oxford Professor, Harriet Boyd. In her article, Boyd mentions the influence of Brecht, Piscator, and Sartre on Nono (as well as his interest in Arnold Schoenberg's spatio-musical experiments, which Nono believed prefigured the direction of his own work). However, neither Adlington nor Boyd explore these influences on Nono's political aesthetic beyond these brief mentions. Additionally, like Adlington, Boyd also misinterprets Nono's work as *representational*. See: Boyd, Harriet. "Remaking Reality: Echoes, noise, and modernist realism in Luigi Nono's *Intolleranza 1960*." *Cambridge Opera Journal*. 24 no. 2, (2012): 177-200.

83 Adlington, 183.

84 Nono hoped that the end of the piece, which featured a pre-recorded agitational speech, would prompt the audience to literally stand up and walk out with the performers. Because of technical problems during the performance, the speech was not played over the loudspeakers and the audience was left silent and confused, watching the performers hurry out of the hall. See: Adlington, 185-186.

85 The phrase *turning point* is often used to describe how this piece initiated the final part of Nono's career. See: Metzger, Heinz-Klaus. "Wendepunkt Quartett." *Musik-Konzepte*. No. 20 (1981): 93-112.

86 The text was taken from the German romantic poet Friedrich Hölderlin. However, as stated before, the piece was instrumental. This text was to be seen and read silently by the performers alone.

87 Cody, 4-5.

88 Nono, "Interview with Walter Prati and Roberto Masotti." 314.

89 Nono, "Autobiography Recounted by Enzo Restagno." 103-108.

90 A halaphone is a microphone that, in addition to picking up audio signals, is able to alter and send these signals to multiple channels. For a brief description of its use see: Schonberg, Harold C. "Music: Now We Have The Halaphone." *The New York Times*, January 7, 1973. https://www.nytimes.com/1973/01/07/archives/music-now-we-have-the-halaphone-the-program.html (Accessed August 3rd, 2019).

91 Nono, "Autobiography Recounted by Enzo Restagno." 119.

92 Emilio Vedova was a Venetian painter who had known Nono since childhood. They collaborated often.

Bibliography

Adlington, Robert. "Whose Voices? The Fate of Luigi Nono's *Voci destroying muros*." *Journal of the American Musicological Society*. 69 no. 1 (2016): 179-236.

Boyd, Harriet. "Remaking Reality: Echoes, noise, and modernist realism in Luigi Nono's *Intolleranza 1960*." *Cambridge Opera Journal*. 24 no. 2 (2012): 177-200.

Brecht, Bertolt. *The Threepenny Opera*. Trans. by Desmond Vessey and Eric Bentley. (New York City, NY: Grove Press, 1960).

— — —. *Brecht on Theatre*. Ed. by John Willett. (New York City, NY: Hill and Wang, 1964). Cody, Joshua. "Nono and Marxist Aesthetics." (New York City, NY: Columbia University, 2014).

Cole, Ross. "On the Politics of Folk-Song Theory in Edwardian England." Ethnomusicology. 63 no. 1 (2019): 19-42.

Engels, Friedrich. Marx and Engels on Literature and Art. Ed. by Lee Baxandall and Stefan Morawski. (Candor, NY: Telos Press, 1973).

Gramsci, Antonio. Selections from the Prison Notebooks. Ed. by Quintin Hoare and Geoffrey Nowell Smith. (New York City, NY: International Publishers, 1971).

21 Iddon, Martin. New Music at Darmstadt: Nono, Stockhausen, Cage, and Boulez. (Cambridge, UK: Cambridge University Press, 2014).

Jameson, Fredric. Brecht and Method. (London, UK: Verso, 1998).

Kempton, Richard. Provo: Amsterdam's Anarchist Revolt. (Brooklyn, NY: Autonomedia, 2007).

Kwiatkowski, Krzysztof. 'The Polish Diaries: Nono

and the Countries of Real Socialism.' The Master of Sound and Silence: Luigi Nono. Trans. by Agata Klichowska. (Warsaw, Poland: Wydawnictwo Krytyki Politycznej, 2015). http://glissando.pl/en/news/the-master-of-sound-and-silence-luigi-nono-book-excerpt/#sdfootnote2sym (Accessed September 7th 2019)

Meldrum Brown, Helda. The Quest for the Gesamtkunstwerk and Richard Wagner . (Oxford, UK: Oxford University Press, 2016).

Metzger, Heinz-Klaus. "Wendepunkt Quartett." Musik-Konzepte . No. 20 (1981): 93-112.

Negri, Antonio. Marx Beyond Marx: Lessons on the Grundrisse. Trans. by Harry Cleaver, Michael Ryan, Maurizio Viano. (Brooklyn, NY: Autonomedia, 1991).

Nielinger-Vakil, Carola. Luigi Nono: A Composer in Context . (Cambridge, UK: Cambridge University Press, 2015).

Nono, Luigi. Nostalgia for the Future: Luigi Nono's Selected Writings and Interviews . Ed. by Angela Ida de Benedictis and Veniero Rizzardi. (Oakland, CA: University of California Press, 2018).

Santini, Andrea. "Multiplicity - Fragmentation - Simultaneity: Sound-Space as a Conveyor of Meaning, and Theatrical Roots in Luigi Nono's Early Spatial Practice." Journal of the Royal Musical Association . 137 no. 1 (2012): 71-106

Sartre, Jean-Paul. "What Is Literature?" And Other Essays. (Cambridge, MA: Harvard University Press, 1988).

Schaeffer, Pierre. Treatise on Musical Objects: An Essay across Disciplines . Trans. By Christine North and John Dack. (Oakland, CA: University of California Press, 2017)

Schonberg, Harold C. "Music: Now We Have The Halaphone." The New York Times, January 7th, 1973 https://www.nytimes.com/1973/01/07/archives/music-now-we-have-the-halaphone-the-program.html (Accessed August 3rd, 2019).

Spangemacher, Friedrich. "Nono's Prometeo. " Tempo. 1 no. 151 (1984): 51-52 Stockhausen, Karlheinz. "Music and Speech." Die Reihe. 6 no. 1 (1964): 40-64.

———. Composers on Music: Eight Centuries of Writings. Ed. by Josiah Fisk. (Boston, MA: Northeastern University Press, 1997)

22

Velasco-Pufleau, Luis. "On Luigi Nono's Political Thought: Emancipation Struggles, Socialist Hegemony, and the Ethic Behind the Composition of Für Paul Dessau. " Music & Politics. 12 no. 2 (2018).

Wilcox, Dean. "Political Allegory or Multimedia Extravaganza? A Historical Reconstruction of the Opera Company of Boston's Intolleranza. " Theatre Survey. 37 no. 2 (1996): 115-134..

Caro zio,

non ho paura della morte, dispiace soltanto di aver vissuto poco, di aver fatto poco per il mio paese. Zio ormai mi sono abituata al carcere, non sono sola, siamo in molti. Io, però non ho paura della morte. Dite alla mamma che non pianga. Tanto non sarei egualmente vissuta per molto tempo con lei. Io avevo la mia strada. Che la mamma nasconda il grano, sennò tedeschi se lo pigliano. Vostra nipote.

LUCAS HUANG

East Asia's Pop-Music
Industry and the Conquest
of Creativity

hen capital has conquered labor, land, and the means of subsistence, where does the blade of conquest next fall? Naturally, when all other options have been explored, it encroaches upon the workers' hours of leisure. In order to counter the slower rate of accumulation brought on by the legal shortening of the working day, the capitalist aims to monetize, and to thoroughly control, the worker outside of his employment contract. When the working day ends, money capital can no longer confront and exploit the worker, and thus commodity capital steps in to fill the void. The capitalist now redirects his aims and attempts to reclaim a portion of his variable capital, originally advanced in the worker's wages, by offering the worker an addicting, drug-like form of entertainment in exchange for the universal equivalent. As a result of imperialist cultural homogeneity abroad and increased social pressure to stay up-to-date with pop culture trends, the laborer of today has become increasingly unable to separate the pleasure of his leisure time from the expenditure of his wages. Whether his money is spent on television, on movies, on the internet, on video games, on books, on music and instruments, or on tools and materials for any number of hobbies, the money always flows back into the hands of the capitalist class.

In order to examine this phenomenon more closely, it is important to select a subject that is familiar to most, if not all, workers of the world. Since the very beginning of human history, music has always been an integral part of our social development. Whether it takes the form of banging two hollow bones together, strumming a line of sheep gut, performing an opera, or manipulating sound waves through a synthesizer, music has been a constant factor of society through every age and civilization. It logically follows that by examining music within the current structure of society, i.e. within the authority of capital, we can view the alteration of conditions as an archetype for the dialectical conflict of cultural forms under capital; we can pinpoint which aspects deteriorate and which aspects progress. Accordingly, this exploration will center upon the music industry of today. However, because of length restrictions, this article will not be covering the entirety of musical history from the onset of capital development. Instead, we will be focusing on the highest form of this industry. In other words, we will be examining the particular form that brings to light the most developed and most blatant contradictions that have arisen from a capital system; a branch of the music industry that is so wholly consumed by a rabid desire for accumulation that it discards even the lowest ethical guidelines in the name of mass appeal and profitability. We will be investigating the East Asian *idol industry*.

fter the end of the Second World War, Japan began to transition from a traditionally imperialist state into a capitalist puppet nation under the strict control of the U.S. military. The dismantling of the emperor's power as well as the liberalization of the market allowed for the development of a so-called free market system. In order to promote faith in the restoration efforts, the U.S. symbolically disbanded the *Zaibatsu* corporate monopolies (which had stood at the center of the Japanese economy since the Meiji Restoration), but the system of corporate trusts persisted regardless, merely taking on the new moniker of the *Keiretsu*. Agitation among the Japanese laboring population had already been high since the start of the 20th century, and the tumultuous changes of the 30's and 40's brought political unrest to a near breaking point. Because of Japan's history of tenacious labor movements, the U.S. began to worry about the possibility of a Japanese Communist struggle. The solidifying of Soviet influence and the approaching Communist victory in the Chinese Civil War only added fuel to the fire.

In 1950, the Korean War provided the Allies with an excuse to further increase military control in Japan, on the grounds of "[Japan's] role as a rear base for the supply and transit of soldiers and materials."[2] After the conclusion of the war, the military presence of allied nations (not including the U.S.) lessened, and the Japanese Prime Minister, Yoshida Shigeru, signed and ratified the Treaty of San Francisco to restore Japan's autonomy (to a certain degree). It is important to note here that Yoshida was a staunch supporter of brutal Japanese imperialism in Manchuria, as well as a proponent of *bokumin* neo-Confucian ideology in fusion with western models of governance.[3] It thus came as no surprise, that after signing the treaty, Yoshida agreed to the U.S.-Japan Security Alliance (known in Japan as the Anpo). The agree-

Thanks mostly to the popularization of television, the 1970's brought an explosive increase in the volume of idol media.

F
T
ORY
HE

OMENON

ment gave the U.S. the authority to maintain military bases in Japan, as well as the discretion to violently suppress any civil disturbances in the region. The agreement limited (and to this day continues to limit) Japan to little more than a neo-colonial puppet state.

As the 1950's progressed into the 1960's, the remilitarization of Japan continued at a fervent pace. In 1954, the transformation of the National Police Reserve into the JSDF (Japan Self-Defense Forces) gave Japan a new military in all but name, and prompted the development of a new brand of controlled nationalism. At the same time, the U.S. started pumping an exorbitant amount of economic stimulus into the country to accelerate the colonization process, creating an "economic miracle" (in the same manner that gavage-based foie gras creates a "culinary miracle"). Within the context of the burgeoning Cold War, Japan was to be a barrier against Soviet and Chinese influence in Asia, and accordingly, any left-leaning tendencies among the Japanese people could not be tolerated. Rampant consumerism began to rise, and the *American Way of Life*™ took over. It is in this arena that the first young Japanese pop singers began to flourish, and where the first seeds of idol pop were sown. At the inception of the contemporary Japanese music industry, many singers performed for American soldiers stationed in the country. Due to the lack of a proper music market, these performances provided up-and-coming pop stars with an avenue to success. In fact, they were so lucrative that "control of access channels to performing on those U.S. military bases meant control of the pop industry."

In 1964, the term idol (*aidoru*) first appeared after the French film, *Cherchez l'idole* (*Aidoru o Sagase* in Japan), introduced Japanese audiences to singer Sylvie Vartan. Vartan's youth, musical talent, and cute appearance were unbelievably popular, garnering the sale of over a million copies of her single "La plus belle pour aller danser." Similar artists began to take on the moniker of "idol," eventually allowing the term to grow out of the confines of a musical genre, and into a cultural phenomenon.

Thanks mostly to the popularization of television, the 1970's brought an explosive increase in the volume of idol media. Nippon Television launched a new series called *Star Tanjou!* (*A Star is Born!*) that introduced a broadcasted audition system for the scouting of idol talents,[6] bringing the dreams of stardom and fame ever closer to a disillusioned populace. From this point on, the idol industry began to garner profits that attracted the capitalists of other nations, spreading the idol model outside of Japan. Most notably, idol bands took root in South Korea and eventually expanded into a global phenomenon during the *hallyu* "Korean wave" of the 1990's.[7] The main difference between the Japanese and South Korean idol industry was, and remains, the Japanese tendency to produce primarily for the domestic market, and the South Korean tendency to produce primarily for export.[8]

Through the 80's and 90's the idol phenomenon continued to expand,[9] and so did the capital of the industry. In order to ramp up accumulation, the process had to evolve. Previously, idols had been limited to mostly single artists, or small trios and duets of singers. In the 80's, the success of large idol "groups" like *Onyanko Club* (which had a total of 52 rotating member-s[]) created a new dynamic for increasing the amount of labor available for idol companies. Today, groups like AKB48, Morning Musume, and Girls' Generation carry on this legacy. In order to solidify the labor pool, a number of entertainment corporations also began to set up idol training facilities. Companies like S.M. Entertainment, JYP Entertainment Co., Y.G. Entertainment, Amuse Inc., and Yoshimoto Kogyo all introduced idol, or pop-star, "schools" that would accept young children and mold them into monetizable personas through a series of multi-year contracts. In recent years, the idol industry has conquered large sectors of the music market, even outside of East Asia. Japan has become the second largest music industry outside of the U.S.,[11] and Korea has risen to the sixth largest.[12] Although idol music does not account for the entirety of sales in these countries' music industries, a large percentage of their revenues stem from the idol-like tradition of selling exclusive merchandise and idol promoted products at exorbitant prices alongside physical and digital copies of their music.[13]

THE MANUF PROCE

The first public audition processes allowed independent members of the populace to put forth their own material, and could sometimes yield a performer who outpaced the control of their employers. Yamaguchi Momoe is a perfect example. After being recruited at age 13 from a *Star Tanjou!* audition in 1972, Yamaguchi exploded into popularity in the following years, giving her the ability to bargain with her employers over her pay, her songwriters, and the genre of her music.[14] In addition to this disadvantageous power dynamic for employers, the original audition system consumed large portions of productive capital in the process of searching for satisfactory talents. In order to reduce these costs, idol agencies developed the "in-house" system. Instead of going to the public to find matured talents, agencies would have the public come to them with "raw materials". Accordingly, the age of recruits was decreased from an already low standard, and financially unstable households began to pour their children into the market for a chance at becoming famous and wealthy. The system placed all factors of idol production under one corporate unit. By taking total control of the child's life and development, and by slowly shaping the child into a satisfactory form, agencies could construct performing groups from the most profitable trainees. SM Entertainment's founder, Lee Soo Man, is often credited with perfecting the system. By "ensuring that all of [the] necessary attributes were combined to create the perfect pop star...SM controlled every process and part that went into the manufacturing of Kpop idols and their hits."[15] Talent agencies in Japan, including Yoshimoto Kogyo and Amuse Inc., have also developed similar programs. In the process of reducing the scouting and training of an idol to a standardized system of manufacture, idol agencies have been able to marginalize the idol trainee to a state much like that of a doll to be assembled. This is not to say that idols and trainees do not labor, nor that their labor does not create a surplus value.

The labor of the idol is often significantly more strenuous, more time consuming, and more demeaning than the average worker. However, idols are not viewed by the capitalist as merely a means for the creation of surplus value; they are also seen as a necessary prerequisite for the creation of the final product. By hiring songwriters, lyricists, choreographers, recording engineers, etc. with a portion of their variable capital, idol agencies apply the living labor of their traditional employees not only to the means of production, but to the idol as well. The idol cannot produce a satisfactory

exchange-value on their own; instead they must be able to absorb the labor of others in order to create a final, saleable commodity. In fact, the final product, the idol's *image*, ends up as a construct separate from the idol. It becomes a source of revenue that does not fall under their own jurisdiction. Due to this relation, idols are expected to meet a standard archetype. Their abilities in song, in dance, in appearance and in weight are heavily codified, to the degree that failure to meet these requirements can often lead to expulsion from a training academy. Because the idol transfers value from the labor-power of others to their saleable image, but is also a "free-laborer" contracted for their labor-power, they can be seen as a peculiar form of productive capital, compromising both fixed capital in the form of a means of labor, as well as fluid capital in the form of purchased labor-power. Similarly, they can be seen as a portion of constant capital that gradually transfers value over a set period of time, as well as a portion of variable capital that is capable of producing surplus labor.

To further solidify this concept, where the traditional employees of talent agencies are hired by piece-wage or by annual salary, the idol is confined by a multi-year contract, known colloquially as a "slave" contract. These agreements start from the beginning of their training career, and at one point, lasted as long as 13 years (though now legally limited to 7 in South Korea). Contracts often specify very little in the way of wages, and almost always contain clauses related to the restriction of personal life choices outside of specifically agency related activities. If any clauses are violated, the idol is invalidated and often severely demoted or even expelled from the agency entirely. In some cases, the idol is also fined a large sum of money. Because idols often give up much of their traditional education in order to undergo training, these punishments can ruin their future career chances, and prevent them from finding employment outside of the industry. In the particular relation established, these multi-year contracts serve as the turnover period for a portion of the means of labor (i.e. the idol as separate from their saleable image), as well as a way to solidify the costs of their maintenance. Through this method, the agency conditions the idol to act as a means of labor that is capable of labor-power. The idol can absorb and gradually transfer values from multiple turnovers of fluid capital, thus acting as fixed and constant capital, while simultaneously existing as a portion of fluid and variable capital by producing surplus-labor that is fully consumed in the production of the final commodity. In other words, the idol can transfer a value to a product while simultaneously valorizing it further. This relation applies to the period of direct employment of the idol, but because the relation technically originates from the purchase of labor-power from a "free-laborer", it is important to note that the laws of the supply and demand of labor-power (as opposed to the supply and demand for means of labor) are still applicable and relevant to the idol's inception. For instance, in conjunction with the in-house system, the use of a graduation model allows for the maintenance of an industrial reserve army. By requiring a constant

stream of recruits, talent agencies conjure up the illusion that anybody can become an idol, thus further glutting the labor market with hopeful cadets.

An additional facet of idol capital to be examined is the extension of surplus labor in proportion to necessary labor. In *Capital Vol. 1*, Marx illuminates three possible methods for capital to increase the rate of surplus value: 1) increasing the absolute surplus value, or increasing relative surplus value by 2) increasing the intensity of labor, and 3) increasing the productive efficiency of labor.[20] The following enumerates a few methods utilized by the idol industry to achieve this extension.

1. Increasing Absolute Surplus Value

This method has already been demonstrated in part by the creation of large idol groups and training academies. By increasing the number of idols, the agency is able to create a larger number of performing acts, and can thus increase the mass of surplus labor expressed in the final sale of each of these products. On the method of lengthening the working day, idol agencies practice something akin to the relay system explained in *Capital Vol. 1* Chp. 10 Section 4.[21] Although idols are limited to a legal maximum of hours in the working day (with some caveats),[22] idol agencies can still set other employees to work in creating materials to be used by the idols,[23] e.g. market-ing, composition, choreography, etc. while the idols are not working. This differs from the relay system only in the specific sense that the industrializing English capitalist aimed to decrease the time in which his means of production lay unused, and that the idol agency aims to maximize the production of preliminary articles necessary for the final commodity's formation. Both do so by conquering a larger portion of the day for the production process. Additionally, the ambiguous wage clauses of idol contracts allow agencies to hold an idol's necessary labor to a minimum standard, thus increasing the ratio of surplus to necessary labor.

2. Increasing Labor Intensity

The idol training model intensifies labor by creating an atmosphere of extreme competition within idol groups and trainee programs. As mentioned previously, the simplest violations of any number of rules can result in severe punishments. Additionally, should the performance of an idol drop below that of others, they also risk being terminated. This creates an incentive for the idols to expend a larger amount of labor-power in a shorter amount of time, in order to secure their position, and also to keep from falling behind.[24] By pitting idols against each other, the agency can also prevent idols from utilizing collective bargaining. Korean idols are also expected to learn different languages, styles, and genres of song and dance to appeal to a larger audience. Because the Korean idol

can adapt to such a wide variety of material, the supply of labor they are expected to absorb and valorize in a fixed amount of time increases proportionally. In other words, higher proficiency creates higher expectations, and a larger quantity of expected expenditure of labor-power in a set period of time. Although Japanese idols are also expected to learn a variety of musical skills, their training methods in this particular aspect are not as intense. Japanese idols direct a higher portion of their skills towards fan interaction as opposed to international appeal, due to their focus on the domestic market.[25] Accordingly, the increase in intensity of labor for a Japanese idol derives more from developing groundwork to facilitate a positive relation with a rapidly expanding audience.

3. Increasing Labor Productivity

The above mentioned diversity in training not only increases intensity, but also productivity. Because the contracted idol is essentially a portion of the means of labor, the ability for an idol to integrate labor from a variety of inputs increases the amount of value produced in proportion to labor absorbed. A set quantity of labor with many acceptable inputs is thus able to produce more value than it did with only a few compatible inputs. For example, the idol agency can hire different managerial groups for the development of music and products; one for the Indonesian market, another for the American market, another for the Vietnamese market, and yet another for the Thai market. If an idol can then absorb all the inputs without requiring the translation or re-design of the ancillary and raw materials, then the efficiency of the manufacturing process increases. Of course, the natural progression of technology also increases the productivity of labor. For instance, the

widespread practice of televising or broadcasting certain acceptable aspects of an idol's training regimen as a sort of "get to know them" program creates a more personable relationship with fans, and thus allows for the training process to be monetized as well. This does not expend any labor that is not proportionally lesser than the value it garners.

Taken as a whole, the idol's relation to capital is generally more exploitative

than what is found in other working conditions of the imperial core, certainly more so than the larger number of independent music artists from the West. The *absolute* alienation of the idol from not only their labor and means of production, but from their own identity, develops an ever increasing list of contradictions between the production and consumption of idol media.

ince its inception, the self-purported objective of the idol industry has always been "to sell dreams".

In Japan, after the political upheaval of the 50's, the 1960's brought the largest surge in radical protest since the Meiji Restoration. Upstanding citizens from all walks of life rose up in response to the strengthening of the Anpo agreement. Hundreds of

ING
AMS

thousands took to the streets, millions signed petitions, and thousands were injured and shot by police during protests.[27] Groups like the communist and anarchist *Zengakuren* movement (as well as its later revolutionary factions) even stirred up popular support from the People's Republic of China, eliciting a series of political cartoons in the 人民日报 (People's Daily).[28] The functionally disjunct and ideologically bereft *Zenkyoto* movement also began to protest American imperialism and Japanese monopoly capitalism. In South Korea, the long line of militaristic and anti-communist dictators

created a similar, but often more acute struggle for the Korean people. The South Korean regime's frequent use of violence, lack of hesitation to kill (see Gwangju Massacre), and close proximity to the DPRK further accelerated the need for a controlling consumer culture. If the U.S. plan to contain Communism was to stand, the revolutionary spirit of East Asia had to be crushed. In conjunction to the traditional use of force, the cultural juggernauts deployed their greatest weapons. Among these was the opium of dreams.

The idol industry began to slowly erode the student desire for political struggle in the 1970's, "when many young people began to seek respite from political violence and turbulent student movements."[29] Both male and female idols rose in prominence, and the birth of a clearly identifiable consumer culture first appeared around these stars. As the industry has evolved, idols have continued to embody the dreams of each successive generation of adoring fans. The first idols of the 70s and 80s displayed extravagance and a luxurious lifestyle, capturing the desires of the people in their destitute conditions. When the living standards of the common worker began to marginally improve, idols adopted a more friendly, relatable demeanor. Today, when the exploitation of capital absorbs nearly all semblance of social life and meaningful interaction, idols have come to emulate the different types of relationships that many young workers have little hope for.[30]

This alienation of the working class is one of the leading reasons as to why the idol image has diversified so rapidly. The consumers of today yearn for what capital dissolves, e.g. romantic, sexual, platonic, and even familial connections. The stereotypical idol fan is characterized as an individual in their twenties or thirties who has lost hope

in developing meaningful interpersonal associations. These fans look up to their idol as an embodiment of their desires. In order to satisfy these manifold cravings, idol agencies manufacture talents who are cultivated for a variety of marketable characteristics. The three most prevalent and most applicable persona archetypes of the modern idol are purity, relatability, and maturity. The first appeals to the consumer's desire for a relationship that is "innocent"; the desire for a construct that is reminiscent of a previous self. Such a nostalgic purity, although often a manufactured facade, evokes a strong emotional (and monetizable) response. The second characteristic, relatability, creates a sense of shared struggle. Being able to identify with the highs and lows that an idol goes through constructs an illusory bond of camaraderie between the idol and the fan. This is often achieved through the televisation of training and fan meetup events. The third characteristic, maturity, takes the emotions of the first characteristic and applies them in the opposite direction. Where purity corresponds to a consumer's desire for the past, maturity corresponds to their wishes for the future. The mature idol thus serves as a figure to depend on, or as someone to look up to.

Alongside these three overarching divisions, an agency can then apply any number of additional niche personality traits to further strengthen the affection a fan feels for an idol. By developing these parasocial relationships, idol agencies are able to hook consumers on the apparent attainability of dreams, and convert fan commitment into a commodity relation. In the most extreme cases, idol enthusiasts can sink the majority of their life savings into a single idol or idol group. Even some of the more casual fans can spend upwards of $100 a month on related merchandise. This nearly religious devotion of idol fans serves as the groundwork for a rabidly loyal consumer base.

Once the idol has reached a certain level of renown, the idol agency is then free to place the idol on the advertising market, linking idol media consumers to a larger web of commodity producers. Essentially, the idol agency develops the idol, not to sell the *idol* as a commodity, but to sell the idol's *image* as such. This malleable form transcends the limitations of a physical commodity, and allows the agency to apply the image to any number of products. Beginning with the group *Onyanko Club*, idol music has since become "so intertwined with TV that it can't be appreciated outside that context," and in today's Japan, nearly 50% to 70% of all advertisements feature some sort of idol. Moreover, the vast quantity and diversity of idol related products allows for the subsumption of a fan's identity to the consumption of idol media. Rather than defining themselves based on who they are or who they wish to be, the idol fan becomes trapped in a cycle, eventually defining themselves through the commodities they consume. It is here that the situational irony of the idol industry reveals itself. Through the creation of a consumer identity on the basis of a fictional construct, a construct that is fully in conflict with its own human vessel, the idol industry has produced lifeless automatons that propagate capital accumulation in the name of "dreams". From this unassailable contradiction, a myriad of horrific abuses have arisen, of which a few will now be presented.

BEHIND THE MASK

I n the process of crafting an idol persona that is separate from its carrier, a rift emerges between the personal life of an idol and their life as a laborer. The idol is contractually obligated to maintain their facade as long as they are within the public eye, for the protection and preservation of "fans' fragile fantasies." However, because of the stalker like devotion of the most infatuated fans, idols are occasionally unable to determine when the "public eye" is upon them. If they are caught violating some aspect of their persona or some ridiculously restrictive clause of their contract, the punishment is often swift and unyielding.

Take the case of Minegishi Minami, a former member of the AKB48 B team, who was seen leaving her boyfriend's home in 2013. After the rumor was published in a gossip magazine, the official AKB48 YouTube channel uploaded a video of Minegishi begging for forgiveness while choking through a torrent of tears. The most shocking aspect was that Minegishi had shaved her entire head, which she unconvincingly claimed to be her own decision. In Japanese culture, the act of cutting one's hair is symbolic of contrition, but for a woman (and an idol who is marketed for physical traits, at that) to completely shave her head was unheard of. Minegishi was allowed to continue working with AKB48, but was demoted back to a training team "for causing a nuisance to the fans". Others had no such luck after similar incidents. To name a couple, Sashihara Rino was exiled to a sister group of AKB48 after her tearful apology, and Masuda Yuka was kicked from the

agency entirely.

In an even more outrageous incident, Yamaguchi Maho from NGT48 was tailed home by two stalkers who proceeded to attack her as she was entering her apartment. The two men attempted to pin her down, but were stopped by a building resident and later arrested by the police. Yamaguchi alleged that other members of NGT48 had helped the attackers locate her home (likely a result of the rabid competitive atmosphere within idol groups). In response, Yamaguchi's management did absolutely nothing. Instead, Yamaguchi was made to apologize for "causing trouble". She was uninjured in the attack, but was soon ousted from NGT48 for being "an assailant against the company". Although her more sensible fans were outraged at NGT48 management for accusing Yamaguchi, no apology was issued until the Niigata prefecture withdrew funding from NGT48 enterprises. In another act of rapacious greed, Yamaguchi's management sued her attackers *after* she had left the group, and obtained a several million yen settlement (none of which was given to Yamaguchi).

A further, more violent example of assault is the case of TV idol Tomita Mayu. Between January and February of 2016, Tomita received a package containing books and a watch in the mail from an obsessive stalker fan. Tomita returned the items, and the stalker began to send multiple harassing messages to her Twitter account and her blog. The stalker began to escalate his actions, and sent upwards of 400 hostile tweets to Tomita, many of which were blatant death threats. Tomita contacted the police in fear of her life, but was dismissed and told that social media messages were not a significant sign of danger. Twelve days later, the stalker confronted Tomita outside of one of her venues and asked her why she had returned his mail. Finding her answer unsatisfactory, he flew into a mad rage and stabbed Tomita from behind more than twenty times with a pocket knife he had prepared beforehand. The man was apprehended, but Tomita was in a critical condition. When she eventually recovered from a two week coma, the 34 stab wounds on her back, neck, and face had partially blinded her left eye. She now has difficulties eating, can no longer sing, and suffers from severe PTSD. In another showing of gross incompetence, the perpetrator was given a sentence of only 14 and a half years in prison for attempted murder. Tomita is still fighting a court case to prevent others from experiencing what she went through.

In addition to the cultivation of vigilant and damning surveillance of behavior, the personality rift also yields a tremendously negative effect upon an idol's mental development. Typically, trainees sign contracts at a young age, often before the onset of puberty, and begin to mature as their fame expands. Due to the unnaturally intense and time consuming process of manufacture, idols often cannot experience the process of growing up in a more traditional environment. This fame can give rise to a number of issues. Although the previous examples illustrate incidents where idols inadvertently crossed a social stigma, there have been multiple occasions where idols have indulged in illegal activities as a result of their stunted development.

Superficial examples of this come primarily from drug abuse. Because of the strict anti-drug laws of South Korea and Japan, the possession and or use of any type of narcotic, including comparatively harmless ones like marijuana, can be punished with long prison sentences. In the case of Takabe Ai, voice actress and pin-up idol, her use of narcotics

brought down her entire career. After being apprehend for drug possession, Takabe was dropped from her agency, her name was erased from the credits shows she voiced in, and the shows were removed from streaming services. However, because personal drug usage does not directly bring harm to others, it would be unjust to place blame upon the idol. Within the context of their exploitation, these desperate actions are merely an expression of alienation and a result of its effects on the worker. For Kim Jong-hyun, former member of the South Korean boy-band SHINee, this alienation led, not to drug use, but to suicide. In his final note, Kim said "it wasn't my path to become famous... it's a miracle that I endured all this time." Essentially, the gap between his contract and his conscience led him to depression, and eventually death.

This same sense of alienation has manifested as an opposite extreme in idols that use their fame to commit heinous acts. Most notably, in 2019, the K-Pop industry was shaken by the discovery of a sex cabal of entertainment moguls and K-Pop stars, now referred to as the Burning Sun Scandal. The Burning Sun nightclub was partially directed by Lee Seung-hyun (stage name Seungri), who was a member of the K-Pop group Big Bang. In response to the assault of a clubgoer by a staff member, the Seoul Metropolitan Police Agency (SMPA) began an investigation of the club, and unearthed copious amounts of evidence concerning drug trafficking, prostitution, date rape, and police corruption. Later on, the police obtained message records between a number of idols, including Lee, revealing the use of spycams to record and distribute videos of women being intoxicated and raped. In one particular group chat, singer-songwriter Jung Joon-young messaged his friends saying, "Let's all get to-

gether online, hit the strip bar and rape them in the car." In response, a member of the chat said, "Our lives are like a movie. We've done so many things that could put us in jail." In the following crackdown, the SMPA investigated a wide swath of entertainment conglomerates, and apprehended or detained nearly 4000 people in establishments where drug trafficking and prostitution were commonplace. Lee has since stepped down from his place in Big Bang and the entertainment industry, but has evaded arrest.

In Japan, similarly horrific practices are commonplace as well. However, instead of examining the perpetrators, this section will illuminate a victim's experience in order to provide a different perspective. In terms of sexual abuse and malicious contracts, Hoshino Asuka, a former adult video actress, epitomizes the experiences that thousands of budding stars go through. Hoshino first entered the show business not as an idol, but as a finalist for a Miss Magazine contest in 2004. She made a number of minor appearances in mainstream films, and was confronted by a man she calls "Mr. A" a few years after her debut. When approaching Hoshino, Mr. A claimed to be an investor in the entertainment industry, mentioning the names of a few large record companies and publishing agencies, and asked Hoshino to contract work with him. She agreed, and was told her first job would be a gravure shoot, but found out that it was for an adult video when she arrived. "My contract didn't mention a word about adult videos," said Hoshino. "They told me to show them my passport, and I was told to sign my name on a blank sheet of paper. They never gave me my copy of my contract, saying they'd lost it." In December of 2010, her first video was published, and sales ranked 23rd on their distribution site. With their revenues, Mr. A and

his associates bought a new office in a high class establishment while paying Hoshino a pittance, telling her they were working hard for "her sake" and told her to "give it everything [she] had."[53] For the next three years, Hoshino was forced to perform sexual acts on film against her will, and without a stage name, which she was never given an option to use in the first place.[54] She developed a mental disorder, causing her to have intense bouts of depression, extreme anxiety when meeting people, and difficulties eating. After escaping the AV business, Hoshino's doctor informed her that her health would have continued to decline, and she eventually would have died if she remained an AV actress.[55] When asked about the agency's recruitment practices, Hoshino compared their tactics to the Aum Shinrikyo doomsday cult, a group of religious extremists that were responsible for a number of terror attacks in the mid 90's.

By brainwashing hopeful actresses into thinking that AV is the only way to succeed in entertainment, Mr. A's agency (and similar companies) could force the signing of dubious contracts, and impose horrendous working conditions with barely sufficient wages. Hoshino revealed that a close friend of hers had committed suicide because of Mr. A's and his compatriots' monstrous methods. She says that Mr. A showed not even the slightest hint of remorse, and has continued to employ the same methods up to this day. Since leaving the business, Hoshino now lives in a small apartment, works part time, and attends fan meetups to get by. Unfortunately, the remnants of the videos still hang over her head. "Even today, it still causes trouble for me," she says. "I thought about my family and friends and the pain had been excruciating. I seriously wished that I'd never been born."

This contrast between the image of an idol and their working conditions, the ideal and the material if you will, is unfortunately the adamantine path of all progression under capital. In any industry, this phenomenon becomes more and more palpable the further that capital develops. Just like how the excesses of society and the lavish overindulgences of a rich country are juxtaposed with the abject poverty of that country's working majority, so are the bright, colorful, and opulent appearances of idols juxtaposed with their immense exploitation. Accordingly, idol culture can be viewed as the most developed stage of manufactured music. There is no doubt that the idol model will eventually become the predominant expression of the musical medium, so long as capitalism remains the driving force behind progress. Eventually, musical creativity will be a dream of the past, and mindless consumption will replace it. The question then arises: how is this to be prevented? How can we halt the expansion of this phenomenon while rolling back the abuses it has already wrought? In other words, what is to be done?

When capital
abuses our right
to work, we fight
to restore it.
When capital
abuses our right
to sustenance, we
fight to secure
it. When capital
abuses our right
to housing, to
health, to life or
to liberty, we
fight tooth and
nail to defend it.
Thus, when capital
seizes creativity
from our hearts,
we must fight to
reclaim it.

The first duty of any revolutionary Marxist-Leninist minded individual is, and always has been, education. To educate others and to *be* educated by others is the basis of our movement. Only through comprehension can we hope to implement any meaningful change; only by *understanding* an issue can we hope to create a solution. By studying how capital originates and circulates, by studying how it accumulates and conquers, and by studying how it oppresses and exploits, our predecessors and contemporaries have been able to achieve the seemingly impossible. However, because of the ever expanding nature of capital, theoretical analysis must always be a continually evolving process. We must be able to understand each and every permutation of capital's oppressions, and we must be able to recognize its manifold markings. Accordingly, the revolutionary minded individual cannot limit themselves to the mere analysis of capital in one of its many forms. Where the boot of capital falls, we must be there to counter it. It logically follows that when put into practice, our actions must be all encompassing.

We cannot limit our actions to merely the political struggle, for capital does not reside solely within the political sphere. In the same way that the rich control the state apparatus, theyalso control the apparatuses of creative expression. Since the very first

UTIONARY
TIVITY

revolutionary movements, the people have expressed themselves in art; they have created great works in the name of their cause. Music, in particular, has always conveyed the emotions of the people more organically, and more simply, than any theoretical treatise. In the Paris Commune, the Internationale, anthem of the working class, rang true for ages to come. In the concert halls of the Soviet Union, the Red Army Choir echoed proudly at the forefront of a nation, changing the future of martial music in countries across the globe. In the People's Republic of China, the people composed and performed great proletarian operas and orchestral masterpieces, taking control of their creativity and presenting the world with their determination. In the countless workers movements around the world, thousands of battle hymns, folk tunes, union songs, and working chanteys have been appended to the annals of revolutionary history.

As we advance into the future, the contradictions in capitalist society will become ever more apparent, dragging the working people of the world further and further into poverty, as the rich grow ever more wealthy. Likewise, the music industry under capital will eventually marginalize the artist to a mere doll through which a corporate decadence will be projected. The sounds of a capitalist future will not be determined through organic creativity, but through a corporately produced and propagated unit. In the same way that we must smash the bourgeois state and place a proletarian one in its place, we must also smash the bourgeois forms of expression and replace them with those that rise from the people. It is therefore our duty not only to educate and to liberate, but to give liberation a voice of expression. When capital abuses our right to work, we fight to restore it. When capital abuses our right to suste-

nance, we fight to secure it. When capital abuses our right to housing, to health, to life or to liberty, we fight tooth and nail to defend it. Thus, when capital seizes creativity from our hearts, we must fight to reclaim it. Only through a determined struggle on all fronts can the final victory be obtained.

Foo orks

Lincoln, James R., and Masahiro Shimotani. "Whither the Keiretsu, Japan's Business Networks? How Were They Structured? What Did They Do? Why Are They Gone?." (2009).

Yasuzo, Ishimaru. "The Korean War and Japanese Ports: Support for the UN Forces and Its Influences." National Institute for Defense Studies Bulletin 5 (2007).

Brown, Roger H. "(The Other) Yoshida Shigeru and the Expansion of Bureaucratic Power in Prewar Japan." Monumenta Nipponica 67.2 (2012): 283-327.

Martin, Ian. "'Golden age' of kayoukyoku holds lessons for modern J-pop." The Japan Times. (26 May 2011) 5. Simone, Gianni. "From cosplay fan to idol, Yuriko Tiger's journey has been a colorful one." The Japan Times. (3 Feb 2019)

Martin, Ian. op. cit.

It is interesting to note that the idol phenomenon took hold (though to a significantly smaller and less exploitative extent) in the DPRK, though only after the widespread popularity of K-Pop in the early 2000s. An example of idol influence in the DPRK can be seen in the Moran Hill Orchestra.

Pastukhov, Dmitry. "Music Market Focus: Japan [Latest Stats, Trends, & Analysis]" Soundcharts Blog. (7 Jan 2019)

Junko, Kitagawa. "Some aspects of Japanese popular music." Popular Music 10.3 (1991): 305-315.

A contraction in the idol market of Japan did occur during the early 90's, but it was primarily the result of a decline in popularity of "cute" female idols in favor of more "rugged" male idols. The Japanese idol industry continued its growth following this small offset.

Anonymous. "Japan Is the Second Biggest Music Market in the World, It's Time We Took Notice." Double J. (18 Sep 2018)

Kelley, Caitlin. "K-Pop Is More Global Than Ever, Helping South Korea's Music Market Grow Into A 'Power Player'" Forbes. (3 Apr 2019)

Imahashi, Rurika. "Japan's music industry rises again in new 'age of discovery'" Nikkei Asian Review. (16 Jan 2020)

Martin, Ian. "Momoe Yamaguchi Artist Biography." AllMusic.

Anonymous. "The History of Kpop, Chapter 4: How Lee Soo

Man's First Big Fail Resulted in Korea's Modern Pop Star System." *moonROK*. (28 Sep 2017)

16. Chua, Jessica. "The Extremes That Koreans Take to Become a Kpop Idol." *Rojak Daily*. (27 Jan 2017)

17. Ohandjanian, Sevana. "What is K-pop's 7-Year Jinx?." *Special Broadcasting Service*. (21 May 2019)

18. Anonymous. "The No-Dating Policy for Japanese Female Idols" *Japan Info*. (5 Feb 2016)

The graduation model practiced by groups such as AKB48 and Girls' Generation involve the introduction of new members as old members leave. This creates a linear stream of labor passing into, and out of a unit. Graduated members may occasionally return to perform, but often move on to other branches of entertainment.

20. Marx, Karl. *Capital*, "Volume 1 / A Critique of Political Economy." International Publishers Co., Inc, (1977)

21. Marx, Karl. op. cit. "Chapter 10: The Working-Day. Section 4 - Day and Night Work. The Relay System."

22. Hyo-Won, Lee. "South Korean Law to Protect Young K-Pop Stars From Sexualization, Overwork." *The Hollywood Reporter*. (8 Jul 2014)

23. Kang, Jenny. "Korean Employees From Idol Management Agencies Share 5 Hardest Things About Working In The Industry." *Koreaboo*. (5 Mar 2020)

World of Buzz. "Ex SNSD Trainee Reveals The Ugly Truth About KPOP And The Korean Entertainment Industry." *World of Buzz*. (30 Sep 2016)

Jin-hai, Park "Why Japanese pop idol trainees are no match for South Korean rivals." *Korea Times*. (6 Jul 2018)

Oi, Mariko. "The Dark Side of Asia's Pop Music Industry." *British Broadcasting Corporation*. (26 Jan 2016)

Jesty, Justin. "Tokyo 1960: Days of Rage & Grief. Hamaya Hiroshi's Photos of Anti-Security-Treaty Protests." *MIT Visualizing Cultures*. (2012)

28. Esselstrom, Erik. "The 1960 'Anpo' Struggle in The People's Daily 人民日報: Shaping Popular Chinese Perceptions of Japan during the Cold War." *The Asia-Pacific Journal*. (16 Dec 2012)

Enami, Hidetsugu. "Show biz exploits 'volunteerism' image in packaging of latest teen idol." *The Japan Times*. (6 Jul 2006)

30. Black, Daniel. "The virtual idol: Producing and consuming digital femininity." *Idols and celebrity in Japanese media culture*. Palgrave Macmillan, London, 2012. 209-228.

31. Reika. "Wota: "All my savings goes towards AKB…" *AKBzine*. (30 Nov 2015)

Belinky, Biju. "For K-Pop Fans, Devotion Can Come at a High Price." *Vice*. (31 May 2019)

Karlin, Jason G. "Through a looking glass darkly: Television advertising, idols, and the making of fan audiences." *Idols and celebrity in Japanese media culture*. Palgrave Macmillan, London, 2012. 72-93.

Martin, Ian. op. cit. (26 May 2011)

Martin, Ian. " AKB48 member's 'penance' shows flaws in idol culture." The Japan Times. (1 Feb 2013)

36. Ibid.

38. Ibid.

Ibid.

39. Tanaka, Chisato. " Outrage erupts online in Japan after assaulted NGT48 pop idol apologizes for 'causing trouble'." *The Japan Times*. (11 Jan 2019)

40. Morissey, Kim. "Maho Yamaguchi Posts Heartfelt Message to Fans After Graduating NGT48." *Anime News Network*. (26 Apr 2019)

41. Sim, Walter. " Police apologise to Japanese pop idol for inaction after she was stabbed over 20 times by stalker." *The Straits Times*. (19 Dec 2016)

42. Kyodo. " Tokyo man pleads guilty to stabbing pop singer in Koganei last May." *The Japan Times*. (20 Feb 2017)

Sim, Walter. "Stalker who stabbed Japanese pop idol dozens of times jailed 14 1/2 years." *The Straits Times*. (28 Feb 2017)

Wakatsuki, Yoko, and Julia Hollingsworth. " Japanese pop star Mayu Tomita sues government for inaction over stalker who stabbed her." *CNN World*. (12 Jul 2019)

45. Ashcraft, Brian. Anime Actor's Cocaine Arrest Proves You Should Never Do Drugs in Japan." *Kotaku East*. (28 Oct 15)

46. Campbell, Matthew, and Sohee Kim. "The Dark Side of K-Pop: Assault, Prostitution, Suicide, and Spycams." *Bloomberg Businessweek*. (6 Nov 2019)

Kang, Haeryun. "The K-pop sex scandal is just the beginning." *The Washington Post*. (19 Mar 2019).

Ibid.

Ibid.

Shim, Elizabeth. "South Korea police make thousands of drug arrests in wake of Burning Sun scandal." *United Press International*. (30 May 2019)

Tsukamoto, Yuki. "Ex-AV actress: 'I seriously wished that I'd never been born'." *Tokyo Reporter*. (11 Dec 2016)

Ibid.

Ibid.

54. Ibid.

55. Ibid.

56. Ibid.

THE IRONIC GOD

The Aesthetic Politics of the Sublime in Verdi's Otello

Mark LaRubio

In the same way that Shakespeare's *Othello* inspires both terror and horror in the hearts and minds of the audiences, *Otello* brings about a unity of these two elements that creates the basis for a *Sublime*.

This Sublime is one which builds upon political, theological, and racial questions to erect a vast edifice of aesthetic might.

This is not only due to the very nature of the sublime itself, but because by engaging with questions of symbolic efficacy, *Otello* goes far beyond the analogous work *Der Ring des Nibelungen* in Germany with working through the immense questions of aesthetics and nationhood.

By bringing these multiple strands together a paradigm shift occurs which marks the conquest of the sublime of not only every inch of the stage but every seat in the theater.

There is always a need to put the *oeuvres* of Verdi and Wagner in conversation with one another. In our case, it is necessary in order to elaborate the aesthetic considerations employed by Verdi. While comparing a single opera to an entire cycle of four music dramas would be impossible in any com-

plete sense, I do find it necessary to put them in conversation here precisely because *Otello* hands many of the heights and depths that occur in *The Ring Cycle*. From the commencement, *Otello* elevates the "self destructive moment,"[1] which is self destructive not just in the case of bringing the dramatic action to a point wherein the violence of the opera can begin but rather that it is the fundamental aspect of Sublimity which sets the groundwork. The removal of the Venetian scenes places us squarely on a craggy island in the middle of the Eastern Mediterranean. The first lines of the opera are ones of roaring and clashing cries of "*una vela! Una vela!*"[2] signify that this opera is not just one of lightning and "swells [that] are sinking her"[3] in reference to ship in the storm and the swelling of music during the murder of Desdemona, but how they are brought to pass by a mere piece of cloth. On one hand, you have the flag of Venice on the other Desdemona's infamous handkerchief; *Otello* the conventional wisdom of the sublime which is limited by time and space by infusing every moment with a sense of it. As Cassio notes, the lightning providing the ability to "reveal it clearly"[4] is not merely a reference to the literal cracking of the sky in twain, but as being a motif of the revelatory aesthetics of the Sublime.

To define the Sublime, one might conjure the verses of Longinus or the prose of Edmund Burke. However, here, I wish to demonstrate how, as Heidegger puts it, "the origin of something is the source of its nature,"[5] when it comes to how Verdi goes beyond these two traditions. What is more, we can see how the sublimity which is evoked by an element which transports the experiencer is brought to the fore precisely because the conditions of opera allow for the expansion of textual and physical Sublimes into one which is more akin to Wagner's gesamtkunstwerk. Verdi, in having so much occur in the opening of the opera doesn't just speak to the changes made to

Giuseppe Verdi

1813 – 1901

Shakespeare's original but how those differences are utilized to remove any semblance of comedy. It is necessary to think of how the intensification of tragedy is necessary to the sublime since "the sublime ought to receive new attention as a variety of aesthetic experience involving the negative emotions"[6] in relation to drama. Drama and in our case, opera is particularly poised to unite the literary, physical, and atmospheric in one. Having "[t]he whirling of ghastly northern / clouds are like gigantic trumpet blasts / from heaven"[7] and creating a scene that coupled with the fact that this scene "begins with the orchestra and chorus creating a storm of cosmic proportions,"[8] removes all hope entirely, it goes beyond *La Divina Commedia* and enters us into a realm without hope.

The masses of the Cypriots rushing to the docks performs an instance where Otello is the master over the *sublime object a*, a moment where Otello triumphs over any affront to the order of the established ideological edifice. That Roderigo wishes "to drown [him]self"[9] is a visceral reaction to the very sublimity that Otello masters over. In opposition to this, Iago's stating that he "remain[s] an ensign to the Moor"[10] demonstrates how Iago and Otello will lock in an ideological battle through the aesthetics of the Sublime. Iago is then an encapsulation of the Sublime as it seeks to dominate the *Otello* and thus his very actions both physically on the stage and in the form of speech-acts are an essential part of what forms the battles and skirmishes between the Sublime and Otello. Iago's ability to control and manipulate the thoughts, ac-

tions, and feelings of those around whom he has within his grasp means that Iago holds the keys to the terror and distress which undoes the model of the Burkean sublime. Indeed, the chorus' paeans that "the wife and her faithful / husband sing of bold palms and sycamores"[11] would suggest that the sublime is one which is deeply psychological and ideological as Zizek's *The Sublime Object of Ideology* seeks to attend to in some capacity.

Iago's self-described title of being "just a critic"[12] undoes any hope that the aesthetics and atmospherics of *Otello* would include the necessary nobility granted to Brunnhilde and Hagen in Wagner's *Der Ring des Nibelungen*. Iago is constantly undoing every neatly tied bow which allows Verdi to create in Iago a figure that is far more sublime as compared to Hagen and Wotan[13] due to the fact that Iago is uniquely totalizing. This is what I believe is the best example of a *sublime object a* which denotes a rhizomatic totality[14] in-and-for itself whose totality is brought about by the very rhizomatic capabilities to create and remove connections constantly. Even in inebriation, the dynamics of terror and horror at Iago's disposal embodies the "ironic god and destiny"[15] which is the Sublime manifest. In true Verdian fashion, the music accompanying the scene and

Iago's spoken parts are embedded into the opera in subtle ways which confirm the Iago being the totalizing object of sublimity.

Whereas Wagner has an accursed ring, Verdi has damnation incarnate. Iago is constantly tempting and attempting to seduce Cassio into "drink[ing] with [him]" every time that Cassio states "I don't fear truth ... / ... I don't fear the truth."[16] This is not because alcohol in this scene would un-

do the truth but rather that Iago functions as the arbiter of truth itself, thus his control of the situation goes into the realm of biopower.[17] Iago's status as just a critic means that his critique is the logos of the ironic god. Iago's temptations are part of his critique and thus part of his biopowered control over the entire play.

Iago is quite clearly the denizen of evil and thus the scholarly conversation concerning Iago's motivations in Shakespeare's *Othello* is vast. Imagining Iago as ideology's champion I claim leads to the richest reading of his motivations insofar as it pertains to Verdi's adaptation. Iago is truth, truth Iago, because that is the nature of ideology that is, to be seen as a truth and destiny. Iago's recognition of ideology and its implications is what makes him so utterly villainous. The

apathetic response to Otello's conquest over the Sublime moment at the start of the opera speaks then to Iago's placement on the stage, his very essence, to his even being ideology itself. Being always present.

Some might wish to disagree with my assertion that Iago is both ideology and cognizant of it and view it as a paradox but as Brady writes:

> "the paradoxes are, after all, smoke and mirrors. They can be explained away, and in their explaining away we may gain a better understanding of the complexity of more negative aesthetic experiences and, importantly, the imaginative, emotional, cognitive, and communicative value they hold."[18]

This is due to the fact that this is a tragedy and therefore the Sublime is inextricably tied to ideology. Iago thus changes the scene in Act 1 by his critique, by his speech and like the Christian god creates something purely sublime because his words create the very world before us. Regardless, it would seem that what inhabits this moment is the "and" between the "ironic god" and "destiny"[19] since Iago functions as the almost divine catalyst which is essential to the dramatic action. Having "chaos, evil, and drunken revelry [be] countered and dispelled by love and beauty"[20] signifies that

the incarnations of those respective aspects undo the initial rumblings of Iago's sublime machinations because they are still the dominant ideology. This means that once Desdemona (Beauty) is killed that leaves Otello (Love) adrift and sinking to the bottom of the sea below a sublime cloud of thunder and lightning. Unlike *Das Rhinegold* which has the giving up of love for power, having these two ideological pillars be cut down before us on stage only magnifies the effects of the tragic Sublime.

> **"Then must you speak / Of one that loved not wisely but too well."** (*Otello* 5.2)

It is no accident that Iago invokes the great adversary, Satan, who "possesses [Cassio]" as being "an evil star [which] overcame [his] good senses"[21] since it speaks to the clash of immense proportions that Iago is the catalyst to. One might ask: does Iago inhabit the place of Satan? Only if he is also the evil start which shines upon the scene even when he isn't visible on stage. His discussions on nature and divinity are linked to aesthetic questions since "nature and art still exemplify the divide between the Sublime and the Beautiful"[22] and thus his recognition that he is operating his schemes under a natural guise is essential to his Sublime nature. His opposite is Desdemona who is, in essence, the intercessory figure of the Virgin Mary who haunts the gilded chapels and statuary of European cathedrals. This is why Cassio's firing is only possible with Desdemona's entrance because her essence is that of an omen. Otel-

"Even so my bloody thoughts with violent pace \ Shall ne'er look back, ne'er ebb to humble love." (*Otello* 3.3)

lo's proclamation that he "shall not leave until I see that peace / has been restored," is a desire to quell the aforementioned ideological sublime of violence as an affront to the symbolic order. Otello's role as a colonial administrator is then to ensure that this is the case, that the symbolic order is upheld.

Otello's position and *modus operandi* in how he on one hand conceives of the Sublime when he states "the sounds of discord sumble, and after / the rage, such a vast love overcomes it."[23] Otello recognizes his position as the defender against the Sublime but the discord he is sensitive like the crescendo that succeeds it is growing. It is not too much longer before Otello registers that it is preferable to "let death come!" since he "finds [him]self in the / ecstasy of this embrace, this supreme / moment"[24] in knowing that the representations of symbolic authority drive the ideological heights to call for a tribute. Otello's heavenward call draws the Sublime toward him as "[o]nly in

this state of Sublimity [*Erhabenheit*] does something deeper become possible, a kind of truth that is the enemy of the merely factual"[25] in that Otello is no longer the dominator over the Sublime he was before, it is no longer the fact. And while the sky eventually clears and the moon rises on this scene it would seem that Otello has seemingly won over the Sublime as in the beginning of Act 1, but he is never free from the Sublime's new demand: *the taste of blood*.

The Symbolic Order which is upheld above all else by Otello rings false in a way which is dramatically ironic because even with his deep loving embraces with Desdemona, Iago is there disrupting it. The incessant need for Otello to keep buying into the Symbolic Order makes it so "the price we pay for [it] is that the order which thus survives is a mockery of itself, a blasphemous imitation of order"[26] and only empowers that is trying to subvert the order entirely. Due to Iago's presence the Order is already out of place and this aforementioned containment of the Sublime is pyrrhic in nature. Since "Love is asserted and celebrated"[27] it begins to seem like a falsehood precisely for this reason; if love is to be Otello and Desdemona's saving grace, it would only work in creating a false revelation as the Order is subverted even further.

> With Desdemona we can find the incarnation of the Beautiful in aesthetic terms as Iago has allowed us to see her as the beatified beauty of the Venetian imaginary.

She is the one to whom you should "plead" to since "[her] genteel soul will intercede for you"[28] and yet her prayers will not counteract the powers of the ironic god, Iago, since her powers are of the decaying Symbolic Order. Desdemona is part of the rea-

OTELLO

is an opera in four acts by Giuseppe Verdi to an Italian libretto by Arrigo Boito, based on Shakespeare's play Othello. It was Verdi's penultimate opera, and was first performed at the Teatro alla Scala, Milan, on 5 February 1887.

son why "Love idealized becomes a kind of religion"[29] that is both embraced and questioned time and time again in the dramatic action. Although Desdemona isn't given the agency to go against it she becomes a Golden Calf[30] which adds a sacerdotal element to the duplicitous divinity of Iago as he is able to simultaneously undo the symbolic order and Desdemona. Iago having "unveiled the path to / [Cassio's] salvation"[31] is the moment that Iago can begin to tip the balance in his favor by enabling the Sublime to be brought into the world under his false pretenses. His violent machinations are becoming violent in reality. When Iago says "I am a the demon"[32], he embodies the concatenation of horror and terror that characterizes his control. Neither Desdemona nor Otello can operate any longer once Iago has made this admission as he becomes the vicious god of the Sublime that directs the couple to their doom as they believe are heading towards the Orphic light.

The dramatic action and the music come together to accomplish a Sublime atmospherics in the Great Hall soliloquy where Iago finalizes his end game. "[Iago] strongly believe[s] / [that] like / a young widow / before the altar, that the evil [he] think[s], / and the evil that flows through [him], is the / fulfillment of [his] destiny."[33] Thus, Iago's ideological underpinnings is succinctly understood in how "Death is nothingness"[34] and thus the only way to undo the Symbolic Order entirely for Iago is to bring about that nothingness. By negating the eternity of heaven with the eternities of nothingness, Iago removes anything but

the aesthetics of the Sublime. He can only negate the Christian god not with an adversarial Satan but a satan of satans, a nothingness that contains and simultaneously undoes all totalities: *The Sublime*.

Otello and Desdemona "ha[ve their] own supreme rules"[35] which Otello in particular will cause the affront of Symbolic Order to disappear. Desdemona however exists as Chastity and being thus symbolically castrates the god of Love, Otello. When "Otello's music is subdued by Desdemona's"[36] it creates an aesthetic barrier to the power Otello was able to subdue the Sublime with. Desdemona's "sainted veil" blinds Otello and his desire to continue to "adorn Desdemona / like a sacred image"[37] overlays her with more and more ideological baggage to the point where she begins to lack symbolic efficacy. The Beautiful thus becomes horrific once it flattens Love, and since Desdemona and Otello represent these aspects respectively their union begins to become overbearing for Otello and creates a smooth space. This smooth space gives way to Iago's striated space[38] as he produces the machinations that become overwhelming to this godly union.

Just as *Nabucco* is credited with being the birth of Italian national consciousness,

Otello is the next link in the chain which explores the fait accompli of nationhood. Otello, I claim, is in conversation with the twin sister of German national consciousness in the form of *Der Ring des Nibelungen*. This does not mean however, that they are companion pieces or that one led to the other. Wagner's drama end with a key shift that is meant to create a sense of hope, Verdi ends *Otello* with the demand that Iago "exculpate [him]self."[39] However, Iago's refusal to do so is perhaps a more suitable shift because it denies the neatness of the end of

Die Gotterdammerung. Moreover, Otello's query of "does heaven have any lightning left?"[40] is his final stand to try to have dominion over the Sublime which only adds to the tragic atmosphere which only heightens the Sublime itself by creating a stark, bleak world on the stage. The unwavering notes of the scene highlight the impotence of Otello and thus his own loss of symbolic efficacy. When Otello states "No one fears me although they see me / with a weapon"[41] is the intrinsic death of the Symbolic Order. Even when thinking about the Desdemona who was "a pious / creature born under an evil star," who is now "cold like [her] chaste life"[42] designates the false consciousness that the ideology of Beauty and Beatitude that was lived out through her. With her actual death, there can be an "orgy of hate"[43] to take out Otello, having now lost his own symbolic efficacy as well.

Otello and Desdemona's deaths are central in that they constitute the necessary deaths needed to bring about the ideology shift for the unification of Italy. Desdemona, the white, blonde, patron saint of Venice succumbs to "the shadow[44] of the Sublime which makes Otello kill her. What's more, this shadow makes it so the Sublime and the Beautiful "no longer constitute complementary but opposite—and unequal—pleasures"[45] for once they clash one the Sublime can remain since it has the preeminent aesthetic force over any saint or idol. The love of a city-state which Otello represents is only through coloniality and expansion beyond Italy which brings about a decomposition of the most emblematic city-state in all of European history. The emergent ideology which Iago is thus able to bring about creates the ideology of a state which is different from Wagner's because it recognizes the subsuming of ideology that will eventually occur.

Love. Beauty. Irony. Destiny. Like pillars these words uphold the vast pediment of the Sublime in Verdi's pantheon of music in *Otello*. Verdi's reproduction is one which unites the musical and dramatic in a way which shows the clashes of ideology that will take place due to aesthetic questions with the predominance of the Sublime. By seeing how Verdi departs from Longinus, Burke, Kant, and even Wagner we can see how *Otello* is a work which answers many of the questions concerning the relationship between ideology and the Sublime. In doing so the interpersonal wars are played out in the larger political landscape and even further in the aesthetic universe this makes it so every action is magnified in such a way that leaves only Sublimity overflowing from the stage as the curtain falls.

ENDNOTES

1 Emily Bartels C. *Speaking of the Moor: From A lcazar to Othello* (Philadelphia: UPenn Press, 2008), 2.

2 Guiseppe Verdi. *Otello*. Ed. Burton D Fisher (New York: Opera Classics Library, 2011), 43.

3 *Ibid*.

4 *Ibid*.

5 Martin Heidegger. *Poetry, Language, Thought*. Trans. Albert Hofstadter (New York: Harpers Perennial, 2001), 17.

6 Emily Brady. *The Sublime in Modern Philosophy: Aesthetics, Ethics, and Nature*. (New York: Cambridge University Press, 2013), 148.

7 Giuseppe Verdi. *Otello*. Ed. Burton D. Fisher. (New York: Opera Classics Library, 2011), 44.

8 Alexander Leggett. "Love and Faith in Othello a nd Otello" *University of Toronto Quarterly*, Volume 81, Number 4. Winter (2010), 840.

9 Giuseppe Verdi. *Otello*. Ed. Burton D. Fisher. (New York: Opera Classics Library, 2011), 45.

10 *Ibid*. 46.

11 *Ibid*. 47.

12 *Ibid*. 48.

13 See *The Ring of the Nibelung*. Richard Wagner, trans. John Deathridge. (New York: Penguin, 2018). *Wotan* is

15 Giuseppe Verdi. *Otello*. Ed. Burton D. Fisher. (New York: Opera Classics Library, 2011), 49.

16 *Ibid*. 50.

17 Michel Foucault. "Society Must Be Defended." *Lectures at the College de France 1975-1976*. (New York: Picador, 2003), 243.

18 Emily Brady. *The Sublime in Modern Philosophy: Aesthetics, Ethics, and Nature*. (New York: Cambridge University Press, 2013), 150.

19 Giuseppe Verdi. *Otello*. Ed. Burton D. Fisher. (New York: Opera Classics Library, 2011), 49.

20 Alexander Leggett. "Love and Faith in Othello a nd Otello," *University of Toronto Quarterly*, Volume 81, Number 4. Winter (2010), 841.

21 Giuseppe Verdi. *Otello* . Ed. Burton D. Fisher. (New York: Opera Classics Library, 2011), 54.

22 Todd Gilman. "Arne, Handel, the Beautiful, and the Sublime." *Eighteenth Century Studies*, Volume 42, Number 4, Summer (2009), 534.

23 Giuseppe Verdi. *Otello*. Ed. Burton D. Fisher. (New York: Opera Classics Library, 2011), 55.

24 *Ibid*. 57.

25 Werner Herzog. "On the Absolute, the Sublime, and the Ecstatic Truth," trans. Moira Weigel. *Arion*. Volume 81, Number 4, Fall (2012), 1.

26 Slavoj Zizek. *In Defense of Lost Causes*. (London: Verso, 2008), 29.

27 Alexander Leggett. "Love and Faith in Othello a nd Otello " *University of Toronto Quarterly*, Volume 81, Number 4. Winter (2010), 840.

28 Giuseppe Verdi. *Otello*. Ed. Burton D. Fisher. (New York: Opera Classics Library, 2011), 59.

29 Alexander Leggett. "Love and Faith in Othello a nd Otello," *University of Toronto Quarterly*, Volume 81, Number 4. Winter (2010), 836.

30 Exodus 32:2-7 (New International Version)

31 Giuseppe Verdi. Otello . Ed. Burton D. Fisher. (New York: Opera Classics Library, 2011), 59.

32 *Ibid*.

33 *Ibid*. 60.

34 *Ibid*.

35 *Ibid*. 63.

36 Alexander Leggett. "Love and Faith in Othello a nd Otello," *University of Toronto Quarterly*, Volume 81, Number 4. Winter (2010), 840.

37 Giuseppe Verdi. *Otello*. Ed. Burton D. Fisher. (New York: Opera Classics Library, 2011), 64-65.

38 Flora Lysen and Patricia Pisters. "Introduction: The Smooth and the Striated," *Deleuze Studies*. (2012), 1.

39 Giuseppe Verdi. *Otello*. Ed. Burton D. Fisher. (New York: Opera Classics Library, 2011), 106.

40 *Ibid*. 107.

41 *Ibid*.

42 *Ibid*.

43 Werner Herzog. "On the Absolute, the Sublime, and the Ecstatic Truth," trans. Moira Weigel. *Arion*. Volume 81, Number 4, Fall (2012), 2.

44 Giuseppe Verdi. *Otello*. Ed. Burton D. Fisher. (New York: Opera Classics Library, 2011), 107.

45 Todd Gilman "Arne, Handel, the Beautiful, and the Sublime." *Eighteenth Century Studies*, Volume 42, Number 4, Summer (2009), 534.

REFERENCES

Adorno, Theodor W. *Aesthetic Theory*. Eds. Gretel Adorno and Rolf Tiedeman. Trans. Robert Hullot-Kentor. London: Bloomsbury, 2012.

Bartels, Emily C. *Speaking of the Moor: From Alcazar to Othello*. Philadephia: UPenn Press, 2008.

Brady, Emily. *The Sublime in Modern Philosophy: Aesthetics, Ethics, and Nature*. New York: Cambridge University Press, 2013.

Deleuze, Gilles and Felix Guattari. *A Thousand Plateaus*. Trans. Brian Massumi. Minneapolis: University of Minnesota Press, 2005.

Foucault, Michel. "Society Must Be Defended": *Lectures at the College de France 1975-1976*. New York: Picador, 2003.

Gilman, Todd. "Arne, Handel, the Beautiful, and the Sublime." *Eighteenth-Century Studies*, Volume 42, Number 4, Summer 2009, pp. 529-555.

Hawkes, David. *Ideology*. London: Routledge, 2004.

Heidegger, Martin. *Poetry, Language, Thought*. Trans. Albert Hofstadter. New York: Harper Perennial, 2001.

Herzog, Werner. "On the Absolute, the Sublime, and Ecstatic Truth," trans. Moira Weigel. *Arion* , Volume 17, Number 3, Winter 2010.

Leggett, Alexander. "Love and Faith in Othello and Otello ," *University of Toronto Quarterly*, Volume 81, Number 4, Fall 2012.

Lysen, Flora and Patricia Pisters. "Introduction: The Smooth and the Striated" *Deleuze Studies*. 6.1, 2012. 1-5.

Verdi, Giuseppe. *Otello*. Ed. Burton D. Fisher. Opera Classics Library, 2011.

Zizek, Slavoj. *In Defense of Lost Causes*. London: Verso, 2017.

———. *The Sublime Object of Ideology*. London: Verso, 2008.

The Work of Cinematic Art

SÉRGIO DIAS BRANCO

Art as Work and Work as Art

INTRODUCTION

In 1924, Soviet filmmaker Dziga Vertov answered five questions posed by *Kino* magazine. One of them was about his attitude towards art. Vertov offered the following answer:

One-millionth part of the inventiveness which every man shows in his daily work in the factory, the works, in the field, that already contains an element of what people single out as so-called "art."

The very term "art" is counter-revolutionary in essence, since it shelters a whole caste of privileged people, who imagine themselves to be not people but the miracle workers of this same "art." Inspiration, or rather an enthusiasm for your work, is not the prerogative of these "Magi," but also of every worker on the Volkhov Hydro-Electric Plant, every driver in his train, every turner at his lathe.

Destroying once and for all the term "art," we should not, of course, bring it back in another form, let's say under the sauce of "artistic labor." It is essential that we establish definitively that there is no border between artistic and non-artistic labor.[1]

In other words, the filmmaker took this opportunity to launch a small, but blunt, manifesto for the destruction of the concept of art, highlighting how such a concept leads to an elitist approach to the issue of work. In the year of Lenin's death, Vertov thus denied that there is such a thing as a line separating the artistic from the non-artistic in the domain of work and production. He was therefore fighting against a perspective that he considered to be counter-revolutionary and idealistic.

This essay develops these suggestions, adopting Karl Marx and Friedrich Engels' critical — both materialist and dialectical — analysis of the topic of work. Capitalism reduces work to an instrumental and forced laboring activity, a means of alienation. The historical and practical transformation of the relations of production, in a process of human emancipation, turns work into a form of human realization and integral development, both productive and creative.

WORK AND HUMANITY

There is a certain understanding of work that is the basis for Vertov's words: that of an activity performed by human beings that uses their physical and intellectual capacities to transform natural resources, so that the product of that transformation meets their needs. Natural resources are the *subject of labor*. The set of physical and intellectual capacities is the *labor force*, which in capitalism becomes the basic commodity. The capitalist exploitation mechanism is that which takes the form of surplus value, the excess value produced by labor, well above the workers' paid salaries. By using its labor force on subjects of labor, humanity produces things that it considers to have use-value, but it also produces *itself* in this process. In this sense, Engels writes:

Labour is the source of all wealth, the political economists assert. And it really is the source — next to nature, which supplies it with the material that it converts into wealth. But it is even infinitely more than this. It is the prime basic condition for all human existence, and this to such an extent that, in a sense, we have to say that labour created man himself.[2]

Engels' hypothesis is that human beings become aware of themselves, of their faculties, through work and its transformative dimensions. At the same time, their use of the products resulting from work — as well as their interaction with them — change what they are as beings. This change becomes noticeable if we consider the ways in which the relations of production and the economic structure complexify and are reflected into social institutions with a cultural and ideological character. In view of this, work condenses the materialist and dialectical development of humans. It is a human factor—that is, a factor of humanity as a process of becoming. When they work, human beings *work themselves*, which means that work has an anthropological trait and integrates a creative-projective power into the sphere of the workforce. Marx makes reference to this aspect in this passage from *Capital* :

A spider conducts operations that resemble those of a weaver, and a bee puts to shame many an architect in the construction of her cells. But what distinguishes the worst architect from the best of bees is this, that the architect raises his structure in imagination before he erects it in reality. At the end of every labour-process, we get a result that already existed in the imagination of the labourer at its commencement. He not only effects a change of form in the material on which he works, but he also realises a purpose of his own that gives the law to his modus operandi, and to which he must subordinate his will. And this subordination is no mere momentary act. Besides the exertion of the bodily organs, the process demands that, during the whole operation, the workman's will be steadily in consonance with his purpose. This means close attention. The less he is attracted by the nature of the work, and the mode in which it is carried on, and the less, therefore, he enjoys it as something which gives play to his bodily and mental powers, the more

close his attention is forced to be.[3]

The goods that result from work are a true creation, of objects and their value, through a process of transformation of nature. For this reason, work activity is still in the natural sphere, insofar as it is linked to the development of human nature, which is neither given nor immutable as metaphysics often tends to claim. At this point, it makes sense to clearly distinguish *work* from *labor*. This distinction will be relevant in the next step of this essay and is related to the difference between the two words in English, "work" and "labor," mentioned by Engels in a footnote in the fourth edition of *Capital*. According to Engels, these two terms describe two opposite historical aspects of human work. The first "creates use-values and is qualitatively determined," and also "creates value and is only measured quantitatively."[4] The second expression describes a type of work that capitalist production relations necessarily make alienated and is associated primarily with wage labor. In other words, work is labor from which its alienating characteristics have been excised. At the end of the previous quote, Marx points out the dialectical tension related to this difference — the idea being that the workers' enthusiasm about nature and the ways in which they carry out their work is *directly* related to the enjoyment of the interplay between their own physical and mental forces.

This leads us to the topic of alienation — the denial of this enthusiasm and enjoyment.

WORK AND ALIENATION

Work creates wealth because it creates value. Marx bases the theory of value on work and distinguishes between two types of value: *use value* and *exchange value*. What defines the use values of a thing is its usefulness — these values "become a reality only by use or consumption: they also constitute the substance of all wealth, whatever may be the social form of that wealth."[5] There are useful things for us that are not the product of human work, such as the air we breathe. There are also useful things that, being a product of human work, are not commodities, because they are either produced for the enjoyment of those who produced them or are not socially exchanged.[6] A commodity is characterized by the dialectical unit *use value-exchange value*, being transferred through an exchange and having a use value for those who acquire it, which then gives a *social* character to the use value. That is to say, the formation of value from work depends on use — a fruit of useless work makes work equally useless, says Marx.[7]

Use value is, therefore, associated with the qualities of a product that meet certain human needs. Exchange value is, in turn, linked to quantity, currently taking the form of money. Furthermore, "Human labor power in motion, or human labour, creates value, but is not itself value. It becomes value only in its congealed state, when embodied in the form of some object."[8] We can, however, ask the question: *what use value can a work of art*

like a film have and what human needs does it respond to? It responds to the historically situated needs of, for example, fulfilling the imagination, educating the senses, finding new perspectives, recording memory, expressing experiences, and writing into reality another reality, both in the sphere of creation and in the realm of appreciation.

The process of answering this question leads us to the double face of work, which we can directly relate to art. As we have seen, work is not just the creation of objects that satisfy human needs, but also the art of human beings making use of their reflective and creative powers. This second facet of work is inseparable from the first, because, as we saw in Engels, work is also a means of human self-awareness. Extending this idea, we can conclude that humans only truly transform natural resources when they are aware of this transformation—immediately aware of the ways in which they affirm, apply, and develop their capabilities in this process. Such human consciousness springs from the knowledge and perception of transformative activity and its integration into *humanness*. Work and art materialize and shape objects, but they also materialize and shape human subjectivity within the framework of the social materiality of human life. As Adolfo Sánchez Vázquez summarizes:

Marx and Engels thus conceive of a society in which artistic creation is neither the activity that concentrates exclusively on exceptionally gifted individuals, nor is it an exclusive and unique activity. It is, on the one hand, a society of humans-artists in that not only art, but work itself, is the expression of the creative nature of humanity. Human work, as a total manifesta-tion of the essential forces of human beings, already contains an aesthetic possibility that art fully realizes. Every human being, therefore, in communist society, will be a creator, that is, an artist.[9]

This Marxist perspective on work contrasts with the one that Sean Sayers calls *hedonistic* and *instrumental*, which sees human beings as seeking only what gives them pleasure and, at the same time, understand work as a burdensome task that they unwittingly complete.[10] This conception motivates the following speculation by the Scottish philosopher David Hume in his writing on the principles of morals:

Let us suppose that nature has bestowed on the human race such a profuse abundance of all external conveniences, that, without any uncertainty in the event, without any care or industry on our part, every individual finds himself fully provided with whatever his most voracious appetites can want, or luxurious imagination wish or desire [...].[11]

This is indeed an idealistic vision, which assumes that human beings are outside nature and history, unalterable, waiting only for the adjustment between themselves and the world. It is a point of view that is, in itself, an effect of bourgeois ideology that opposes work to satisfaction and manual to intellectual activity. Marx disputes this position and instead details the awkward human experience of labor as a specific historical condition of the

capitalist system, which means that such a condition is neither perpetual nor unchanging. Marx's analysis is based on the fact of alienation, of which estrangement is an integral part.[12]

Workers are removed from themselves as producers because the means and subjects of labor do not belong to them. They are separated from the crystallization of their labor, they are opposed to the fruit of their activity, which in the capitalist system is taken away from them to become strange and independent. They are distanced from the act of production through routine, the intense rhythm of production, the disconnected division of labor, low level of professional qualification, and the reduction of the labor force to a commodity — to wages as exchange value. Finally, they are alienated from the other workers, with whom they compete instead of cooperating. In the *Economic and Philosophical Manuscripts of 1844*, Marx calls work a vital human activity, to such a great extent that alienated work leads to an "*estrangement of man from man.*"[13]

The solution becomes evident for Marx. Only through the revolutionary transformation of the relations of production can the *dispossessed* labor disappear to make way for another experience of *work*. Hence the need for the private ownership of the means of production to be abolished. This would result in the reestablishment of the connection between workers and the means, subject, product of work, and their workforce; therefore with nature, therefore with themselves, carrying out that which their historical-political conscience dictates and their material-historical situation allows. Historically situating this change prevents one from thinking of this reconnection as a kind of move back or a withdrawal, a return to the past. To make this connection again, on the contrary, involves the establishment of a new stage in human history. Work then becomes production, workers become producers, affirming their productive and creative powers, and fulfilling themselves at and through work. Art is a transparent example of this, even when it emerges within the capitalist system, because, as the Marxist philosopher José Barata-Moura contends, "it represents a direct and proper expression of human creativity in the world."[14] The same thinker summaries that "artistic expression, in the colorful panoptic of its developments and in the varied panoply of its instantiations, constitutes an integral element of the human work of realities, in the sense of printing in them an enriching seal of humanity."[15]

CONCLUSION: ART AND WORK

In art as work we can find work as art, which is the liberation of work from the domain of necessity, from the forced activity in order to survive, as it exists in capitalism. In this regard, it is worth mentioning Marx's following words from the third book in *Capital*:

Freedom in this field can only consist in so-cialised man, the associated producers, ratio-nally regulating their interchange with Na-ture, bringing it under their common control, instead of being ruled by it as by the blind forces of Nature; and achieving this with the least ex-penditure of energy and under conditions most favourable to, and worthy of, their human na-ture. But it nonetheless still remains a realm of necessity. Beyond it begins that development of human energy which is an end in itself, the true realm of freedom, which, however, can blossom forth only with this realm of necessity as its ba-sis. The shortening of the working-day is its ba-sic prerequisite.[16]

We may be tempted to see work in the field of art as an exception, something that has to be dealt with separately given the labor and eco-nomic relationships that support it. Howev-er, this approach is an ideological conse-quence of capitalism that obscures this kind of work as an example as well as an alterna-tive in the prevailing system of production relations. It is an example because it demon-strates how the workforce is devalued in cap-italism and how art loses its social function in order to fulfill a limited role of refinement or entertainment. This is related to the strong ideological component that art often has and consequently to the critical possibilities it can open, with relative autonomy in a con-text dominated by bourgeois ideology. It is in this sense that it may be seen as an alterna-tive, given that art is an activity in which, due to its own characteristics of production and reception, estrangement from humanity and alienation are less present. Through art, hu-man beings can look at themselves not only as a product of history, but above all as mak-

ers of history—as part of the interre-lationships that situate them and al-low them to situate themselves in the social whole.[17]

Álvaro Cunhal calls attention to the way in which social life influences and is reflected in the work of art. Artists may refuse or deny social influences, but they cannot avoid them:

The influence and reflexes of social life on artistic creation may or may not de-pend on the artist's will. In any case, they are an objective reality. They stem from the fact that the human being lives in society and that the artist, as a human being, is under permanent external in-fluences, namely social ones.[18]

Like Marx before him, Cunhal does not isolate phenomena. He does not examine them in a deterministic or mechanistic way, as the vulgar mate-rialists criticised by Lenin did,[19] but dialectically. Works of art appear within the web of social relations, at a certain historical moment, and so they are also marked by class conflict both in their origin and in their differ-ent interpretations and appropria-tions.

Vertov's bombastic words reassert the revolution and its popular compo-nent. Cunhal says that art history rec-ognizes the works of great artists and, at times, recovers and appreciates the works of others that have been disre-garded, omitted, or erased from his-torical accounts. But, "it is also in it-

self an affirmation of the artistic creativity of and the contribution of creativity of peoples for the creativity of artists and for the art heritage of humanity."[20] This is a critical issue due to the antagonism that is often laid down by liberal thinking between the singular and the common, singularity and community, the individual and the collective. What Vertov suggests in his answer is a dialectical approach to this question. Similarly, Barata-Moura argues that singularity only emerges as such "in an interactive community framework of relationalities" and adds that, in fact, "[w]hat characterizes the current metaphysical dichotomizations, of an irreducible 'atomism' contrasted with the abstract dissolution in the 'mass,' is precisely, from a philosophical point of view, a disconcerting absence of dialectics."[21]

It is no accident that Vertov mentions the Volkhov hydroelectric power station, which was in the process of being completed when he gave his reply. It was to be inaugurated in December 1926. And it was the achievement of a people, the result of the joint effort of many workers to build a fundamental piece for the industrial and economic development of Russia and the USSR. Vertov, Sergei M. Eisenstein, Vsevolod Pudovkin, and other Soviet filmmakers, always valued the contribution of those who worked with them, never forgetting the collective feature of film production.

Inseparable from this important appreciation of human cooperation is the political and historical awareness that Vertov's answer reveals about the need to articulate, in concert, *art as work* and *work as art*. None of them would be the filmmakers they were, regarding their artistic work as a complex form of tangled imaginative, transformative, emancipatory, individual as well as collective practices, without the October 1917 Revolution and the socialist theoretical contributions to art more generally.

ENDNOTES

1 Dziga Vertov, "An Answer to Five Questions", in *Lines of Resistance: Dziga Vertov and the Twenties*, ed. Yuri Tsivian, trans. Julian Graffy (Bloomington: Indiana University Press, 2005), 94.

2 Friedrich Engels, "The Part Played by Labour in the Transition from Ape to Man" [1876], trans. Clemens Dutt, *Marxist Internet Archive*, 1996, par. 1, https://www.marxists.org/archive/marx/works/1876/part-played-labour/index.htm . Accessed 2 Sept 2020.

3 Karl Marx, *Capital: A Critique of Political Economy*, vol. I [1867], trans. Samuel Moore and Edward Aveling, ed. Frederick Engels (Marxists Internet Archive, 2015), 127, https://www.marxists.org/archive/marx/works/download/pdf/Capital-Volume-I.pdf . Accessed 2 Sept. 2020.

4 Marx, *Capital*, vol. I, trans. Ben Fowkes (London: Penguin, 1990), 138, n. 16.

5 Marx, *Capital: A Critique of Political Economy*, vol. 1, 27.

6 See Engels's addition to the text in *ibid.*, 30.

7 *Ibid.*

8 *Ibid.*, 35.

9. Adolfo Sánchez Vázquez, *Las ideas estéticas de Marx* (Mexico City: Siglo Veintiuno Editores, 2005), 284 (trans. mine).

10 See Sean Sayers, "Why Work?: Marx and Human Nature", Science & Society 69, no. 4 (2005): 607-9.

11 David Hume, *An Enquiry Concerning the Principles of Morals*, in *Enquiries* [1751], ed. L. A. Selby-Bigge (Oxford: Clarendon Press, 1894), 183.

12 On the distinction between alienation (*Entäusserung*) and estrangement (*Entfremdung*), see Jesus Ranieri, *A Câmara Escura: Alienação e Estranhamento em Marx* [*The Dark Chamber: Alienation and Estrangement in Marx*] (Sao Paulo: Boitempo, 2001).

13 Marx, *Economic and Philosophical Manuscripts of 1844* [1932], trans. Martin Milligan (Moscow: Progress Publishers,1959), 1st ms., XXIV, https://www.marxists.org/archive/marx/works/1844/manuscripts/labour.htm . Accessed 2 Sept. 2020.

14 José Barata-Moura, "Sobre a Reflexão de Álvaro Cunhal em Torno da Arte. Um Alinhavo de Notas" ["On Álvaro Cunhal's Reflection Around Art. An Alignment of Notes"], in *Três Ensaios em Torno do Pensamento Político e Estético de Álvaro Cunhal* [*Three Essays Around Álvaro Cunhal's Political and Aesthetic Thinking*] (Lisbon: Edições "Avante!", 2014), 95 (trans.mine).

15 *Ibid.*, 96 (trans. mine).

16 Marx, *Capital: A Critique of Political Econo-my*, vol. III [1894], ed. Friedrich Engels, trans. Institute of Marxism-Leninism, USSR (New York: International Publishers, 1894), pt. VII, ch. 48, https://www.marxists.org/archive/marx/works/1894-c3/ch48.htm . Accessed 2 Sept. 2020.

17 See Marx, *Grundrisse: Foundations of the Critique of Political Economy* [1939-41], trans. Martin Nicolaus (Marxists Internet Archive, 2015), 529, https://www.marxists.org/archive/marx/works/download/pdf/grundrisse.pdf . Accessed 2 Sept. 2020.

18 Álvaro Cunhal, *A Arte, o Artista e a Sociedade* [*Art, the Artist and Society*], 2nd ed. (Lisbon: Editorial Caminho, 1998), 25 (trans. mine).

19 See V. I. Lenin, *Materialism and Empirio-criticism: Critical Comments on a Reactionary Philosophy* [1909], trans. Abraham Fineberg (Marxists Internet Archive, 2014), https://www.marxists.org/archive/lenin/works/1908/mec. Accessed 2 Sept. 2020.

20 Cunhal, *A Arte, o Artista e a Sociedade*, 116 (trans. mine).

21 Barata-Moura, "Sobre a Reflexão de Álvaro Cunhal em Torno da Arte", 111.

JARROD GRAMMEL & ETHAN DEERE

Sense and *Sensoria*

Epistemology and Thought in McKenzie Wark's *Sensoria: Thinkers for the Twentieth Century*

Sensoria
Thinkers for the Twenty-First Century
McKenzie Wark

In her newest book, *Sensoria: Thinkers for the Twenty-First Century*, McKenzie Wark casts a wide net, taking on the project of epistemology in a world of ever increasing specialization. As Wark rightly points out, scholars in their respective fields often become blinded to the shortcomings of their own ways of producing knowledge while simultaneously claiming a "privileged knowledge of the world as a totality."[1] For Wark, the problem lies precisely in these claims of knowledge of the totality, as in the age-old story about blind scholars touching an elephant while all providing vastly different, and often contradictory, accounts.

Yet, Wark does not necessarily want to do away with the possibility of knowing the totality in general. Rather, she believes that the best hope we have of producing anything close to a knowledge of the totality has to begin with an acknowledgement of the shortcomings inherent in every method of knowledge production. In her own words:

Each way of knowing the world touches a part of the elephant. Rather than give in to claims to know the whole elephant in advance, let's work out collaboratively, as a common task, some practices of putting parts of the elephant as we sense and know them next to one another. Not so much to produce a seamless picture of the whole, but to understand the differences between all of the partial sensings. The common task is to produce a knowledge of the world made up of the differences between ways of knowing it.[2]

Sensoria is divided up into three sections: aesthetics, ethnographics, and technics (or "design"). Each of the sections feature six individual thinkers who Wark attempts to situate within her larger goal of "putting parts of the ele-

phant" together.

One of the major challenges of the text arises from the scope of the various thinkers, combined with a lack of sustained engagement in theoretical groundwork for each of the given topics covered. For example, in the first chapter, Wark attempts to introduce, via Sianne Ngai, the three new aesthetic categories of "zany, cute, and interesting."[3] Wark argues that these three categories are both more relevant and distinct from the classic categories of the beautiful and the sublime, but she does not once engage with theorists of these latter two categories.

In her chapter on Hito Steyerl, Wark notes that "Steyerl does not hesitate to use the F-word: fascism."[4] Yet, in the half page or so that fascism is mentioned, it is described as merely a stage in which political representation has collapsed. Even more, in this analysis, fascism is the result of this collapse in representation. Again, as in the Ngai chapter, the lack of engagement with foundational theorists leaves the discussion both misleading and confusing. While Wark is certainly right to situate Antonio Gramsci here, fascism needs to be understood within the specific material conditions that give rise to this collapse in representation. Both Daniel Guérin and Robert Paxton have written excellent works in this regard.

One of the strongest chapters is on Jackie Wang's *Carceral Capitalism*. Wark astutely recognizes the liberal need for

Black people murdered by state forces to "be innocent."[5] There is a rush to posthumously prove that the murdered Black victim was not just innocent but also an upstanding citizen. But "[w]hy should only the innocent children be worthy of care? Of life? Why not adults who may not be pure innocent beings?"[6] Further, Wark is correct to point out that expanding incarceration is a popular policy in rural areas where employment opportunities are often scarce[7] and cheap land makes construction of prisons much more appealing. One should well keep this in mind when liberals point specifically to private prisons as the primary driver of mass incarceration. Whether privatized or not, prisons provide both cheap prison labor and desperately needed jobs in post-industrial rural U.S. towns. The only thing to upend here is the assertion that "[p]olicing protects property, not social relations."[8] Why not both?

However, the structure of the text does not lend itself to, and largely fails, to provide a vehicle for synthesizing these diverse thinkers into something resembling a unified argu-

ment. Wark's most consistent theme lies in her argument that a rising *vectoralist* class is dramatically reshaping the nature of society and culture. Although this new class, along with its companion, the hacker class, appears a number of times in *Sensoria*, Wark leaves this argument to her other books. This is troubling primarily because she lifts the vectoralist class to a central position as a lever of the primary contradiction of capitalism today. She writes that, "I call them the vectoralist class. Where the capitalist class owned the means of production, the vectoralist class owns the vector of information. That is the ruling class of our time."[9] While the control of information is no doubt a vital feature of capitalism, this major claim is left as a given from her other work. Without further justification, the centrality of the vectoralist class to the text appears less necessary than its repeated emphasis might otherwise hint.

Despite this lack of unity, if not because of it, *Sensoria* offers up a collection of interesting, and sometimes valuable, observations of capitalism today. Almost every chapter of *Sensoria* reflects on truths obscure and obscured, whether in reflecting on the pirate origins of most U.S. media conglomerates[10] or how newer versions of technology use old versions of that same technology as representative icons (think the old-school handset in a green square on many modern cell phones) as a way easing us into new machines with a sense of familiarity.[11]

"The ruin our civilization is leaving does not look like the pyramids. It's a planet wrapped in fiber optic,"[12] Wark writes in the final section of her *Sensoria*; and it is this kind of poetic statement that captures and defines the work. Sensoria offers a fantastic, often dizzying, view of the sociotechnical complexity arising around us, shaping us as much, if not more so, than we shape it: "[T]he forces of production...reveal and create an ontology of information that is both historical and yet ontologically real."[13]

In another sense, perhaps Wark floats too high and too far. Her insistence that such an exploration is "[...] best conducted on the basis of a rough equality of all ways of knowing"[14] seems more an embrace of a postmodern ethos than a solid epistemic foundation. The desire to explore transdisciplinary territory, searching for the edge effects arising between divergent domains of knowledge, is a promising motive, but it is not a guarantee of success in and of itself. We are left wondering whether it was necessary or helpful to discuss the Afrofuturism of Sun Ra or the ethics of piracy or even if there was ever meant to be a definite conclusion in the first place. In short, be it through a lack of structural cohesion or conceptual clarity, it is not entirely clear that the work itself justifies the method.

Yet it might not be fair to judge Wark's work so harshly. It is true that we have left ourselves with relative blindspots where our problematic twenty-first century reality finds its sharpest expression, where the historical-theoretical legacy of Marxism, rigidly defined, seems least fit to operate. In this context, the value of Wark's work for today's Marxists is not so difficult to appreciate. As Wark stated in a 2017 interview, "[M]y job is to corrupt other people's grad students." Perhaps the point is not about achieving some ill-defined level of correctness, but to get us thinking, especially about those things that we would otherwise wish to avoid.

Endnotes

1. *Sensoria*, p. 3

2. *Sensoria*, p. 4

3. *Sensoria*, p. 9

4. *Sensoria*, p. 56

5. *Sensoria*, p. 88

6. *Sensoria*, p. 88

7. *Sensoria*, p. 90

8. *Sensoria*, p. 90

9. *Sensoria*, p. 55-56

10. *Sensoria*, p. 166

11. *Sensoria*, p. 196

12. *Sensoria*, p. 184

13. *Sensoria*, p. 188

14. *Sensoria*, p. 14

Works Cited

Wark, McKenzie. *An Interview with McKenzie Wark*. b2o, 7 Apr. 2017, https://www.boundary2.org/2017/04/alexander-r-galloway-an-interview-with-mckenzie-wark/. Accessed 9 Oct. 2020.

THINGS BEFORE

HISTORY AND MATERIALISM

Ireland 2020: An End to 'Civil War Politics' or Counter-Revolution by New Means?

REFLECTIONS ON COUNTER-REVOLUTION IN IRELAND AND THE FORESIGHT OF LIAM MELLOWS

BY JOE DWYER

THE FEBRUARY 2020 general election represented a transformation of the Irish political landscape. The electoral surge towards the left-republican party, Sinn Féin, has chipped away at the political dominance and popular hegemony of the two traditional 'civil war parties': Fianna Fáil and Fine Gael.

Since the foundation of the State, the handover of power between Fianna Fáil and Fine Gael marked a mainstay of Irish politics. At varying points in their history, both parties had shifted and veered from the political-centre to the political-right, and back again, with relative ease. Neither party has maintained a consistent ideological position decidedly separate from the other. Rather than by any ideological disagreement, the two parties were principally defined by their implacable opposition and aversion towards each other—particularly at a grassroots level. Once in office, neither pursued anything approaching a policy of radical social transformation. As John M. Regan notes, "The absence of class conflict, social revolution and social instability underpinned the post-revolutionary settlement."[1] The political veteran Desmond O'Malley[2] described the political culture that existed between Fianna Fáil and Fine Gael, accordingly:

There was little or no ideology involved. Office and not policy was the main objective. The reasons for the divisions in the 1920s were irrelevant and long forgotten except for a few well-worn phrases. But emotions were not. Distrust and loathing were the inheritances of the time.[3]

The emotional reverberations of the 1920s is a reference to the Irish civil war; a ten month long conflict which served as the origin myth for both political parties.

Historical Background

IRELAND'S *revolutionary period* at the beginning of the 20ᵗʰ Century is typically characterised by three phases. Firstly, the *1916 Easter Rising* - a pitched rebellion contained mostly to the capital city of Dublin. Secondly, the *1919-21 Tan War* (or *War of Independence*) - a nationwide guerrilla military campaign waged against British Crown Forces. Concluding, finally, with the *1922-23 Civil War* – an internal conflict fought between the proponents and opponents of the 1921 Anglo-Irish Treaty.

From the end of the 18ᵗʰ century onwards, underground revolutionary forces had engaged in a struggle for Irish national liberation from British rule. Since Theobald Wolfe Tone (1763-1798), the founding father of Irish republicanism, the stated aim had remained absolute and inviolable: an independent Irish Republic. By 1921, the militant forces of the Irish Republican Army (IRA) - alongside the women's auxiliary organisation Cumann na mBan -

Standing Up

The 1916 Easter Rising: a pitched rebellion

had brought the British Empire to the negotiating table. Following a six month 'truce', in December 1921, the Irish negotiation delegation returned from London with an agreed accord with the British government: the Anglo-Irish Treaty.

'The Treaty', as it was generally known, secured for Ireland a substantial, but limited, degree of self-government. Twenty-six counties were to become an Irish 'Free State' with its own parliament, judiciary, and armed forces. The remaining six north-eastern counties, six of the nine counties of the historic province of Ulster, would remain within the United Kingdom as 'Northern Ireland'. The new Irish Free State would exercise *Dominion Status* within the British Empire; akin to Canada, New Zealand, and Australia. Therefore, Irish Parliamentarians would be required to swear an oath of fealty to the British Monarch. For the most part, the British Military presence would cease to have a presence within the twenty-six counties.[4] However, the economic exploitation and impact of imperial conquest would continue. British colonial interest in Ireland remained secure and safeguarded. It was not the thirty-two county independent Republic that so many had struggled and sacrificed to realise. Sinn Féin, the political expression of the independence movement, rapidly divided into two camps: those who were 'pro-Treaty' and those who were 'anti-Treaty'.

The civil war that followed, began on 28 June 1922, when pro-Treaty Free State forces, under pressure from the British Government, launched an attack on an anti-Treaty IRA garrison stationed inside the Four Courts building in Dublin.[5] The conflict concluded on 24 May 1924, when the beleaguered IRA ordered its volunteers to dump arms.

In the aftermath of the civil war, two principal political

parties emerged. Splitting away from a demoralised and divided Sinn Féin; Fianna Fáil was founded in 1926 by Éamon de Valera alongside many of the leading anti-Treaty figures. Subsequently, in 1933; Cumann na nGael, the pro-Treaty party which had governed the Free State from its establishment until 1932, merged with various other pro-Treatyite groupings to form a new party: Fine Gael. As has been outlined, Fianna Fáil and Fine Gael would go on to become the two dominant political forces within the twenty-six county State. So-called 'civil war politics' was born and soon became entrenched into society. In 1937, the Free State adopted a new constitution stripping away many of the symbolic vestiges of imperial rule. But, only in 1949, did the State declare itself a Republic; removing the final remnants of British interference within the twenty-six counties.

As Fianna Fáil and Fine Gael grew to dominate the electoral arena, those who remained faithful to the Sinn Féin party found themselves in a *political cul-de-sac*. Civil war defeat, combined with the ensuing exodus of many of its most capable activists to Fianna Fáil, saw Sinn Féin retreat into constitutional dogma and inward-factionalism.

As it sought to reject the new State and bypass its institutions, the party increasingly became characterised by expulsions, splits, and walkouts. The veteran republican, Maire Comer-

The 1970 Split

John Joe McGirl, Ruairí Ó Brádaigh and Charlie McGlade

ford later reflected, "as a modern state grows up, it becomes very difficult to avoid being enmeshed by it."[6] It was only in 1949, that the beleaguered party was revived, by a new generation of IRA leadership, to serve as the official political-wing of the republican movement. As Kevin Rafter outlines, such was its poor standing organisationally, "the IRA was able to simply take over Sinn Féin without any fuss and, in tandem, obtain a long-established political name."[7] Despite brief flourishes in electoral fortunes in the 1950s,[8] the party largely remained, in the words of J. Bowyer Bell, "the depository of retired revolutionaries clinging to the idols of their youth."[9] Towards the end of the 1960s, as political violence erupted in the North, the republican movement again underwent a split. There were a myriad of reasons and personalities that lay behind this split. But principally, it was a divide between those advocating for a broad-based political strategy and those who wanted to maintain a more traditional militarist orientation. At the 1970 Ard Fheis (*party conference*), the split reached Sinn Féin and a walkout ensued. Those who left the conference, representing the militants, were soon branded: *Provisional* Sinn Féin. It was this grouping which would hold onto the 'Sinn Féin' mantle over subsequent years.[10] As the north-

ern conflict waged on, a new generation, of mostly northerners, rose to positions of authority within Sinn Féin. These younger activists increasingly rejected false fidelity to outdated dogma and instead sought to develop new strategies of struggle; both militarily, via a revived IRA campaign, and electorally, via Sinn Féin. As Gerry Adams explains, prior to this strategic re-evaluation, "Sinn Féin was by and large perceived, and was in reality, a poor second cousin to the IRA."[11] Over the course of the next three decades, through the adoption of greater tactical flexibility and revolutionary subjectivity, and under the combined political leadership of Gerry Adams and Martin McGuinness, Sinn Féin was recast from a fringe protest grouping into a cutting-edge electoral machine. Following the end of the IRA's campaign in 2005, the late 2000s saw Sinn Féin stand as a key political player in the North and a growing electoral force in the South.

2020: The 'End of Civil War Politics'

THE RE-EMERGENCE of Sinn Féin, as a viable party of government, broke the cosy consensus that had existed between the two 'civil war parties'. In the 2020 general election, for the first time ever, both Fianna Fáil and Fine Gael saw a drop in their vote share and a loss of seats. While, under the leadership of Mary Lou McDonald, a resurgent Sinn Féin unexpectedly received the highest share of the vote and returned with just one seat short of Fianna Fáil.[12] With no party securing a parliamentary majority; government formation talks soon commenced with both Fianna Fáil and Fine Gael ruling Sinn Féin out as a potential partner in government. On 15 June 2020, a final 'Programme for Government' was agreed between Fianna Fáil, Fine Gael and the Irish Green Party.[13] The most popular party in the State, Sinn Féin, was excluded from office; while the supposedly diametrically opposed 'civil war par-

ties' agreed to govern together. The once unthinkable had come to pass.

The crossing of this Rubicon led to a flurry of headlines heralding the "end of civil war politics."[14] In much of the accompanying commentary, the step was presented as the realisation of political maturity and progress. Writing for *The Irish Examiner*, Michael Clifford remarked, "politics in this State may be finally growing up."[15] While, in the *Sunday Independent*, Eoghan Harris suggested the coalition finally brought Irish politics "into the European mainstream."[16] Speaking in Dáil Éireann, the Fine Gael leader, Leo Varadkar, stated, "Civil war politics ended a long time ago in our country, but today civil war politics ends in our parliament."[17] The symbolism of the coalition was further demonstrated when the new Taoiseach, Fianna Fáil leader Micheál Martin, announced that the portraits of *both* Éamon de Valera and Michael Collins, the two nominal figureheads of civil war divide, would hang in his office.[18] *Swords had been turned to ploughshares* and in the wake; the story of Sinn Féin's unexpected advance was sidelined. The overriding establishment narrative was clear: the wounds of civil war were finally being healed.

However, unsurprisingly, such public discourse deliberately ignored the social, political, and ideological factors which lay behind the civil war conflict. It would be reductive and simplistic to solely present the civil war through a lens of personalities and parties. Especially through two political parties, Fianna Fáil and Fine Gael, both founded *years* after the civil war had concluded.

As Regan has outlined in detail elsewhere, the modern Irish State relies on three fundamental 'foundation myths'. Firstly, the idea that the current twenty-six county State emerged from a popular nationalist revolutionary struggle rather than from an imposed British settlement cemented and enforced by a counter-revolution. Secondly, that the legal provenance of the new State and its institutions originate from the institutions of the revolutionary period (i.e. the First and Second Dáil Éireann and the revolutionary forces of the Irish Republican Army and

Cumann na mBan) rather than the suppression of these revolutionary bodies, with the actual legal provenance stemming from British statute. And thirdly, that the founders of the State upheld constitutional, democratic, and legal means to establish the State's institutions. Despite the reality that, summary executions and violent repression was a touchstone of Irish state-building and a utilised means of removing dissenting voices.[19] These three 'foundation myths' provide a fixed narrative which has been reinforced and parroted by successive Fianna Fáil and Fine Gael governments.

The Road to Civil War

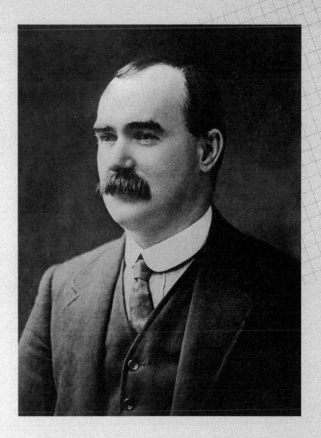

DURING THE revolutionary period, the notion that the 'National struggle' would fall short of a wider social revolution was not unanticipated. Prior to the 1916 Easter Rising, James Connolly, the only avowed socialist of the rebel leaders, is said to have warned his Irish Citizen Army: "In the event of victory, hold on to your rifles, as those with whom we are fighting may stop before our goal is reached. We are out for economic as well as political liberty."[20] In ideological terms, the independence movement had always been all-encompassing. As Feargal McGarry notes, IRA membership could often span from "right-wing bigots to communists."[21] Similarly, Eoin Ó Broin characterises the post-1916 Sinn Féin party as an "uneasy but stable alliance" that accommodated all strands of thought; from conservatives, to pragmatists, to social radicals.[22] At repeated stages throughout the period, the need to maintain unity between such disparate forces and individuals often trumped the ability to openly discuss what post-independence would look like.

It is necessary, however, to state that the social and ideological mix within the independence movement should not negate the revolutionary legitimacy of the liberation struggle from a Marxist perspective. In the case of Ireland, Karl Marx repeatedly argued that first its people had

The Great Connolly

"In the event of victory, hold on to your rifles, as those with whom we are fighting may stop before our goal is reached. We are out for economic as well as political liberty."

to secure self-rule before any final push towards social emancipation could materialise. A fundamental step on the road to dismantling capitalism lay in the dismantlement of imperialism.[23] Adopting this ideological framework, V.I. Lenin reacted furiously when fellow socialists branded the 1916 Easter Rising as a "putsch" conducted by a "purely urban petty-bourgeois movement." Replying in force, Lenin wrote:

To imagine that social revolution is conceivable without revolts by small nations in the colonies and in Europe, without the revolutionary outbursts by a section of the petty bourgeoisie with all its prejudices, without the movement of non-class conscious proletarian and semi-proletarian masses against the oppression of the landlords, the church, the monarch, the foreign nations etc. – to imagine this means repudiating social revolution. [...] only

those who hold such a ridiculously pedantic opinion could vilify the Irish Rebellion by calling it a "putsch." Whoever expects a "pure" social revolution will never live to see it. Such a person pays lip service to revolution without understanding what revolution is.[24]

It is, therefore, entirely justifiable that the more socially radical and class-conscious republicans – be they James Connolly, Liam Mellows, Constance Markievicz, Hanna Sheehy-Skeffington, or Peadar O'Donnell – entered the nationalist movement despite all the trappings of bourgeois and liberal nationalism that lay within.

Liam Mellows

Irish republican, Sinn Féin politician, and revolutionary, Mellows was active in the Republican Brotherhood and the Irish Volunteers, fighting in the Easter Rising as well as the War of Independence.

It should also be noted that there were some *brief* flashes of *socialistic* aspiration during the revolutionary period. It is beyond the remit of this piece to outline them all entirely, but perhaps the most notable was the 1919 Democratic Programme of Dáil Éireann. The Democratic Programme was intended as a mission statement of the revolutionary government of the Irish Republic. It set-out in explicit terms that the:

nation's sovereignty extends not only to all men and women of the nation, but to all its material possessions; the nation's soil and all its resources, all the wealth and all the wealth-producing processes within the nation...

Furthermore, it declared that all rights in private property would be "subordinate to the public right and welfare." It called for an end to the British Poor Law System and pledged to "ensure the physical as well as the moral well-being of the Nation."[25] However, despite its official status, the Programme was far from representative of most members of the First Dáil. As Brian Farrell notes, "most of its members had not read the document in advance; the few who had seen it in draft form were reluctant enough to subscribe to it and there was a last minute redrafting of the document only hours before the Dáil met."[26] Indeed, even in its final diluted form, it still went largely ignored. It would later be dismissed in its entirety by the Free State Minister for Justice, Kevin O'Higgins, as "largely poetry."[27]

The ultimate undoing of the Irish revolution lay in the inability of the more socially radical republicans to instil revolutionary theory and class politics into the post-1916 independence movement. The socialist republican, Peadar O'Donnell would later opine: "the economic framework and social relationships,

which expressed tyrannical aspects of the conquest, were declared outside the scope of the republican struggle."[28] For the duration of the Tan War, even traditional agrarian cleavages such as: *rancher against small farmer or landlord against tenant*, were momentarily parked in a bid to build national unity. As O'Donnell summarised, "We had a pretty barren mind socially."[29]

The Foresight of Liam Mellows

THIS POLITICAL downfall was perhaps best recognised by the leading Irish republican, Liam Mellows. Mellows was a committed IRA volunteer and Sinn Féin activist who had famously rallied volunteers in Galway during the 1916 Easter Rising and, whilst on the run, organised in the USA in support of the independence movement. Following the publication of the 1921 Anglo-Irish Treaty, in December 1921, Mellows became one of its most vociferous and implacable opponents. From his perspective, the Irish Republic had been proclaimed in Easter Week 1916. The Republic had subsequently been ratified by the people, via the 1918 general election, and took its place on the international stage through the 1919 Declaration of Independence.[30] Mellows was therefore incensed to see that it was being disestablished before his very eyes. Indeed, to make matters worse, the people dismantling it were the very same who had sworn to uphold it. As he remarked himself, the Treaty represented "not a step towards the Republic but a step away from it."[31]

Seán Cronin is correct to lament that, when the Treaty came to be debated, "there were few radicals in the Second Dáil when it needed a radical stand."[32] In this respect, Mellows stands out as one of the few radicals who did make a worthy, albeit futile, stand. His debate contributions represented, in the words of Conor McNamara, "classic distillations of Irish republican thought."[33] A recurrent argument from the pro-Treaty benches was that rejection of the Treaty would lead to a full-scale invasion by British Forces and "immediate and terrible war" for the people of Ireland.[34] Mellows refuted this and famously retorted that to support the Treaty, under such conditions, "is not the will of the people, that is the fear of the people."[35] He maintained that popular-will could not guide revolutionary practice if the people were being threatened and coerced by the enemy. He also rejected the economic arguments presented in favour of compromise; arguing, "We do not seek to make this country a materially great country at the expense of its honour in any way whatsoever."[36] Despite his personal dislike of public-speaking,[37] the coherence and consistency of his argument meant that few could discount what he said entirely. Indeed, it is notable that the pro-Treaty speaker who followed him in the debate, Desmond FitzGerald, began his contribution by saying: "I want to say at the beginning, with regard to the last speaker before lunch, that I agree practically with every word he said."[38] It was to be a cruel twist of fate that, just 11 months later, FitzGerald would sit as a member of the Free State cabinet that signed-off on the summary execution of Liam Mellows.

The Attack on the Four Courts

DESPITE MULTIPLE attempts to hold the two sides together, by March 1922 civil war looked to be unavoidable. On 26 March, the IRA elected a new sixteen-member Army Executive loyal to the Republic and opposed to the Treaty. Mellows was among those elected.[39] On 15 April 1922, the IRA Dublin garrison seized the Four Courts to serve as a new IRA headquarters. The choice of location was not without intended symbolism. The building had previously been occupied by rebel forces during the 1916 Easter Rising. Indeed, some of the anti-Treaty IRA men who entered the Four Courts in 1922 were

the same who had entered it six years prior. However, symbolism aside, there is little to indicate that the IRA was bracing itself for what was to follow. As Michael Fewer explains, "very little planning was carried out, or measures put in place, then or later, for a realistic military defence of the Four Courts complex."[40] Demonstrative of this lax attitude, over the subsequent weeks, Mellows continued to walk from the occupied Four Courts to the Dáil[41] in order to carry out his Parliamentary duties and daily cross-paths with pro-Treaty colleagues.[42]

For a period, an uneasy stand-off persisted. However, this hiatus was to break on 22 June 1922 when the IRA assassinated the British Field Marshal Sir Henry Wilson outside his home in London.[43] The British establishment was outraged by the provocation. In the House of Commons, Winston Churchill called for action to be taken against the "band of men" stationed in the Four Courts.[44] The pro-Treaty leader Michael Collins, who had previously been the IRA's Director of Intelligence, was well aware that if he did not act, the British would soon move in to do so.[45] Therefore, on 28 June, the Free State National Army gave notice to the IRA garrison stationed in the Four Courts to evacuate within twenty minutes or the building would be taken by force. A short time later, with the IRA volunteers refusing to withdraw, the 18-pounder gun situated across the River Liffey opened fire. The siege of the Four Courts had begun.[46] Civil war in Ireland had commenced.

After three days of shelling, at midday on 30 June, the Four Court garrison surrendered. Despite the strenuous objection of Liam Mellows.[47] The captured IRA volunteers were taken to Mountjoy Jail. Once there, in line with republican policy, they requested to be treated as prisoners of war. The IRA men were swiftly informed that the Free State commanding officer overseeing their arrest had ordered that no such concessions were to be granted.[48] The commanding officer in question was none other than a certain: Eoin O'Duffy. O'Duffy would later gain notoriety when, in 1932, enamoured with the fascist corporatism of Italy and Germany, he founded the proto-fascist Army Com-

rades Association, colloquially known as 'the Blueshirts'. He would later serve as the first leader of Fine Gael and form Irish Brigade to fight on the side of Francisco Franco during the Spanish Civil War. However, back in June 1922, this early designation of *criminality* is perhaps one of the first indicators of the counter-revolutionary nature of the conflict that followed. Former comrades had become common criminals overnight. British Statute had supplanted revolutionary defiance. In the words of Regan, from the outset of the fighting, pro-Treatyites presented the civil war "not as a struggle between competing revolutionary factions but as a war against actions which were deemed criminal, not ideological."[49]

However, the conflict was fundamentally ideological. Indeed, it was from his cell in Mountjoy that Liam Mellows produced his greatest contribution to republican ideology. It was a report, written in two parts, which would become known as: *The Notes from Mountjoy*. A piece of writing which Seán Cronin would later celebrate as "the only radical document to emerge from the civil war."[50]

The Notes from Mountjoy

ON 18 AUGUST 1922, the anti-Treaty IRA volunteer Ernie O'Malley, who had escaped arrest following the fall of the Four Courts, wrote to Mellows seeking strategic guidance on the escalating civil war outside.[51] Following some general correspondence relating to minor matters, Mellows wrote to O'Malley again, on 26 August, with the first-half of a full report providing his perspective on the wider political situation. Three days later, on 29 August, the adjoining second-half was posted. Copies of both *Notes* were also sent to the leading anti-Treatyite Austin Stack for his consideration. Their contents were never intended for publication or outside consumption. However, as Cronin outlines, the *Notes* would reveal Mellows to be "the most clear thinking and far

sighted Republican leader of the civil war period."[52] Taken in totality, his analysis represented: a repudiation of the conservatism of the Catholic Church, a rejection of the moderation of the Irish Labour movement, and a break-away from the exclusively militarist focus of Irish republicanism.

Mr. Joseph McKelvey, of Belfast, who was executed in Mountjoy Prison on Friday morning.

In September 1922, O'Malley made copies of the *Notes* for the attention of Liam Lynch, the IRA Chief of Staff. Unfortunately, the Cumann na mBan courier tasked with delivering them to Lynch was intercepted by the Free State authorities.[53] Recognising the propaganda value contained within, the Notes were printed in full, with accompanying pro-Treaty commentary, in both the *Irish Independent* and *The Irish Times* on 22 September.[54]

The first of the *Notes*, dated 26 August, begins with a plea for greater cohesion between republican political and military strategy. Within the IRA, there had been a tendency to focus exclusively on military matters. As Cronin notes, "Republicans had no politics, they sometimes liked to claim."[55] At the IRA Convention of 26 March 1922, it was reported that a popular cry from the floor was, "We don't want any politicians."[56] Mellows recognised the folly of this attitude. In his *Notes*, he outlined how the previous six months had witnessed "responsible officers in their desire to act as soldiers, and because of their attitude towards 'politicians' [...] only judge of situations in terms of guns and men."[57] Such posturing had allowed *politics* to fall into the hands of others. Particularly, into the hands of individuals removed from the military strategy. As Peadar O'Donnell reflected, Liam Lynch was unable to "descend from the

The Mountjoy Notebook

Written in his cell at Mountjoy, Mellows produced what Seán Cronin would later celebrate as "the only radical document to emerge from the civil war."

high ground of the Republic to the level of politics."[58] In such a vacuum, an individual like Éamon de Valera became the *de facto* political voice of the anti-Treatyites. It was a role which he himself admitted he was ill-suited for. In a private correspondence to Mary MacSwiney, de Valera wrote, "Every instinct of mine would indicate that I was meant to be a dyed-in-the wool Tory or even a Bishop, rather than the leader of a revolution."[59]

The *Notes* called for the formation of an alternative Provisional Republican Government to enact a popular programme of reform. Mellows argued that this should be done as a matter "most urgent" to counter any budding support for the Free State Provisional Government. This proposed alternative government would, therefore, be tasked with ensuring that the 1919 Democratic Programme was "translated into something definite." Maintaining that only

a truly revolutionary programme could win over the working-classes and Labour movement to the cause of the Republic. To achieve this, Mellows quoted at length from an article featured in the 22 July edition of *Worker's Republic* (the official newspaper of the Communist Party of Ireland). This apparent endorsement was unquestionably the most controversial aspect of the *Notes*. The reproduced quote stated that:

Under the Republic all industry will be controlled by the state for the Workers and Farmers benefit. All transport, railways and canals. etc. will be operated by the State – the Republican state – for the benefit of the workers and farmers, all banks will be operated by the state for the benefit of Industry and Agriculture, not for the purpose of profit making by loans, mortgages, etc. That the lands of the aristocracy (who support the Free State and the British connection) will be seized and divided amongst those who can and will operate it for the Nation's benefit, etc. [60]

Perhaps predictably, when the *Notes* were published in the national newspapers, this citation received particular attention. It was promptly presented as evidence that the anti-Treatyites were hellbent on establishing a "Communistic State" in Ireland.[61] In the *Irish Independent*, the *Notes* appeared with a cover-article drafted by the Free State Publicity Department. The introductory text, warned that "the new Republican programme is to be dangled before the eyes of the landless men, the unemployed, the thousands of people whom starvation is facing, so that the situation may be 'utilised for the Republic.'" Furthermore, it cautioned its readers that, "in the history of politics few things can be more callously unscrupulous than this programme."[62]

The two *Notes* concluded by listing various topics and areas of interest which Mellows suggested required greater "propaganda" attention. In effect, this represented a call for greater political education within republican ranks. Mellows argued that concepts like 'imperialism' needed to be explained to ordinary people:

What the rejection of it [imperialism] by Ireland means. What its acceptance by Ireland means. This should be fully explained. What Imperialism is; what Empires are; what the British Empire is – its growth. [63]

He outlined how an Irish Free State, still situated within the British Empire, only represented the maintenance of British imperialist interests by domestic means. He warned that Ireland's rulers would no longer "use British arguments to cloak their action, but Irish ones 'out of our own mouths', etc."[64] As Desmond Greaves notes, such analysis and description of the new means of imperial domination pre-empted much of R. Palme Dutt's later articulation of *neo-colonialism*.[65] In the latter half of his *Notes*, Mellows again returned to the need for early political education. He appealed for his comrades on the outside to "concentrate on youth" because "salvation of country lies in this – both boys and girls." Reflecting on the Treaty split, he remarked, "the reason for so many young soldiers going wrong [pro-Treaty] is that they never had a proper grasp of fundamentals. They were absorbed into [the] movement and [the] fight – not educated into it. Hence no real convictions."[66]

The other controversial aspect of the *Notes from Mountjoy*, was Mellows' critique of the Catholic Church hierarchy. He began by outlining the Church's historic opposition towards Irish republican struggle through the decades. He condemned the Church's "exaltation of deceit and hypocrisy" and denounced it for treating religion as "something to be preached about from pulpits on Sundays, but never put into

practice in the affairs of the nation."[67] Although, excoriating of the Catholic hierarchy, Mellows made clear that his attack was not against Catholicism as an article of faith. Indeed, he argued that that the hierarchy in fact presented a "danger to Catholicism in Ireland from their bad example." To counter their negative example, Mellows proposed that "propaganda" be produced on the life of Cardinal Désiré-Joseph Mercier (1851-1926), the Belgian Cardinal who had rallied Belgian nationalists during the German occupation in 1914.[68]

Unfortunately, when the IRA Executive eventually met on 16 and 17 October, in Ballybacon, Co. Tipperary, Mellows' proposals were not even considered for discussion. Undoubtedly, the press coverage and the accompanying 'red scare' tactics had damaged their reception. Also, as McNamara explains, by this point the outside republican leadership was largely preoccupied with "fighting for their own survival."[69] The civil war had quickly descended into a primarily rural conflict of ambush and assassination. Mellows was himself uneasy with the presentation of his Notes in the press. Writing to his comrade, Seán Etchingham, he remarked, "Of course you saw the publication of my hastily written ideas that fell into their hands [Pro-Treaty]. The effort to brand it 'communistic' is so silly. I only referred to the "Worker" [*Workers' Republic*] because it had set forth so succinctly a programme of constructive work that certainly appealed to me."[70]

At this point, it is necessary, to note that Mellows never considered himself a 'socialist'. Given the general conservatism of Irish society, it was not a label that sat easy for many republicans of this period. As a member of the clandestine Irish Republican Brotherhood, Mellows preferred to style himself as traditionalist in the Fenian mould. As O'Donnell later wrote:

Mellows was a great Fenian who saw the poor as the freedom force of the nation; as [Wolfe]Tone did. He was influenced by the lessons of Irish history, his experience as an organiser of the Fianna[71], his memory of the men who rose with him in Galway and the way of life of the prisoners around him in Mountjoy. It was clear to him that the middle class, which lurked in the shadow of the republican movement from its rise to popularity, was no part of the freedom forces; it had no aim that could not be realised in Home Rule within the British Empire.[72]

While in America, he was asked by Nora Connolly, daughter of James Connolly, and Frank Robbins, of the Irish Citizen Army, for his opinion on socialism. His response was only that he had read James Connolly's *Labour in Irish History* and agreed with its conclusions, "but he was not sure that he understood Connolly's Marxism."[73] His time spent in America certainly broadened his thinking and brought him into contact with more radical thinkers. As Greaves records in detail, this included Irish-American radicals such as Patrick L. Quinlan, J.E.C. Donnelly, and Con O'Lyhane.[74] Undoubtedly, Mellows was mindful that his thinking was increasingly *to the left* of many of his comrades back home. Indeed, in a moment of political frustration whilst in Philadelphia, he wrote to Nora Connolly, "I'm beyond redemption [...] Am looked on as wild, hot-headed, undisciplined – liable to get [the] movement into trouble – dubbed a Socialist and Anarchist."[75] However, as O'Donnell notes, Mellows repeatedly returned to Irish history for guidance rather than contemporary socialist-thinkers on the European Continent.[76] His famous pronouncement in *The Notes from Mountjoy*: "We are back to Tone – and it is just as well – relying on that great body 'the men of no property'..." is representative of this train of thought.[77] Tone had famously stated, on 11 March 1796, that, "If the men of property will not support us, they must fall; we can support ourselves by the aid of that numerous and respectable class of the community, *the men of no property*."[78] Such thinking was certainly in-step with Mellows' own conclusions by the end of August 1922.

Unfortunately, Mellows did not get the chance to expound on his thinking or develop his ideas any further. On 7 December 1922, two pro-Treaty politicians were ambushed by the IRA, and one of them, Seán Hales, died. The Free State cabinet was incensed by the ambush and in reprisal ordered the summary execution of four republican prisoners. Those selected were Rory O'Connor, Dick Barrett, Joe McKelvey,

and Liam Mellows. It is not known why these four were chosen. A prevailing theory was that a man was chosen to represent each of Ireland's four provinces; to send a stark warning to IRA volunteers nationally. With O'Connor for Leinster; Barrett for Munster; McKelvey for Ulster; and Mellows – despite being a Leinsterman – standing in for Connacht given his association with Galway during Easter Week 1916.[79] However, Desmond Greaves presents a much more compelling argument, and instead suggests that the real motivation was considerably more calculated and politically-minded. Indeed, he argues that the four were selected in a moment of opportunism because their silence assisted the consolidation of the new Free State. As he asks, "Who can deny that when these four tongues were silenced the world became much safer for 'official history?'"[80]

Mellows Murdered

Without trial, Mellows, O'Connor, Barrett, and McKelvey were murdered by the Free State on the morning of 8 December 1922. "*Slán Libh, Lads*" [Goodbye, Lads] were Mellows' final words.

Thus, on the morning of 8 December 1922; Mellows, O'Connor, Barrett, and McKelvey were shot by firing squad. They received neither trial nor sentence. The new government's justification for their execution was solely given in terms of retribution for Seán Hales. The executions caused widespread revulsion, and even the Hales family issued a letter to the press repudiating the '*Mountjoy murders.*'[81] The Cannon who accompanied the condemned men to their fate, later relayed that the final thing he heard before the volley of gunfire was Liam Mellows utter the words, "Slán Libh Lads [*Goodbye Lads*]."[82] With this extra-judicial execution, Mellows was silenced forever. It would be left to others to pick up his work and interpret his words.

What Followed

IN HIS NOTES, Mellows identified that capital would support the Treaty compromise. As he

wrote; "money and the gombeen man[83] — are on the side of the Treaty, because the Treaty means Imperialism and England."[84] Following the civil war, many defeated anti-Treatyites consoled themselves with the notion that their defeat was primarily due to 'betrayal'. However, the unfortunate truth was that those who took the pro-Treaty side were never *truly* with the revolution to begin with. As Gerry Adams later summarised:

The Cumann na nGael government which ruled the new Free State from 1922 to 1932 represented the most pro-imperialist elements in the state. Their economic interests in commerce, banking, trade, large farming concerns, brewing and distilling, or in sections of the high professional groups, required free trade with Britain and close political and cultural ties with her. It was not that they sold out the republic of 1916: as Liam Mellows said of them at the time, 'the men with a stake in the country were never for the republic.'[85]

Hanna Sheehy-Skeffington, one of the most advanced socialist republicans of the revolutionary period, had initially been cautious about taking up a side in the Treaty split. However, by February 1922, she could already see that all the reactionary forces of the old-guard were lining up behind the Free State, "There is a regular stampede for it of all the moderates, and the 'safe' people with stakes in the country, of the press, and the clerics."[86] It was a trend that was not lost on the pro-Treaty leader Michael Collins. Prior to his death, during an IRA ambush on 22 August 1922, Collins ruefully confided to a colleague, "I wish we [pro-Treaty] had the bishops against us."[87]

Once the civil war had concluded and the new State was firmly embedded, the main beneficiaries were, unsurprisingly, the middle class bourgeoisie and the ruling classes. The counter-revolution had served its purpose. One of the earliest measures of the Free State was the passage of the Amnesty Bill. A piece of legislation which indemnified "persons who supported the British Government for the last few years, by carrying out orders, or being in any way responsible for acts, which would be or might be the subject of legal proceedings."[88] By 1924, a

Nora Connolly

Connolly summarised the post-civil war mood well, describing how, "The first fiery resistance became a long sad retreat, with the executions strung out like milestones along the way. We felt beaten and deflated."

Free State Business Committee expressed concern that:

Those who won the fight have not done well out of the victory, whereas pro-British ascendancy who lost the fight have done disproportionately well and got a new lease of life from the Free State.[89]

In the words of Cronin, the 1919 Democratic Programme "remained a dead letter."[90] The new Free State administration oversaw a programme of conservative fiscal policies and *laissez-faire* economics. Agriculture remained the primary economic focus with the 1926 census showing 53% of the Free State's work-force employed in the agricultural sector.[91] When the Secretary of Industry and Commerce pushed for a modicum of state-directed industrial development the cabinet rejected it outright.[92] The level of social expenditure bequeathed by the outgoing British administration was deemed "inappropriate for a poor, small country" and, accordingly, the Free State cut back on welfare measures. Most notorious of these cuts was the old age pension in 1924.[93] Despite the promise of the Democratic Programme, little importance was placed on the "physical well-being" of the Nation. 'Health' was lumped together as a junior partner within the Department for Local Government and it was not until 1947 that it became a Department in its own right.[94] As Dermot Keogh concluded, "even the harshness of the times cannot account for the swinging economic cuts made on the poorer sections of the community during the 1920s."[95]

The post-civil war republican movement found itself in a political quagmire. Nora Connolly summarised the mood well, describing how, "The first fiery resistance became a long sad retreat, with the executions strung out like milestones along the way. We felt beaten and deflated."[96] It was not long before the splits and splinters began. The first came in 1926. Now prepared to enter the Free State Parliament, Éamon de Valera, the Sinn Féin party president and political figurehead of the anti-Treatyites, left to found Fianna Fáil.[97] Fianna Fáil would go on to become "one of the most effective political organisations ever to operate in any western democracy."[98] Those who remained with Sinn Féin stood isolated from the new political mainstream. As the young republican Frank Ryan, arguably one of the closest there was to a *successor* to Mellows, wrote during the 1927 general election:

Honestly, I can't take sides in what I consider a domestic row between moderates [Fianna Fáil and Cumann na nGael]. I'm more concerned with trying to hold together the remnants of the 100 per cent revolutionaries, so that there will be someone left to talk – at least – of Lalor[99] and Connolly.[100]

As Fianna Fáil gained momentum, Sinn Féin's support base dwindled. Frank Edwards[101] later reflected on this period of activism, saying "You can't keep people, potential revolutionaries, going forever on a diet of hustings, commemorations, flags, banners and Bodenstowns."[102][103] There were fleeting attempts to launch alternative political vehicles. Chiefly, in a bid to unshackle radical republican activists from their more conservative comrades inside the Sinn Féin party. In February 1931, an IRA Convention authorised the establishment of Saor Éire as a new left-orientated republican political party. A Free State Justice Department report would later call the Saor Éire programme "frankly communistic" and the party was proscribed in October 1931.[104] By 1933, the proposal was resuscitated, and the Republican Congress was founded by left-wing republicans. Unlike Saor Éire, the Congress was not intended to be a political party and instead presented itself as an umbrella-organisation for republicans and anti-imperialists irrespective of party or organisational affiliation. However, in the words of Edwards, the Congress soon suffered "a disastrous split" and swiftly disintegrated.[105] As previously outlined, it would take the outbreak of a long protracted conflict in the north of Ireland, during the second half of the century, to recast Sinn Féin once again as an effective political alternative.

Conclusion

MELLOWS' IDEOLOGICAL positioning was perhaps best encapsulated by a speech he delivered in New York City on St Patrick's Day, 1918. There Mellows stated:

It is the workers of Ireland who are fighting now, it is the workers who have always fought the battle for freedom, and it is to the people that we propose to give Ireland when she is free. [...] This is the present movement in Ireland. It is not called socialism. It is called many names. Some have called it Sinn Féin, but call it what you will, Ireland wants to continue her old civilisation along the lines of socialism, communism, or co-operation. [106]

Mellows was not a Marxist. Indeed, he was even uncomfortable with the label of 'socialism'. However, what set him apart from others of his generation was his instinctive understanding and ability to read of the dynamics of revolution. As Peadar O'Donnell later summarised, although Mellows' *Notes* consisted of only "the bare bones of a social policy," they nonetheless presented "the glimmerings of a successor to James Connolly was in our midst." [107] This was an observation echoed by Hanna Sheehy-Skeffington, who wrote following his execution to the *Irish World*, "He of all men might have taken James Connolly's place – of late especially he had moved along the paths trodden by Connolly." [108] Like Connolly, Mellows recognised that national liberation could not be syphoned off from wider social emancipation. He foresaw that the middle-classes could not be left to lead the independence movement and that the working classes - or the 'men of no property' as Wolfe Tone termed it - had to be front-and-centre of republican struggle.

During the Dáil debates on the Treaty, Mellows warned his colleagues that once the Free State came into existence:

...you will have a permanent government in the country, and permanent governments in any country have a dislike to being turned out, and they will seek to fight their own corner before anything else. Men will get into positions, men will hold power, and men who get into positions and hold power will desire to remain undisturbed and will not want to be removed, or will not take a step that will mean removal in case of failure. [109]

Although spoken in January 1922, the words are almost prophetic for what took place in June 2020 following the February election. The two right-wing parties of Fianna Fáil and Fine Gael abandoned their pretence of supposed historical animosity and coalesced. They did so solely to keep Sinn Féin away from the levers of power. They did so to hold onto power.

The Irish State remains the product of a counter-revolution. For most of its existence, Fianna Fáil and Fine Gael have jointly acted as custodians of this counter-revolutionary acquisition. As Regan argues, "The difference between Collins and de Valera in December 1921 was tactical not ideological and extraordinarily subtle for all that." [110] Accordingly, it should come as little surprise that the *political heirs* of de Valera and the *political heirs* of Collins were so readily able to reconcile after decades of stage-fighting and shadow-boxing. Both, Fianna Fáil and Fine Gael, rose out of the bourgeois elements of the independence movement. Neither party was ever truly revolutionary. Neither party was ever socially radical. *Full* national liberation and social transformation had long been parked by both.

The aftermath of the February 2020 election saw the deliberate and concerted exclusion of the collective political-left from power and office by an old-guard, right-wing, political establishment. The fact that the most popular party in the state, Sinn Féin, was precluded from government formation talks demonstrated, in ideological terms at least, that 'civil war politics' was not overcome. It had simply been recast. Despite media commentary and fanfare, the coming together of Fianna Fáil and Fine Gael was *not* the final healing of the age-old divide of the revolutionary period. But rather, it represented the latest symptom of the continued subjugation of an unfinished revolution. It was counter-revolution by new means.

As we approach one-hundred years since the execution of Liam Mellows, it is notable that his

political heirs are still considered — to borrow a phrase of his - 'beyond redemption.'

Endnotes

1 Regan, J. M. (1999) *The Irish Counter Revolution: Treatyite Politics and Settlement in Independent Ireland.* Dublin: Gill & Macmillan p. 378

2 Who himself attempted, in 1985, to break the political duopoly of Fianna Fáil and Fine Gael by establishing his own party: the Progressive Democrats.

3 O'Malley, D. '*Life in a Minor Party*' in Weeks, L. & Clark, A. Eds (2020) *Radical or Redundant: Minor Parties in Irish Politics.* Dublin: The History Press p. 80

4 Under the terms of the Treaty, the British Army maintained a military presence in three deep water ports within the Free State (Berehaven [Cóbh], Spike Island, and Lough Swilly).

5 A building complex which accommodated the Exchequer Court, the Court of Chancery, the Court of King's Bench, and the Court of Common Pleas. It also housed the Public Record Office, the Land Registry Office and the Solicitors' Building.

6 Mac Eoin, U. (1987) *Survivors.* Dublin, Argenta Publications p. 53

7 Rafter, K. (2005) *Sinn Féin 1905-2005: In the Shadow of Gunmen.* Dublin: Gill & Macmillan p. 81

8 See the 1955 Westminster Election and 1957 Irish General Election.

9 Bowyer Bell, J. (1995) *The Secret Army: The IRA 1916-1979.* Dublin: Poolbeg Press Ltd pp. 339-340

10 The other side of the 1969/70 split, so-called 'Official Sinn Féin', would ultimately go on to rebrand itself as 'The Worker's Party of Ireland.'

11 Adams, G. (1986) *The Politics of Irish Freedom* Co. Kerry: Brandon p. 150

12 Fianna Fáil subsequently took the Ceann Comhairle position (speaker) leaving Sinn Féin with an equal number of seats in the Dáil chamber.

13 'Agreement reached on final programme for government,' *RTÉ News*, 15 June 2020. Online <https://www.rte.ie/news/politics/2020/0615/1147519-government-formation/> (accessed 29/07/2020)

14 McGreevy, R. (2020) 'Historic coalition agreement ends almost a century of Civil War politics' The Irish Times, 27 June 2020. Online < https://www.irishtimes.com/news/ireland/irish-news/historic-coalition-agreement-ends-almost-a-century-of- civil-war-politics-1.4290514> (accessed 29/07/2020); Reidy, T. (2020) 'End of an era as Civil War parties take the once-unthinkable step' Irish Independent, 27 June 2020. Online <https://www.independent.ie/irish-news/politics/end-of-an-era-as-civil-war-parties-take-the-once-unthinkabl e-step-39320067.html> (accessed 29/07/2020); and ' Fianna Fáil and Fine Gael - sworn enemies work together' RTÉ News, 27 June 2020. Online <https://www.rte.ie/news/newslens/2020/0626/1149770-fianna-fail-fine-gael-civil-war-politics/> (accessed 29/07/2020)

15 Clifford, M. (2020) 'New government could be sign of Irish politics finally growing up' *The Irish Examiner*, 27 June 2020. Online <https://www.irishexaminer.com/opinion/commentanalysis/arid-31007856.html> (accessed 04/08/2020)

16 Harris, E. (2020) 'Leo Varadkar must learn to live with less media,' *Irish Independent*, 02 August 2020. Online <https://www.independent.ie/opinion/comment/leo-varadkar-must-learn-to-live-with-less-media-39416371.h tml> (accessed 04/08/2020)

17 McCurry, C. & McMahon, A. (2020) 'Leo Varadkar hails end of 'Civil War politics' in

Ireland's parliament' The Belfast Telegraph , 27 June 2020. Online <https://www.belfast-telegraph.co.uk/news/republic-of-ireland/leo-varadkar-hails-end-of-civil-war-politics-in-i relands-parliament-39320632.html> (accessed 29/07/2020)

18 Downing, J. (2020) 'Collins and Dev on the same wall could be more than just a clue about things to come,' *Irish Independent*, 29 June 2020. Online <https://www.independent.ie/opinion/collins-and-dev-on-the-same-wall-could-be-more-than-just-a-clue-abo ut-things-to-come-39323541.html> (accessed 04/08/2020)

19 Regan, J. M. (2013) *Myth and the Irish State Sallins*, Kildare: Irish Academic Press p. 229

20 Desmond Greaves, C. (2018) *The Life and Times of James Connolly*, Croydon Manifesto Press p. 227

21 McGarry, F. (2010) *Frank Ryan*, Dublin: University College, Dublin Press p. 8

22 Ó Broin, E. (2009) *Sinn Féin and the Politics of Left Republicanism*, London: Pluto Press p. 120

23 Marx to Ludwig Kugelmann, November 29, 1869 in Marx, K. & Engels, F. (1971) *On Ireland*, London: Lawrence & Wishart p. 281

24 Lenin, V.I. (2004) *The Right of Nations to Self Determination*, Honolulu, Hawaii: University Press of the Pacific pp. 116-117

25 https://www.dail100.ie/en/debates/1919-01-21/1903 (accessed 29/07/2020)

26 Farrell, B. '*The first Dáil and its constitutional documents*' in Farrell, B. Ed (1994) *The Creation of the Dail* Dublin pp. 61-75 *referenced in* Ferriter, D. (2005) *The Transformation of Ireland 1900-2000*, London: Profile Books Ltd p. 197

27 Ferriter, D. (2005) p. 296

28 O'Donnell, P. (2017) *There Will Be Another Day: The Inside Story of the 1920s Land*

struggle, Donegal/Glasgow: Red Sky Books p. 8

29 Mac Eoin, U. (1987) *Survivors*, Dublin, Argenta Publications p. 25

30 McNamara, C. (2019) *Liam Mellows: Soldier of the Irish Republic — Selected Writings, 1914-1922*, Kildare: Irish Academic Press p. 114

31 *Ibid*. p. 131

32 Cronin, S. (1981) *Irish Nationalism: A History of its Roots and Ideology*, New York: The Continuum Publishing Company p. 146

33 McNamara, C. (2019) p. 114

34 Cronin, S. (1971) *Ireland Since the Treaty*, Dublin: Irish Freedom Press p. 38

35 McNamara, C. (2019) p. 123

36 McNamara, C. (2019) p. 127

37 *Ibid*. p. 155

38 Dáil Éireann debate - Wednesday, 4 Jan 1922 - Vol. T No. 11 https://www.oireachtas.ie/en/debates/debate/dail/1922-01-04/speech/53/ (accessed 29/07/2020)

39 Fewer, M. (2018) *The Battle of the Four Courts: The First Three Days of the Irish Civil War*, London: Head of Zeus Ltd. p. 29

40 *Ibid*. pp. 38-40

41 Then situated in UCD, Earlsfort Terrace.

42 Ward, M. (2019) *Fearless Woman: Hanna Sheehy-Skeffington, Feminism and the Irish Revolution*, Dublin: University College Dublin Press p. 325

43 Although anti-Treatyites were blamed for the assassination, it is now widely accepted that the IRA men responsible were acting under the orders of the pro-Treaty leader Michael Collins. [see Coogan (1990) pp. 372-377]

44 https://api.parliament.uk/historic-hansard/commons/1922/jun/26/irish-of-

fice-etc#column_1712 (accessed 29/07/2020)

45 Coogan, T. P. (1990) *Michael Collins: A Biography,* London: Hutchinson p.330

46 Fewer, M. (2018) pp. 141-145

47 *Ibid*. p. 234

48 Desmond Greaves, C. (2004) *Liam Mellows and the Irish Revolution,* Belfast: An Ghlóe Gafa p. 350

49 Regan, J. M. ' The Dynamics of Treatyite Government and Policy, 1922-33,' *Irish Historical Studies*, Vol. 30, No. 120, pp. 542-563 (Nov, 1997) p. 554

50 Cronin, S. (1981) p. 154

51 Desmond Greaves, C. (2004) p. 362

52 Cronin, S. (1971) *The Revolutionaries* p. 191

53 Desmond Greaves, C. (2004) p. 375

54 O'Donnell, P. (2017) p. 6 and McNamara, C. (2019) p. 136

55 Cronin, S. (1981) p. 154

56 Gerry Boland in an interview with Michael McInerney, *Irish Times*, 9 October 1968 referenced in Maher, J. (1998) *Harry Boland: A Biography,* Dublin: Mercier Press p. 193

57 McNamara, C. (2019) p. 140

58 Mac Eoin, U. (1987) p. 25

59 UCDA, P150/657, De Valera to Mary MacSwiney, 11 September 1922 in Ferriter, D. (2007) *Judging Dev: A Reassessment of the Life and Legacy of Éamonde Valera*, Dublin: Royal Irish Academy p.91

60 McNamara, C. (2019) p. 141

61 *Ibid*. p. 138

62 Cronin, S. (1971) *The Revolutionaries* p. 191

63 McNamara, C. (2019) p. 142

64 McNamara, C. (2019) p. 144

65 Desmond Greaves, C. (2004) p. 369

66 McNamara, C. (2019) p. 145

67 *Ibid*. p. 143

68 *Ibid*. p. 139

69 *Ibid*.

70 *Ibid*.

71 Na Fianna Éireann, the Irish nationalist youth organisation.

72 O'Donnell, P. (2017) pp. 7-8

73 Desmond Greaves, C. (2004) p. 149

74 *Ibid*.

75 Cronin, S. (1971) The Revolutionaries p. 177

76 O'Donnell, P. (2017) pp. 7-8

77 McNamara, C. (2019) p. 142

78 Wolfe Tone, T. (2009) [Moody, T.W., McDowell, R.B., & Woods, C.J. Eds.] *The Writings of Theobald Wolfe Tone 1763-98, Volume II: America, France and Bantry Bay, August 1795 to December 1796,* Oxford: Clarendon Press p. 107

79 Cronin, S. (1971) *The Revolutionaries* p. 192

80 Desmond Greaves, C. (2004) p. 385

81 *Ibid*. p. 981

82 Piggott, Cannon J. '1922 Executions Recalled,' *Athenry Journal*, 8 (Christmas 1997), p. 9 *referenced in* McNamara, C. (2019) p. 185

83 An Irish pejorative for someone seeking a quick profit or self-gain.

84 McNamara, C. (2019) p. 142

85 Adams, G. (1986) p. 40

86 Hanna Sheehy-Skeffington to Alice Park, 25 Feb 1922, Alice Park Collection, Hoover Institution Archives, Stanford, California *ref-*

erenced in Ward, M. (2019) p. 320

87 Griffith, K. & O'Grady, T.E. (2007) *Curious Journey: An Oral History of Ireland's Unfinished Revolution,* London: Hutchinson & Co. (Publishers) Ltd. pp. 270-271

88 McCarthy, J. P. (2006) *Kevin O'Higgins: Builder of the Irish State,* Dublin: Irish Academic Press p. 108

89 Statement of Views of Coiste Gnotha Relative to the Political Aspect of the Present Situation (10 October 1924), UCDA, FitzGerald Papers, P 80.1101 (1-4) *referenced in* McCarthy, J. P. (2006) p. 160

90 Cronin, S. (1971) *The Revolutionaries* p. 191

91 Fanning, R. (1983) *Independent Ireland,* Dublin: Helicon Limited p. 72

92 *Ibid.* p. 76

93 *Ibid.* p. 64

94 *Ibid.* p. 70

95 Keogh, D. (2005) *Twentieth Century Ireland,* Dublin: Gill & Macmillan Ltd. p. 38

96 Mac Eoin, U. (1987) p. 212

97 Foster, R. F. (1989) *Modern Ireland 1600-1972,* London: Penguin Books Ltd. p. 525

98 Whelan, N. (2011) p. 2

99 James Fintan Lalor (1807-1849).

100 Ryan to Rosamond Jacob, 11 Sept 1927 (NLI, MS 31130/I) in McGarry, F. (2010) p. 11

101 Lieut Waterford City Battalion, IRA; later Sergt. XV International Brigade, Spain

102 The Bodenstown Commemoration is the annual commemoration in memory of Theobald Wolfe Tone.

103 Mac Eoin, U. (1987) p. 7

104 Keogh, D. (2005) p. 54

105 Mac Eoin, U. (1987) p. 7

106 Desmond Greaves, C. (2004) p. 155

107 Mac Eoin, U. (1987) p. 29

108 Cronin, S. (1971) *The Revolutionaries* p. 192

109 McNamara, C. (2019) p. 126

110 Regan, J. M. (1999) p. 374

Bibliography

Books

Adams, G. (1986) *The Politics of Irish Freedom.* Co. Kerry: Brandon

Bowyer Bell, J. (1995) *The Secret Army: The IRA 1916-1979.* Dublin: Poolbeg Press Ltd

Coogan, T. P. (1990) *Michael Collins: A Biography.* London: Hutchinson

Cronin, S. (1971) *The Revolutionaries.* Dublin: Republican Publications Ltd.

Cronin, S. (1971) *Ireland Since the Treaty.* Dublin: Irish Freedom Press

Cronin, S. (1981) *Irish Nationalism: A History of its Roots and Ideology.* New York: The Continuum Publishing Company

Desmond Greaves, C. (2004) *Liam Mellows and the Irish Revolution.* Belfast: An Ghlóe Gafa

Desmond Greaves, C. (2018) *The Life and Times of James Connolly.* Croydon Manifesto Press

Ferriter, D. (2005) *The Transformation of Ireland 1900-2000.* London: Profile books ltd

Ferriter, D. (2007) *Judging Dev: A reassessment of the life and legacy of Éamon de Valera.* Dublin: Royal Irish Academy

Fewer, M. (2018) *The Battle of the Four*

Courts: *The First Three Days of the Irish Civil War.* London: Head of Zeus Ltd.

Fanning, R. (1983) *Independent Irelan* Dublin: Helicon Limited

Foster, R. F. (1989) *Modern Ireland 1600-1972.* London: Penguin Books Ltd.

Griffith, K. & O'Grady, T.E. (2007) *Curious Journey: An Oral History of Ireland's Unfinished Revolution.* London: Hutchinson & Co. (Publishers) Ltd.

Keogh, D. (2005) *Twentieth Century Ireland.* Dublin: Gill & Macmillan Ltd.

Lenin, V.I. (2004) *The Right of Nations to Self Determination.* Honolulu, Hawaii: University Press of the Pacific

Mac Eoin, U. (1987) *Survivors.* Dublin, Argenta Publications

McCarthy, J. P. (2006) *Kevin O'Higgins: Builder of the Irish State.* Dublin: Irish Academic Press

McNamara, C. (2019) *Liam Mellows: Soldier of the Irish Republic – Selected Writings, 1914-1922.* Kildare: Irish Academic Press

McGarry, F. (2010) *Frank Ryan.* Dublin: University College Dublin Press

Maher, J. (1998) *Harry Boland: A Biography.* Dublin: Mercier Press

Marx, K. & Engels, F. (1971) *On Ireland.* London: Lawrence & Wishart

Ó Broin, E. (2009) *Sinn Féin and the Politics of Left Republicanism.* London: Pluto Press

O'Donnell, P. (2017) *There Will Be Another Day: The Inside Story of the 1920s Land Struggle.* Donegal/Glasgow: Red Sky Books

Rafter, K. (2005) *Sinn Féin 1905-2005: In the Shadow of Gunmen.* Dublin: Gill & Macmillan

Rafter, K. (2011) *The Road To Power: How Fine Gael Made History.* Dublin: New Island

Regan, J. M. (1999) *The Irish Counter Revolution: Treatyite Politics and Settlement in Independent Ireland.* Dublin: Gill & Macmillan

Regan, J. M. (2013) *Myth and the Irish State.* Sallins, Kildare: Irish Academic Press

Ward, M. (2019) *Fearless Woman: Hanna Sheehy-Skeffington, Feminism and the Irish Revolution.* Dublin: University College Dublin Press

Weeks, L. & Clark, A. Eds (2020) *Radical or Redundant: Minor Parties in Irish Politics.* Dublin: The History Press

Whelan, N. (2011) *Fianna Fáil: A Biography of the Party* Dublin: Gill & Macmillan

White, R. W. (1993) *Provisional Irish Republicans: An Oral and Interpretive History.* London: Greenwood Press

Wolfe Tone, T. (2009) [Moody, T.W., McDowell, R.B., & Woods, C.J. Eds] *The Writings of Theobald Wolfe Tone 1763-98, Volume II: America, France and Bantry Bary, August 1795 to December 1796.* Oxford: Clarendon Press

Journals

Regan, J. M. ' The Dynamics of Treatyite Government and Policy, 1922-33' *Irish Historical Studies*, Vol. 30, No. 120, pp. 542-563 (Nov, 1997)

Online Sources

'Agreement reached on final programme for government' *RTÉ News*, 15 June 2020. Online <https://www.rte.ie/news/politics/2020/0615/1147519-government-formation/> (accessed 29/07/2020)

McGreevy, R. (2020) 'Historic coalition agreement ends almost a century of Civil War politics' *The Irish Times*, 27 June 2020. Online <https://www.irishtimes.com/news/ireland/irish-news/historic-coalition-agreement-ends-almost-a- century-of-civil-war-politics-1.4290514> (accessed 29/07/2020)

Reidy, T. (2020) 'End of an era as Civil War parties take the once-unthinkable step' *Irish Independent*, 27 June 2020. Online <https://www.independent.ie/irish-news/politics/end-of-an-era-as-civil-war-parties-take-the-once-u nthinkable-step-39320067.html> (accessed 29/07/2020)

'Fianna Fáil and Fine Gael - sworn enemies work together' *RTÉ News*, 27 June 2020. Online <https://www.rte.ie/news/newslens/2020/0626/1149770-fianna-fail-fine-gael-civil-war-politics/> (accessed 29/07/2020)

Clifford, M. (2020) 'New government could be sign of Irish politics finally growing up' *The Irish Examiner*, 27 June 2020. Online <https://www.irishexaminer.com/opinion/commentanalysis/arid-31007856.html> (accessed 29/07/2020)

Harris, E. (2020) 'Leo Varadkar must learn to live with less media' *Irish Independent*, 02 August 2020. Online <https://www.independent.ie/opinion/comment/leo-varadkar-must-learn-to-live-with-less-media-3 9416371.html> (accessed 04/08/2020)

McCurry, C. & McMahon, A. (2020) 'Leo Varadkar hails end of 'Civil War politics' in Ireland's parliament' *The Belfast Telegraph*, 27 June 2020. Online <https://www.belfast-telegraph.co.uk/news/republic-of-ireland/leo-varadkar-hails-end-of-civil-war-p olitics-in-irelands-parliament-39320632.html> (accessed 29/07/2020)

Downing, J. (2020) 'Collins and Dev on the same wall could be more than just a clue about things to come' *Irish Independent*, 29 June 2020. Online <https://www.independent.ie/opinion/collins-and-dev-on-the-same-wall-could-be-more-than-just-a -clue-about-things-to-come-39323541.html> (accessed 04/08/2020)

https://www.dail100.ie/en/debates/1919-01-21/1903 (accessed 29/07/2020)

https://api.parliament.uk/historic-hansard/commons/1922/jun/26/irish-office-etc#column_1712 (accessed 29/07/2020)

Dáil Éireann debate - Wednesday, 4 Jan 1922 - Vol. T No. 11 https://www.oireachtas.ie/en/debates/debate/dail/1922-01-04/speech/53/ (accessed 29/07/2020)

BLACK LEFT FEMINISM,
AND THE
'OLD LEFT'

REAL GIRL'S
TALK

JOHN FORTE

Marxism continues to influence the lives of radical black women. To paraphrase Marx in *The Eighteenth Brumaire of Louis Bonaparte*, the traditions of the dead haunt the minds of the living. Black Marxist feminism, or black left feminism, rose during the 'Old left' of the 1920s and the 1930s. Black women worked inside and adjacent to the Communist Party in places like Chicago, Harlem, and the urban South. These black left feminists were profoundly shaped by the politics of the Communist Party. In turn, they pushed traditional Marxist theory to the left by developing alternative forms of street politics, deepening theories of women's oppression, and expanding internationalist commitments. Through their work with the International Labor Defense, Unemployed Councils, Tenants Unions, and other CP-affiliated organizations, black left feminists carved out a space for themselves that centered the basic needs of working people. Through their lived experiences, they challenged traditional notions of black womanhood and theorized intersections between race, class, and gender that demonstrated the unique revolutionary capabilities of radical black women. Their travels abroad and interest in Pan-African solidarity elevated commitments to internationalism. Even so, the dynamic between the Comintern's directives and their own grassroots initiatives was complex due to black women's rich legacy of collective agency.

Domestic workers organized for their rights as free laborers during the era of reconstruction. As Tera Hunter's book *To 'Joy My Freedom* shows, domestics – many of them formerly enslaved - viewed their work as a means to self-sufficiency. They resisted Antebellum valuing of black women's bodies in terms of their reproductive capabilities.[2] The politics of "quitting" was

"... we never talked about men or clothes or other such inconsequential things when we got together. It was always Marx, Lenin, and revolution – real girl's talk."[1]

widespread, as they left jobs that did not suit their liking. Quitting could not guarantee better working conditions or pay, but it was a political act that deprived largely white employers of their power in relations with laborers.[3] As early as 1866, black washerwomen organized strikes against predominantly white patrons in Jackson, Mississippi. Similar rebellions erupted in Galveston, Texas in 1877 and Atlanta, Georgia in 1881. At the same time, black women engaged in political work for the Republican Party and organized mutual aid groups, secret societies, and church groups.[4] Thus, many working-class black women were well versed in social and political organizing as the nineteenth century ended.

The early twentieth century saw an organized left that swelled, despite its inability to adequately address issues of race and gender.

Eugene Debs ran for president under the Socialist Party ticket five times – receiving nearly one million votes from prison in 1920.[5] In his article "The Negro in the Class Struggle," written in 1903, Debs acknowledged that blacks were "doubly enslaved." Personally, he felt a "burning sense of guilt… that makes me blush for the unspeakable crimes committed by my own race." Nevertheless, Debs prioritized concerns of class over of race, arguing that "we have nothing special to offer the Negro, and we cannot make separate appeals to all the races."[6] Similarly, black socialist Lucy Parsons viewed sexism and racism as economic problems. She blamed employers for sewing identarian divisions among workers in order to exploit them.[7] On the other hand, pioneering black socialist Hubert Harrison captivated black audiences with rousing street corner speeches that demonstrated the intersection between capitalist exploitation and racism. Harrison's West Indian background and working-class demeanor appealed to black immigrants in Harlem. This contributed to the rise of a particularly transnational form of Caribbean socialism.[8] Recognizing the Socialist Party's limitations, Black women concerned with everyday experiences of racism and sexism looked elsewhere for their politics.

Most importantly, it was the Women's Conventions of the black Baptist church that gave black women reformers a voice for their political needs. They articulated what scholar Evelyn Higginbotham calls the "politics of respectability," which advocated racial uplift and assimilation to high-class Victorian manners. Fundamentally, it championed individual moral reform as the path to structural change. To appeal to middle-class Americans and white philanthropists, Women's Conventions condemned "idleness" and "vice" among the black lower classes, but also materialism among the upper class.[9] Women's Con-

ventions tapped into Christian teachings that emphasized the struggles of the poor and downtrodden, echoing later pronouncements of liberation theology.[10] By the early 1920s, women's clubs were seen by the black masses as increasingly elitist, concerned with middle-class respectability, and disdainful of the working poor.[11] Despite its contradictions, the "politics of respectability" created a space for working class black women to engage in organizing that directly addressed their unique experiences.

In contrast, the Universal Negro Improvement Association (UNIA) and the African Blood Brotherhood (ABB) appealed to African Americans who were impatient with assimilationism and moderate reforms. This ideological formation was committed to black nationalism, or what African American studies scholar Eric McDuffie calls "New Negro Radicalism." Rooted in the urban United States, this militancy was sparked by Northern migration, anti-colonial struggles, and race riots in American cities that culminated in the Red Summer of 1919. The New Negro movement promoted racial uplift, self-help, temperance, and the accumulation of individual wealth.[12] In 1920, 25,000 UNIA delegates drafted a statement in Harlem, titled "Declaration of the Rights of the Negro Peoples of the World." Exemplifying its Pan-African politics, it condemned European colonialism and demanded self-determination, independent social institutions, and an end to discrimination for black people.[13] In spite of the UNIA's paternalism, the influence of women such as Amy Ashwood and Amy Jacques Garvey — Marcus Garvey's first and second wife, respectively

– contributed to Pan-African theorizing and prompted a "lady president" at each local UNIA branch.[14] In *Black Marxism, the Making of the Black Radical Tradition*, Cedric Robinson contended that traditional accounts of the UNIA tend to focus on the cult of personality surrounding Garvey and accusations of opportunism. The aspirations and interests of black working people mobilized under its sway are rarely given attention.[15] Symbolic of the UNIA's lasting influence, black nationalism was a major point of interest for the African Blood Brotherhood and the Communist Party.

The African Blood Brotherhood was formed in 1919 as the first group to fuse socialist politics and racial liberation in the United States. Its founding members included Cyril Briggs, Richard B. Moore, Harry Haywood, and Grace Campbell – all of whom were active on the Communist left a decade later.[16] Although the group was committed to liberation, Grace Campbell's role was limited to secretarial work, as men assumed the lead positions in the organiza-

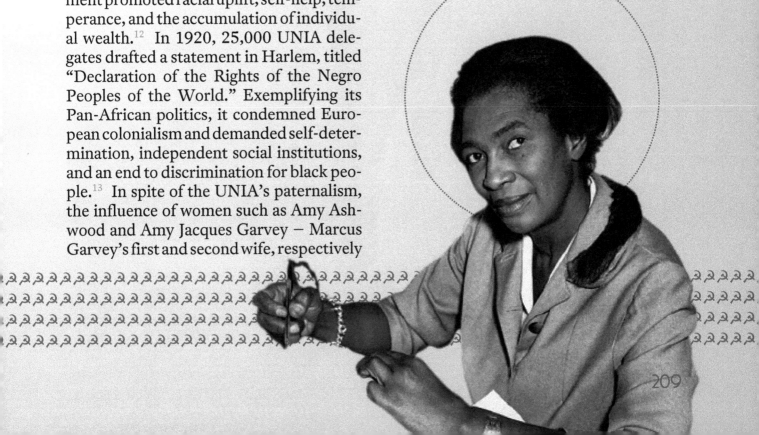

tion.[17] Liberation of women under capitalism was not a priority. According to scholar of black intellectual history Minkah Makalani, the ABB included some of the first black Communists in the world, but never adopted feminist leanings. In general, it viewed liberation through the lens of armed self-defense and black manhood, relegating women to caretaking positions as "mothers."[18] The African Blood Brotherhood never matched the size and influence of the UNIA, but it was the basis for Communist International's commitment to black liberation.

The Communist movement in the United States rose out of the ashes of a split in the Socialist Party after the Bolshevik revolution in Russia in 1917. The Socialist Party's left formed the Communist Party of America, consisting mostly of foreigners born in Eastern Europe and well versed in Marxist theory. Other left socialists - mostly American born and lacking experience in formal political work - formed the Communist Labor Party. Both groups were united as the Workers Party, later renamed the Communist Party USA under pressure from the Communist International in Moscow.[19] The CPUSA was a unique fusion of previously existing tendencies in the left wing of the Socialist Party and principles of the Bolsheviks in Russia.

The rhetoric of "the new Soviet woman" attracted American leftist women, as it depicted women as modern and sexually liberated. Russian Marxist revolutionary and theoretician Alexandra Kollontai was one of the key drivers of Soviet women's liberation. In her 1909 essay, *The Social Basis of the Woman Question*, she attacked middle-class feminists for their neglect of working-class women:

It is true that several specific aspects of the contemporary system lie with double weight upon women, as it is also true that the conditions of hired labour sometimes turn working women into competitors and rivals to men. But in these unfavourable situations, the working class knows who is guilty.[20]

Kollontai's notion of "double oppression," echoed similar American articulations, such as Sojourner Truth's

1851 speech *Ain't I a Woman*. In comparison, Kollontai rooted women's oppression in class oppression. Soviet policy towards women was directly influenced by these expressions of socialist feminism.

The Soviet Union was the first nation in the world to legalize divorce and abortion, positioning it as a leader of progressive struggles for women.[21] In response to the "women's question," the Third Congress of the Communist International declared in 1921:

But as long as the proletarian woman remains economically dependent upon the capitalist boss and her husband, the breadwinner, and in the absence of comprehensive measures to protect motherhood and childhood and provide socialised child-care and education, this cannot equalise the position of women in marriage or solve the problem of relationships between the sexes.[22]

In essence, the Soviet Union insisted that women's rights had to be advanced beyond suffrage. Some of its policymakers recognized that the social position of women was rooted in their role as caretakers and providers of unpaid social reproduction in the home. The Bolshevik Revolution was seen as a model for women around the globe.

In the 1920s, two landmark directives on the "Negro question" came out of the Soviet International that directly addressed the position of Africans Americans. In the Communist Party's early years, its position on race differed little from the Socialist Party's class-reductionism. In 1920, Lenin addressed the American Communist Party's lack of interest in the "Negro question." This led to the CP actively organizing blacks in 1921. Inspired by the 1922 Fourth Comintern Congress resolution that endorsed black liberation, Cyril Briggs, Richard B. Moore, and other black leftists joined the Workers Party in 1923.[23] One year later, "Negro Women Workers," was published in the *Daily Worker*, the CP's main publication. Written by a white woman, it articulated the party's changing positions. It cited the unique struggles of black women both at home and at work, quoting a black mother who remarked, "I am so worried and worn in my strength that I feel at times as if I can stand it no longer. It is not alone the need of money but the responsibility of being nurse, housekeeper and wage earner at one time."[24] The special oppression of black working women was noted, but not theorized by the party. Drawn to Communism for its special recognition of racial oppression, black women brought their own talents and experiences that challenged the Party's positions on race and gender.

Grace Campbell

Grace Campbell was born in Georgia in 1882 to an African American mother and a Jamaican father. She was one of the first black women to join the Communist Party. After graduating from Howard University, she taught in Washington D.C. and Chicago, seeing this as racially uplifting work. She moved to New York City in 1905 and became a probation officer for the New York Court of General Sessions. In 1916 she established the Empire Friendly Shelter for single mothers in need.[25] It was her experiences in New York City that exposed Campbell to poverty and discrimination in the criminal justice system that working class black women regularly faced. Grace Campbell was radicalized as she began to view the causes of oppression as systemic, rather than rooted in individual moral failures.

Campbell's changing views brought her into contact with intellectual and radical cir-

cles in Harlem. After World War I, she be-friended black socialist luminaries such as Hubert Harrison, Cyril Briggs, Richard B. Moore, and A. Phillip Randolph.[26] Previously, women were absent from this milieu. In the summer of 1917, she helped launch the People's Education Forum. The PEF sponsored lectures and debates on Sunday afternoons. Some of the lectures included W.E.B. Dubois on "The War and the Darker World," William Pickens of the NAACP on "What I saw in Russia," and Hubert Harrison's talk "Is the White Race Doomed?" Discussion events included topics such as "The Relation of the Race Problem to the Proletarian Movement," which connected black liberation with anticolonial struggles and socialism. Referred to as an "intellectual battleground," it is hard to believe that Campbell did not interject concerns of gender at PEF events.[27] Campbell did not put much of her writing into print, but her activities set the stage for African American women to assert their own issues in the CP.

One of Grace Campbell's greatest contributions was her work with the Harlem Tenants League. Formed in January 1928, its original leadership included black radical women such as Elizabeth Hendrickson, Hermina Dumont Huiswoud, Williana Burroughs and Grace Campbell - reflecting black women's unique interest in addressing the basic needs of the working-class. Its activities included demonstrations, rent strikes, physically blocking evictions, and fighting for housing regulations to be enforced through direct action. In its rhetorical analysis, this group connected housing issues to imperialism, capitalism, and white supremacy. The HTL became the model for the CP-affiliated Unemployment Councils — which were some of the most popular organizing platforms during the height of the Great Depression. With as many as 500 members, the female led HTL connected

everyday experiences to capitalism by focusing on cost-of-living issues that directly affected families.[28] This suggests that black women on the left recognized the need for a different means to raise class consciousness, which then brought an entirely new swath of people into CP networks. Even more, it was one of the first uptakes of the Comintern's "Black Belt thesis."

Grace Campbell's intellectual thought progressed in tandem with her organizing. She published a column entitled "Women in Current Topics" in the *New York Age*—a column that differed remarkably from earlier views which blamed poverty on individual moral failings. In her column, she argued that the criminal justice system functioned primarily to reproduce hierarchies of race, class, and gender. She went on to note that institutional oppression reinforced stereotypes about poor black women as criminal and deviant.[29] Truly, this work was ahead of its time. It predates Louis Althusser's Marxist theory of *interpellation* - how ideology transforms individuals into pliant subjects through actions, which was illustrated in the early 1970s.[30] In addition, it was a precursor to *Are Prisons Obsolete?* - Angela Davis's landmark book on prison abolition.[31] Therefore, Campbell was one of the first black left feminists to argue that the hyper-exploitation of black women put them in a position to be the premier vanguard for social change.

Williana Burroughs

Williana Burroughs was another early contributor to the tradition of black Marxist feminists in the US. She was born to a formerly enslaved woman in Petersburg, Virginia in 1882.[32] After moving to New York City, she graduated from Hunter College in 1902 and met Hubert Harrison in 1909. She was radicalized as an elementary school

teacher in poor neighborhoods in New York City and joined the CP in 1926. Throughout the early 1930s, Burroughs was involved with the Rank and File Caucus of the New York City Teachers Union, which was dominated by Communists. In 1934, Burroughs was dismissed from her teaching position for "conduct unbecoming a teacher," after she criticized the school board for failing to provide adequate lunches to students and for discriminating against black teachers. As historian Clarence Taylor argues, the militant actions of Burroughs and others increased the Rank and File's favorability, showing teachers that radicals were willing to risk their livelihoods to advocate for colleagues and students.[33] In addition to running for lieutenant governor, she ran for city comptroller and received more votes than other candidate on the CP ticket for a New York City office.[34] Eventually, Burroughs became the director of the Harlem Workers School, a Marxist study center that offered courses and lectures on issues such as the national question. Following the Harlem riot of 1935, she was an effective witness for the Party. During her testimony, she indicted the city for the deepening structural racism and poverty that led to the riot. Thus, Burroughs demonstrated that she was a dedicated and daring grassroots activist who could be trusted by Harlem CP leaders.

It was Williana Burroughs' international work, however, that elevated her status in the party. In 1928, she attended the Sixth Party Congress in Moscow. There, she came in contact with black Communists from all over the world, including Otto Hall, Harry Haywood, William Patterson, and Maude White. From new research in the Russian State Archive on Social and Political History, professor of history Minkah Makalani detailed Williana Bur-

In essence, the Soviet Union insisted that women's rights had to be advanced beyond suffrage. Some of its policymakers recognized that the social position of women was rooted in their role as caretakers and providers of unpaid social reproduction in the home. The Bolshevik Revolution was seen as a model for women around the globe.

roughs's address. It was the first speech by a black woman to the Comintern. She argued that the Communist parties of the west poorly addressed racism and anticolonial struggles. She criticized the American Communist Party's lack of strategy in organizing Southern blacks. Even in the North, she called out the CP's failure to send organizers into cities. In her view, Party organs for African Americans such as the American Negro Labor Congress lacked resources. Most strikingly, she lambasted the CP for its complete lack of diversity in its leadership. To her, West Indian, African, unemployed, and young black women were crucial to mass party work.[35] Williana Burroughs fought for black women to be recognized as revolutionary leaders by highlighting their ability to connect deeply with the African diaspora. Undoubtedly, her speech influenced the Comintern's 1928 "Black Belt thesis" and its emerging focus on black self-determination.

The International Trade Union Committee of Negro Workers represented the Communist International's highest commitment to Pan-Africanism. Burroughs served on the ITUCNW's Provisional Executive Committee, which organized the group's founding conference in Hamburg, Germany. Internal reports in preparation for the conference reveal that she pushed the organization to address child labor. Furthermore, she wanted it to organize black women industrial workers across the United States and the Caribbean. Burroughs pointed to the fact that, "Negro women, among whom are a large number of foreigners from the Caribbean, [are] themselves sufferers from imperialism."[36] To her, struggles for women and anticolonialism were interlocking: they offered a means to capture women's cultural imaginations and to prove that a new world was possible.

During this time, Burroughs wrote regularly for the *Daily Worker* under the Pseudonym Mary Adams. Her article in a 1928 May Day issue, titled "Record of Revolts in Negro Workers' Past," depicted the history of black struggles against racism in the United States.[37] In November of 1930, Williana Burroughs wrote an article for the *Negro Worker* on the importance of the ITUCNW to the black freedom movement in conjunction with the Red International of Labor Unions. She explicitly called for workers in the imperial metropolises of Britain and the United States to unite with

workers in the colonies. Showing the depth of her analysis, she detailed American imperialism's penetration into Africa with statistics of investments in Belgian copper mines in the Congo, as well as Firestone's investments in Liberia.[38] Her analysis showed an astute understanding of emerging forms of economic imperialism. Also, she called on leftist publications to pay closer attention to international workers' struggles:

The Negro workers in America know very little about the heroic fight of the Chinese workers, very little about the revolutionary movement of the workers of India; they know almost nothing of the movement in South Africa, simply because our press is very small and very weak.[39]

Burroughs concluded by demanding that workers in the west "make real to the workers in the colonies the solidarity of the workers of the world."[40] Despite Williana Burroughs's calls for internationalism, her article did not pay specific attention to women of color. Perhaps, her writing in high profile CP publications was limited by the desires of the men who dominated their editorial boards.

In 1937, Williana Burroughs returned to the Soviet Union to work with English-language radical broadcasts in Moscow — where she had previously sent her two children to school.[41] Williana Burroughs represented a Marxist feminist figure who pushed the Communist left to build international bridges between workers in the United States, Soviet Russia, and the third world. Still, other women emerged out of black cultural circles in similar roles.

Louise Thompson Patterson

One of the key conduits between the Harlem Renaissance, the American left, and the Soviet Union was Louise Thompson Patterson. Born in Chicago in 1901, her family moved to Seattle, West Oakland, and Arkansas. The reality of racism was glaring during her childhood and she suffered racist taunts from white children.[42] She recalled the impact that a lynching had on her perception of white Americans:

They took this body and burned it in the main street of the black community in Little Rock and all of the top Negroes ran, left the town. They either went to Chicago or they came over to Pine Bluff [Arkansas]. I was enraged. I went around for days. I just couldn't see. I hated anything white.[43]

She recalled how school board members in Pine Bluff, Arkansas, openly referred to African Americans with harsh slurs. Understandably, these experiences and Thompson's middle-class background motivated her to acquire a formal education and to work to uplift the black masses.

Louise Thompson was the first black woman to graduate from University of California, Berkeley. Her education itself did not bring her to the left, as she stated: "Imagine going through the school of economics at the University of California and I never heard of Karl Marx. Never heard of him."[44] Still, Thompson met W.E.B. Du Bois after a lecture at Berkeley. This meeting inspired her to dedicate her life to fighting racial injustice.[45] At this point, W.E.B. Du Bois's theory of the "talented tenth," which called for a black leadership to cultivate intellectualism among the black masses, was central to Thompson's philosophy.[46]

Louise Thompson's experience working at black political institutions such as the

Hampton Institute in Virginia and the National Urban League in New York City alienated her from traditional black elites. She criticized these figures for their "bourgeois fraternalism," coming to see their close ties to white capitalism as hypocritical. After supporting a strike by black students against segregation at the Hampton Institute in 1927, Thompson was asked to leave. Echoing the 'politics of respectability,' the administration condemned her actions as inappropriate for a teacher. In 1928, she accepted a one-year Urban League fellowship as a social worker at the Institute for Social Research in New York City. Building relationships with the urban poor, she was convinced that social work did not address the root cause of urban poverty.[47] Louise Thompson's disillusionment with liberalism brought her closer to the left.

Despite her problems with the outlook of the Institute for Social Research, Thompson's setting in New York offered other avenues for more radical political work. She left the institute to become the editorial secretary for Langston Hughes and Zora Neal Hurston. Through these connections, she organized seminars on race and labor for the Congregational Educational Society. But it was her founding of the "Vanguard Club" and its subsequent discussion groups that sparked her intellectual curiosity with the left.[48] The "Vanguard Club" was a public forum and a Marxist study group. Harlem Renaissance artist Aaron Douglas and writer Langston Hughes were regular participants.[49] In addition to discussing social issues during Saturday night parties, the "Vanguard Club" held Sunday forums involving writers, prominent figures who visited the Soviet Union, and leading intellectuals such as Carter G. Woodson. In one instance, they held a debate over whether the National Recovery Act "was a step forward or a step towards fascism."[50] All in all, Louise Thompson Patterson's calling as an organizer changed her life.

In 1931, she helped establish the Harlem Chapter of Friends of the Soviet Union.[51] This group discussed events in the Soviet Union and raised funds for the defense of the Scottsboro Boys.[52] Interested in Marxism, Thompson began attending political science classes at the Workers' School in New York City. She read classic Marxist texts such as Vladimir Lenin's *State and Revolution* and Friedrich Engels's *Origins of the Family, Private Property and the State*. In her words, studying Marxism was "eye opening." She "began to understand much more about the character of the society in which we lived."[53] At this time, Thompson was more familiar with Marxism, but she was not a member of the CP. Such a step offered close friends and a sense of purpose, but often resulted in social isolation outside of the Party. Even so, many African Americans were drawn to the CP due to its support for black self-determination.

African Americans frequently saw the Soviet Union's interest in black history as admirable, but also tainted by propaganda. The Soviet state launched a project to create a musical called *Black and White* using American actors. Its goal was to depict the development of African American life in the United States amidst deeply entrenched racism. On June 14, 1932, twenty-two Americans, mostly middle-class, white-collar, and black, sailed for Moscow.[54] Louise Thompson Patterson and Langston Hughes, both participants, took issue with the script's stereotypical depiction of black life and the German director's ignorance of the complexities of African American history.

Thompson commented that "most people

think that all Negroes can sing and dance. Most of us could do neither."[55] In one scene, the film depicted white workers from the North saving black union workers in Montgomery, Alabama from a racist Southern mob. Russians had little concept of racial violence in the North, such as the Red Summer of 1919. The film was called off for reasons that are numerous and debatable, but it is clear that the script's content and the director's preconceived notions about race in America were not well received by Thompson, Langston Hughes, and others.[56] Despite these problems with *Black and White*, Thompson defended it.

Thompson's defense of *Black and White* was likely due to her travels in the Soviet Union that exposed her to the treatment of minorities in a foreign country. Soviet authorities, working for a new nation that was still an imperial power, probably exaggerated its equal treatment of minorities. Still, it contrasted sharply with Thompson's experiences with racism in the United States. She was impressed by the Soviet people's knowledge of the Scottsboro case, which was not widely known by African Americans at the time. Several of the cast members visited Soviet port cities across Central Asia and were surprised that so many Soviet citizens were non-white. Louise Thompson Patterson commented that, "many Americans don't realize that under the Soviet Union not everybody's white. And that in central Asia you have

> In Patterson's view, the remedy for black women's oppression was solidarity. Progressive-minded women, both white and black, had to show support for each other without sadness or pessimism.

people that are brown and black. The only difference between them and blacks in the United States is that they don't have curly hair."[57] The absence of Jim Crow laws and blatant racism certainly left a profound impression on her as she commented that, "what I had witnessed, especially in Central Asia, convinced me that only a new social order could remedy the American racial injustices I know so well. I went to the Soviet Union with leftist leanings; I returned home a committed revolutionary."[58] To say the least, Thompson's visit to the Soviet Union fully convinced her that racism and capitalism were anything but permanent.

The Communist Party offered new opportunities for Louise Thompson, but some of her close friends criticized her choice. After joining in 1933, her friends Mary McLeed Bethune and W.E.B. Du Bois expressed concern that her decision to join the Communist Party would ruin her career prospects. She chose to ignore their pleas, believing that the time for reform was over. Thompson no longer had patience for political moderation. She went on to join the CP-affiliated International Working Order.[59] The IWO functioned essentially as an insurance and fraternal organization for workers, but it also provided much more.[60]

In 1935, she became the IWO's national recording secretary, demonstrating the party's interest in promoting people of color to high positions. According to Thomp-

son, there were few black members in the organization, which sparked her interest in bringing black members into the IWO.[61] Although the IWO was primarily concerned with providing workers with a basic social safety net, Patterson was motivated by its potential to unite the international working class.

In Louise Thompson Patterson's view, the International Working Order helped bridge the gap between the experiences of immigrant workers and their native cultures. Speaking positively of the IWO, she commented that it was an "organization of which a great deal of the culture of the old countries was kept alive. And young people were given an appreciation of their history." She was likely referring to the effect of IWO sponsored native-language newspapers on second generation immigrants.[62] Such multicultural work defied ugly nativist traditions in the United States. More than being multicultural, Thompson saw the IWO as an organization that could directly counter manifestations of white supremacy:

not only did the IWO help to keep alive and to perpetuate the contributions of the various ethnic groups that have come to make America the United States. But the concept of what is an American, which, by and large, over the centuries, has been what is the perfect American? An Anglo-Saxon. What is the culture? Anglo-Saxon.[63]

Louise Thompson saw a distinction between the imagined "native born" whiteness of Americans, which was largely Protestant and Anglo-Saxon, and European immigrants with less social advantage. Many of these first and second-generation immigrants did not benefit from what Du Bois called the "psychological wage" of whiteness.[64] Additionally, Thompson recognized the allure of whiteness, both culturally and as a marker of status:

if you think of the early movies, and even up to today, the people who are the heroes are primarily blonde and blue eyed. The villains are swarthy and dark, if they're not black. And this affects the younger generations, so that the children of immigrants who wanna get away, who wanna become Americanized, what do they become?[65]

To Louise Thompson Patterson, her work in the IWO was personal. Drawing back on her experiences in the Soviet Union with its minority population, she saw the IWO as a vehicle to combat racism and unite workers across ethnic lines. On the other hand, opportunities for women in the organization were limited to running the children's section, the youth division, and summer camps such as the leftist Kinderland Camp. Women were always in the minority of decision makers in the International Working Order. Although Louise Thompson was effectively restricted from the executive committee, she did not shy away from expressing the inferior position of black women.

In her 1936 article "Toward a Brighter Dawn" published in the CP-affiliated publication *Women Today*, Patterson cast light on the special oppression that black women faced as domestic workers. Through her poetic and lyrical tone, she described their near soul-breaking work:

Early dawn on any Southern road. Shadowy figures emerge from the little unpainted, wooden shacks alongside the road. There are Negro women trudging into town to the Big House to cook, to wash, to clean, to nurse children – all for two, three, dollars for the whole week. Sunday comes – rest day. But what rest is there for a Negro mother who must crowd into one day the care of her own large family? Church of course, where for a few brief hours she may forget, listening to the sonorous voice

of the pastor, the liquid harmony of the choir, the week's gossip of neighbors. But Monday is right after Sunday, and the week's grind begins all over.[66]

To Thompson, the pain and suffering that these women endured was symptomatic of employers' views that domestic workers were less than human. Sunday was both a blessing and a curse. It was the day for unpaid housework for the family, but also a day of spiritual rejuvenation and collective joy. Church services prepared domestic workers for the challenges of the following week. In comparison, Thompson described domestic work in the North using the image of the "slave market":

So thrifty "housewives" drive sharper bargains. There are plenty of women to choose from. And every dollar saved leaves that much more for one's bridge game or theater party! The Bronx "slave market" is a graphic monument to the bitter exploitation of this most exploited section of the American working population – the Negro women.[67]

With a sarcastic tone, Thompson excoriated middle class white women for their selfish materialism and hypocritical exploitation of black domestics. The symbolism of the slave market was not hyperbole. The Great Depression hit African Americans disproportionately hard. Notably, black domestic workers had to compete with white women who fell on hard times.[68] Middle class white women took advantage of this increased competition in what Ella Baker and Marvel Cooke referred to as "the Bronx slave market." Their 1935 article for the NAACP's *The Crisis* was a watershed expose of domestic workers' lives, but it did not explicitly theorize interlocking oppressions facing poor black women.[69] Baker, a well-known community activist, and Cooke, secretly a Communist, were probably in contact with Louise Thompson, as all

219

three of these women were active in New York City social movements. Driven by this rising consciousness, many black women joined organizations like the NAACP, the Communist Party, and the Domestic Workers Union (DWU) – which was formed in June of 1936 in New York City and quickly totaled around one thousand members.[70] Their anger against social and economic injustice fueled collective action.

<hr>

It was Louise Thompson Patterson's coining of the phrase "triple exploitation" that was most notable. In "Toward a Brighter Dawn," she remarked that, "over the whole land, Negro women meet this triple exploitation – as workers, as women, and as Negroes. About 85 per cent of all Negro women workers are domestics, two-thirds of the two million domestic workers in the United States."[71]

<hr>

This was a very clear expression of intersectionality – the overlapping of different identities instead of viewing them in isolation. As Ashley Farmer suggests, this was the first use of the term "triple oppression."[72] It was expressed later in different forms by Claudia Jones, Angela Davis, the Combahee River Collective, and Kimberlé Crenshaw. In Patterson's view, the remedy for black women's oppression was soli-

darity. Progressive-minded women, both white and black, had to show support for each other without sadness or pessimism. Her experience with the Women's Sub-Session at the National Negro Congress in 1936 sparked this realization, as she recalled that "women from all walks of life, unskilled and professional, Negro and white women found themselves drawn together, found that they liked being together, found that there was hope for change in coming together."[73] In sum, collective organizing was the means to develop an intersectional consciousness that viewed race, class, and gender as inseparable.

Louise Thompson remained an activist throughout her life. She was involved in the Scottsboro campaign, various workers' struggles, and the civil rights movement of the 1950s and 1960s. She married William L. Patterson, a leader of the CP-affiliated International Labor Defense and a Communist. Essentially, she married herself to a life of activism.[74] Louise Thompson's legacy demonstrates that black left feminists used the CP as a vehicle to address issues that were outside the Party's priorities. Chiefly, they pushed the Party further to the left. While the Communist Party was a space for middle class women such as Thompson, its mass politics attracted women from more modest means, such as Bonita Williams and Audley Moore.

Bonita Williams

Most illustrative of women Party organizers among the masses was Bonita Williams. Born in the West Indies to a family of modest means, she took up the banner of Grace Campbell as the leader of the Harlem Unemployed Council and the Harlem Tenants League. In the party, she was an executive member of the New York

branch of the League of Struggles for Negro Rights - an anti-racist and anti-lynching mass organization that advocated for black self-determination. She was also a member of the ILD, and helped to organize campaigns in defense of the Scottsboro Boys. Her colloquial speech and lack of a formal education was strength that allowed her to develop close relationships with working class black Americans in Harlem whom she treated warmly with dignity . Widely known for her poetry, she published "Fifteen Million Negroes Speak" in the *Harlem Liberator* on the topic of the Scottsboro Boys. Expressing her views openly and without reservation, her poem demanded a civil rights bill for African Americans.[75] Williams' organizing shows how black left feminists imagined a political space that connected various struggles for basic living conditions, across various CP-affiliated groups, into a matrix of intersectional mutual aid.

In a mass action known as the "Revolt of the Housewives," Bonita Williams led hundreds of working-class women in Harlem – both black and white - against exorbitant meat prices. By the spring of 1935, butcher prices rose over fifty percent in most Harlem neighborhoods. Recognizing this issue, Williams formed the Harlem Action Committee in June of 1935.[76] Under the guise of this committee, women met in churches, lodges, and prayer meetings - all well-established social circles for women – to discuss direct action. An article in the *New Masses*, an American Marxist magazine published that year on June eighteenth, reported that, "women who have never ventured farther than a neighbor's flat to voice their views, have flung themselves into the activities of the meat strike."[77] This action galvanized housewives into militant action. Open air meetings and elections for local committees

against the high price of meat erupted across the city. Demonstrating their unity, the *New Masses* article depicted remarkable unity:

In Harlem, where the unemployment rate - and the food prices - are higher than anywhere else in the city, three hundred Negroes, mainly women, stand before a single butcher shop and chant "Don't Buy Meat Until the Price Comes Down!" "Don't Buy Meat Until the Price Comes Down!!"[78]

In many cases, meat retailers closed their doors. Other butchers actually joined demonstrations against wholesalers and suppliers. In the aftermath of strikes, marches, and picketing, meat prices fell as far as Chicago, with local newspapers reporting that the New York Action Committee Against the High Cost of Living was to blame. As many as 300 butchers agreed to close their stores to pressure wholesalers from June twelfth to June fifteenth and other Harlem butchers lowered their prices to as much as twenty-five percent.[79]

The most significant impact of the "Revolt of the Housewives" was its effect on the rising expectations of working women in Harlem. During the protests, women connected meat prices to malnutrition and children's health in their street corner speeches. As one organizer proclaimed, "this is a fight for the right to eat - for the right to feed our children. Isn't it so, sisters?" Collective action galvanized these women to challenge prevailing notions of the 'politics of respectability.' Housewives aggressively pressured men who owned butcher shops. This was done unrepentantly due to political leverage, as one woman told a butcher, "we do hope you'll cooperate with us. Because, you see, if you don't, the women will picket your place. You wouldn't want that. So, we'll both cooperate." In another instance, a housewife signaled the in-

fluence of internationalism in Harlem's diverse communities, proclaiming "that's the way to do it - fight for your rights! That's the way they do it where I come from - in Panama!"[80] Not only did street politics arouse a strong sense of multiracial class consciousness, they encouraged women to assert themselves without reservations.

On top of organizing houseworkers, Bonita Williams participated in a number of actions that exhibited her dedication to grassroots activism and internationalism. In May of 1938, Bonita Williams, along with Party functionary Richard Moore, organized a protest in solidarity with Jamaican sugarcane workers who were shot by British colonial forces. In addition, Williams was involved in the "Don't Buy Where You Can't Work" campaign to address racial discrimination in employment in Harlem. At the Works Progress Administration where she worked, Williams helped organize a union with other black, Italian, and Puerto Rican immigrant women.[81] It seems clear that Bonita Williams was fearless and exceptionally capable of

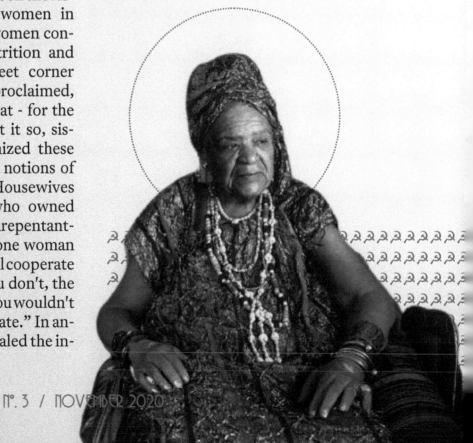

organizing. While she participated in formal Party work, that was not her focus. Working class organizers such as Bonita Williams and Audley Moore represented the potential of black left feminism to truly transform the social order in an American context that was deeply divided on grounds of race, ethnicity, and gender.

Audley Moore

Audley Moore came from a life of hardship in the rural South. She was born in New Iberia, Louisiana. Her paternal grandmother was raped by a white slave master, giving birth to her lighter skinned father.[82] He worked for himself and was a sheriff's deputy for a period. Her mother worked as a housewife. Both of her parents were enchanted by the politics of Marcus Garvey.[83] She was five years old when her mother died, while her father died when she was sixteen. Moore stopped attending school after the age of eleven because she had to take care of her siblings and was discouraged by her frequent tardiness. Her father was a part of what she called the "resistance movement" against Southern racists. He escaped a white mob that entered his home to attack him.[84] At a young age, Moore's brother was horsewhipped by a white man for playing with his white son. The threat of racism and violence in her youth was constant and it engendered in Moore a strong sense of racial consciousness.

After her father died, it was Audley Moore's experience as a domestic worker that brought her to a life of social struggle. She dropped out of school around the fourth grade.[85] As the caretaker of her siblings, she was compelled into domestic work.[86] She recalled one employer who molested her, remarking:

that was every case. Every job I got was the same thing. I had to leave because the boss of the house always came, found his way in my department, wherever I was. If I was in the nursery or if I was in the kitchen, and you just couldn't keep a job for the white man.[87]

Facing rampant sexual assault that so many domestics faced, Audley Moore chose to leave domestic work. Yet, this experience imbued in her a sense of struggle: "There never was a time when we were not in struggle. I don't think that anybody needed to come on to the scene to lead us, either. Innately, in our very bones, we wanted to be free. Always."[88] Propelled by experiences of oppression and inspired by the imagery and rhetoric of Marcus Garvey, Moore left New Orleans for New York City during World War I.[89]

Moore's arrival in New York City was emblematic of her increasing engagement in politics. She came to the city to witness the launching of the UNIA's Black State Line and ended up getting involved in local Republican Party politics.[90] It was the appeal of street politics and the left's fight against racism that brought her into the CP. Prompted by her sister, she went to see a CP demonstration in Harlem in support of the Scottsboro Boys:

I saw signs, "DEATH TO THE LYNCHERS!" Oh! That inspired me to no end. And I saw a young woman, carrying a sign, "DEATH TO THE LYNCHERS!" And I walked up to her and I said, "No you give me that sign!" I said "you can walk beside me, but I must carry the sign. I'm the black woman, I must carry that sign." So, I took the sign from her and I walked around."

It was clear that the Communist Party spoke to Moore's burning sense of black nationalism. Inspired by thousands of black and white demonstrators fighting to free the Scottsboro Boys, Moore and many other African Americans joined the CP because they believed it would address their needs

and interests. As Moore later commented, "this was a wonderful vehicle. If they've got a movement like that, and they're conscious of this thing that Garvey had been speaking about, then this may be a good thing for me to get in to help free my people."[91] It seems plausible that many radical-minded women of color in American cities saw the Communist Party as the next best organization for racial liberation after the decline of the UNIA in the 1920s. Truly, this was an organization that they believed would carry the banner of Garvey's black nationalism.

Audley Moore was active in leftist circles immediately after her first Scottsboro rally in Harlem. Moore remarked that she "worked like a beaver," distributing pamphlets, while selling literature and picnic tickets. She was swept up so quickly in the fervor that she did not realize she joined the International Labor Defense, the CP-affiliated legal defense front, not the CP.[92] She became a card carrying member, but was distressed by the Harlem Party's overwhelmingly white membership, remembering that they were "all whites in Harlem, all positions. Everything was white. All, everything. All the leading people. And of course, they had James Ford, he was the chairman of the Harlem Communist Party. But everything else was white. All the people were white then."[93] Certainly, her large figure, booming voice, and loose demeanor stuck out amongst party gatherings.[94] However, the Party's willingness to put her in positions of leadership and influence signaled its ability to adapt to new cultural and social demands.

Audley Moore's activism in the party was energetic and broad. She fought for the removal of racist principles and against corporal punishment in the Harlem Committee for Better Schools. Formed in 1935, this committee was composed of community members and radical Jewish teachers who were shocked by physical decay and blatant racism in schools.[95] In other cases, principles concerned with white teachers' attitudes towards black students asked Moore for help. She recalled that, "the white teachers used to call our children [slurs], in the classroom. Yes, they did. The white teachers used to fling books across the room and have the blood gushing." Whether this was exaggeration or not, it was personal for Moore, given racism's constraints on her own education as a child. Connecting these issues to racial advancement, she pointed out that "it's so disheartening to see our children come into school in first grade all bright eyed, eager, hungry to learn, and go out drooping in sixth grade."[96] While such forms of organizing were not at the heart of the CP's program, Party women such as Moore pushed to prioritize everyday conditions of working African Americans.

Additionally, Audley Moore was at the forefront of struggles for tenants' rights and better hospital conditions. During the height of the Great Depression, struggles against evictions and for better housing conditions were a paramount concern. During the late 1930s, with the Consolidated Tenants League, Party activists such as Moore helped organize marches against high rents and for the construction of additional public housing. They carried out rent strikes against rent increases and poor conditions in buildings.[97] Self-educated Party members from working class backgrounds

were quick to recognize the importance of these actions, and, as Moore stated, "the first strikes we had, I organized 'em. I mean, I was organizing the houses when I joined the Communist Party. I was right in the process of organizing the houses."[98] In addition to poor housing, African Americans in Harlem faced poor conditions in neighborhood hospitals. The issue of inadequate public resources was more than a depression-era problem; it was an issue of racial discrimination:

we had to fight to get black nurses in Harlem hospitals, and we had to fight for decent treatment, every day, every day, every day was a struggle. We had to fight to get black doctors in Harlem hospitals. It was something. even to get clean sheets on the receiving table. There were dirty and bloody sheets and they didn't mind putting you right on somebody else's blood.[99]

Audley Moore's movement building helped push the Harlem Communist Party closer to the people. As she remarked, "every struggle was Communist initiated." Blacks in Harlem had a sense of this, as the Party was generally well received. Moore pointed out that, "our people didn't have the red scare like the white people had it. The party did so much positive things, fought so hard, against Jim Crow, and so on."[100] Further, the Party's devotion to internationalism and anti-fascism inspired growing grass-roots activism.

It was Italy's invasion of Ethiopia in 1935 that sparked a wave of antifascist solidarity. This began in Harlem on August 3, 1935, as the Provisional Committee for the Defense of Ethiopia assembled liberal groups, church groups, and the Communist Party for one of the largest interracial marches Harlem has ever seen, turning out over 25,000 people.[101] Inspired by black volunteers of the Abraham Lincoln Bridge who fought alongside Republican forces in Spain, Moore and others wanted to travel to Ethiopia to defend what they viewed to be the last independent African nation.[102] She reminisced that, "I participated in organizing. Many of our people wanted to go and the United States government said if you go, you'll lose your citizenship. What citizenship? We would ask." Thinking internationally, she viewed African Americans as a nation within a nation, more connected to Ethiopia than the United States. Instead, she opted to collect and send materials to Ethiopia, recalling that, "we collected bandages and sheets, old sheets and tore them up, and the nurses in Harlem hospitals, they sterilized 'em. We collected medicine and

> Early Communist Party leadership held onto the notion that men of the industrial working-class were often the vanguard of the revolution. Black left feminists argued otherwise.

so on."[103] Although the United Front created opportunities to bridge connections between African Americans and the African diaspora, it eliminated other positions that were central to black women's political organizing.

Ultimately, Audley Moore's position as a Communist and her lifelong commitment to Garveyism became an untenable contradiction. In 1938, she was elected chair of the Harlem Communist Party's Women Commission, in addition to becoming the executive secretary of the Upper Harlem Section of the Party.[104] Despite her status and emphasis on bread-and-butter issues in working class neighborhoods, the CP was relatively marginal in black political life. As Mark Naison contends in *Communists in Harlem during the Great Depression*, had the party, at the time, adopted rituals of the black church, embraced black culture more openly, and allowed black members to dominate branches in their neighborhoods, it might have created a mass movement akin to the UNIA.[105] Audley Moore's sentiments were similar, reflecting the Party's stance that shifted away from black self-determination during the "Popular Front" era:

I resigned in 1950. I resigned because I couldn't get them to discuss the question that was bothering me uppermost, on the term Negro, and the fact that they had really relinquished their position, as a nation, that we were a nation. And I wanted to talk about those things, you know?

Moore's pronouncements foreshadowed her subsequent embrace of more explicit forms of black nationalism. Still, they reflected wider issues that occurred at the time. Many black Communist women were concerned with the number of white women who dated black men in the Party. Conversely, they argued that black women rarely dated white men.[106] To her, this represented the broader internal problem of "racial chauvinism" in the Party:

Being a Negro is a condition, not just a name. When I realized that we were going wrong, I went to the Communist Party. I really wanted the Communist Party to discuss the thing and analyze... if blacks wouldn't touch it - Ben Davis and none of them would touch it - and um , the whites wouldn't touch it because they said the blacks hadn't brought it up... and I kept getting bile in my stomach because I could see we were going wrong.[107]

However, the Party allowed Moore to see the world in a new light, as she admitted, "I'm grateful for the party. It taught me the class character of this society. It taught me the science of society."[108] Fundamentally, the Party's inability at the time to create a discourse of race that was as sharp and distinct as its analysis of class proved its obsolescence for women like Audley Moore.

Conclusion

Early Communist Party leadership held onto the notion that men of the industrial working-class were often the vanguard of the revolution. Black left feminists argued otherwise. In doing so, they undoubtedly pushed the Communist Party to the left. Their organizing represented a politics that was unique in its ability to unite working people by directly addressing their needs. Ideologically, they centered the oppression of women in ways that emphasized their hyper-exploitation as domestic workers and redefined the notion of 'black womanhood.' In their eyes, black women were exceptionally militant, well-versed in the community, and capable of connecting to African American cultural traditions. Internationalism, anti-fascism, and anticolo-

nialism came naturally to these women, as they lived lives that were simultaneously American and immigrant West Indian, embodying what cultural studies scholar Paul Gilroy called 'the Black Atlantic.'[109] Their identities were both nationally 'west' and culturally African, forming a politics that was noteworthy for its transnationalism. Significantly, the Communist International's "Black Belt thesis" was an opportunity that black women seized upon. They used institutions of the political left to hone their unique talents.

Rather than essentialize the legacy of black left feminists, it is important to recognize how they contributed to the 'black radical tradition.' Later black feminists such as Claudia Jones, Angela Davis, the Combahee River Collective, and Audre Lorde are the intellectual descendants of the black Communist women who rose to prominence during the 1920s and 1930s. These pioneering women used Communism to advance their own vision of racial, gender, and class liberation. Visiting the Soviet Union and fighting for Pan-African solidarity helped them rethink the relationship between gender, race, and class and ultimately, the lives and the work of the black left feminists shed quite a bit of light on issues of identity within mass movements. These pioneering women also demonstrated that the social and political advancement of black women was not only urgently necessary, but could also be achieved through the application of practical dedication and fervent hard work.

Endnotes

1 Simone, Nina. *I Put a Spell on You: the Autobiography of Nina Simone; with Stephen Cleary*. Cambridge (Massachusetts): Da Capo Press, 2003, 87.

2 Hunter, Tera W. *To 'Joy My Freedom: Southern Black Women's Lives and Labors after the Civil War*. Cambridge, MA: Harvard University Press, 1997, 3.

3 Hunter, 28.

4 Hunter, 74-75.

5 Gregory, James. "Socialist Party Votes by Counties and States 1904-1948." *Mapping American Social Movements*. University of Washington, 1915. http://depts.washington.edu/moves/SP_map-votes.shtml.

6 Debs, E. V. (1903, November 5). The Negro in the Class Struggle [Editorial]. *International Socialist Review*. Retrieved July 22, 2020, from https://www.marxists.org/archive/debs/works/1903/negro.html

7 Davis, Angela Yvonne. *Women, Race and Class*. New York: Vintage Books, 1983, 153.

8 Mark I. Solomon, *The Cry Was Unity: Communists and African Americans, 1919-36* (Jackson: University Press of Mississippi, 1998), 4.

9 Higginbotham, Evelyn Brooks. *Righteous Discontent the Women's Movement in the Black Baptist Church, 1880-1920*. Cambridge, MA: Harvard University Press, 1993, 186-187.

10 Higginbotham, 191.

11 McDuffie, Erik S. *Sojourning for Freedom: Black Women, American Communism, and the Making of Black Left Feminism*. Durham: Duke University Press, 2011, 28.

12 McDuffie, 27-28.

13 "UNIA Declaration of Rights of the Negro Peoples of the World," New York, August 13, 1920. Reprinted in Robert Hill, ed., *The Marcus Garvey and Universal Negro Improvement Papers, vol.*

2 (Berkeley, University of California Press, 1983), 571–580.

14 McDuffie, Erik S. *Sojourning for Freedom*, 38-39.

15 Robinson, Cedric J. *Black Marxism: The Making of the Black Radical Tradition*. United States: The University of North Carolina Press, 2005, 215.

16 Robinson, 215.

227

17 McDuffie, 37.

18 Makalani, Minkah. "An Apparatus for Negro Women: Black Women's Organizing, Communism, and the Institutional Spaces of Radical Pan-African Thought." *Women, Gender, and Families of Color*, vol. 4, no. 2, 2016, pp. 250–273. *JSTOR* , doi:10.5406/womgenfamcol.4.2.0250. Accessed 21 July 2020, 251-252.

19 Zumoff, Jacob A. *The Communist International and US Communism: 1919-1929* . Chicago, IL: Haymarket Books, 2015, 41.

20 Alexandra Kollontai, "The Social Basis of the Woman Question," 1909, https://www.marxists.org/archive/kollonta/1909/social-basis.htm#:~:text=Only%20the%20complete%20disappearance%20of,and%20change%20their%20social%20position.

21 McDuffie, *Sojourning for Truth* , 29.

22 "Methods and Forms of Work among Communist Party Women: Theses." *Third Congress of the Communist International* translated by Alix Holt and Barbara Holland, July 8, 1921. https://www.citationmachine.net/chicago/cite-a-editorial/custom.

23 McDuffie, *Sojourning for Truth*, 34.

24 Pearl, Jeanette D. "Negro Women Workers." *Daily Worker* . February 16, 1924, Volume 1, No. 341.

25 Minkah Makalani, "An Apparatus for Negro Women," 255.

26 McDuffie, *Sojourning for Freedom, 33.*

27 Makalani, "An Apparatus for Negro Women," 257.

28 McDuffie, *Sojourning for Freedom,* 44-45.

29 McDuffie, Sojourning for Freedom, 50-51.

30 Louis Althusser, "Ideology and Ideological State Apparatuses (Notes towards an Investigation)," in *"Lenin and Philosophy" and Other Essays* , ed. And Blunden (New York, NY: Monthly Review Press,

1970).

31 Angela Y. Davis, *Are Prisons Obsolete?* (Toronto, Canada: Seven Stories Press, 2003), 105-106.

32 McDuffie , *Sojourning for Freedom,* 31.

33 Clarence Taylor, *Reds at the Blackboard: Communism, Civil Rights, and the New York City Teachers Union* (New York: Columbia University Press, 2013), 29.

34 McDuffie, 83.

35 Makalani, "An Apparatus for Negro Women," 265-266.

36 Makalani, 266-267.

37 Makalani, "An Apparatus for Negro Women," 261-262.

38 Mary Adams, "The Negro Movement in North and Latin America," *The Negro Worker* , November 1, 1930, pp. 23.

39 Adams, "The Negro Movement in North and Latin America," 24.

40 Adams, 24.

41 Solomon, *The Cry Was Unity,* 265.

42 Louise Thompson Patterson, interview by Ruth F. Prago, *Communist Party Oral Histories* (NYU's Tamiment Library, July 14, 2017), https://wp.nyu.edu/tamimentcpusa/louise-patterson/.

43 Louise Thompson Patterson, interview by Ruth F. Prago.

44 Patterson.

45 McDuffie, *Sojourning for Freedom,* 63.

46 W.E.B. Du Bois, "The Talented Tenth," *The Negro Problem: A Series of Articles by Representative Negroes of To-Day,* 1903, https://glc.yale.edu/talented-tenth-excerpts.

47 Lashawn Harris, "Running with the Reds: African American Women and the Communist Party during the Great Depression," *The Journal of African American History* 91, no. 1 (2008): pp. 21-43, https://doi.org/https://www.jstor.org/stable/25610047?seq=1, 36.

48 Solomon, *The Cry was Unity* , 174.

49 Solomon, 264.

50 Louise Thompson Patterson, interview by Ruth F. Prago.

51 Solomon, 174.

52 Naison, *Communists in Harlem During the Depression,* 57-58. The Scottsboro Case involved nine black boys, aged 13 to 21, accused of the "gang rape" of two white women in Scottsboro, Alabama. The evidence and pretense for arrest were flimsy, but the Communist Party turned the incident into an indictment of American racism. The CP undertook the legal defense of the boys – eight of whom were sentenced to death.

53 Louise Thompson Patterson, interview by Ruth F. Prago.

54 Solomon, 174.

55 Patterson.

56 Solomon, *The Cry was Unity*, 175.

57 Louise Thompson Patterson, interview by Ruth F. Prago.

58 McDuffie, *Sojourning for Freedom*, 58-59.

59 Louise Thompson Patterson, interview by Ruth F. Prago.

60 Naison, *Communists in Harlem during the Depression*, 136.

61 Patterson.

62 McDuffie, *Sojourning for Freedom*, 105.

63 Louise Thompson Patterson, interview by Ruth F. Prago.

64 Du Bois W. E. B. and David Levering Lewis, *Black Reconstruction in America* (New York: Free Press, 1998), 700-701.

65 Patterson.

66 Louise Thompson Patterson, "Toward a Brighter Dawn," *Woman Today*, April 1936, https://www.viewpointmag.com/2015/10/31/toward-a-brighter-dawn-1936/.

67 Patterson, "Toward a Brighter Dawn."

68 Ashley D. Farmer, *Remaking Black Power: How Black Women Transformed an Era* (Chapel Hill, NJ: University of North Carolina Press, 2019), 23

69 Ella Baker and Marvel Cook, "The Slave Market," *The Crisis*, November 1935, 42 edition, https://caringlabor.wordpress.com/2010/11/24/ella-baker-and-marvel-cooke-the-slave-market/.

70 McDuffie, *Sojourning for Freedom*, 116.

71 Patterson, "Toward a Brighter Dawn."

72 Farmer, 27.

73 Patterson, "Toward a Brighter Dawn."

74 Harris, "Running with the Reds." 37-38.

75 Harris, "Running with the Reds," 26.

76 McDuffie, *Sojourning for Freedom*, 85.

77 Anna Barton, "Revolt of the Housewives," *New Masses*, June 18, 1935, Vol. 15 edition, sec. No. 12, pp. 18-19, https://www.marxists.org/history/usa/pubs/new-masses/1935/v15n12-jun-18-1935-NM.pdf.

78 Anna Barton, "Revolt of the Housewives."

79 Anna Barton.

80 Anna Barton, "Revolt of the Housewives."

81 McDuffie, *Sojourning for Freedom*, 85.

82 McDuffie, 78.

83 Solomon, *The Cry Was Unity*, 265.

84 Audley Moore, *Communist Party Oral Histories* (NYU's Tamiment Library, July 17, 2017), https://wp.nyu.edu/tamimentcpusa/audley-queen-mother-moore/.

85 Solomon, 265.

86 Audley Moore.

87 Audley Moore.

88 Audley Moore, *Communist Party Oral Histories*.

89 Audley Moore.

90 Solomon, *The Cry Was Unity*, 265.

91 Black Women Oral History Project, *Black Women Oral History Project* (Radcliffe Institute for Advanced Study at Harvard University, June 8, 1978), https://sds.lib.harvard.edu/sds/audio/460147962.

92 Audley Moore, *Communist Party Oral Histories*.

93 Audley Moore.

94 Solomon, *The Cry Was Unity*, 265.

95 Naison, *Communists in Harlem During the Great Depression*, 214.

96 Audley Moore, *Communist Party Oral Histories*.

97 Naison, 258-259.

98 Audley Moore.

99 Audley Moore.

100 Audley Moore.

101 Naison, *Communists in Harlem During the Great Depression*, 155-157.

102 McDuffie, *Sojourning for Freedom*, 95.

103 Audley Moore, *Communist Party Oral Histories*.

104 McDuffie, 85.

105 Naison, *Communists in Harlem During the Great Depression*, 155-157.

106 Solomon, *The Cry Was Unity*, 283.

107 Audley Moore, *Communist Party Oral Histories*.

108 Audley Moore.

109 Paul Gilroy, *The Black Atlantic: Modernity and Double Consciousness* (London: Verso, 2007), 2-3.

Bibliography

Adams, Mary. "The Negro Movement in North and Latin America." *The Negro Worker* III, no. Special, November 1, 1930.

Althusser, Louis. "Ideology and Ideological State Apparatuses (Notes towards an Investigation)." Essay. In *"Lenin and Philosophy" and Other Essays,* edited by And Blunden. New York, NY: Monthly Review Press, 1970.

Baker, Ella, and Marvel Cook. "The Slave Market." *The Crisis.* November 1935, 42 edition. https://caringlabor.wordpress.com/2010/11/24/ella-baker-and-marvel-cooke-th e-slave-market/ .

Barton, Anna. "Revolt of the Housewives." *New Masses.* June 18, 1935, Vol. 15 edition, sec. No. 12. https://www.marxists.org/history/usa/pubs/new-masses/1935/v15n12-jun-18-1 935-NM.pdf .

Davis, Angela Y. *Are Prisons Obsolete?* Toronto, Canada: Seven Stories Press, 2003.

Davis, Angela Yvonne. *Women, Race and Class* . New York: Vintage Books, 1983.

Debs, Eugene V. "The Negro in the Class Struggle." *International Socialist Review,* November 5, 1903. https://www.marxists.org/archive/debs/works/1903/negro.htm .

Du Bois, W.E.B. *Black Reconstruction in America* . New York: Free Press, 1998. Du Bois, W.E.B. "The Talented Tenth." *The Negro Problem: A Series of Articles by Representative Negroes of To-day,* 1903. https://glc.yale.edu/talented-tenth-excerpts .

Farmer, Ashley D. *Remaking Black Power: How Black Women Transformed an Era* . Chapel Hill, NJ: University of North Carolina Press, 2019.

Gilkes, Cheryl Townsend. Audley Moore. Other. *Black Women Oral History Project.* Radcliffe Institute for Advanced Study at Harvard University, June 8, 1978. https://sds.lib.harvard.edu/sds/audio/460147962 .

Gilroy, Paul. *The Black Atlantic: Modernity and Double Consciousness.* London: Verso, 2007.

Gregory, James. "Socialist Party Votes by Counties and States 1904-1948." Mapping American Social Movements. University of Washington, 1915. http://depts.washington.edu/moves/SP_map-votes.shtml .

Harris, Lashawn. "Running with the Reds: African American Women and the Communist Party during the Great Depression." *The Journal of African American History* 91, no. 1 (2008): 21–43. https://doi.org/https://www.jstor.org/stable/25610047?seq=1 .

Higginbotham, Evelyn Brooks. *Righteous Discontent: The Women's Movement in the Black Baptist Church, 1880-1920.* Cambridge, MA: Harvard University Press, 1993.

Hunter, Tera W. *To 'Joy My Freedom: Southern Black Women's Lives and Labors after the Civil War* . Cambridge, MA: Harvard University Press, 1997.

Kollontai, Alexandra. "The Social Basis of the Woman Question." *Selected Writings of Alexandra Kollontai,* 1909. https://www.marxists.org/archive/kollonta/1909/social-basis.htm#:~:text=Only %20the%20complete %20disappearance%20of,and%20change%20their %20soci al%20position .

Makalani, Minkah. "An Apparatus for Negro Women: Black Women's Organizing, Communism, and the Institutional Spaces of Radical Pan-African Thought." *Women, Gender, and Families of Color* 4, no. 2 (2016): 250. https://doi.org/10.5406/womgenfamcol.4.2.0250 .

McDuffie, Erik S. *Sojourning for Freedom: Black Women, American Communism, and the Making of Black Left Feminism* . Durham: Duke University Press, 2011.

"Methods and Forms of Work among Communist Party Women: Theses." *Third Congress of the Communist International* translated by Alix Holt and Barbara Holland, July 8, 1921. https://www.citationmachine.net/chicago/cite-a-editorial/custom .

Moore, Audley. Audley (Queen Mother) Moore. Other. *Communist Party Oral Histories.* NYU's Tamiment Library, July 17, 2017. https://wp.nyu.edu/tamimentcpusa/audley-queen-mother-moore/ .

Naison, Mark D. *The Communist Party in Harlem during the Depression, 1928-1936.* Urbana: University of Illinois Press, 2005.

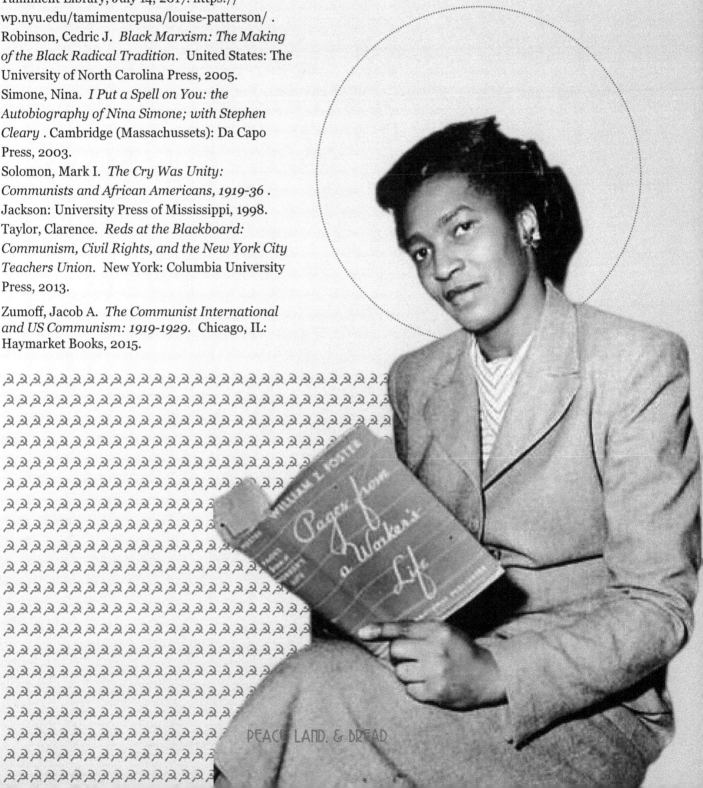

Patterson, Louise Thompson. "Toward a Brighter Dawn." *Woman Today*, April 1936. https://www.viewpointmag.com/2015/10/31/toward-a-brighter-dawn-1936/ .

Pearl, Jeanette D. "Negro Women Workers." *Daily Worker*. February 16, 1924, Volume 1 edition, sec. No. 341.

Prago, Ruth F. Louise Thompson Patterson. Other. *Communist Party Oral Histories*. NYU's Tamiment Library, July 14, 2017. https://wp.nyu.edu/tamimentcpusa/louise-patterson/ .

Robinson, Cedric J. *Black Marxism: The Making of the Black Radical Tradition*. United States: The University of North Carolina Press, 2005.

Simone, Nina. *I Put a Spell on You: the Autobiography of Nina Simone; with Stephen Cleary* . Cambridge (Massachussets): Da Capo Press, 2003.

Solomon, Mark I. *The Cry Was Unity: Communists and African Americans, 1919-36* . Jackson: University Press of Mississippi, 1998.

Taylor, Clarence. *Reds at the Blackboard: Communism, Civil Rights, and the New York City Teachers Union*. New York: Columbia University Press, 2013.

Zumoff, Jacob A. *The Communist International and US Communism: 1919-1929*. Chicago, IL: Haymarket Books, 2015.

PEACE LAND. & BREAD

RIVER AND ROCK

BEN STAHNKE

CHURCH AND GUN

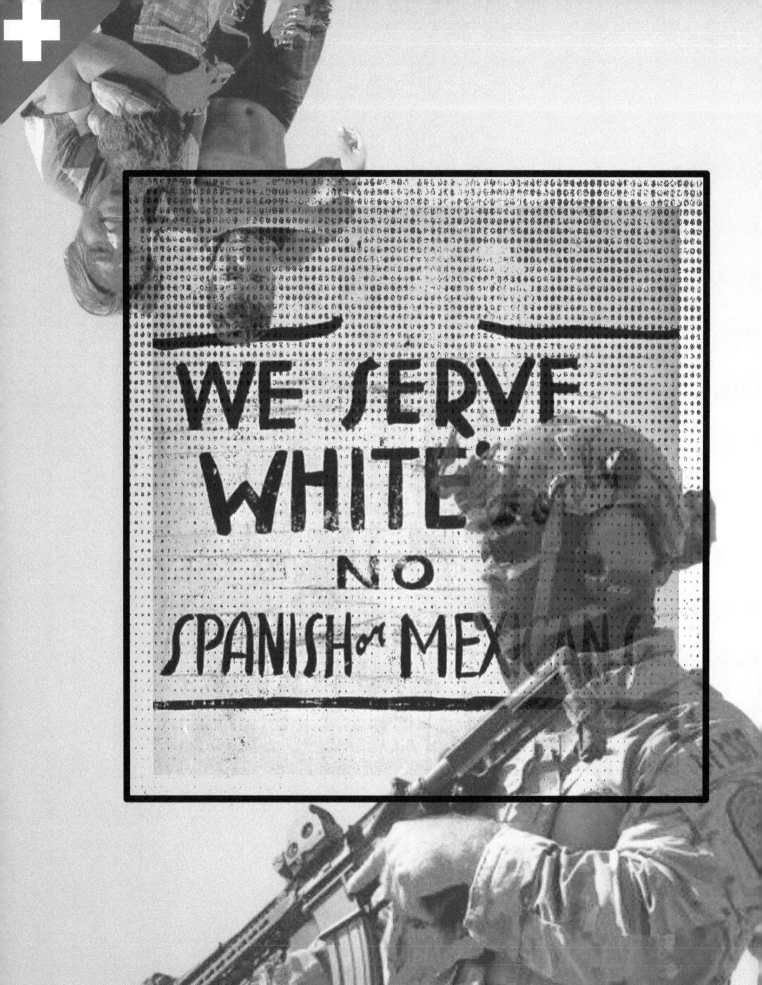

A Political Ecology of Expulsion, Racism, and Violence in the US-Mexico Border Region

"The wall itself purports to be the materialization of the border, but the border itself is a projected entity, the creature of a treaty signed in 1848."

-Edward S. Casey and Mary Watkins, *Up Against the Wall: Re-Imagining the U.S.-Mexico Border*, p. 5.

Ben Stahnke

Racism and Ruin on the US-Mexico Border

A history of prejudice and exclusion towards indigenous and LatinX peoples in the US Mexico border region.

Pictured: militarized USCBP, migrants, and a 1940s restaurant sign.

A political border is both an idea and a material phenomenon: for those who live in their shadow, this fact can be observed both in the physical barriers —the looming walls, the militarized security, and the razor wire—and in the impact that such a physicality has upon one's daily life. In her prescient text, *Walled States, Waning Sovereignty*, political scientist Wendy Brown observed that, "nation-state walling responds in part to psychic fantasies, anxieties, and wishes and does so by generating visual effects and a national imaginary apart from what walls purport to 'do.'"[1] Fortified political borders—border walls—both shape *and* respond to not only the material conditions of a nation-state, but to the ideological structures of nation-states as well. In *Border People: Life and Society in the U.S.-Mexico Borderlands*, border historian Oscar J. Martinez noted that, "borderlands live in a unique human environment shaped by physical distance from central areas and constant exposure to transnational processes."[2] For the residents of a borderland, the border dominates one's immediate physical life, as well as the thoughts experienced about such a life; yet the shadow of a border region looms large—over the history as well as the contemporary politics of the region. In

the United States in 2019, the current administration rose to power—in part—on the promise of a large-scale and militarized border wall along the 1,954 miles of the nation's southern border; a wall designed to stem the northward flow of migration; a wall to separate the have-nots from the haves. The right-wing president Trump ham-handedly exclaimed that, "[t]his barrier is absolutely critical to border security. It's also what our professionals at the border want and need. This is just common sense."[3] But, to a critical eye, the so-called common sense of politicking is never quite what it appears to be at face value. The common sense of rightism is, in this case, a xenophobia made manifest in a policy strategy. It is a response to a rapidly changing world—both climatologically and geopolitically. And it is, as Ian Angus noted in *Facing the Anthropocene*, "a call for the use of armed force against starving people."[4]

In *Planning Across Borders in a Climate of Change*, Michael Neuman noted that, "bor-

ders are always dynamic, ever shifting. Borders are human constructs enshrined in laws, treaties, regulations, strategies, policies, plans, and so on. We draft them, modify them and erase them at our will. We create, and recreate them, and cannot escape

Poverty and Militarism in the Border Region

The forceful, military domination of the border region has been a continued theme since the Spanish conquest and is continued under American border enforcement doctrine.

Pictured: Mexican dwellings in a settlement along the border region and mounted border patrol agents.

them."[5] Yet, borders are not simply political in nature; they are economic as well. And these political economic phenomena have a history which is important. Under capitalism, borders are uniquely capitalistic; their logistical and material functions directed not only by security and military interests, but by bank, trade, and distribution interests as well. The 2011 publication of the World Bank, *Border Management Modernization*, defined a border as:

the limit of two countries' sovereignties—or the limit beyond which the sovereignty of one no longer applies. The border, if on land, separates two countries. Crossing the border means that persons, and goods must comply with the laws of the exit country and—if immediately contiguous—the entry country. [...] Borders are not holistic. Different processes can take place at different places. For example, a truck's driver may be cleared by immigration at the border, but the goods transported in the truck may be cleared at an inland location. Borders then essentially become institution-based and are no longer geographic.[6]

As intricate complexes of geographical, institutional, and administrational factors, borders are thus managed, maintained, and reformed by a host of political and economic forces. However, as the sociologist Timothy Dunn observed in *The Militarization of the U.S.—Mexico Border*, "Such issues are too important to be left to the discretion of bureaucratic and policy-making elites, or to be defined by jingoistic demagogues, who scapegoat vulnerable groups."[7] Under capitalism, and along the southern United States border in particular, the erection of fortifications along the border delineation are entirely swayed by such jingoistic demagoguery.

As the World Bank's *Border Management Modernization* argued, "inefficient border management deters foreign investment and creates opportunities for administrative corruption."[8] Under capitalism, and under the aegis of jingoistic, racist, and conservative policies following the spirit of a new global Manifest Destiny, an inefficiently-managed border equates to a loss of potential profit: an unthinkable evil where capitalism's logic of profit *über alles* prevails. And as Tim Marshall observed in *The Age of Walls*, "[w]alls tell us much about international politics, but the anxieties they represent transcend the nation-state boundaries on which they sit [...] President Trump's proposed wall along the US-Mexico border is intended to stem the flow of migrants from the south, but it also taps into a wider fear many of its supporters feel about changing demographies."[9] The land currently identified as the Mexico-United States border has seen, over time, its share of shifting

demographies. The national anxieties and fears which presently add the requisite degree of legitimation to the Mexico-United States border wall are, in truth, the fears of a white settler—a stranger upon a land to which he does not belong.

PRE-CONQUEST

The present-day Mexico-United States borderland was not always defined by the administrational and jurisdictional limits of the Mexican and American nation-states. In truth, the region has been well-populated since at least the onset of the Younger Dryas and the Last Glacial Period—and human habitation has been suggested in the southern region of North America for at least 18,500 years. The historian Paul Ganster noted that the region itself, "has a human history stretching back approximately twelve thousand years. The Americas in 1492 are estimated to have had a population of 60 million; 21 million, or 35 percent, of this total are thought to have lived in Mexico."[10] The imposition of the present day border region of Mexico and the United States fractured—both geographically and socially—a landscape and peoples for whom no such fracture previously existed. Despite the mythos, colonization did not—in almost every instance—occur in wild, unsettled lands, but lands abundant with inhabitants. The very essence of colonialism is at once bound up in a logic of displacement, genocide, and denial. In *Border Visions: Mexican cultures of the Southwest United States*, anthropologist Carlos Vélez-Ibáñez noted that it was "highly likely that major parts of Northern Greater Southwest were well populated at the time of Spanish expansion in the sixteenth century,"[11] with the inhabitants of the region occupying socially and economically complex "permanent villages and urbanized towns with platform mounds, ball courts, irrigation systems, altars, and earth pyramids."[12] Vélez-Ibáñez went on to note that, "at the time of [Spanish] conquest, the region was not an empty physical space bereft of human populations but an area with more than likely a lively interactive system of 'chiefdom'-like centers or *rancherías*, each with its own *cazadores* (hunters), material inventions, and exchange systems."[13] The majority of the pre-conquest inhabitants of the region were, according to Paul Ganster:

what early Spanish explorers termed ranchería people, those who lived in small hamlets with populations only a few hundred each. Such settlements, often scattered over large surrounding territories, relied on wild foods as much as on planted crops. Where favorable agricultural conditions permitted, larger villages and more densely settled subregions existed. [...] Along the Rio Grande an estimated forty thousand people, practicing intensive agriculture, lived in highly organized villages.[14]

The notion that European colonization and settlement occurred in a depopulated wilderness is, as mentioned, naught but a myth of settlement—an ahistorical tool of legitimation for the children of settlers. In the much-lauded *Changes in the Land*, historian William Cronon observed that, "It is tempting to believe that when Europeans arrived in the New World they confronted Virgin Land, the Forest Primeval, a wilderness which had existed for eons uninfluenced by human hands. Nothing could be further from the truth."[15]

The story of the pre-conquest border region is, as is the story of all of the Americas, one of violent displacement, of harsh and rapid resource extraction, and of pillage. In *Open Veins of Latin America: Five Centuries of the Pillage of a Continent*, Eduardo Galeano lamented that:

A History of Wealth Extraction and Forced Labor

The US-Mexico border region is an ecologically and culturally diverse region with an (at least) 12,000 year history of human habitation. It is also an important and resource rich environment that has long been the home to many now-displaced populations. Spanish and American conquests have destroyed the delicate biotic and cultural ecosystems.

Pictured: settlers and natives along the Rio Grande.

Latin America is the region of open veins. Everything, from the discovery until our times, has always been transmuted into European— or later United States—capital, and as such has accumulated in distant centers of power. Everything: the soil, its fruits and its mineral-rich depths, the people and their capacity to work and to consume, natural resources and human resources. Production methods and class structure have been successively determined from outside for each area by meshing it into the universal gearbox of capitalism.[16]

The indigenous peoples of the Mexico-United States border region lived, and still live—along the border region's western half—in the warmth and the aridity of the High Sonoran Region; an area characterized by:

high aridity and high temperatures. Typically, about half of the eastern part of the region's precipitation falls in the summer months, associated with the North American monsoon, while the majority of annual precipitation in the Californias falls between November and March. The region is subject to both significant inter-annual and multi- decadal variability in precipitation. This variability, associated with ENSO, has driven droughts and foods and challenged hydrological planning in the region.[17]

The area itself is also mountainous—"criss-crossed by a maze of inhospitable ranges that divide the area into isolated subregions."[18] Further, according to the Commission for Environmental Cooperation (CEC), and by way of the U.S. Environmental Protection Agency's (EPA) *Ecological*

Restoration in the U.S.-Mexico Border Region report, the present day border region is itself home to no fewer than seven unique ecosystems: the Californian Coastal Sage, Chaparral, and Oak Woodlands, the Sonoran Desert, the Madrean Archipelago, the Chihuahuan Desert, the Edwards Plateau, the Southern Texas Plains, and the Western Gulf Coastal Plain.[19]

While the Mexico-U.S. border region now is a "place where two historical-cultural tectonic plates are grinding against each other,"[20] it is a region whose delineations and delimitations have only been imposed recently: a "result of the Treaty of Guadalupe Hidalgo in 1848, [which] has never changed location except for the modifications introduced by the Gadsden Purchase of 1853 and one small sliver of land called 'El Chamizal' just north of the Rio Grande in El Paso that was set aside in 1963."[21] Prior, however, to the American and Mexican treaties, and prior to the delimitation of the present-day border region, the area was home not only to indigenous peoples, but also to Spanish colonial aspirations.

CONQUEST

Beginning with the 1492 journey of Christopher Columbus—a man who, on that very same 1492 journey, observed that, "[o]ne who has gold does as he wills in the world, and it even sends souls to Paradise"[22]; an insightful comment on the journey's primary motivations—the resultant Spanish conquest of the Americas over the next several centuries was no less than a systematic genocide.[23] The indigenous peoples of the Americas suffered greatly under Spanish colonialism, and "[i]n little more than a century," the economist and historian Michel Beaud observed, "the Indian population was reduced by 90 percent in

Mexico (where the population fell from 25 million to 1.5 million), and by 95 percent in Peru. Las Casas estimated that between 1495 and 1503 more than 3 million people disappeared from the islands of the New World. They were slain in wars, sent to Castile as slaves, or consumed in the mines and other labors."[24] The Council of Castile, "resolved to take possession of a land whose inhabitants were unable to defend themselves,"[25] and the wealth of the Spanish nobility increased exponentially—the cost being—both simply and brutally—genocide, slavery, and the rapacious extraction of resources. At its heart, the Spanish colonial impetus was one dominated by themes of greed, oppression, theft, murder, personal ennoblement, and of continued, relentless conquest. Virtually every colonial effort from the era seems to be dominated by these themes. Paul Ganster noted that:

In the five decades after Columbus, the Spanish made a series of expeditions: Juan Ponce de León's 1513 expedition to Florida; Alonso Álvarez de Pineda's 1519 voyage around the Gulf of Mexico; Estevão de Gomes's 1524-1525 recorrido (trip) up the northeastern seaboard; Pedro de Quejo's 1525 voyage from Española to Delaware; Hernando de Soto's 1539-1543 visit to what is today Florida and the Atlantic Southeast; and João Ridrigues Cabrilho's 1542-1543 expedition along the California coast.[26]

The Spanish colonial expeditions had as their goal the procurement of wealth for the Spanish crown, as well as the securement of lands in the New World under Spanish sovereignty. "The production of sugarcane for rum, molasses, and sugar, the trade in black slaves, and the extraction of precious metals established considerable sources of wealth for Spain throughout the sixteenth century."[27] For the Spanish, this growing wealth—following on the heels of the dominance of a growing territory—only fed the

desire for more wealth; and where the "wealth of the kingdom depended upon the wealth of the merchants and manufacturers,"[28] there followed the insatiable growth of the Spanish conquest in and among the Americas.

Spanish conquest secured, for the monarchs of Castile, a vast majority of the land in the Americas, and, at its height, governance was divided amongst several viceroyalties—the Viceroyalty of New Spain, the Viceroyalty of Peru, the Viceroyalty of New Granada, and the Viceroyalty of Rio de la Plata. The viceroyalties, with their capitals centered in such present day metropoles as Mexico City, Lima, Bogotá, and Buenos Aires, were subject to the dictates and whims of the monarchs of Castile, where:

king[s] possessed not only the sovereign right but the property rights; he was the absolute proprietor, the sole political head of his American dominions. Every privilege and position, economic political, or religious came from him. It was on this basis that the conquest, occupation, and government of the [Spanish] New World was achieved.[29]

Nothing to Celebrate

The genocides and ethnocides carried out by the Spanish and the United States against indigenous peoples in the US-Mexico border region, and elsewhere in the Americas, is one of the most brutal acts of destruction in the modern era. Feudal expansion and capitalist accumulation are responsible for the death of up to 90% of the indigenous peoples in the border region.

Pictured: Spanish conquest and the violent murderer, Cristóbal Colón (Columbus).

In the era of European empire, nascent capitalism, and the carving up of the world by the dominant European powers—expressions of both rapaciousness and technological might—monarchical whims became increasingly protectionist. "As other European powers became interested in the [present-day border] region and Spain's interest in protecting its empire grew, the Far North was increasingly the focus of attempts to impede intrusions. Defense against the spreading influence of the French, English, and Russians became one of the main foundations of settlement."[30]

THE MOVE NORTHWARDS: CHRISTIANITY AND THE GUN

Where late Spanish feudalism was still heavily dominated by the sphere of influence of the Catholic Church—a vestige of the ancient Roman imperialism, enamored with imperialism's political logics of expansion and accumulation—there *both* went, hand-in-hand, upon the American landscape in the form of the northward settlements. Where the Spanish conquest of the Americas was concerned, both military *and* church acted in strategic coordination to secure lands and resources for the Crown. On this, Paul Ganster observed that, "[i]n order to pacify and populate the area at minimal cost, the Crown came to rely on two institutions with funds and personnel of their own: the military and the religious orders. This approach gave rise to the classic duo of European settlement in the North: the presidio and the mission." Here, the unification of Christianity and the gun, of religious and militaristic dominance, emblematized the dialectic of late feudal political dominance—and it grew steadily northward upon the arid landscapes of what would later become the southern United States.

Over time, many of the early presidios—walled, defensible towns peopled by soldiers, officers and their families—grew to become permanent towns, and gradually, "warfare against raiding natives gave way to campaigns by new settlers and the government to distribute food and supplies to indigenous populations."[31] Similarly, and alongside the presidios, the missions grew northward—the slow, insidious creep of European settlement seeped into abutting indigenous communities—and within a hundred years of Spanish conquest, "a string of missions stitched from east to west, cross the frontier and up the Pacific

tera. Another, arguably stronger force followed in their shadow: the civilian settler. During the colonial period of 1492-1832, an estimated 2 million Spanish citizens flocked to the Americas to both colonize and settle the land. "Closely behind the Jesuits," historian Samuel Truett observed, "came Spanish miners, merchants and ranchers. [...] Yet there was more to these migrations than the lure of profit, for Crown officials expected miners, merchants, and ranchers to defend as well as transform space. To hold the borders of the body politic, whether against Indians or other empires, colonists also went north as civilian warriors, with gun in hand."[34] Civilian settlers—greater in number than the soldier of the presidio or the padre of the mission—came at first from Spain, and then Mexico City. But gradually, however, "immigrants were drawn from adjacent provinces. Sinaloa supply colonists for Sonora and Baja California, and these in turn supplied settlers for Alta California."[35] As Paul Ganster noted, two distinct characteristics made these new Spanish frontier populations unique: racial diversity and the growing prevalence of wage labor.

The inhabitants were of varied and mixed ethnicities, including Native Americans from all over the North and from central Mexico, as well as African Americans. Frontier society was also characterized by the prevalence of wage labor, which spread from the mines and urban settlements to agricultural areas, as a result of the high return on investment in the region, the need for skilled labor, and the location of the mining towns in areas of sparse indigenous population.[36]

By the mid-1700s, however, Spain's northward expansion of the church and the gun, of presidio and mission, and of capitalist wage labor and colonial settlement began to wane. "Practical frontiers had to be drawn, and the imperial emphasis shifted from

coast from Sinaloa to California."[32] Alongside the presidios, the missions were also "expected to help pacify and incorporate Native Americans; they reduced into settled units the diverse and complex populations, particularly those who were semisedentary or nomadic."[33] Thus both soldier and priest worked to settle the northern Spanish frontier in ways which were violent, politically recuperative, and emblematic of late-feudal/early-capitalist European colonization the world over.

However, soldier and priest alone did not colonize and subjugate the American *fron-*

northward expansion to defend and consolidation."[37] The unification of humans and nature, and the transformation of native American nature into something resembling European manorial economy was, in part, the mission of the mission; where, for the Jesuits, "the incorporation of humans and nature were part of the same equation. To attract converts and build mission economy, they sought to transform Sonora into a world of pastures and fields."[38] Such efforts, however, were not only stymied by native populations unaccustomed to such an economy, but by nature itself. "Often," noted Truett, "natural disorder followed in the wake of social disorder."[39] Social, political, and environmental pressures all lent themselves to the halting of Spain's northward movement, and, with the onset of the nineteenth century, an increasing friction between the New Spain and the Old, and the Napoleonic invasion of the Iberian peninsula, New Spain soon declared its independence from the Old.

AMERICAN IMPERIALISM AND MANIFEST DESTINY

Mexican independence from Spain, and the slow emergence of the present day Mexico-United Stated border delimitation, did not occur all at once; but through an overdetermination of historical, political, and economic factors. The geographer Joseph Nevins noted that:

The origins of the U.S.-Mexico boundary are to be found in the imperial competition between Spain, France, and England for 'possessions' in North America. The Treaty of Paris of 1783, which marked the end of the American war for independence, resulted in the United States inheriting the boundaries established by its English colonial overseer. [...] The Treaty of Paris thus resulted in a situation where the United States shared its southern and western boundaries with Spain.[40]

New Spain *qua* the newly-independent nation of Mexico similarly found its borders shifting in the tumult of the nineteenth century. Independence brought with it a removal of the sovereignty of the Spanish Crown, but also a new type of vassalage to France, for whom it became, essentially a client state.[41] The eyes of the United States soon turned to Sonora, and "[b]y the time Americans began to dream of Sonora, Sonora was a dream that had traveled across national borders, halfway around the world, and back again."[42] Capitalist interest in the rich Sonoran region—inextricably entangled with Europe's settler colonial interests in the New World— continued unabated, and shifting borders, losses of heretofore sovereign interests, and a geography in flux all presented themselves as ripe fruits for the capitalist interest. Historian Samuel Truett observed that the German geographer Alexander von Humboldt's *Political Essay on the Kingdom of New Spain*, for example, "was translated into English in 1811 with the goal of luring European capital to Mexican mines. And the idea of unfinished conquests appealed to a British capitalist class that was beginning to invest energetically at home and abroad."[43] Equally true of both the nineteenth century and the present day, nothing quite draws capitalist interest like political instability, exploitable economies, and the dream of so-called "opportunity" in the service of personal profit.

The 1821 independence of Mexico from Spain brought with it many new instabilities. Historian Rachel St. John noted that, "[t]erritorial competition defined North America in the early nineteenth century. At the beginning of the century, the continent was still very much up for grabs."[44] And Samuel Truett noted that, "[w]ith indepen-

dence in 1821, [Spanish] trade barriers were dissolved, to the great relief of entrepreneurs."[45] For both the new nation of Mexico and the increasingly imperialistic United States, political upheavals, economies-in-waiting, and geographical instabilities became the driving themes of the nineteenth century in North America —particularly where the future Mexico-U.S. border region was concerned. Paul Ganster noted that, "During the relatively brief span from Mexican independence in 1821 to the end of the between the United States and Mexico in 1848, Spain's far-northern frontier territories became borderlands—the relatively unrefined and frequently contested terrains between Mexico and the United States."[46] Mexico's recent independence, the machinations of empire, and the increasingly contested borderlands entailed by the Louisiana Purchase and Texas soon drove the United States and Mexico to war. On the Louisiana Purchase, Joseph Nevins noted that:

Napoleon compelled Charles IV of Spain to cede an enormous territory west of the Mississippi River to France in 1800 in return for lands in Italy. [...] Three years later, however, Napoleon sold the vast territory to the United States for $15 million—an exchange known as the Louisiana Purchase—without taking Spanish opinion into consideration. [...] Almost immediately after the signing of the treaty, however, U.S. President Thomas Jefferson foreshadowed U.S. expansionist designs on Mexico, expressing the view that Louisiana included all lands north and east of the Rio Grande, thus laying claim to Spanish settlements such as San Antonio and Santa Fe.[47]

With the Louisiana Purchase nearly doubling the size of the young and land-hungry United States, questions and conflict of delimitation and boundary soon arose with the newly- independent Mexico. Historian Oscar Martínez noted that:

With independence achieved in 1821, Mexico inherited from Spain the challenge of safeguarding the vast northern frontier. More population was needed to strengthen the defenses of California and Texas particularly. Following policies begun by Spain, Mexico in the 1820s allowed entry into Texas of large numbers of immigrants from the United States in order to further populate that sparsely settled province. [...] Within a short time Mexico would realize what a volatile situation it had unwittingly created within its own borders.[48]

With eastern and western Florida having already been acquired from Spain between 1795 and 1819, the Louisiana Purchase of 1803, and the cession of northern lands in Minnesota by Britain in 1818, the eyes of the United States gazed hungrily at the lands north of present-day Mexico in Texas, the now-southwestern states of Arizona, New Mexico, and California. These U.S. imperialist-expansionist efforts—efforts which emerged, ideologically, as the concept of Manifest Destiny—quickly brought the United States and Mexico to war. "Once the philosophy of Manifest Destiny took firm hold in the European American mind the outcome seemed clear: sooner or later the United States would detach and annex Mexico's northern territories."[49] In a now well-known strategy of American imperial-economic interventionism, the United States acted quickly to foment dissent in the northern Mexican territory; foreshadowing war and military annexation. Joseph Nevins observed that:

In the aftermath of Mexican independence in 1821, U.S. economic actors exploited political instability in what today is the Southwest. Through their long-distance trade routes, the associated socio-cultural ties they engendered, and sponsorship of raids by Native

groups against Mexican communities and Mexico's emerging state apparatus, they helped to undermine those communities and the state.[50]

After the 1836 Texas declaration of independence from Mexico—an independence fed, largely, by American settlement in the region—and the eventual 1845 annexation of Texas by the United States, an annexation that faced popular approval by Texan "pro-slavery southerners,"[51] the doctrine of Manifest Destiny—the idea that "it would be beneficial to both countries to absorb Mexico into the United States"[52]—diplomatic relations between the United States and Mexico rapidly deteriorated and war loomed on the horizon. In the early part of 1846, U.S. President James Polk sent troops to the Rio Grande, hoping to provoke Mexico into war, and "to make Mexico recognize the Rio Grande as Texas' southern boundary, and (perhaps most importantly) to face Mexico to cede California and New Mexico to the United States."[53] War, by way of American provocation, of course did erupt, and the two-year Mexican-American War eventually took the lives of over 25,000 Mexicans and 13,500 Americans.

The war ended on February 2, 1848 with the signing of the treaty of Guadalupe Hidalgo—officially entitled the "Treaty of Peace, Friendship, Limits and Settlement between the United States of America and the Mexican Republic"—and the new southern border of the United States was set at the Rio Grande, with the additional land concession of the Gadsden Purchase in 1853 solidifying the current southern border of the United States. Historian Rachel St. John recorded that:

With U.S soldiers [in 1848] occupying the Mexican capital, a group of Mexican and American diplomats redrew the map of North America. In the east they chose a well-known geographic feature, the Rio Grande, settling a decade-old debate about Texas's southern border and dividing the communities that had long lived along the river. In the west, they did something different; they drew a line across a map and conjured up an entirely new space where there had not been one before.[54]

The newly designated southern delimitation of the United States was, as all borders tend to be, an imaginary line with very real material consequences. The United States border severed communities and families from each other, arbitrarily divided homogenous ecosystems and species, and drew, essentially, a series of straight lines in the sand from El Paso and Ciudad Juárez to the Pacific Ocean. The historian Thomas Martin observed that:

The United States pioneered the idea of the straight-line geometric border, based on surveying techniques that (bizarrely, if you think about it) use magnetism and the position of stars rather than the actual lay of the land or ethnic considerations. The habit was formed even before the Revolution, when the proprietors of Maryland and Pennsylvania hired the astronomers Charles Mason and Jeremiah Dixon to discover the exact boundary between their colonies.[55]

The straight-line approach to border delimitation occurred, in 1848, by "U.S. and Mexican officials [...] simply drawing straight lines between a few geographically important points on a map—El Paso, the Gila River, the junction of the Colorado and Gila rivers, and San Diego Bay."[56] Importantly, the only "natural" boundary delimitation along the southern border of 1848—the Gila River, was made obsolete and irrelevant by the 1853 Gadsden Treaty. The unique straight-line peculiarity of the western portion of the United States southern border would soon prove to provide nu-

No More Men Are Needed for
the Watch on the Rhine, but

26,000 Men Are Wanted
to Relieve the
Watch on the Rio Grande

The Violence of Border Enforcement

The US Border Patrol, since its inception, has been a racist organization, created solely for the purposes of pacification, terrorization, and the enforcement of oppressive US border policy.

Pictured: A border patrol recruitment poster and a depiction of the wars of pacification on and along the US-Mexico border.

merable economic, political, and security consideration for the United States—considerations which still occur to this day.

THE BORDER SINCE 1848

Since 1848, the trend of border management for the southern United States delimitation has taken on an increasingly violent character. Further, the primary themes of southern border management for the United States have been, since 1848, racist, economic, protectionist, and militaristic in character. As Joseph Nevins observed, "[i]t took many decades for the United States to pacify the area along its southern boundary, as part of a process of bringing 'order' and 'civilization' to a region perceived as one of lawlessness and chaos."[57] Of course, order and civilization equate, for capitalism, to the often violent and repressive impositions of federal authority. Rachel St. John noted that, "In the years following the boundary line's creation, government agents would mark the desert border with monuments, cleared strips, and, eventually, fences to make it a more visible and controllable dividing line,"[58] a dividing line which "allowed the easy passage of some people, animals, and

The Border Today

Increasing expenditures and a fascistic push for total militarization defines the US-Mexico border region today.

US Customs and Border Protection (USCBP) is the nation's largest federal law enforcement agency.

Enforcement Actions: **526,901** in FY17, **683,178** in FY18, **1,148,024** in FY19, **646,822** in FY20.

62,400+ employees, $20.85 billion budget (FY20), 45,741 sworn enforcement officers.

21,180 CBP officers at 328 ports of entry, 2,200 agricutlrue specialists, 21,370 border patrol agents.

1,900 miles of Mexican border, 5,000 miles of Canadian border; jurisdiction 100 miles inward border.

Provide aerial surveillance for local law enforcement, notably during the George Floyd protests.

10,000 people have died crossing border since 1994.

Hyperthermia, drowning, accidents, and USCBP use of extreme force.

Vigilante killings and gunmen terrorize migrants and local communities.

goods, while restricting the movement of others."[59] The Mexico-U.S. border in the second half of the nineteenth century was, a settled matter, never quite a settled matter. The legal agreements between the governments of the United States and Mexico stood, yet many expansionist-minded Americans—filibusters—saw fit to make incursions into Mexican territory in an effort to establish new southern slave states for the United States—actions to which the United States often turned a blind eye. The filibustering incursions both preceded and followed the Mexican- American War, but, as Oscar Martínez observed:

The years following the U.S.-Mexico War have been called the golden age of filibustering. Men seeking fortune or power cast their eyes on the resource-rich and thinly populated northern tier of Mexican states. War veterans, forty-niners, and miscellaneous travelers during the late 1840s and early 1850s had portrayed the region in colorful, exotic, and economically attractive terms.[60]

Martínez went on to observe that the early filibustering efforts—efforts and excursions which lasted well into the early part of the 1900s—constituted "a central part of U.S. expansionist aggression directed at Mexico. The periods of the greatest unlawful invasions organized in the United States coincide with weakness and instability in Mexico."[61] The filibustering and pseudo-filibustering excursions added heavily to the distrust between Mexicans and European Americans, and it was not until the 1930s and 1940s that "fear [began] to dissipate south of the border"[62] of future filibuster incursions.

As a largely un-policed, heavily-contested, and volatile region for the bulk of the nineteenth century, the onset of the twentieth century saw an increasing trajectory of control along the United States' southern border. In July 1882, the United States and

Mexico formed "a new International Boundary Commission and charged it with resurveying and reaping the border, replacing monuments that had been displaced or destroyed, and adding monuments so that they would be no more than 8,000 meters apart in even the most isolated stretches of the border and closer in areas 'inhabited or capable of habitation.'"[63] The Mexican Revolution of 1910, violence, diplomatic disputes, and an economic instability which had disrupted the transborder economy, all led towards an increasing militarization of the Mexico-U.S. border in the early 1900s. Rachel St. John noted that the persistent smuggling of cattle, narcotics, and immigrants— all fallouts from the Mexican Revolution—led to the United States government's (now- persistent) decision to dispatch troops to its southern boundary to "insure that revolutionaries did not access American arms or launch invasions from U.S. soil."[64] The increasing militarization of the southern boundary delimitation was also, as noted by sociologist Timothy Dunn, "defined by efforts to maintain control over the flow of Mexican immigrant workers into the United States, typically in ways that also significantly affected Mexican Americans."[65] Increasing control of the cross-border flow of migrants and goods—the "revolving door" immigration policy—led to the establishment in 1924 of the U.S. Border Patrol—by way of the Immigration Act legislation—as "the chief guardian of the 'revolving door' and the main agent of the comparatively less severe forms of border militarization carried out during ensuing decades."[66] Historian Kelly Hernández observed that the newly-designated "Border Patrol officers—often landless, working-class white men— gained unique entry into the region's principle system of social and economic relations by directing the violence of immigration law enforcement against the region's primary labor force, Mexican migrant laborers."[67]

Since 1924, the U.S. Border Patrol—now a component of the United States Department of Homeland Security—has grown to become a law enforcement agency with almost 20,000 agents and officers and an almost 4 billion dollar yearly budget.[68] Expanded arrest authority,[69] an expansion of legal jurisdiction, and an increase in the paramilitary character of the agency[70] have all occurred in the twentieth century, and as the twenty-first century is now underway, the trajectory of this increasing militarization appears to move forward unabated. The Secure Fence Act of 2006 provided for the construction of around 700 miles of fortified fencing, and Trump's 2017 Executive Order 13767—"Border Security and Immigration Enforcement Improvements"—all represent the increasing militarization of the southern border; a militarization which is at once troublesome yet not-unexpected. Instability, immigration, cross-border illegal (and legal) trade, and the necessity for the United States to not only secure its southern border from illicit economies—for the United States must have total economic control—but to flex its imperial might, have all been factors in the increasing militarization of the southern border. The escalation of the so-called "War on Drugs," and an increase in migrant populations from Mexico, Central, and South America due to political and climatological instabilities have all lent themselves to an increase in the militaristic fortification along the southern border—yet the story is far from over.

THE BORDER AND THE WALL

In a January 2018 tweet, the white nationalist U.S. president Donald Trump exclaimed that, "[t]he Wall is the Wall, it has

never changed or evolved from the first day *I conceived of it*[71]; but the truth of the matter is that "The Wall" itself has long been in the works—the logical outgrowth of a lengthy history of colonization, settlement, and a protectionist, hegemonic political strategy in the face of rising resource inequalities and modern-day global instabilities. What began as a disputed boundary zone—a relic of the European imperial struggles of the seventeenth and eighteenth centuries—and once "the site of considerable, wide-ranging military and security measures",[72] has not, on a fundamental level, changed. The land is still mountainous and arid, indigenous populations still inhabit the area, yet something fundamental has changed about the border region. The increase in militarization, the growing spans of the border wall, the surveillance, the security, and the police presence; all of these have progressed as the United States has worked to fortify itself from Mexico and the southern Americas, to stem the flow of immigration from an increasingly unstable and climatologically-shifting south. The border region is, on one level, naught but a line in the sand; a forced agreement between the United States and Mexico propped up by a lengthy and violent history of imperialism, capitalism, and European colonization in the Americas. Yet, for those who live with and around the border, it is a material reality—and a harsh one at that.

Wendy Brown wrote that:

Ancient temples housed gods within an unhorizoned and overwhelming landscape. Nation-state walls are modern-day temples housing the ghost of political sovereignty. They organize deflection from crises of national cultural identity, from colonial domination in a postcolonial age, and from the discomfort of privilege obtained through superexploitation in an increasingly interconnected and interdependent global political economy. They con-fer magical protection against powers incomprehensibly large, corrosive, and humanly uncontrolled, against reckoning with the effects of a nation's own exploits and aggressions, and against dilution of the nation by globalization.[73]

The US-Mexico border wall is an effort to shore up the vestiges and appearances of imperial might; it is a permanent problematization and the material admission of an unwinnable frontier. The *waning imperial sovereignty* implied by the US-Mexico border wall is made manifest in the materiality of its vastness and scale.

For the structural, Marxist dimensions of border studies and political ecology, the increasing militarization of the U.S.-Mexico border presents a unique opportunity for both critical analysis and the application of the dialectical materialist lens. On the one hand, the militarization, fortification, and planned walling of the United States' southern border is a material response to movement: to migration and to economic flow. Yet, on the other hand, the construction of a continuous border wall along the Mexican boundary line *means something* in regard to the *state of the union* itself: it emerges conspicuously at a time of great upheaval—an intersectional overdetermination of political, social, economic, and ecological tumult.

In a December 2018 article entitled "Walls Work," the US Department of Homeland Security (DHS) wrote that they were, "committed to building a wall at our southern border and building a wall quickly. Under this President, we are building a new wall for the first time in a decade that is 30-feet high to prevent illegal entry and drug smuggling."[74] Federal funding toward wall construction has increased steadily since 2017. In fiscal year (FY) 2017, for example, United States Congress provided the DHS

with 292 million dollars, while in FY2018 that number jumped to 1.4 billion in funding for border wall section-constructions. The DHS, through their own admission, seek to "strengthen security and resilience while also promoting our Nation's economic prosperity."[75] According to the DHS 2019 budget, FY2019 saw an allocation of "$1.6 billion for 65 miles of new border wall construction in the Rio Grande Valley Sector to deny access to drug trafficking organizations and illegal migration flows in high traffic zones where apprehensions are the highest along the Southwest Border."[76] And, reflecting the *Pax Romana/barbaricum* rhetoric of Imperial Rome, the DHS stated that:

Securing our Nation's land borders is necessary to stem the tide of illicit goods, terrorists and unwanted criminals across the sovereign physical border of the Nation. To stop criminals and terrorists from threatening our homeland, we must invest in our people, infrastructure, and technology.[77]

Echoing Michael Neuman's assertion that, "[b]orders are always dynamic, ever shifting,"[78] the political philosopher Thomas Nail observed that, "The US-Mexico border is in constant motion. The border does not stop motion, nor is it simply an act of political theater that merely functions symbolically to give the appearance of stopping movement. The border is both in motion and directs motion."[79] The United States is an empire; and, further, it is the empire of the modern era. Thus, by extension, its borders are imperial borders. To better understand not only the ways in which the US deals with its border regions, but also why it is driven to militarize and fortify them, and what the future may hold for the US borderlands, a historical lens is thus of great benefit.

The word "border" itself derives from the Proto Indo-European (PIE) root word *bherdh-*; a term which means to "cut, split, or divide."

Fascism and White Nationalism as Policy

The increasing racism and inflammatory rhetoric of US domestic culture reflects border policy and border enforcement tactics.

Pictured: Donald Trump's performative nationalism.

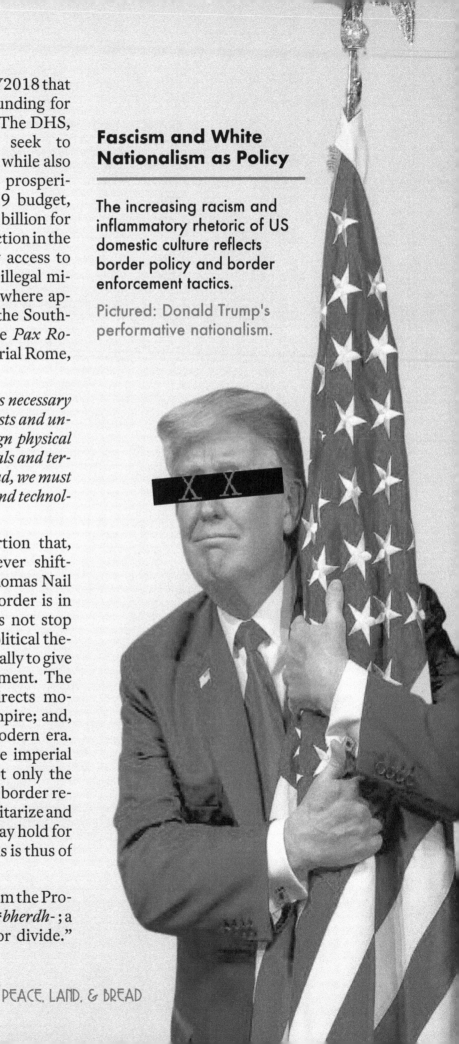

The word itself, in the modern usage of the term, has been inherited from Middle English *bordure*, from the Old French *bordeure*, and the Middle High German *borte*. While, initially, the European usage of the word held heraldic connotations—as in the trim or border-trim which enclosed heraldic devices such as shields and flags—the term, in the late fourteenth century, came to replace the older term *march*. *March*, a now obsolete term for the border—which comes to us from the PIE term **marko*—was understood as both "borderland" and "frontier." The US-Mexico border is, ultimately, all of these things—it is a frontier, a march, and a border; and it is also much more.

As not only a distinct historical borderscape, but a region which represents imperial machinations in the twenty-first century, the U.S-Mexico border region is one which has much to offer radical political ecology in the way of critical analysis. For example, when we examine historical border regions, such as the Roman frontiers in northern Britain, we are able to derive our ideas from a timeline that has a beginning, an end, and an after. We are able to tell the story of the initial Roman invasion, the period of Roman conquest, Roman consolidation, and, finally, the Roman withdrawal. Thus we are able to view, *in toto* and from an historical lens, the Roman border regions from their birth until their death. Yet with the southern border region of the United States, we are only able to view a small subsection of this story; we have only a beginning and a middle—and we live during the time of its becoming. While we might be tempted to project our ideas and our abstractions upon the future of this border region, the future, as always, is unwritten. Thus we find ourselves at once limited and quite fortunate. We are limited in the sense that we are only able to tell a part of the story; yet we are incredibly fortunate to have, as an object of critical analysis, a border-in-motion—one upon which a border wall is presently being constructed, and one which, for our purposes, signifies the *imperial* border-in-motion.

As a geographical zone of inquiry, laden with theoretical implications, "the US/Mexico Border is a region unto itself, one that supersedes the more abstract state boundaries on either side and which is considered by the powers that be—whether in Washington, DC; México, D.F.; Austin, TX; or Sacramento, CA—as irrelevant except as a place of passage for goods and people."[80] The region is both a material-geographical zone *and* an abstracted set of ideas transposed upon a landscape—it cannot be reduced to either one or the other. Following this, the border can be viewed not simply as a site of motion, but as a layered, nuanced region—overdetermined in its meaning by cultural, political, economic, and ideological currents. The border is both *in motion* and *controls motion*; yet a lens of motion alone is not quite sufficient where critical border analyses are concerned. As the geographer Lawrence Herzog observed, "Boundary zones derive their meaning from a role determined by the workings of the world economy."[81] Yet, similarly, a lens of economy alone is not enough when it comes to border critique and the articulation of a theory which contains the ability to hold the multivariate factors which, *in actu*, create the borderscape. In short, to most correctly understand the imperial border, our understanding, and our scope, must of course be *dialectical*.

The southern United States border is a region in the midst of a great and progressive militarization; a region which increasingly sees the construction of surveillance apparatuses, fence fortifications, detention centers, and border police garrisons. As a re-

gion not confined to the material-geographical border-line itself, the border regime of the United States in relationship to its southern border is one which is fed by a large sociopolitical infrastructure of militarized police along and a complicit public —police whose jurisdiction extends far beyond the border- line itself and who target, disproportionately, working people of color; and a public which, by and large, either support the nationalist rhetoric of expulsion, or who are largely unaware of the incredibly vast infrastructure along the border and thus implicitly support its expansion.

During the fiscal year 2019, 2.8 *billion* US dollars were allocated for the purchase of 52,000 detention beds, while only 511 million dollars were allocated for the transportation infrastructure needed to shuttle those migrants whom the United States has determined *illegal* out of the nation state's boundaries.[82] The sociologist Timothy Dunn noted that, "The potentially far reaching implications of the militarization of the U.S.-Mexico border have not been widely considered, as the phenomenon of border militarization has gone largely unrecognized."[83] The incrementalism of creeping border militarization is one which, as with all incrementalisms, largely goes unnoticed by a distracted and ideologized public. Violence, and the themes of both expansion and expulsion, *define*, and have historically defined, the U.S.-Mexico border region; and it is precisely the violent history of the region itself which must define our critical analysis of the region. As the historian Kelly Hernández observed, "the racial violence of immigration law enforcement stemmed from the history of conquest in the U.S.-Mexico border lands."[84] As an imperial border—fed by the violence of the Spanish conquest and the American acquisitions— the U.S.-Mexico border region is a region defined by its past.

Similar to the Roman fracture of *Brigantes* territory with the imposition and construction of Hadrian's Wall in Roman Britannia, the United States border, and the growing border wall, does much to not only fracture the indigenous peoples of the region, but, in fact, *all* regional biota. Eliza Barclay and Sarah Frostenson noted that:

What's undeniable is that the 654 miles of walls and fences already on the US-Mexico border have made a mess out of the environment there. The existing barrier has cut off, isolated, and reduced populations of some of the rarest and most amazing animals in North America, like the jaguar. They've led to the creation of miles of roads through pristine wilderness areas. They've even exacerbated flooding, becoming dams when rivers have overflowed.[85]

Rob Jordan, from the Stanford Woods Institute for the Environment observed that:

Physical barriers prevent or discourage animals from accessing food, water, mates and other critical resources by disrupting annual or seasonal migration and dispersal routes. Work on border walls, fences and related infrastructure, such as roads, fragments habitat, erodes soil, changes fire regimes and alters hydrological processes by causing floods, for example.[86]

And, in an article endorsed by more than 2,500 scientist signatories from across the globe, entitled "Nature Divided, Scientists United: US–Mexico Border Wall Threatens Biodiversity and Binational Conservation," the renowned biologist Paul Ehrlich commented that:

Fences and walls erected along international boundaries in the name of national security have unintended but significant consequences for biodiversity [...]. In North America, along the 3200-kilometer US–Mexico border,

fence and wall construction over the past decade and efforts by the Trump administration to complete a continuous border "wall" threaten some of the continent's most biologically diverse regions. Already-built sections of the wall are reducing the area, quality, and connectivity of plant and animal habitats and are compromising more than a century of binational investment in conservation. Political and media attention, however, often understate or misrepresent the harm done to biodiversity.[87]

Thus, not only does the fortification and the increasing militarization of the U.S.-Mexico border region fragment indigenous groups, control social motion, and regulate cross-border economy and migration; it shatters ecosystems, fragments habitats, decreases biodiversity, and contributes heavily to the deleterious imposition of a global imperial economy which has set itself against the earth as a destructive and cataclysmic force. Border walls—and the U.S.-Mexico border wall specifically—thus contribute to *and* catalyze global environmental change in ways that are far reaching, damaging, and destructive. However, the ecological argument should be but one aspect of the overall critique.

As an imperial state *by design*—founded upon an economy of colonial advancement and cataclysmic extraction—the political and economic tendrils of the United States have, in a relatively short time, crept into all spaces of the earth. First a site of resource and slave extraction for the European feudal powers, next a region of conquest and colonization; the military expenditures, and the calculated machinations of imperial control have pushed the United States to the position of prime suzerain—a global superpower amongst superpowers. Yet its position is held upon a lengthy history of violence, racism, genocide, and slavery; upon the backs of an impoverished working poor, an increasingly stratified social hierarchy comprising a minority élite and a proletarian majority, and a long history of warfare, conquest, and subversion. Having grown from a small collection of European

Border as Control

The border has long been a contested region, but increasingly the region itself is militarized with the express purpose of stopping and controlling the flow of goods and people in favor of the domestic policy of the US.

Pictured: A border crossing during the middle of the twentieth century.

colonies along its eastern shore, the westward expansion of settlers, commerce, and the military—the church and the gun—have since displaced the at least *12,000 year habitation* by indigenous peoples, imperial claims by various other European feudal powers such as the Spanish and the English, and global resistances in the form of Cold War-era oppositional states such as the Soviet Union and the Eastern Bloc. Unassailed, the United States appears to do what it wishes, with little respect for international heterodoxy, global ecology, and the subaltern populations against whom it sets itself. Following all of this, its border regime could *only ever* emerge as a logical extension of not only its political and economic history, but the ways in which it organizes and is organized by its social structure and its military doctrine.

Yet the southern US border is one which has *two* sides. Where an increasingly "hard" border regime ossifies relationships of us/them, civilization/barbarism, and self/other, the Mexican state finds itself in an increasingly precarious position. The historian Oscar Martínez noted that:

The historical record reveals an evolving border relationship between Mexico and the United States. Turbulence dominated during the nineteenth and twentieth centuries, with serious conflict erupting repeatedly over issues such as the delimitation and maintenance of the boundary, filibustering, Indian raids, banditry, revolutionary activities, and ethnic strife.[88]

Martínez went on to note that:

Mexican border cities will continue to bear the brunt of the criminal activity that is required to sustain the illegal distribution system that services the insatiable U.S. market. It means more frequent shootings, kidnappings, tortures, killings, femicides, massacres, and mass burial graves involving not only traffick-

ers but innocent people as well.[89]

As an increasingly hostile zone of friction, the US-Mexico border region is thus one which, following the trajectory of militarization, will remain as such until it is no longer. In this regard, there are not only ecological, social, political, and economic implications that can be drawn from a critical analysis of the border region; there are legal, ethical, and philosophical implications that present themselves as well.

LA FRONTERA: CONCLUSIONS AND SOME THEORETICAL CONSIDERATIONS

As a living historical artifact, the US-Mexico border region might be seen as a site of conflict between three modes of production: *primitive*, *feudal*, and *capitalist*. In social metabolic terminology, we might note the friction between the *extractive*, the *organic*, and the *industrial* metabolisms during the historical generation of what is today the border region. And, in the language of social kinetics and kinopolitics, drawn from the theoretical work of the leading materialist political philosopher Thomas Nail, the border itself thus becomes a site of overlap for *centripetal*, *centrifugal*, *tensional*, and *elastic* forces. The border, thus conceived, is not only a site of confluence between these historically-determinate and theoretical notions, but a site of *conflict* as well.

In the history of the US-Mexico borderlands, we see the dialectic of confluence and conflict not only of metabolisms, modes, and kinetics, but of inter-metabolic friction as well.

The historian Samuel Truett observed that:

In the borderlands, history moves us beyond such dichotomies, for here market and state operated in tandem for years, tacking back

and forth between national and transnational coordinates. Even more important, it reveals the persisting failures of market and state actors, for neither controlled their worlds as expected.[90]

The US-Mexico borderland is a region that is not only defined by conflict and confluence, but delimited by its ecological parameters as well: it is an arid, mountainous, and vast region. And, to-date, the region is unique in that it is "the only place in the world where a highly developed country and a developing nation meet and interact."[91] The political scientist Kathleen Staudt noted that international "border regions are an odd sort of integral space with characteristics shared by both sides."[92] In keeping with its overdetermined nature, the U.S.-Mexico borderscape thus requires that our analytical and critical lenses be similarly overdetermined and dialectical *in nature*; that is, that we must recognize the complex, contradictory, and co-existing factors that go into the creation of the border and that we avoid reducing or polarizing these factors into either positivist or constructivist categories.

As the philosopher Étienne Balibar has warned:

The idea of a simple definition of what constitutes a border is, by definition, absurd: to mark out a border is precisely, to define a territory, to delimit it, and so to register the identity of that territory, or confer one upon it. Conversely, however, to define or identify in general is nothing other than to trace a border, to assign boundaries or borders (in Greek, horos; in Latin, finis or terminus; in German, Grenze; in French, borne). The theorist who attempts to define what a border is is in danger of going round in circles, as the very representation of the border is the precondition for any definition.[93]

The US-Mexico border region is, as mentioned previously, *always-already* an overdetermined phenomenon. One factor alone can not tell us all there is to know about the meaning, the import, and the purpose of the border itself; many factors, forces, and movements (over)determine their existence. The border region is primarily ecological, but it is also economic; it is political, but it is also immigratory; it is material, but it is also social; it impacts the psychologies of those who live with and around it, and it is also impacted by those psychologies; ultimately, it is both *produced by* and *produces* the the region. The border *must* be conceived dialectically, as a tensioned unity of all the aforementioned contradictions where, as Hegel argued, the dialectical analysis is the "comprehension of the Unity of Opposites, or of the Positive in the negative."[94] In other words, border walls both *are* and *mean* something; that is, they are at once physical structures and psychological edifices. Their physicality is known to those who live amidst and around them and their psychological impact both represents and impacts the societies and states in which they emerge.

As the philosopher Thomas Nail observed, "Every state and state border is criss-crossed and composed of numerous other kinds of border mobilities that cannot be understood by state or political power alone. Critical limology reveals that the state is the product of these more primary process[es] of multiple bordering regimes."[95] Simply put, the state produces bordering regimes which are themselves historically-contingent, and these regimes similarly produce the state in ways that are formative, corrective, and reproductive. At the heart of such a dialectical motion between *produced* and *producing* is the force of motion itself.

Viewed through a lens of theoretical synthesis, where we begin to incorporate *modes*

of production, *metabolism*, and *kinetics*, as in **figure 1** below, we can begin to understand the border as a zone where every circulative junction becomes part of a larger circulation where the forces, modes, and metabolisms of production at once move, collide, *and* interact with each other. And, along a standard Cartesian coordinate system, where the x-axis represents a forward progression of time, we can begin to understand, firstly, the US-Mexico border region as a zone where primitive production precedes and collides with feudal production, where the expansive and expulsive forces of Spanish conquest violently absorbed and replaced the earlier, indigenous modes; and we can understand, secondly, how the onset of the modern industrial mode, which, as the final junction in a grander historical arc encompassing all three modes—*primitive*, *feudal*, and *industrial*—must still engage in an intercourse with the earlier modes it has both subsumed and replaced. Thirdly, and finally, we can begin to under-

stand that, as is the case with all political and productive hegemonies, other modes in the zone continue to persist and both impact and inform the movement of the zone itself.

In the case of the US-Mexico border region, the final historical moment in this conceptual representation is the point at which militarized wall fortifications begin to emerge; subsuming and drawing from earlier historical border regimes such as the *fence*, the *cell*, and the *checkpoint*. In regard to the present analysis, however, the border wall is an artificial separation and a bifurcation in the metabolism of the region—from a flow of transition, replacement, and movement. The militarized wall also suggests that the kinetic flow of the *metabolic* movement of capitalism in general can no longer operate in the zone without monumental artifice and divisive edifice; without an increasing militarization to maintain a trajectory which has long outlived its viability. In **figure 1**, the US-Mexico border wall thus becomes a regressive and self-destruc-

Figure 1.

The kinopolitical-metabolic circulation of the US-Mexico border region.

Primitive/Extractive Feudal/Organic Industrial/Capitalist Bifurcation/Wall

tive device: one which moves retrogressively against the progression of capitalism itself. Similarly, in the language of social metabolism and metabolic rift, the wall emerges at the metabolic output site of waste (in the theoretical sense alone), which then catalyzes a back-up of forces thus reinserted back into the circulation of the imperial state's larger metabolism. In so many words, and unencumbered by the analytical jargon, the border wall stops that which is required for the health of the state—the free flow of people, goods, and resources. In this regard, the border suggests itself as a material signifier of an eventual end—a long, drawn-out end which seems to entail a progressive and total militarization of all geographies claimed by the US; the hard ossification of imperial state boundaries aimed to stop the free flow of people and goods endemic to the region; and the build-up of insuperable kinetic and metabolic pressures.

Thomas Nail observed that, "The wall is the second major border regime of the U.S.-Mexico border. Although the usage of walls as social borders first emerged as the dominant form of bordered motion during the urban revolution of the ancient period, its centrifugal kinetic function persists today."[96] The wall, according to Nail, acts, contradictorily, as both a force of expansion and expulsion—dominant themes of the border walls of every epoch—and works to push power out from a central point. On this, Nail observed that:

The wall regime adds to the territorial conjunction of the earth's flows a central point of political force: the city. [...] Kinetically, the wall regime is defined by two functions: the creation of homogenized parts (blocks) based on a central model, and their ordered stacking around a central point of force or power.[97]

The wall along the southern United States border is emblematic of a bordering regime which not only merges and subsumes prior regimes, but which also represents an historical peculiarity endemic to our time: a new kind of wall—a wall of *capitalism*. A wall which signifies and represents both a rift and a bifurcation in the imperial social metabolism of the United States; a wall which seems to prefigure the build-ups of pressures responsible for an eventual internal collapse of the imperial state itself; and, maybe most importantly, a wall which acts as a type of *negative feedback loop*—acting to catalyze the movement of waste, immobility, and ossification back into a failing system which itself becomes increasingly septic, volatile, and deadly. It is the logical conclusion of a long history of racism and imperial violence carried out in the name of colonialism, captialism, and conquest; the result of centuries of incursions, genocide, and expulsions which characterize not only the imperial impetus of Europeans in the Americas more generally, but the very nature of captialism itself to act in ways that are politically, demographically, and ecologically catastrophic.

ENDNOTES

1. Brown 121
2. Martinez, *Border People* xvii-xviii
3. https://www.ajc.com/news/national/trump-border-wall-speech-read-the-full-transcript/Zm6DfoKTbOb6mOvzxOBLwI/
4. Angus 183
5. Neuman 15
6. *Border Management Modernization* 37-38
7. Dunn 170
8. McLinden 1-2
9. Marshall 3
10. Ganster 20
11. Vélez-Ibáñez 20

12. Vélez-Ibáñez 21
13. *Ibid*. 21
14. Ganster 20-21
15. Cronon 12
16. Galeano 2
17. Wilder *et al.* 344
18. Ganster 19
19. EPA, *Ecological Restoration in the U.S.-Mexico Border Region* 11
20. Casey and Watkins 9
21. *Ibid*. 14
22. *The Log of Christopher Columbus' First Voyage to America the Year 1492*, qtd. in Galeano 24
23. Forsythe 297
24. Beaud 15
25. *Ibid*. 14-15
26. Ganster 21
27. Beaud 15
28. *Ibid*. 19
29. Haring 7
30. Ganster 23
31. *Ibid*. 23
32. *Ibid*. 23
33. *Ibid*. 23
34. Truett 18-19
35. Ganster 24
36. *Ibid*. 24
37. Ganster 27
38. Truett 21
39. *Ibid*. 22
40. Nevins 19
41. Nevins 19
42. Truett 33
43. Truett 34
44. St. John 15
45. Truett 34
46. Ganster 28
47. Nevins 19
48. Martínez 11
49. Martínez 12
50. Nevins 21
51. Nevins 22
52. Ganster 32
53. Nevins 23
54. St. John 2
55. Martin 5
56. St. John 2
57. Nevins 25
58. St. John 2
59. *Ibid*. 2
60. Martínez 35
61. Martínez 46
62. *Ibid*. 47
63. St. John 91
64. *Ibid*. 123
65. Dunn 11
66. *Ibid*. 11
67. Hernández 5
68. "United States Enacted Border Patrol Program Budget by Fiscal Year"
69. Dunn 81
70. *Ibid*. 76
71. Trump, emphasis added
72. Dunn 1
73. Brown 145
74. https://www.dhs.gov/news/2018/12/12/walls-work
75. https://www.dhs.gov/sites/default/files/publications/DHS%20BIB%202019.pdf
76. *Ibid*. 3
77. *Ibid*. 3 emphasis added
78. Neuman 5
79. Nail 167
80. Byrd viii
81. Herzog 13
82. DHS, "FY 2019 Budget in Brief" 4
83. Dunn 156
84. Hernández 224
85. https://www.vox.com/energy-and-environment/2017/4/10/14471304/trump-border-wall-animals
86. https://news.stanford.edu/2018/07/24/border-wall-threatens-biodiversity/

87. Ehrlich *et al.*, 740
88. Martínez 148
89. Martínez 151-152
90. Truett 184
91. Ganster 1
92. Staudt 10-11
93. Qtd. in Mezzadra and Neilson 16
94. Hegel, "General Concept of Logic" 73
95. Nail 223
96. Nail 183
97. *Ibid.* 183

WORKS CITED

@realdonaldtrump. "The Wall is the Wall, it has never changed or evolved from the first day I conceived of it. Parts will be, of necessity, see through and it was never intended to be built in areas where there is natural protection such as mountains, wastelands or tough rivers or water....." *Twitter*, 18 Jan. 2018, 03:15 a.m.

Angus, Ian. *A Redder Shade of Green: Intersections of Science and Socialism.* Monthly Review Press, 2017.

———. *Facing the Anthropocene: Fossil Capitalism and the Crisis of the Earth System.* NYU Press, 2016.

Beaud, Michel. *A History of Capitalism: 1500-2000.* Monthly Review Press, 2001.

Brown, Wendy. *Walled States, Waning Sovereignty.* Zone Books, 2010.

Byrd, Bobby, and Susannah Byrd, eds. *The Late Great Mexican Border: Reports from a Disappearing Line.* Cinco Puntos Press, 1996.

Casey, Edward S., and Mary Watkins. *Up Against the Wall: Re-imagining the US-Mexico Border.* University of Texas Press, 2014.

Cronon, William. *Changes in the Land: Indians, Colonists, and the Ecology of New England.* Hill and Wang, 2011.
Department of Homeland Security. *FY 2019 Budget in Brief.* Homeland Security, 2019.
Department of Homeland Security. "Walls Work." *DHS.gov*, 12 Dec. 2018, accessed 10 Aug. 2019.

Dunn, Timothy J. *The Militarization of the U.S.-Mexico Border 1978-1992: Low Intensity Conflict Doctrine Comes Home.* CMAS Books, 1996.

Ehrlich, Paul, et al. "Nature Divided, Scientists United: US–Mexico Border Wall Threatens Biodiversity and Binational Conservation." *BioScience.* 2018, vol. 68, no. 10, pp. 740-743.

Forsythe, David P. *Encyclopedia of Human Rights, Volume 4.* Oxford University Press, 2009.

Galeano, Eduardo. *Open Veins of Latin America: Five Centuries of the Pillage of a Continent.* NYU Press, 1997.

Ganster, Paul. *The US-Mexico Border Today: Conflict and Cooperation in Historical Perspective.* Rowman and Littlefield, 2016.

Haring, Clarence. *The Spanish Empire in America.* Oxford University Press, 1947.

Hernández, José Angel. *Mexican American Colonization During the Nineteenth Century: A History of the US-Mexico Borderlands.* Cambridge University Press, 2012.

Hernández, Kelly Lyttle. *Migra! A History of the U.S. Border Patrol.* University of California Press, 2010.

Herzog, Lawrence. *Where North Meets South: Cities, Space, and Politics on the US-Mexico Border.* University of Texas-Austin, 1990.

Marshall, Tim. *The Age of Walls.* Scribner, 2018.

Martin, Thomas. *Greening the Past: Towards a Social Ecological Analysis of History.* International Scholars Publications, 1997.

———. "Shapes of Contempt: A Meditation on Anarchism and Boundaries." *Social Anarchism* 45 (2012): 22.

Martinez, Oscar J. *Border People: Life and*

Society in the US-Mexico Borderlands.
University of Arizona Press, Tucson, 1994.

Martínez, Oscar Jáquez. *Troublesome Border.*
University of Arizona Press, 2006.

McLinden, Gerard, et al., eds. *Border Management Modernization.* The World Bank, 2010.

Mezzadra, Sandro, and Brett Neilson. "Between Inclusion and Exclusion: On the Topology of Global Space and Borders." *Theory, Culture & Society* 29.4-5 (2012): 58-75.

Nail, Thomas. *Theory of the Border.* Oxford, 2016.

Neuman, Michael. "Rethinking Borders." *Planning Across Borders in a Climate of Change.* Routledge, 2014.

Nevins, Joseph. *Operation Gatekeeper and Beyond: The War on Illegals and the Remaking of the US—Mexico Boundary.* Routledge, 2010.

Staudt, Kathleen. *Free Trade? Informal Economies at the US-Mexico Border.* Temple University Press, 1998.

St. John, Rachel. *Line in the Sand: A History of the Western U.S.-Mexico Border.* Princeton University Press, 2011.

Truett, Samuel. *Fugitive Landscapes: The Forgotten History of the US-Mexico Borderlands.* Yale, 2006.

Vélez-Ibáñez, Carlos G. Border Visions: *Mexican Cultures of the Southwest United States.* University of Arizona Press, 1996.

Wilder, Margaret, et al. "Climate change and US-Mexico border communities." *Assessment of Climate Change in the Southwest United States.* Island, pp. 340-384, 2013.

———

ÉIRE, ESPAÑA, AND THE CONNOLLY COLUMN

WRITTEN BY

UMA ARRUGA

Spain, 1936. A conspiracy against the established Spanish Second Republic is being engineered. The head of the conspiracy, which would end up being a coup d'état, was General Mola, aided by other important Spanish military figures such as José Sanjurjo, Gonzalo Queipo de Llano, Juan Yagüe, and Francisco Franco. The coup d'état started in the Spanish colonies of Ceuta, Melilla, and Tetuán in the afternoon of the 17th of July, 1936, and carried on into the rest of Spain on the 18th of July. Since it initially failed to succeed in all of the Spanish peninsula, a civil war ensued.

The reactions of Irish society to the outbreak of the Spanish Civil War were widely influenced by both the Catholic Church and the newspapers' reports of the time, which focused solely on atrocities committed by Spanish communists and anarchists to members of the Church—some of which were fabricated. Eoin O'Duffy (founder of the fascist association commonly known as the Blueshirts, the political party Fine Gael and later the National Corporate Party in 1935) was a strong voice in favour of the Alzamiento, the Spanish coup d'état. The National Corporate Party's (and thus O'Duffy's) final act (before its disappear-

The Spanish Civil War

The *Guerra Civil Española* emblematized class struggle, and gained international recognition as a an important struggle between the forces of progress and reaction.

ance in 1937) was to organise support for Franco and the rebels in Spain. General Eoin O'Duffy led around 700-800 Irishmen to fight against the democratically established second Spanish Republic. These men would form the Irish Brigade.

Although O'Duffy was an open and proud fascist, the support that the Spanish rebel forces received from the majority of Irish society

CONTINUED ON THE NEXT PAGE

was backed by a Catholic sentiment and not a political one. The Irish Church was prominently anti-communist, influencing society, both publicly (in mass) and privately (during confession). According to Donal Donnelly, "the Irish public were subject to persistant propaganda designed to to pain the Spanish Republic as anti-Catholic... Many of the wildest, most blood-curdling incidents reported were fabricated or exaggerated."[1] Although the Irish

The Fascist O'Duffy

28 January 1890 – 30 November 1944

government had the official say in the matter, the Church carried an unofficial, personal stance on the subject that people were more willing to listen to. Phil McBride, a member of the Irish Brigade, told an interviewer that his parish priest encouraged his enlistment to O'Duffy's brigade. The same priest told a friend, during confession, that McBride was doing a fine thing because he was "going to fight anticlericalism in Spain."[2] Confession was an effective way for priests to privately influence men, and the defence of Catholic Spain was recommended as an adequate penance for their sins.[3]

Clerical, pro-Nationalist (how the Spanish rebels described themselves) magazines were also very popular. These cheap magazines would spread false and exaggerated reports of the Spanish Republicans' crimes against nuns or priests. A particularly gruesome and exaggerated (invented) tale comes from *The Cross*, which related how a Spanish Republican woman bit into the neck of a priest and drank all of his blood.[4]

The Irish government, led by Éamon de Valera, decided to stay neutral and participate in the European Non-Intervention Agreement. Nonetheless, while the official position of the government might have been one of neutrality,

de Valera did not ignore the overwhelming pro-Franco sentiment of Irish society. Franco was unconditionally recognised by the Irish Free State at midnight 10 February 1939, more than a month before the British and French government and almost two months prior to the end of the Spanish Civil War.

Due to the framing of the conflict as inherently religious, O'Duffy's Irish Brigade, which only spent a few months in Spain and saw almost no action, was widely supported by Irish society. Due to the fact that O'Duffy appealed to the men's faith and not politics, the Brigade members held varying political views, and some had even fought each other during the Irish Civil War. It was considered a Catholic brigade by Irish conservatives, sent to Spain to save the Spanish Church, which was allegedly under attack by the communists. For example, Phil McBride, one of the Irish Brigadiers, claimed in a radio interview with Jim Fahy broadcasted by RTE Radio in 1988 that "if they had left the priests and nuns alone, I wouldn't have went there". Nonetheless, the Church and the Brigadiers were pro-Franco, and fascism was openly accepted. While it is true that not all Catholics who joined the Brigade were fascists, all the fascists were Catholics. Despite being framed as a Catholic Crusade, O'Duffy was himself a fascist, there-

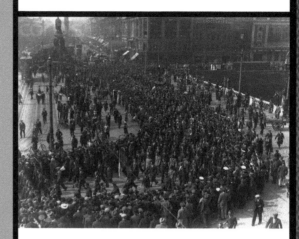

O'Duffy's Irish Brigade

Returning to Ireland after a failed Spanish campaign.

by steeping the organization in fascist values and putting it to work for a fascist cause.

The Irish Brigade was an overall failure: excessive drunkenness due to the cheap Spanish wine, mutinies, refusal to go back to the battlefield, fights between members due to differing political views. Not even Franco, the person they had gone to Spain to to help, was happy with them. According to historian Tim Fanning:

The Irish Brigade was an ill-conceived adventure and its officers woefully unprepared. Less than a handful of officers had any idea about the historical and political

CONTINUED ON THE NEXT PAGE

context of the war. Only one or two of them could speak Spanish or made any attempt to learn it. More forgivable, perhaps, was their lack of military preparedness. Arthur O'Farrel, who was on O'Duffy's staff, told [Father] McCabe after the brigade had gone home that the Irish officers could not read a map, knew nothing about triangulation or range-finding and some of them couldn't understand how a shell could be fired directly to a target out of sight. [...] That lay with O'Duffy, who deceived the nationalist high command about the military training of his officers and men.[5]

However, amidst the overwhelmingly conservative climate fostered by the Church, a different group of men, inspired by radically different ideals than those in the Irish Brigade, decided to travel to Spain. A few years back, the IRA had suffered one of its many secessions. In an anti-Treaty IRA convention in 1934, Michael Price, IRA's director of training, proclaimed that the Irish Republican Army should strive to create the Irish Republic that James Connolly had wanted to establish. His vision of an Irish Republic was influenced by his Marxist ideology, an ideology that Price's supporters in the 1934 con-

vention, including Frank Ryan, also subscribed to. However, Michael Price's proclamation was met with a heated argument by those opposed to Connolly's vision, and Price ended up withdrawing from the convention. Peadar O'Donnell and George Gilmore, two of Price's supporters, claimed that the IRA should create a Republican Congress which would support the creation of a Communist movement in Ireland (following the example of the international United Front and the Comintern). Nonetheless, their calls fell on deaf ears, triggering the secession of O'Donnell, Gilmore, Frank Ryan, and Michael Price from the IRA. On the 8th of April, 1934, the Republican Congress Bureau Committee was formed in a meeting attended by approximately 200 former IRA officers, members of the Communist Party of Ireland, soldiers of the republlican women's organization *Cumann na mBan*, and several trade unionists. The new Republican Congress Bureau Committee had the obligation to form a Republican Congress and create a manifesto. Thus, the Republican Congress (*An Chomhdháil Phoblachtach* in Irish) was created. The political organisation's ideology was established as Marxist-Leninist, and it served as

an attempt to join Republicanism and Socialism in one organisation.

Nonetheless, *An Chomhdháil Phoblachtach* was a short-lived organisation. Outnumbered and repressed by fascist and Catholic organisations such as the Blueshirts and the National Corporate Party, their Marxist ideology was repudiated by the vast majority of Irish society. Their last campaign was the organisation of support for the Spanish Republic at the outbreak of the Spanish Civil War in 1936. Frank Ryan, one of the founders of the Congress and ex-IRA member, travelled to Spain with around 80 other Irishmen to fight for the Spanish Republic. These Irishmen would be known as the Connolly Column. They were Irish Republicans, communists, socialists, and even anarchists. These men did not subscribe to the ideology of the overwhelmingly conservative Irish society of the time, and therefore saw the conflict through a political, rather than a religious, lens.

In September 1936, the Irish branch of the pro-Republican Spanish Medical Aid Committee was founded by the Communist Party of Ireland and the Republican Congress. However, the committee was not popular amongst Irish society. With the creation of General Eoin O'Duffy's Irish Brigade, Ireland's leftists realised a more direct action had to be taken.

Bill Scott, an Irishman who had found himself in Barcelona during the Alzamiento and immediately joined the fight against fascism, frequently wrote home to his friends, including Séan Murray, the general secretary of the Communist Party of Ireland (CPI). In his letters he would describe the situation of the Spanish Republicans who were fighting against Fascism and the horrors the Spanish civilians had to endure. In one of those letters quoted in the The Irish Worker's Voice, the CPI's official newspaper, Scott wrote:

I was free for a few days and decided to see Madrid. Here is what I saw: On December 4th, thirty low flying Fascist planes loomed over the city as if considering where to release their loads of death. Suddenly, a succession of terrific explosions shook the city, and dense volumes of smoke were seen rising about a mile from the centre. I went to the scene of the raid. I saw firemen and militiamen endeavouring to rescue dying men, women and children from the burning pile, which half an hour before had been a block of tenement flats. I saw the mutilated bodies of children wedged between heavy

CONTINUED ON THE NEXT PAGE

beams. In the midst of the street I saw what on examination proved to be a child's cot containing a mangled body. People in adjoining streets, not fortunate enough to be killed outright, were blinded and shell-shocked by the explosions.[6]

Scott's words were a wakeup call for Irish leftists. Thus, the idea of creating an Irish Unit of the International Brigades came to life and recruitment and logistics fell into the hands

Frank Ryan

Top right, pictured alongside Joe Ryan and other colleagues from the International Brigade.

of Bill Gannon, a popular ex-IRA veteran member of the CPI. Tommy Woods, a seventeen-year-old Dubliner who had learned to use weapons with Na Fianna Eireann (the Republican Boy Scouts) left a letter for his mother after enlisting. In this letter, he wrote that the Irishmen, including himself, "are going out to fight for the working class" and that it was "not a religious war, that is all propaganda."[7] On the 12th of December 1936, Frank Ryan left Dublin with a group of approximately 80 other Irishmen. Many more other Irishmen would join them in the following months, travelling to Spain from Ireland and places such as Australia or the United States of America, where they had been forced into exile after the Irish Civil War.

Frank Ryan, a respected ex-IRA member and one of the founders of the Republican Congress, was unanimously regarded as the leader of these departing Irishmen. Due to his nationalist, anti-British, and anti-treaty views, Ryan was imprisoned many times, including once when he was arrested due to his involvement in the Irish Civil War. He spent 1922 and 1923 at Harepark Internment Camp and was one of the last prisoners to be released. Other legendary anti-treaty IRA members

such as Kit Conway and Jack Nalty joined Frank Ryan in the Spanish Civil War. Ryan, however, was regarded by the Irishmen as their commanding officer. Unlike Eoin O'Duffy, Frank Ryan was present in the front, fighting alongside the other Irishmen and the International Brigadiers.

A few days after leaving Ireland, the men arrived at the International Brigade headquarters in Albacete. The Irishmen were sent to the base of the English-speaking Brigade, which in December 1936 was only formed by the British Battalion. By February 1937, however, it would be known as the XV International Brigade, formed by men from other English-speaking countries such as the United States of America along with Belgian, French, and Balkan soldiers. The base was located in Madrigueras, thirty kilometres north of Albacete, and served as a military training camp. Their commander was Captain George Nathan, a British army veteran. Being part of the British Battalion, however, did not sit well with the Irishmen. They were (ex-) IRA members, soldiers who had led a war against the British occupational forces in their homeland, and having to obey British officers went against what they had fought for in the Irish War of Independence. Tensions heightened between the Irish and the British when it was discovered that George

The Black and Tans

Ever the enemy of the working peoples and revolutionaries in Ireland.

Nathan, their commander, had been an important member of the Auxiliary Division of the Royal Irish Constabulary—an imperialist paramilitary unit that worked closely with the Black and Tans, and had personally murdered two Sinn Féin members in 1920.[8]

Class solidarity and the fight against Fascism, however, were regarded by some of the Irishmen, such as Charlie Donnelly, as more important than the historical enmities. Frank Ryan, although himself a dedicated Irish Republican, tried to defuse the tension addressing the problems in a New Year statement:

CONTINUED ON THE NEXT PAGE

An Irish unit of the International Brigades is being formed. [...] This unit will be part of the English-speaking Battalion which is to be formed. Irish, English, Scots and Welsh comrades will fight side by side against the common enemy-Fascism. It must also be made clear that in the International Brigades in which we serve there are no national differences [...]. For the sake of the people of Spain and the success of the fight against Fascism -and in the name of the folks at home whom we must never disgrace, I ask for a complete unity and the fullest concentration in this, the decisive fight for the liberty of the human race.[9]

On Christmas Eve, 1936, forty-five volunteers of the Connolly Column started marching towards the front alongside the 12th French Battalion of the XIV Brigade and the First Company of the British Battalion. They were ordered to take part in the southern offensive, which aimed to take back the village of Lopera. Nathan had selected Kit Conway, and not Frank Ryan, to lead the Irish section of the Battalion, to the consternation of Irish soldiers such as Joe Monks.[10] Frank Ryan, in turn, was shipped off to help the 12th International Brigade in the Madrid front, and the Irishmen who had not volunteered for this counter-offensive, around forty, remained in Madrigueras. The marching brigadiers came under fire during their journey to the southern Córdoba front, and it was only then that the Irishmen realized the poor condition of their weapons. The Irish carried trench-helmets, grenades, gas masks and 250 rounds of ammunition; however, their Chauchat machine guns continually jammed and their old Austrian rifles were single shot. While covering from the Fascist fire, they also observed the Republican artillery shells were inadequate: two out of five shells did not explode. The Irishmen stayed in the proximities of Lopera in the Córdoba front for almost a month before being transferred to the Madrid front, where Fascist Italian and German troops were attempting to capture the capital. The Connolly Column had lost eight men in Córdoba, including seventeen-year-old Tommy Woods.

While Frank Ryan was fighting in Madrid and the bulk of the Connolly Column found itself along the Córdoba front, the remaining Irishmen in Madrigueras were sent off to the Abraham Lincoln Battalion, the North American Unit of the International Brigades. Accounts of why they were sent off

vary depending on the source. Some say the Irishmen voted to join the North Americans because of their animosity with their British comrades. Other sources, such as Frank Ryan himself, claim the British disposed of them to eliminate the tension they created between the soldiers. Ryan joined the members of the Connolly Column who were still in the British Battalion during their journey to the Madrid front, where he had been during the past month. They took part in the capture of Majadahonda and the battle in Las Rozas, where they lost one more soldier, Dinny Coady.

However, it was in the Battle of Jarama where the Irishmen suffered the most. The Battle of Jarama was part of Franco's new offensive to take the Spanish capital. After the failure of the first Madrid offensive in November 1936, the fascist forces had regrouped and developed a new strategy. Their new plan included cutting the road that linked Madrid with Valencia. Franco's attack started on the 6th of February, 1937, with five brigades of the Nazi Condor Legion and several Moorish squadrons which added up to around ten thousand troops. Six days later, the Fascist forces had captured Pingarrón Hill, the geographically dominant hill providing a clear view of the area surrounding the road. It was on the same day, the 12th of February,

that approximately sixteen hundred men of the XV International Brigade, including forty Irishmen, jumped out of their lorries and into the main road a few kilometres from the village of Morata de Tajuña.

It was there, amongst the olive groves and irregular terrain, that the XVth International Brigade made contact with the Fascist soldiers. They would be the only ones standing between the fascists and the capital. The Irishmen, led by Kit Conway, were included in the first Company of the British Battalion. It was the first Company to clash with the enemy, a platoon of Moorish regulars. The Irishmen and the other soldiers from the XVth International Brigade endured heavy fire in an area which offered virtually no cover. Their own rifles and Maxim guns were practically useless because they had been given the wrong ammunition. Carnage ensued from the lack of ammunition and solid cover. Amongst others, the Irishmen lost Kit Conway, who had led them in Córdoba, Majadahonda and Las Rozas. Nonetheless, while only 25 percent of the First Company and 33 percent of the whole Brigade were still in the line at the end of the 12th of February,[11] the XVth International Brigade succeeded in stopping the advance of

CONTINUED ON THE NEXT PAGE

Franco's troops. They also inflicted great casualties in the Fascist ranks, which could not be easily replaced because they were Franco's elite troops.

After all the losses, the men's morale was low. On the 14th of February, after having their lines undermined and their troops overwhelmed by a new attack, Ryan, alongside János Gálicz and fellow Irishman Jock Cunningham, led 140 men of the British Battalion back towards the enemy. They forced the Fascist troops to fall back, all while singing the Internationale. Ryan, who fought alongside his men, was wounded a day later, on the 15th of February. In a letter he

The Connolly Column

Young leftist militants in España.

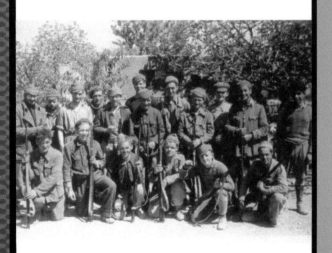

sent to his friend General O'Reilly, written on the 5th of March 1937, he recalled the events:

I got a slight flesh-wound in the arm from a bullet which went through the head of a man beside me. It made me - even gentle me! - fighting mad. [...] Half an hour later a tank shell burst beside me and I got a wallop in the left leg that knocked me down. [...] There was no blood. It must have been a stone thrown by the shell. I limped for a few minutes, then I felt OK. [...] Shortly after I got a bullet through the left arm. It's a clean wound, high up, and will be OK in a few weeks.[12]

The Abraham Lincoln Battalion, and thus the Irishmen of the Connolly Column who had joined them, also fought in the Battle of Jarama. They faced the same fate as their British Battalion counterparts, losing hundreds of men on the last day of fighting alone. Charlie Donnelly, a young poet from Killybrackey, fought with them. A Canadian soldier, quoted in Joseph O'Connor's book about Donnelly, recalled:

We ran for cover, Charlie Donnelly, the commander of an Irish company is crouched

behind an olive tree. He has picked up a bunch of olives from the ground and is squeezing them. I hear him say something quietly between a lull in machine gun fire: 'Even the olives are bleeding.'[13]

A few minutes later, he was struck by machine gun fire three times, including his head. He died instantly. It was the last day of the Battle of Jarama. The fighting lasted for 21 days (from the 6th to 27th of February), but the men, including the Irish, stayed in the trenches of the Jarama front for approximately three months. Nineteen Irishmen were killed in action, and around 20 thousand men were lost.[14] Just over fifty of the approximately eighty Irishmen who had crossed the Pyrenees with Ryan were alive after Jarama. Both sides suffered substantial losses, and no explicit victor was proclaimed. The Republicans, however, managed to clear the Madrid-Valencia road from Fascist troops—an action which was regarded as a strategic victory for the Spanish Republic. In the Jarama front trenches, the Irishmen celebrated their national festivities. A concert was held in honour of the anniversary of the Easter Rising. On May 12th, a ceremony was held on the 21st anniversary of James Connolly's execution, attended by soldiers and officers from all the nationalities present. It was during this time

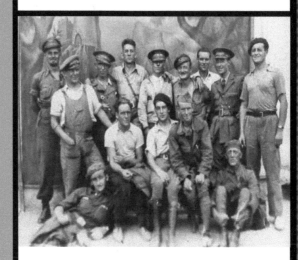

Irish Volunteers

The *XV Brigada Internacional* was a mixed brigade, fighting for the Spanish Republic, against the fascists, in the Spanish Civil War. Alongside the British Battalion and the North American Lincoln Battalion, the International Brigade also included two non-English speaking Battalions: a Balkan Battalion and a Franco-Belgian Battalion.

in the trenches that the anti-Fascist Irishmen came the closest to a direct confrontation with O'Duffy's Bandera. The Irish Communist Tom Murphy recalled in a 1996 interview:

Our trenches were maybe a few hundred yards away. Frank Ryan used to speak on the speaker, he says 'Irish-

CONTINUED ON THE NEXT PAGE ➡

men go home! Your fathers would turn in their graves if they knew that you'd come to fight for imperialism. This is the real Republican army, the real, the real men of Ireland.'[15]

Although there is evidence of both Irish sides being in close proximity, there is no evidence whatsoever of them actually engaging in combat with one another. In March 1937, around the time of the Battle of Jarama, a pro-Spanish Republic newspaper called *Irish Democrat* was set up in Ireland by the small community of leftist activists that had remained there. The newspaper was the only way the Irish soldiers had to tell their stories of their fight in Spain. After Jarama, the Irishmen were faced with the Brunete Offensive. The offensive was an attempt by the Republic to ease the Nationalist pressure around Madrid, and it took place from the 6th to the 25th of July, 1937. It was the first real offensive launched by the Republicans, who had been on the defensive since the start of the Alzamiento. The XV Brigade played an important part in the Battle of Brunete, especially in the taking of the city itself. The Irishmen had been split into three different sections of the XV Brigade. Peter O'Connor recalls a feeling of loneliness as he, at some point, found himself to be the only Irishman on the Brunete frontline.[16] The attack start-

ed on the 6th of July at 5 a.m. Although the Republican forces made great progress in the first few days (such as taking Brunete, Villanueva de la Cañada and Quijorna) of the offensive, the Fascists' counter-attacks were fierce and they ended up winning the battle. Franco had access to Nazi planes and pilots, giving the fascist forces a clear advantage. The planes would constantly strafe the Republican soldiers, making it almost impossible to find cover. The heat, shortage of food, and water scarcity also took a toll on the Republican soldiers. Peter O'Connor recorded in his diary in an entry for July 20th:

The Fascists made a fierce attack this morning on our right flank using 40 or 50 bombers, machine guns and tanks. Our flank gave way. We are retreating slowly. The heat is terrific. We are parched with thirst, we are now 12hrs. without drink. Some of our Spanish comrades have collapsed with the heat. The bombardment and machine-gunning from the air by Hitler's Junkers is terrible. It is the most demoralising of all, but still our troops are holding heroically under the strain.[17]

The human cost of the Republic

was around twenty-five thousand men, including seven Irishmen from the original Connolly Column.[18] Major George Nathan was killed by an air bombing on the last day of the battle. Frank Ryan had not fought with his men in the Battle of Brunete. He had been stationed at the International Brigades HQ in Albacete, where he had taken over the propaganda and publicity work. The Irishman and his fellow soldiers rested during the first weeks of August but found themselves in the Aragon front by the end of the month. The Spanish Republic's new offensive aimed to apply pressure to, and possibly capture, the city of Zaragoza. The XV Brigade's objective was to take the town of Quinto. The Nazi soldiers belonging to Franco's ranks had heavily fortified Porburell Hill, on the outskirts of the small town. The Republican forces, however, managed to take Quinto and Porburell Hil. Peter Daly, Battalion Commander, was fatally wounded during the first days of the assault on Porburell. By taking the Hill's fortress, the Republicans had forced the Fascist line to retreat to the town of Belchite.

After intense fighting which cost several lives, including those of two Irishmen, the Fascists surrendered Belchite on the 6th of September. After Belchite's fall, the XV Brigade was moved into reserve but returned to the Aragon front on October 12th.

The renewed Republican attack failed, but the XV Brigade was kept on trench duty until they were relieved by new Spanish troops. The XV Brigade, including the few Irishmen still alive and not hospitalised, were allowed to rest until the first days of January 1938, when they were moved to take part in the Battle of Teruel. On the last days of 1937 and the first days of 1938, the Republican forces had managed to take the city of Teruel. On the 17th of January, however, Franco launched a counterattack to take back the city, and the XV Brigade was taken out of reserves. The battle would last three months and would end with the recapture of the town by Fascist troops. Three Irishmen lost their lives in the Teruel fighting. March 8th, 1938, saw the launch of the biggest Fascist offensive on the Aragon front. Franco's forces, besides the Spanish and Moroccan troops, including several Nazi airplanes, four battalions from the Nazi Tank Corps (with 45 tanks in total), and the Fascist Italian "Black Arrows" Division.

The Republican soldiers, especially the XV International Brigade were exhausted and ill equipped after the Battle of Teruel, and their lines broke quickly. The fascists overran the Republican positions,

CONTINUED ON THE NEXT PAGE

and again, three more Irishmen lost their lives. It was during this Nationalist offensive that Frank Ryan was captured by the Italian fascists. In the spring and summer of 1938, hundreds of new volunteers joined the International Brigades, including

A Young Michael O'Riordan

Founder of the Communist Party of Ireland, and International Brigade volunteer.

four other Irishmen. Amongst them was Michael O'Riordan, one of the founders of the Communist Party of Ireland. These Irishmen and the other volunteers joined the XV Brigade during their rest in between the Aragon front battles and their last battle: the Battle of the River Ebro. On the 24th of July 1938, the XV International Brigade was ordered to cross the Ebro River as part of the last Republican offensive. The aim of that offensive was to surprise the Francoist troops all along the Ebro River, to reconnect Catalunya with the rest of the Republican zone, and to alleviate pressure on Valencia. The Battle of the Ebro would last from July to November of 1938. The failure of this last major offensive would mark the beginning of the Republic's final days. On the night of the 25th of July, the International Brigadiers crossed the river. The British Battalion Commander, Sam Wilde, handed a Catalan flag to Michael O'Riordan for him to carry through and across the Ebro river and into the Fascist occupied territory of Catalunya.[19] The International Brigadier's main objective was to take Hill 481, which was highly fortified by the Fascists. The Republican soldiers, however, were at a clear disadvantage. Thirteen hundred Nazi and Italian

planes were used against them, and during the whole Battle of the Ebro, Franco's troops had a superiority of 15 to 1 bomber planes, 10 to 1 fighter planes and 12 to 1 heavy artillery.[20] In other words, Franco controlled the sky and subsequently, controlled the ground with the planes' bombs and machine guns.

After five days of intense fighting to take Hill 481 and after losing multiple men, the attack on the fortified hill was called off. Three Irishmen had lost their lives in the struggle. August 2nd saw a hold on the Republican advance and on the 3rd of August Franco launched a counter-attack. The XV International Brigade alternated between fighting and being pulled back into reserve. Their troops were weakened by all the struggles they had taken part in. They were exhausted, both mentally and physically. On the 21st of September, Dr. Juan Negrín, the Prime Minister of the Spanish Republican Government announced that the International Brigades were to be withdrawn and the soldiers repatriated. The XV International Brigade, including the last few surviving Irishmen, however, were pulled into the Battle of the Ebro once more on the 23rd of September. It would be their last fight for the Spanish Republic. It was on this last day that Jack Nulty was killed. Nulty had been one of the original Connol-

The Battle of the Ebro

The longest and the largest battle of the Spanish Civil War, taking place between July and November 1938 along the lower course of the Ebro River.

ly Column members and had returned with his fellow Irishmen after being hit in Córdoba. Liam McGregor also lost his life on that last day of fighting.

The Irishmen and their fellow soldiers officially left the front after midnight on September 24th, 1938. On December 7th, after many popular ceremonies in their honour, the XV International Brigade left Spain. One badly wounded Irishman, Paddy Duffy, had to be left behind. The Irish and British volunteers took boats to Newhaven from France and then a train to London's Victoria Station. Some Irishmen decided to

CONTINUED ON THE NEXT PAGE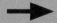

stay in London due to the prospect of being treated like pariah in Ireland. They were afraid of not finding any jobs due to the fact they were anti-Fascists who had fought for the Reds in Spain—a likely outcome in a society where the basis of the Spanish Civil War was actively misframed as being a religious conflict. Only seven Irishmen, including Michael O'Riordan, returned to their Ireland. They were the last Irishmen to return home.

However, Frank Ryan never made it back to Ireland. An American International Brigadier, who was also taken prisoner by the Italian fascists, remembered a dramatic moment of Ryan's captivity:

They brought up Frank Ryan and about thirty British prisoners. A Fascist officer demanded to know who their commanding officer was. Captain Ryan immediately stood up. The English prisoners -all of them were in pretty bad shape, but fearing for Ryan's life they all shouted, "No, Frank! No! Sit down!" But Ryan simply said: "I am." [...] The Italian officer told us that Gandesa had fallen. Ryan didn't believe him and told him so. At that point another officer joined us. He was German- Gestapo. He told us who he was. He got into a discussion in English with Captain Ryan - about why he was in Spain, etc. Frank told him - spelled it out for him; then asked the Gestapo officer what he was doing in Spain. The officer said simply: "You're a brave man", then turned around and left us.[21]

The Italian Black Arrows positioned Ryan in front of the prisoners and tried to force him to do the Fascist salute. Ryan refused. They positioned a firing squad in front of him and mocked an execution. Ryan still refused. The only reason why he wasn't executed was because he was a high-ranking officer and they hoped to exchange him for Italian and German prisoners of war. He was first taken to a concentration camp set up in Miranda del Ebro, then a detention centre at San Pedro de Cardenas. Later, he was transferred to the Central Prison at Burgos, a prison built for 500 men but that held more than five thousand men. It was 1940 when he was sentenced to die by a Court Martial. In Ireland, however, a Release Frank Ryan Committee had been created, and their efforts did not go in vain. They forced Éamon de Valera to intervene, and Ryan's death sentence was commuted to 30 years in prison. He spent two years and four months in the Bur-

gos before he was handed over to the Germans. The Abwehr, the Nazi military intelligence agency, wanted to use Ryan, a famous Irish Republican, to undermine the British. Despite opportunistic efforts by those that likely sided with Italian fascists, there is no evidence nor records of Ryan voluntarily collaborating with the Nazis. In January 1943, while still in Germany, his health deteriorated due to the conditions he had endured while being Franco's prisoner. After an apoplectic fit, he lived in pain until his death on June 10th, 1944, aged 41.[22] He was originally buried in Dresden. His remains were repatriated in 1979, and now lay in Glasnevin Cemetery in Dublin.

In the 1930s, the Spanish Civil War was regarded by the majority of Irish society as a war against Catholicism. This framing of the conflict, which served the Fascist cause, was in stark contrast to that of the Irish left. In the words of Peadar O'Donnell, "All wars are fought between devils and angels; war propaganda remains the most monotonous of all human cries. Pens sprinkle soot or halos."[23] However, many years have passed since the end of the conflict, and the studies that arose about the Spanish Civil War and the news that came from Franco's dictatorship changed the opinion of Irish society and institutions. The Irish members of the International Brigades, who were

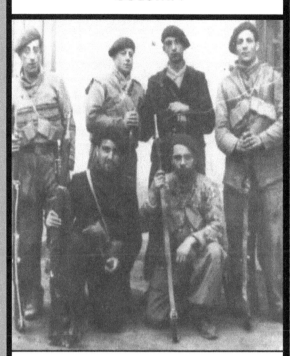

The International Brigades

As an important component of the war effort, the International Brigades not only offered logistical and combat support, they emblematized international proletarian and working class solidarity.

once ostracised by Irish society, are now remembered and even commemorated in some instances. The same cannot be said of the members of the Irish Brigade.

The Irish Labour Party, which was anti-communist and did not support the Irish International Brigadiers at the time, now has a

CONTINUED ON THE NEXT PAGE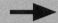

picture of said Brigadiers in its head-quarters in Dublin. The Irish Trade Unionists, which had demanded the Irish Government cease relations

A Tribute to Internationalism

A Belfast City Hall stained glass, commemorating the Irish antifascist involvement in the International Brigades.

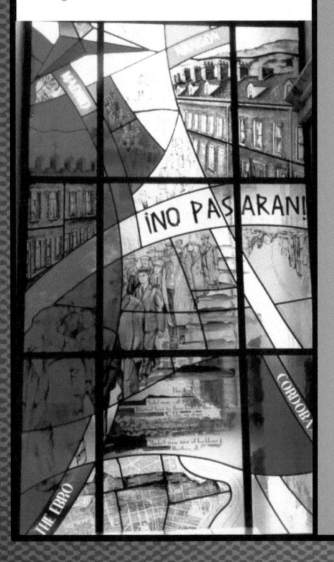

with the Republican Spanish Government, have now funded many of the memorials scattered all over Ireland. As of 2020, the author of this article has counted 38 memorials (including murals, plaques, headstones, bridges, etc.) for members of the Connolly Column (who fought and even died in Spain), in both the Irish Free State and the occupied Six Counties. Most of these memorials are funded by the local communities of these brave Irishmen. For example, Dooega Achill Island, in County Mayo, has a memorial dedicated to Thomas Patton, who was born there. The memorial was unveiled in 1984 and funded by the community. There are also memorials funded by public institutions. At Belfast City Hall, we find a coloured glass window dedicated to the International Brigades. It was unveiled in 2015 and funded by Belfast's own City Council. At University College Dublin there is a commemorative plaque in memory of Charlie Donnelly, the young poet who died in Jarama and had previously studied at UCD. Funded by the University, it was unveiled in 2008. Donnelly is also the protagonist of a memorial plaque for the International Brigadiers fallen in Jarama found at the site of the Jarama Battle.

Frank Ryan's resting place at Glas-

nevin Cemetery has a memorial headstone with an inscription in Irish. The translation goes as follows: "Francis Ryan. Born in Elton, County Limerick 1902. Died in Dresden, 1944. His body was brought back to his homeland on 22 June 1979. He fought for freedom in this country [Ireland] and in Spain. May God reward him. (Translation by the author of the article)." Such praise is a world away from the pro-Fascist narrative that was propagated at the time of the conflict. In contrast, there is only one small memorial belonging to a member of the Irish Brigades: a plaque in Dublin to the name of Gabriel Lee, who fought for Franco and died in Spain in 1937. Eoin O'Duffy is also buried in Glasnevin Cemetery, but no memorial headstone decorates his resting place. It therefore seems that, with the exception of ultra-conservative elements that still valorize the likes of O'Duffy, history has absolved the brave Connolly Column while the Irish Brigade are now regarded not as soldiers for religious freedom but as thugs for fascist oppression.

Endnotes

1. Donal Donnelly, in the foreward to *Salud!* by Peadar O'Donnell, 2020 (1937), Friends of the International Brigades in Ireland, p.6.

2. Stradling, 1999: p. 3

3. *Ibid.*, p. 10

4. McGarry, 1999: p.143

5. Fanning, 2019: p. 179-180

6. Scott: 1936

7. O'Riordan, 2005: p. 65

8. Irish Press: 26 March 1961

9. Ryan, New Year's Day 1937

10. Monks, 1985: p. 8

11. Stradling, 1999: p. 167

12. Cronin, 1980: p. 97-98

13. O'Connor, 1992: p. 105

14. O'Riordan, 2005: p. 73/77

15. Stradling, 1999: p. 3

16. O'Riordan, 2005: p. 88

17. *Ibid.*, p. 88

18. *Ibid.*, p. 84

19. *Ibid.*, p. 126

20. Ibid., p. 127

21. Qtd in O'Riordan, pp. 119-120

22. O'Riordan, 2005: pp. 151-157)

23. Peadar O'Donnell, *Salud! An Irishman in Spain*. 2020 (1937), Friends of the International Brigades in Ireland, p. 10.

Bibliography

Secondary Sources

Cronin, Séan. *Frank Ryan: The Search for The Republic.* Repsol Publications, 1980, Dublin.

CONTINUED ON THE NEXT PAGE

UMA

Fanning, Tim. *The Salamanca Diaries. Father McCabe and the Spanish Civil War.* Merrion Press, 2019, Co. Kildare.

McGarry, Fearghal. *Eoin O'Duffy: A Self-Made Hero.* OUP Oxford, 2005, Oxford.

McGarry, Fearghal. *Irish Politics and the Spanish Civil War.* Cork University Press, 1999, Cork.

O'Connor, Joseph. *Even the Olives are Bleeding: Life and Times of Charles Donnelly.* New Island Books, 1992, Ireland.

Othen, Christopher. *Franco's International Brigades: Adventurers, Fascists, and Christian Crusaders in the Spanish Civil War.* Columbia University Press, 2013, New York.

Preston, Paul. *A People Betrayed: A History of Corruption, Political Incompetence and Social Division in Modern Spain 1874 - 2018.* HarperCollins, 2019, New York.

Stradling, Robert. *The Irish and the Spanish Civil War: 1936-1939: Crusades in Conflict.* Mandolin, 1999, Manchester.

Primary Sources

"Even the Olives are Bleeding." Documentary, directed by C. O' Shannon for RTE, 1975.

Graham, Frank. *The Book of the XV Brigade: Records of British, American, Canadian, and Irish Volunteers*

ARRUGA

in the XV International Brigade in Spain, 1936-1938. Warren and Pell Publishing, 2003, Pontypool (UK).

Monks, Joe. *With the Reds in Andalusia.* John Cornford Poetry Group, 1985, London.

O'Riordan, Michael. *Connolly Column: The Story of the Irishmen who fought for the Spanish Republic, 1936-1939.* Warren and Pell Publishing, 2005, Pontypool (UK).

"Prisoners of War." File G: Material on Frank Ryan. Marx Memorial Library, Box 28, G/1 to G/18. Consulted thanks to Jordi Martí-Rueda.

Radio interview with Jim Fahy, broadcasted in RTÉ Radio, 1988.

Retrieved from Robert A. Stradling's Book:

Article from *Irish Press.* 29th of March 1961.

Articles from *Irish Independent:* 10th of August and 21st of September 1936.

Retrieved from Michael O' Riordan's Book:

Letter by Bill Scott featured in an article from the *Irish Worker's Voice.* 9th of January 1937.

V. LENIN

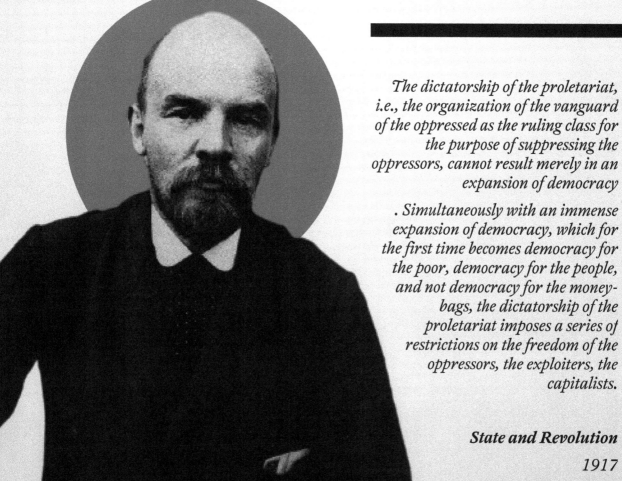

The dictatorship of the proletariat, i.e., the organization of the vanguard of the oppressed as the ruling class for the purpose of suppressing the oppressors, cannot result merely in an expansion of democracy

. Simultaneously with an immense expansion of democracy, which for the first time becomes democracy for the poor, democracy for the people, and not democracy for the money-bags, the dictatorship of the proletariat imposes a series of restrictions on the freedom of the oppressors, the exploiters, the capitalists.

State and Revolution

1917

The Nina Andreeva Affair

Part One: Unwavering Principles Amidst a Wave of Reform

Donald Courter

Nina Andreeva was influential in the anti-revisionist, anti-perestroika movement.

Pictured: Andreeva with communist student activists and anti-perestroika protests in the Soviet Union.

Past & Present Collide

"If there was no Nina Andreeva, we would have had to invent her."[1] These were the words uttered by Soviet market reformer Anatoly Chernyaev as he recalled the pivotal event of 1988 that would ultimately clear the way for the restoration of capitalism and the dissolution of the Soviet Union itself—the Nina Andreeva affair. The events which came to comprise the Nina Andreeva affair began to unfold with the publication of a Leningrad chemistry teacher's letter to the editor in the newspaper *Sovetskaya Rossiya*, scandalously titled "I Cannot Renounce My Principles" in reference to one of General Secretary Mikhail Gorbachev's speeches defending Marxist-Leninist ideology. Andreeva's letter immediately caught the attention of all spheres of Soviet society as a result of her unyielding criticism of the newly liberalized media's attacks on Soviet history and its renunciation of the ideological principles upon which the USSR was constructed. Her call for a reform course rooted in economic planning and under the leadership of the Communist Party of the Soviet Union (CPSU), as opposed to market economics under the guidance of emerging petty capitalists and liberal politicians, immediately received sig-

...ucturing
and
...parency

A Soviet
...restroika
...from the
era.

...nificant support from Gorbachev's Marx-...st-Leninist colleagues in the highest or-...gans of the CPSU.

...While the liberal media's attacks on Soviet ...history were defended as expressions of ...Gorbachev's policy of *glasnost*, so too did ...Andreeva's supporters—and even some ...western historians—rationalize her letter ...as a legal manifestation of newfound social ...openness. However, market reformers and ...media representatives, like Anatoly ...Chernyaev, immediately labeled Andree-...va's letter an "anti-*perestroika* manifesto" ...and accused Andreeva herself of unwaver-...ing neo-Stalinism, antisemitism, and polit-...cal conspiracy for utilizing *glasnost* to de-...fend the history of the USSR against what ...she considered unilateral ideological sur-...render to the west. Party members who ...supported the letter were not only coerced ...nto later denouncing it, but some were ...even purged or demoted to superfluous po-...sitions as a result of their reluctance to de-...fend liberal policies from the criticism of ...average people like Nina Andreeva. The se-...vere response of the market reformers—...those who were purportedly introducing ...freedom and democracy to the Soviet peo-...

...cates that the political nature of these ac-...tions directly contradicted their purporte-...democratic values. Their accusations, pa-...ticularly of neo-Stalinism decades afte-...Stalin's policies had been condemned b-...the CPSU, did not represent an attack o-...authoritarianism but an opportunistic a-...tempt to discredit an opposition that re-...jected the establishment of markets and po-...litical pluralism as a legitimate Soviet re-...form path, and indeed, viewed such mea-...sures as precursory to the restoration o-...capitalism.

The political turmoil embodied by the Nir-...Andreeva affair and the emergence of ...market faction within the CPSU were mad-...possible by the political, social, and eco-...nomic stagnation that pervaded the latte-...years of Leonid Brezhnev's eighteen yea-...term (1964-1982) as CPSU General Secre-...tary. The USSR had been the first countr-...to implement national economic planning-...an economic system in which production i-...planned in five year increments accordin-...to the nation's requirements for growth ...and despite its development amidst wars-...hardship, and political instability, econom-...ic planning became a successful mode o-...

USSR. The system's provision of economic benefits such as full employment alongside steady growth and its eradication of business cycle fluctuations comprised an appeal that rivaled that of market economies for citizens of the Eastern Bloc. Likewise, the Soviet one-party system's parallel development afforded the CPSU the status of leading political organ of the USSR's development. However, the Brezhnev administration's pursuit of policies unfavorable to the improvement of planning methods caused economic growth rates to stagnate.[2] Roger Keeran & Thomas Kenny's, *Socialism Betrayed: Behind the Collapse of the Soviet Union*, provides a thorough analysis of both the black market activity that resulted from the state's failure to modernize the planning process and the inner Party corruption that developed as a consequence. Concurrent repercussions of outdated planning methods, such as declining labor productivity, a lack of incentive to integrate new technologies into production, and a focus on the production of large quantities of commodities rather than improving their quality, further contributed to the growth of black market activity, Party corruption, and the popularity of market solutions.[3]

Even the CPSU Politburo fell victim to corruption, as close relatives to Leonid Brezhnev were caught attempting to sell stolen state property on the black market.[4][5] The reluctance of economic planners to take risks with new methods combined with growing corruption within the Party further fueled the arguments of Gorbachev and market-oriented Party members like Alexander Yakovlev and Anatoly Chernyayev, that economic planning was a bankrupt system and that the CPSU's hegemony over political power made corruption inevitable. However, the past accomplishments of the Soviet economy, as well as the fact that inflation and the rapid growth of the Black Market consequence of earlier market reforms, reveal that economic planning required reform rather than replacement.

In an attempt to revolutionize Soviet society and revitalize its stagnating economy, CPSU members embarked upon a massive reform project initiated with the election of Yuri Andropov as General Secretary in 1982. Despite his death a year later, Andropov led the CPSU along a path focused on the modernization and democratization of economic planning, largely through the transfer of economic agency from bureaucratic organs to localized workers' councils. He called for a system of decentralized economic planning that would solidify economic power in the hands of average workers, incentivize technological integration into the production process, and crack down on corruption in the Party.[6] Andropov's proposed policies rejected the expansion of market forces in the Soviet economy and prioritized planning in a way distinctly different from both the policy suggestions of Brezhnevites and market-oriented Party members, leading many to observe that Andropov was "not on the side of Khrushchev nor on the side of Brezhnev."

Out of this revolutionary reform tendency and after the quick death of Andropov's successor Konstantin Chernenko, emerged one of Andropov's closest comrades, Mikhail Gorbachev, as General Secretary of the CPSU at the 27th Party Congress of 1986. Following Andropov's reform legacy, Gorbachev quickly took initiative on several reform projects cut short by the untimely death of his mentor, such as a social campaign against alcoholism, an economic project to reduce workplace absenteeism, and an internal political crusade against corruption. Gorbachev's initial reluctance to consider the market as a viable solution

y members, regardless of their own inclinations, that the Soviet Union would continue to reform within the framework of economic planning.

However, market-oriented Party members like Anatoly Chernyaev and Alexander Yakovlev exerted progressively greater influence over Gorbachev and official policy throughout the course of *perestroika* and would eventually force the Party to decisively determine whether the future of socialist reform would rely on market mechanisms or economic planning. Numerous ideologically motivated western scholars have attempted to portray the evolution of *perestroika* as an inevitable trajectory toward liberal capitalism, resulting from deficiencies inherent to the theoretical framework of socialist development, and frame those who opposed market reforms as detractors from *perestroika* itself. Robert Kaiser, correspondent for the Wall Street Journal and author of *Why Gorbachev Happened*, forms a narrative of *perestroika* with his journalistic experiences in the USSR of the late 1980s, arguing that the "Party conservatives" were lead by "a straight-laced Communist puritan, a believer in the contributions of earlier leaders from Stalin to Brezhnev" and were incapable of working toward reform in any capacity.[8] Secondary source accounts of *perestroika* and the Nina Andreeva affair, such as Archie Brown's *The Gorbachev Factor*, Ben Eklof's *Soviet Briefing: Gorbachev and the Reform Period*, and Joseph Gibbs' *Gorbachev's Glasnost: The Soviet Media in the First Phase of Perestroika* in particular, echo the sentiment that *perestroika* belonged solely to those Party members whose market-oriented policies would eventually lead to the restoration of capitalism. Unfortunately, both primary and secondary western sources have generally recreated one sided narratives of *perestroika* that rely on recol-

lections from market-oriented reformers and reject their opposition as neo-Stalinists, echoing the claims of Party members like Chernyaev and Yakovlev. In spite of the lack of thorough analysis surrounding planning-oriented reformers' historical contributions to perestroika , their stories, when put in conversation through the recollections of Party members as commonly explored in western scholarship, provide vital insight into the forces which brought about the demise of the Soviet Union and create the necessity for radically new historical interpretations of *perestroika* and its consequences.

Sovetskaya Rossiya's publication of the controversial Andreeva letter in March 1988 ignited a political struggle between two emerging rival factions within the CPSU over the nature of Soviet reform—the supporters of the Andreeva letter led by Yegor Ligachev and its opponents led by Mikhail Gorbachev. The Andreeva letter's instant popularity within the Party and throughout Soviet society indicated that its arguments voiced the concern of many planning-oriented reformers and their sympathizers. Contrary to the claims of western historians and market-oriented reformers, Andreeva's letter reiterated the necessity of reform in the USSR but did so while bringing attention to the contemporary media's liberal attacks on the historical achievements of Soviet culture and economy, the west's exploitation of these attacks for propagandistic purposes, and the ideological confusion that had resulted throughout the younger generations as a result. For Andreeva and her sympathisers, the letter's publication represented nothing more than a free political expression protected by the *perestroika* policy of *glasnost*.

Nevertheless, market-oriented Politburo members used the Andreeva letter as an opportunity to disenfranchise those who

Nina Aleksandrova Andreyeva (12 October 1938 – 24 July 2020) was a Soviet anti-revisionist, chemist, teacher, author, political activist, and a social critique of Mikhail Gorbachev's restructuring policies.

ported the polemic, accusing the letter, its author, and its supporters of neo-Stalinism, antisemitism, and taking part in a conspiracy to reverse *perestroika*. Yegor Ligachev recalls the events that lead to his demotion and disenfranchisement, as well as the repressive measures Gorbachev and his comrades utilized, which he describes as elements of a "political witch hunt" in his memoirs, *Inside Gorbachev's Kremlin*. Contrarily, Gorbachev and Chernyaev defend the one-sided imposition of "openness" in their memoirs, *Memoirs* and *My Six Years With Gorbachev* respectively. These memoirs, when analysed in a manner that does not take for granted the market-oriented interpretation of *perestroika*, reveal a bleaker side of the reformers' interpretation of democracy and openness—an interpretation which left little room for disagreement.

Gorbachev, Chernyaev, and other market reformers' response to Andreeva's letter manifested itself through two mediums: the Soviet media and the CPSU Politburo

Upon Gorbachev's return to the USSR from a diplomatic trip to Yugoslavia several days after the Andreeva Letter's publication, Chernyaev and Yakovlev informed him of the publication of what they termed an "anti-*perestroika* manifesto" and pushed for a decisive top-down response to the letter and its supporters.[9] Yakovlev immediately published a response to the Andreeva letter in *Pravda*, titled "Pravda Rebuts Antirestructuring Manifesto," attacking political opponents as perpetrators of stagnation and declaring his assertions to be the true Party line.

The market reformers' assault extended beyond the pages of *Pravda*. Following the publication of Yakovlev's article, Gorbachev had organized three Politburo meetings intended on weeding out support for the Andreeva letter and imposing extra-judicial consequences upon those who dissented. Political opposition to the market reformers virtually ceased to exist by the end of the third Politburo meeting, with Party members like Ligachev having been

demoted or fired for failing to reject the Andreeva letter. Gorbachev has published the transcripts for these meetings in his book, *Годы Трудных Решений* (*Years of Difficult Decisions*), providing historians with a primary source account of the meetings as they transpired. Gorbachev's transcripts, combined with his unapologetic account of the Nina Andreeva affair in *Memoirs*, reveal that the former General Secretary continued to justify his views as necessary to propel forward his interpretation of *perestroika*.

Neo-Stalinism and the "Anti-Perestroika Manifesto"

Market-oriented Party members' claim that economic planning was an outdated system allowed them to conflate its supporters with the fabricated camp of neo-Stalinism. Andreeva's letter suffered some of the earliest attacks meant to silence all resistance to the forces poised to overthrow socialism in the Soviet Union. These market elements in the CPSU and Soviet media, under the direction of Yakovlev, attacked the letter for "whitewashing Stalinism" and "trying to revise party decisions" in an at-

tempt to spread the notion that "the rejection of restructuring...is fraught with very serious costs...for the internal development of [their] society."[10] Although there was little doubt in any Soviet citizen's mind that the USSR required significant political and economic reform, the propagation of the liberal path as the *only* course *perestroika* could take necessarily marked the planning-oriented reformers as the conservative opposition, an obvious euphemism for their supposed backwardness. The market reformers' western sympathisers quickly echoed the same propaganda that accused "conservative" reformers of "fiercely defend[ing] Stalin" and "crediting [him] with 'bringing our country into the ranks of the great world powers.'"[11] Despite the fact that Andreeva mentions one of her relatives who was "repressed and rehabilitated [only] after the 20th Party Congress" and that she stood in solidarity with those who felt "the anger and indignation over the large-scale repressions that took place in the 1930s and 1940s through the fault of the Party and state leadership," the market reformers declared her an enemy of *perestroika* and attacked her call for a balanced appraisal of history as a pardon for state repression.[12] The cause of such vehement criti-

cism leveled at Andreeva and her like-minded comrades could not, therefore, originate as a response to the reemergence of Stalinist ideas. Rather, the reaction of the market reformers was an opportunistic maneuver in the ongoing process of delegitimation and wholesale rejection of the Soviet historical experience.

Several weeks after the publication of the Andreeva letter, a chorus of condemnation aimed at the "anti-*perestroika* manifesto" resounded across Soviet televisions and periodicals. Yakovlev's comrades—determined to frame those who disagreed with the course of *perestroika* as a hostile political conspiracy—intensified the defamation of the achievements of socialism in the media and dramatically increased political pressure on the letter's supporters. At an emergency Politburo meeting organized for March 24–25th, Gorbachev, after many months of neutrality regarding the escalating tension between Yakovlev and Ligachev, accused Andreeva of organizing an "anti-*perestroika* platform" and claimed that she publicized information that was "known only by a small circle of people."[13] Yakovlev was able to convince Gorbachev of the supposed anti-*perestroika* narrative on account of the letter's publication being a day before Gorbachev's diplomatic mission to Yugoslavia and Yakovlev's mission to Mongolia on March 14, 1988. Suspicions against Andreeva, Ligachev, and others further intensified when Ligachev held a meeting with Soviet newspaper editors on March 15, at which the attendees discussed the Andreeva letter and—according to western and dubious Soviet sources—Lig-

achev advocated for its reprinting in other Soviet media outlets.[14] These suspicions and accusations ultimately amounted to a campaign of repression which attempted to silence the majority opinion of the Party as well as the concerns of thousands of workers who identified with Andreeva's message.

While Yakovlev's manipulation of Gorbachev and the market reformers' attack on their political opposition were ultimately successful, closer examination suggests that their claim that Andreeva's letter comprised a premeditated, conpiratorial call to action against *perestroika* was unsound. Firstly, *Sovetskaya Rossiya* initially published Andreeva's letter in the polemics section of their periodical, a section unfit for political manifestos or Party declarations of any sort. It is unlikely any Soviet citizen listening to the state media, a forum in which the CPSU explicitly labels its statements as the Party line, would have thought such a polemical letter could represent an official shift in the reform policy of the Party. Yakovlev, nevertheless, publicly attacked the article as an attempt to confuse the masses and assert a new Party policy of reversing *perestroika* in his *Pravda* article "Pravda Rebuts 'Anti-*Perestroika* Manifesto.'"[15] According to Ligachev, many Party members—those who would soon face sanctions or dismissal as a result of Yakovlev's fear-mongering—actually thought the letter "was a manifestation of *glasnost*, of democratism" and that such trends should be encouraged alongside healthy self-criticism in the newly emerging Soviet society.[16] Indeed, the letter's in

formal prose and historical inaccuracies suggest it was a manifestation of unabated speech rather than a coordinated attack on *perestroika*. For one, Andreeva incorrectly attributes a statement about Stalin, uttered by Polish writer and political activist Isaac Deutscher, to Winston Churchill:

He was a man of outstanding personality who left an impression on our harsh times, the period in which his life ran its course. Stalin was a man of extraordinary energy, erudition and inflexible will, blunt, tough and merciless in both action and conversation, whom even I, reared in the British Parliament, was at a loss to counter.[17]

No carefully written and revised political manifesto would contain such a mistake, and it would be quite difficult to convincingly suggest that such mistakes could serve an ulterior motive. Moreover, nowhere in the letter does Andreeva call for the return of old societal norms or for opposition to *perestroika*, only for a reevaluation of how to best carry out reform policies without undermining socialism and the historical experience of the Soviet Union. The fact that Andreeva's letter merely outlined what she saw as the contemporary problems of *perestroika* and hinted at how to overcome them, therefore, contradicts the assertion that it attempted to encourage opposition to reform in general.

Yakovlev's comrades in the Party and media not only claimed that Andreeva's polemic was a premeditated attempt to overthrow *perestroika*, but even more fantastically, that there existed an anti-*perestroika* conspiracy led by Andreeva and Ligachev, aided by Valentin Chikin and Victor Afanasiev, the editors of *Sovetskaya Rossiya* and *Pravda*, respectively. Most suspicion of such a conspiracy materialized out of Ligachev's meeting with Chikin and other media officials following the depar-

ture of Gorbachev and Yakovlev on political missions. However suspicious this meeting may have appeared at the time, Ligachev, in his memoirs, explains that "in general, such meetings were planned in advance, and Central Committee divisions prepared for them by studying publications...so it was in this case...it had been scheduled a week before the publication of Andreeva's letter."[18] This meeting's discussion did not even focus on the Andreeva letter, but briefly touched upon its publication amidst a number of other pressing media subjects that comprised the agenda. Every Party member was, therefore, informed in advance of Ligachev's apparently insidious meeting which comprised part of his duties as Secretary of Ideology, making it very unlikely to have been a springboard for a political conspiracy. Afanasiev, who was later condemned by the Politburo for being complicit in what Yakovlev saw as political conspiracy, even demonstrated his political neutrality by later publishing Yakovlev's article in *Pravda* attacking the Andreeva letter. If Chikin, Afanasiev, and Ligachev had truly conspired with Andreeva against *perestroika* policies, why should their purportedly suspicious activities be the very duties that the reforming Party itself had delegated to them?

Many market-oriented Party members and onlookers who believed the rumors of political conspiracy further asserted that the conspirators had planned for the letter's publication and reprinting in other major Soviet periodicals at Ligachev's meeting with media officials. Yakovlev and western historians assert that "although he was later to deny that he [Ligachev] had anything to do with the Andreeva letter until after it had appeared, the weight of evidence suggests that he was involved both before and after."[19] While Ligachev did praise the article as a manifestation of a previously unvoiced

popular opinion, no meeting transcripts or Party members who worked closely with the Secretary of Ideology have verified this accusation as anything more than hearsay. In fact, Gorbachev, who at this point retained a deep distrust for Ligachev and supporters of the Andreeva letter, claimed to have thought rumors of Ligachev's intent to reprint the letter to be ludicrous, stating "there will be no need for any investigation" when Ligachev himself insisted on one.[20] Perhaps, in typical obscurantist fashion, Gorbachev's refusal to call for an investigation was but another means to legitimize, or prevent the delegitimation of, the claim to conspiracy.

Further, it is possible, but unverifiable, that more liberal periodical editors were determined to attack Ligachev with accusations they knew to be false. The first and most significant hysteria surrounding the claim that Ligachev published and reprinted the polemic occurred after one of the consultants who prepared the Andreeva letter for publication, Valery Denisov, wrote an article in the magazine publication *Rodina* titled "Backing Perestroika with Stalin." In his article, Denisov accused Ligachev of having Chikin provide him with a photocopy of Andreeva's letter, via a telephone

conversation "with Ligachev [which] had only just taken place."[21] Denisov later in the article claimed that Ligachev underlined sections of the letter which he deemed most important, consequently accusing Ligachev of having something to do with the letter's publication. If Chikin had truly brought Denisov the letter directly after a telephone conversation with Ligachev, then it would have been impossible for Ligachev to have handwritten the underlines in his copy of the letter. This logical inconsistency, among others in the article, suggest that Denisov may have been echoing a fabricated story provided to him by one or more of Ligachev's political opponents rather than inaccuracies derived from a poor memory. At any rate, Denisov's recollections, as well as other sources based on hearsay, fail to comprise the "weight of evidence" that Brown claims incriminates Ligachev in a political conspiracy.

Although Andreeva's letter appeared in *Sovetskaya Rossiya*'s polemical section and hardly gives precedent to accusations of political conspiracy, the memoirs of Yakovlev's constituency continue to maintain that Ligachev attempted to obscure the Party line, providing factually unsound primary sources for ideologically anti-Soviet

historians. In agreement with Denisov's contradictory article, Anatoly Chernyaev claims that Ligachev did not merely edit the letter, as Denisov states, but that he sent "a team to Leningrad, where she lived, to turn the letter into an article taking up a whole newspaper column."[22] There is no documentary evidence or consistent verbal source to confirm that Ligachev and Andreeva had any interaction before or after the letter's publication. Transcripts of later Politburo meetings illustrate a hostile Party atmosphere in which Ligachev and other planning-oriented reformers were ostracised for simply voicing their support for the letter's ideological content. And yet, Chernyaev further accuses Ligachev of having "trumpeted the article at a Central Committee meeting with newspaper editors, in effect saying 'This is the new Party Line.'"[23] As Secretary of Ideology, Ligachev had no authority to make arbitrary declarations on Party lines that were traditionally formed collectively, and Party members must have been aware of the protocols surrounding this practice. Consequently, Politburo members who supported the letter democratically voiced their opinions at routine meetings that soon became arenas of denunciation and purges. The market reformers' accusations regarding the distortion of the Party line amounted to nothing more than a fear that their conception of *perestroika* would come under popular criticism from all levels of the CPSU.

Despite the various contradictions connected to the claim that Andreeva's letter constituted a premeditated political conspiracy, western historians continue to echo the market reformers' narrative of the Andreeva letter. Archie Brown, prominent British anti-Soviet Cold War historian, continues to defend the claim that the Andreeva letter was "professionally rewrit-

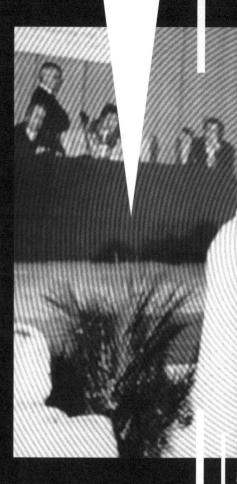

Upholding the Science

Neena Andreeva speaking in from of portraits of both Lenin and Stalin. the Science. Andreeva was instrumental in Gorbachev's explusion from the CPSU in September of 1991.

ten...in consultation with officials in the Central Committee apparatus" and "was an attack on the main thrust of Gorbachev's reforms."[24] Seeing as most of Brown's work was published before the end of the 1990s and, therefore, remains firmly within the backdrop of Cold War ideology, it is not surprising to find such claims, unsubstantiated by primary source evidence, presented as fact. Indeed, it is true that Andreeva sent her letter to be edited by members of the Party Central Committee, as was typical for citizens who hoped to publish extensive treatises in Party newspapers. However, the duty of shortening and editing the letter fell to unnamed bureaucrats who were employed to prepare polemics for mass consumption in newspapers—articles that "members of the Politburo and Central Committee...[were] in no position to study."[25]

Robert Kaiser, a western historian who travelled to the Soviet Union in the 1980s and saw these events transpire firsthand, also reinforces the claim that "Ligachev had used the occasion of Gorbachev and Yakovlev's absence from Moscow to launch what one Soviet official later called "an uprising against Gorbachev and *perestroika*."[26] Shockingly, Kaiser follows these statements by stating, "my sources were not the key participants, but people with access to some of them. Their information was incomplete, and could have been wrong in some details."[27] With numerous contradictions between these rumor-based assertions regarding political conspiracy and the fact that Ligachev, Chikin, and Andreeva's activities represented nothing out of the ordinary in the Soviet media, it is not surprising, though telling, that Kaiser would admit to the lack of reliable evidence supporting the claim that these commu-nists were trying to overthrow *perestroika*.

Western scholarship also claimed Andreeva's letter had antisemitic undertones that reflected the entire "political conspiracy's" political disposition. Scholars like Brown and Kaiser viewed the letter as an echo of ideological tendencies prevalent during the Cosmopolitan Campaigns of the early 1950's. Whether these campaigns were in fact facilitated by antisemitic policies or not, as most western historians claim, the term cosmopolitan to most Soviet citizens was not simply a codeword for a citizen of Jewish descent and Soviet law punished Antisemitism with imprisonment. Andreeva is no different than most Soviet citizens in this respect, as she criticized the "cosmopolitan tendency...held by the 'left-liberals'" to deny the significance of one's nationality on the stage of historical development.[28] Andreeva anecdotally targeted Leon Trotsky in her denunciation of cosmopolitanism not on account of his Jewish descent, but because he was someone who was denounced by the CPSU on grounds unrelated to his nationality. She, immediately following her attacks on cosmopolitanism, denounced "neo-Slavophiles" and "traditionalists" who defend nationalist conceptions of "peasant socialism"—a historically antisemitic and anti Bolshevik political tendency.[29] Andreeva clearly believed that it was important to not engage in "any disparagement of the historical contribution of other nations and nationalities," articulating her anti-cosmopolitan position from the perspective of a planning-oriented reformer, not as a Russian nationalist.[30]

Nevertheless, Brown accuses Andreeva of blaming "Jews for most of Russia's troubles" based on his observation that "of the several people of Jewish origin mentioned in her article, the only one to escape criticism was Karl Marx."[31] Sovietologist Ben

Eklof likewise charges the Andreeva letter with being "packed with anti-semitism" and "patriotic xenophobia" without elaboration or even citing the letter's content.[32] For the analyses of historians such as Brown and Eklof, anti-Soviet Cold War ideology had sabotaged any vestige of the letter's fair appraisal and continued to perpetuate anti-communism without sufficient research into what had actually transpired.

The irony of the market reformers' attempts to frame Andreeva's letter as a conspiratorial coup d'etat against democratic reform was that the letter, discussions on its significance, and the openly divided opinion within the Politburo, all represented manifestations of *glasnost*. Not only did Party members like Gorbachev and Yakovlev suppress these consequences of *glasnost* policy, but they themselves bragged about how great the Andreeva letter was a manifestation of new freedoms. Gorbachev spared no time to point out, at a Politburo meeting called after his return from Yugoslavia, that "the publication of Nina Andreyeva's article was only made possible by *perestroika* and *glasnost*."[33] Although he "strongly disagreed" with Politburo members who supported the letter, Gorbachev declared his intention of operating "within the framework of a democratic process."[34] Despite his crusade against what he considered to be neo-Stalinism and his call for communists to be true to their principles, Gorbachev himself contradicted his declared principle of *glasnost* by undemocratically silencing Ligachev's opposing ideological current within the CPSU. Chernyaev echoed his sentiments at the same Politburo meeting while later calling for some of the harshest penalties against Ligachev. The admissions from market reformers like Gorbachev and Chernyaev that the Andreeva letter had been a manifestation of *glasnost*, and their concurrent

decision to treat its supporters as renegades, indicates that their political maneuvering was driven more by opportunism than their own supposed principles.[35]

ENDNOTES

1 Anatoly S. Chernyayev, *My Six Years With Gorbachev* (University Park, Pennsylvania: The Pennsylvania State University Press, 2000), 156.

2 Victor Perlo, *Super Profits and Crises: Modern U.S. Capitalism* (New York: International Publishers, 1988), 491.

3 Roger Keeran & Thomas Kenny, *Socialism Betrayed: Behind the Collapse of the Soviet Union* (New York, New York: International Publishers, 2003), 52, 53, 74.

4 *Ibid.*, 75.

5 Roger Keeran & Thomas Kenny, *Socialism Betrayed: Behind the Collapse of the Soviet Union* (New York, New York: International Publishers, 2003), 52, 53, 74.

6 Yuri Andropov, "Speech to a plenum of the CPSU Central Committee", November 22, 1982.

7 Albert Resis, ed., *Molotov Remembers: Inside Kremlin Politics* (Chicago, Illinois: Ivan R. Dee, 1993), 360.

8 Robert C. Kaiser, *Why Gorbachev Happened: His Triumphs and His Failures* (New York, New York: Simon & Schuster, 1991), 206.

9 "Pravda Rebuts 'Antirestructuring Manifesto'", *Current Digest of the Soviet Press XL*, No. 14, 1988, pg 1.

10 "Pravda Rebuts 'Antirestructuring Manifesto'", *Current Digest of the Soviet Press XL*, No. 14, 1988, pg 1.

11 Robert C. Kaiser, *Why Gorbachev Happened*, 204.

12 Nina Andreeva, "I Cannot Renounce My Principles", in *The Soviet System: From*

Crisis to Collapse", ed. Alexander Dallin and Gail W. Lapidus (San Francisco, California: Westview Press, 1991), 291.

13 Mikhail Gorbachev, *Годы Трудных Решений* (Moscow, Russia: Alpha Print, 1993), 99.

14 Archie Brown, The Gorbachev Factor (New York, New York: Oxford University Press, 1996), 173.

15 "Pravda Rebuts 'Antirestructuring Manifesto'", *Current Digest of the Soviet Press XL*, No. 14, 1988, pg 2.

16 Ligachev, *Inside Gorbachev's Kremlin*, 305.

17 Nina Andreeva, "I Cannot Renounce My Principles" in *The Soviet System: From Crisis To Collapse*, 291.

18 Ligachev, *Inside Gorbachev's Kremlin*, 301.

19 Brown, *The Gorbachev Factor*, 173.

20 Mikhail Gorbachev, *Memoirs* (New York, New York: Bantam Doubleday Dell Publishing, 1995), 253.

21 Ligachev, *Inside Gorbachev's Kremlin*, 300.

22 Chernyaev, *My Six Years With Gorbachev*, 154.

23 *Ibid*.

24 Brown, *The Gorbachev Factor*, 172.

25 Ligachev, *Inside Gorbachev's Kremlin*, 300.

26 Kaiser, *Why Gorbachev Happened*, 206.

27 *Ibid*.

28 Nina Andreeva, "I Cannot Forsake My Principles", 294.

29 *Ibid*., 295.

30 *Ibid*., 294

31 Brown, *The Gorbachev Factor*, 172.

32 Ben Eklof, *Soviet Briefing: Gorbachev and the Reform Period*, 29.

33 Gorbachev, *Memoirs*, 252.

34 Gorbachev, *Memoirs*, 252.

35 Chernyayev, *Shest Let S Gorbachovom*, 159.